Photo·pedia

The Ultimate Digital Photography Resource

que®

800 East 96th Street,
Indianapolis, Indiana 46240

Photopedia: The Ultimate Digital Photography Resource

Copyright © 2008 by Michael Miller

ISBN-10: 0-789-73725-6

ISBN-13: 978-0-789-73725-0

Library of Congress Cataloging-in-Publication Data
Miller, Michael, 1958-
 Photopedia : the ultimate digital photography resource / Michael Miller. -- 1st ed.
 p. cm.
 Includes index.
 ISBN 0-7897-3725-6
 1. Photography--Digital techniques--Handbooks, manuals, etc. I. Title.
 TR267.M5843 2007
 775--dc22
 2007047261

Printed in the United States of America

First Printing: December 2007

Trademarks

Warning and Disclaimer

Bulk Sales

Que Publishing offers excellent discounts on this book when ordered in quantity for bulk purchases or special sales. For more information, please contact

U.S. Corporate and Government Sales
1-800-382-3419
corpsales@pearsontechgroup.com

For sales outside of the U.S., please contact

International Sales
international@pearsoned.com

This Book Is Safari Enabled

This Book Is Safari Enabled

The Safari® Enabled icon on the cover of your favorite technology book means the book is available through Safari Bookshelf. When you buy this book, you get free access to the online edition for 45 days.

Safari Bookshelf is an electronic reference library that lets you easily search thousands of technical books, find code samples, download chapters, and access technical information whenever and wherever you need it.

To gain 45-day Safari Enabled access to this book:

• Go to http://www.quepublishing.com/safarienabled.

• Complete the brief registration form.

• Enter the coupon code SRA4-GZKB-UVQN-KXCN-EW94.

If you have difficulty registering on Safari Bookshelf or accessing the online edition, please email customer-service@safaribooksonline.com.

Associate Publisher
Greg Wiegand

Acquisitions Editor
Michelle Newcomb

Development Editor
Laura Norman

Managing Editor
Patrick Kanouse

Project Editor
Seth Kerney

Copy Editor
Geneil Breeze

Indexer
Tim Wright

Proofreader
Leslie Joseph

Technical Editors
Robyn Ness
Matthew S. Thomas

Photo Editor
Sherry Elliott

Publishing Coordinator
Cindy J. Teeters

Book Designer
Anne Jones

Page Layout
Bronkella Publishing, LLC

Contents at a Glance

Table of Contents

About the Author

Michael Miller has written more than 75 nonfiction how-to books over the past 20 years, including Que's *iPodpedia: The Ultimate iPod and iTunes Resource, Googlepedia: The Ultimate Google Resource, Absolute Beginner's Guide to Computer Basics, Absolute Beginner's Guide to eBay, YouTube 4 You,* and *Bad Pics Fixed Quick.*

Mr. Miller has established a reputation for clearly explaining complex topics to everyday readers, and for offering useful real-world advice about complicated topics. More information can be found at the author's website, located at www.molehillgroup.com.

Dedication

To Sherry—you made this project possible, and fun.

Acknowledgments

All books are group projects to some extent, but this one more than most. The cast of characters necessary to create the words and pictures on these pages is large and talented, and they all deserve appreciation.

I'll start by thanking the usual suspects at Que, including but not limited to Greg Wiegand, Michelle Newcomb, Laura Norman, Seth Kerney, and Geneil Breeze. Thanks as well to the book's technical editors, Robyn Ness and Matthew S. Thomas, who helped ensure the accuracy of what you see here.

Many thanks are due to all the photographers who contributed their pictures to this book. These are a talented mix of pros, semi-pros, and amateurs from a dozen different countries, and include Barb Anderson, Richelle Antipolo, Iorenza Bolla, Steve Cain, Therese Carlson, Amy Elliott Christensen, Jurek Durczak, Alexandre Duret-Lutz, Dawn Endico, Richard French, Christopher Guilmet, Barrett Hall, Dennis Hauser, David Israel, Rebecca Key, Jay Lammers, Kristi Lee, Tof Lee, TC Lin, Andrew Magill, Matthew McKnight, Chad Miller, David Poe, David Prior, Matt Purcell, Michael Reinhart, Nina Ricci, Gerry Rosser, Ivonne Seide, Hans Splinter, Matthew Storz, Tom Taintor, Ms. Kazue Tanaka, Matthew S. Thomas, Francisca Ulloa, Daniel Ullrich, Greg Wiegand, Steven Wilke, and Zixi.

Thanks as well to the many people who modeled for these photos—especially (but not exclusively) Kevin Barnard, Courtney Bombardo, Stephanie Cain, Chris Carney, Reeves Cary, Ian Ryley Curry, Amy Elliott Christensen, Collin Christensen, Greg Eiden, Ben Elliott, Laura Elliott, Mark French, Norma French, Elizabeth Gardner, Maya Gilbert, Teressa Grega, Alec Hauser, Ben Hauser, Melanie Hauser, Bill Hellenberg, Tessie Henderson, David Israel, Lisa Johnson, Mallory Lammers, Joe Laskey, Alethia Lee, Elodie Lee, Kristi Lee, Tof Lee, Jody McCormick, Mark Miller, Norman Miller, Pat Miller, Stephanie Miller, Christine Olson, Mike Richards, Brett Smith, Kirsten Solem, and Jenna Sund. And, representing the pet world, Kaylee and Phil.

Finally, special thanks to my photo editor and soulmate, Sherry Elliott. Sherry's job was to round up all the photos used in this book and to take any photos necessary to illustrate specific techniques. As you can tell from the results, she went above and beyond the call of duty. Sherry, you have my heartfelt appreciation for all the work you put into this project—and for always being there for me.

Photo Credits

The following individuals contributed photographs to this book, all of which are copyrighted by the respective photographers:

Barb Anderson (Vadnais Heights, Minnesota, USA): 26.10

Steve Cain (Brookston, Indiana, USA): 24.5

Therese Carlson (Burnsville, Minnesota, USA): 10.33

Amy Elliott Christensen (Apple Valley, Minnesota, USA): 23.13

Sherry Elliott (Apple Valley, Minnesota, USA): 1.3, 4.8, 4.9, 4.10, 4.11, 4.12, 4.13, 4.14, 4.15, 4.16, 4.18, 4.19, 4.20, 4.21, 4.24, 4.25, 5.6, 5.7, 5.10, 5.11, 5.12, 5.13, 5.14, 5.15, 5.16, 5.18, 5.21, 8.5, 8.6, 8.7, 9.3, 9.7, 9.8, 9.10, 9.11, 9.12, 9.13, 9.14, 10.4, 10.5, 10.8, 10.9, 10.10, 10.11, 10.17, 10.18, 10.19, 10.24, 10.25, 10.26, 10.27, 10.28, 10.29, 10.30, 10.31, 10.32, 11.2, 11.3, 11.4, 11.5, 11.6, 11.10, 11.11, 11.12, 11.13, 11.14, 11.16, 11.17, 11.24, 12.3, 12.5, 12.7, 12.9, 13.5, 13.7, 14.1, 14.2, 14.3, 14.6, 14.7, 14.8, 14.9, 18.15, 18.16, 20.1, 20.2, 20.3, 20.4, 20.5, 20.6, 20.9, 20.10, 20.11, 20.13, 20.15, 20.17, 20.18, 20.20, 20.22, 20.24, 20.25, 20.26, 20.27, 20.29, 20.30, 20.31, 20.33, 21.2, 21.3, 21.4, 21.5, 21.7, 21.8, 21.9, 21.10, 21.14, 21.15, 22.2, 22.3, 22.4, 22.6, 22.7, 23.1, 23.4, 23.17, 24.3, 24.9, 25.1, 25.7, 25.8, 25.11, 26.1, 26.7, 26.8, 26.11, 27.3, 27.8, 27.10, 27.11, 27.12, 27.14, 27.15, 28.3, 28.6, Part II opening, Part IV opening

Dennis Hauser (Glen Ellyn, Illinois, USA): 12.11

David Israel (Esher, Surrey, UK): 28.7, 28.8

Jay Lammers (Apple Valley, Minnesota, USA): 20.32

Tof and Kristi Lee (Winona, Minnesota, USA): 22.9, 23.12, Part V opening

Michael Miller (Carmel, Indiana, USA): 4.17, 8.8, 8.9, 9.5, 9.6, 10.6, 10.7, 10.13, 10.20, 10.21, 10.22, 10.23, 10.34, 11.7, 11.8, 11.9, 12.12, 13.1, 13.6, 13.8, 13.9, 14.4, 14.5, 16.2, 18.11, 18.13, 19.16, 19.18, 19.20, 19.21, 19.24, 20.37, 21.1, 21.12, 21.13, 22.5, 22.8, 22.13, 22.14, 22.15, 22.16, 22.17, 23.10, 23.15, 23.16, 24.10, 24.11, 25.9, 25.12, 28.1, Part VIII opening

Matt Purcell (Indianapolis, Indiana, USA): 12.8

Tom Taintor (Apple Valley, Minnesota, USA, www.flickr.com/photos/89262193@N00/): 20.28, 21.6, 22.1, 22.10, 22.11, 22.12, 23.2, 23.3, 23.5, 23.6, 23.7, 23.9, 23.14, 23.18, 23.19, 25.6, 28.2, 28.5, Part III opening

Matthew S. Thomas (Maui, Hawaii, USA): 10.15

Greg Wiegand (Indianapolis, Indiana, USA): 19.4

The following individuals provided photographs to this book under the Creative Commons Attribution license (www.creativecommons.org), and retain copyright to their respective works:

Richelle Antipolo (Conway, Arkansas, USA, www.flickr.com/photos/richelleantipolo/): 24.7

Iorenza Bolla (Milan, Italy, www.flickr.com/photos/lbolla/): 28.4

Jurek Durczak (Lublin, Poland, www.flickr.com/photos/jurek_durczak/): 12.4, Part VII opening

Alexandre Duret-Lutz (Paris, France, www.flickr.com/photos/gadl/): 27.4

Dawn Endico (Menlo Park, California, USA, www.flickr.com/photos/candiedwomanire/): 25.13

Christopher Guilmet (Seattle, Washington, USA, www.flickr.com/photos/70577065@N00/): 25.3

Barrett Hall (Cambridge, Massachusetts, USA, www.flickr.com/photos/barretthall/): 24.6

Rebecca Key (Manchester, UK, www.flickr.com/photos/rebeccakey/): 27.6

TC Lin (Hsin-tien, Taiwan, www.poagao.org, www.flickr.com/photos/poagao/): 26.11

Andrew Magill (Boulder, Colorado, USA, www.flickr.com/photos/amagill/): 26.5

Matthew McKnight (Dublin, Ireland, www.flickr.com/photos/helios04/): 25.10

Chad Miller (Winter Park, Florida, USA, www.flickr.com/photos/chadmiller/): 25.4, Part I opening

David Poe (New York City, New York, USA, www.flickr.com/photos/mockstar/): 21.11

David Prior (Stockton, Suffolk, UK, www.flickr.com/photos/davidprior/): 24.8

Michael Reinhart (Edmonton, Alberta, Canada, www.flickr.com/photos/mykl/): 25.5

Nina Ricci (Pesaro, Italy, www.flickr.com/photos/ninette_luz/): 20.7

Gerry Rosser (Cape Cod, Massachusetts, www.flickr.com/photos/twoblueday/): 23.8, Part VI opening

Ivonne Seide (Berlin, Germany, www.flickr.com/photos/positiv/): 27.9

Hans Splinter (Alphen aan den Rijn, Netherlands, www.flickr.com/photos/archeon/): 12.6

Matthew Storz (Eau Claire, Wisconsin, USA, www.flickr.com/photos/mstorz/): 24.4

Ms. Kazue Tanaka (Tokyo, Japan, www.flickr.com/photos/28481088@N00/): 23.11

Francisca Ulloa (Santiago, Chile, www.flickr.com/photos/alosojos/): 27.7

Daniel Ullrich (Dorsten, Germany, www.flickr.com/photos/threedots/): 26.9

Steven Wilke (College Station, TX, USA, www.flickr.com/photos/stevenwilke/): 24.1

Zixi (England, www.flickr.com/photos/zixi/): 27.5

star5112 (San Francisco, California, USA, www.flickr.com/photos/johnjoh/766344553/)

The following companies provided photographs of their products to this book, all of which are copyrighted and used via permission of the respective companies:

Bowens International Limited: 11.19

Canon U.S.A., Inc.: 2.7, 3.2, 9.4

Cokin S.A.S.: 9.2

Cullmann Foto-Audio-Video GmbH: 6.3, 6.9

Datacolor: 2.10

Eastman Kodak Company: 2.10, 4.7, 6.14

Eizo Nanao Corporation: 2.3

Epson America, Inc.: 2.8, 6.13,

Fujifilm U.S.A., Inc.: 3.1

Gateway, Inc.: 2.2

Gruppo Manfrotto S.r.I.: 6.8

Hewlett-Packard Development Company, L.P.: 2.9

Interfit Photographic Limited: 11.20

Lexar Media, Inc.: 2.5

Lowepro USA: 6.4, 6.5, 6.6

Nikon, Inc.: 3.3, 4.1, 4.2, 4.3, 4.4, 4.5, 5.1, 5.2, 5.3, 5.4, 5.5, 5.8, 5.19, 5.20, 6.1, 6.11, 7.2, 7.3, 8.11, 11.15, 26.2

Olympus Corporation: 26.4

Op/Tech USA: 6.2

Photogenic Professional Lighting: 11.21, 11.23

Pioneer Research: 3.4

Seiko Epson Corp.: 2.1

Sekonic: 6.10

Smith-Victor Corporation: 11.18, 11.22

Sony Electronics, Inc.: 3.6, 8.10

Spectrum Brands, Inc.: 7.1

SR Inc.: 26.3

The Tiffen Company: 6.7, 9.1

Wacom Company, Ltd.: 2.6

Western Digital Corporation: 2.4

The author and the publisher thank all the individuals and companies who graciously allowed us to use their photographs in this book.

We Want to Hear from You!

As the reader of this book, *you* are our most important critic and commentator. We value your opinion and want to know what we're doing right, what we could do better, what areas you'd like to see us publish in, and any other words of wisdom you're willing to pass our way.

As an associate publisher for Que Publishing, I welcome your comments. You can email or write me directly to let me know what you did or didn't like about this book—as well as what we can do to make our books better.

When you write, please be sure to include this book's title and author as well as your name, email address, and phone number. I will carefully review your comments and share them with the author and editors who worked on the book.

Email: feedback@quepublishing.com

Mail: Greg Wiegand
Associate Publisher
Que Publishing
800 East 96th Street
Indianapolis, IN 46240 USA

Reader Services

Visit our website and register this book at www.quepublishing.com/register for convenient access to any updates, downloads, or errata that might be available for this book.

Introduction

If you're like most Americans (indeed, like most residents of civilized countries today), you own at least one digital camera. It may be an easy-to-carry point-and-shoot model, a fancy-shmancy (and quite expensive) digital SLR, or it may be something in-between. Maybe you purchased it a few years ago, when it meant a lot to have megapixel capacity, or more recently when even the lowest-priced models shoot pictures of 5 megapixel or higher resolution. Your camera may be a Canon or a Fuji or a Kodak or a Nikon or a Sony; it may be black or silver or even pink.

The point is, you have a digital camera, and you use it—probably a lot. You use it to shoot vacation pictures and graduation pictures and pictures of your growing family and your closest friends. You use it to shoot candid photographs and formal portraits, practical pictures of items you sell on eBay, and pretty pictures of the flowers in your garden. If you took the time to look, you'd find hundreds if not thousands of digital photographs stored on your computer's hard disk, with that number growing weekly.

In short, you take a lot of photographs with your digital camera. But are all those *great* photographs—or are many of them somehow less than ideal?

If your photos seldom turn out picture perfect, count yourself in the majority. Whether you're a casual photographer, a dedicated hobbyist, or an aspiring professional, it's difficult to take consistently good photos. There's always something that can go wrong—too much shadow here, too much light there, bad color from indoor lighting, poor composition, blurry images, red-eyed subjects, you name it. It's not that you don't try to take good photos, it's just that things don't always work out right.

That's where this book comes in. *Photopedia: The Ultimate Digital Photography Resource* is designed to be your guide to creating better digital photos. Whether you take the occasional holiday snap or tons of artistic shots, you'll benefit from the techniques discussed here. The steps to taking better photographs, after all, are accessible to anyone.

The first step toward taking better photos is to better understand your camera and the whole digital photography process. Did you know, for example, that your camera probably has a special mode just for shooting sports and action photos? Or that you can adjust your camera's aperture and shutter speed manually? Or that you can attach a filter to improve the colors in your photographs? I bet you didn't, but that information is exceedingly useful.

The next step, and perhaps the most important, is learning how to take specific types of photographs. What do you need to do to take the perfect portrait? What camera settings result in the best action shots? How do you compose great-looking landscape photos? You don't have to reinvent the wheel; all this information exists, and it's all in this book.

Finally, know that not every photograph is created perfectly in the camera. Sometimes a little post-camera manipulation is necessary to fix small errors or turn an average shot into an above-average one. That means mastering the tools in your favorite photo editing program, such as Adobe Photoshop Elements or Photoshop CS. Do you know how to crop a photo for better composition? Or use levels to punch up a shot's brightness and contrast? Or use

the Clone Stamp tool to remove unwanted elements from an image? If you want to fine-tune your photos for best effect, you need to learn these techniques.

And that's what this book is about. I'll lead you step-by-step from the basics of selecting a camera through what you need to create top-flight photo prints, and everything in-between. It doesn't matter what type of digital camera you have, either; you can use the techniques and advice presented in this book to get great results from an inexpensive point-and-shoot camera just as well as you can from a high-end digital SLR. A good photo is a good photo, after all, no matter what kind of equipment you have.

That said, I do have a bias towards getting the picture right in the camera, rather than fixing it after-the-fact in Photoshop. As powerful as Photoshop is, you can only fix so much; you get much better results when you employ time-proven photographic techniques to take better pictures from the start. It's easy to do a quick touchup on a picture that was composed and exposed properly. It's much harder to try to salvage a poorly-shot photo.

The bottom line is this: Anyone can take great photographs, if you know the right things to do. I show you those things in this book, and then you can take the photographs.

What's in This Book

Photopedia: The Ultimate Digital Photography Resource is a comprehensive guide to all aspects of digital photography—from choosing a camera to composing the shot all the way through printing or displaying the photograph on the Web. After all, a lot is involved in taking a good picture, so this book has to cover a lot of ground.

To that end, this book contains 30 chapters of information, organized into 8 major sections:

- **Part I, "Understanding Digital Photography,"** is an introduction to how digital camera photography works. You'll learn about how a digital camera takes pictures, and how those pictures are edited and enhanced in the digital darkroom.

- **Part II, "Digital Camera Essentials,"** contains everything you need to know about choosing and using a digital camera. You'll learn all about the three major types of digital cameras in use today—point-and-shoot cameras, prosumer cameras, and the increasingly popular digital SLR cameras.

- **Part III, "Digital Camera Accessories,"** shows you what you need to get the most out of your digital camera. You'll learn about all the various types of camera accessories, as well as how to extend your camera's battery life, use different types of lenses, and enhance your lenses with different lens filters.

- **Part IV, "Photography Essentials,"** is a detailed guide to basic photographic techniques. I'm talking about the things that every photographer needs to know and master: composition, lighting and flash, color, exposure, and focus and depth of field. This is important stuff, even for casual photographers.

- **Part V, "Transferring and Managing Photos,"** is a short section that shows you what to do with your photos after you've taken them—that is, how to get your photos from your camera to your computer and manage them after they're there.

- **Part VI, "Digital Photo Editing,"** is the Photoshop section. Turn to the chapters in this part when you want to choose a photo editing program, and then edit and enhance your photos. It's all covered, from basic cropping and red eye removal to advanced editing and special effects.

- **Part VII, "Digital Photography Techniques,"** puts it all together, both in the camera and on your computer, to show you how to create specific types of photographs. This section takes a holistic approach, starting with step-by-step camera techniques and including the most common Photoshop enhancements. You'll learn how to create all sorts of photos: portraits, candids, travel and vacation shots, landscapes and nature photos, sports and action shots, still life photos, and black-and-white shots. You'll even learn how to shoot in special conditions, such as at night or underwater. Turn here to learn how to shoot great photos of any type.

- **Part VIII, "Photo Printing and Sharing,"** puts a bow on the entire package by showing you what to do with the photos you create. Want to create great photo prints? The information's here. Want to send your photos via email to family and friends? Also here. Want to post your photos to the Web? Ditto.

And when you're finished reading the body of the book, or if you just run across a term you're unfamiliar with, turn to the book's appendix, which is a detailed glossary of common photographic terms. If you don't know an aperture from a zoom lens, you can find out what's what here.

Who Can Use This Book

Photopedia can be used by any level or type of photographer; it doesn't matter whether you have a point-and-shoot camera or a digital SLR, the information and advice still applies. In fact, I've specifically tried to provide instructions and examples that can be used by even the most casual photographer, using any type of digital camera.

Of course, you will need a digital camera, as well as a photo editing program of some kind. While the pros like the somewhat expensive Photoshop CS software, the techniques presented here can be easily adapted to work with just about any software. Then, with digital camera and photo editing program at the ready, you're ready to start shooting!

How to Use This Book

I hope that this book is easy enough to read that you don't need instructions. That said, there are a few elements that bear explaining.

First, there are several special elements in this book, presented in what we in the publishing business call "margin notes." There are different types of margin notes for different types of information, as you see here.

This is a tip that might prove useful for whatever it is you're in the process of doing.

This is a caution that something you might accidentally do might have undesirable results.

In addition, all chapters end with a bit of personal commentary, presented in the form of a sidebar. These sections are meant to be read separately, as they exist "outside" the main text. And remember—these sidebars are my opinions only, so feel free to agree or disagree as you like.

Obviously, there are lots of web page addresses in the book, like this one: www.molehillgroup.com. When you see one of these addresses (also known as URLs), you can go to that web page by entering the URL into the address box in your web browser. I've made every effort to ensure the accuracy of the web addresses presented here, but given the ever-changing nature of the Web, don't be surprised if you run across an address or two that's changed. I apologize in advance.

About the Photographs in This Book

This is a long book, but fortunately the text is broken up and illustrated by lots of great photographs. The photos come from a number of different photographers, both amateur and professional; they were taken with all different types of digital cameras, from simple point-and-shooters to fancy professional D-SLRs. In fact, some of the best photos came from nonprofessionals using low-cost cameras—which just goes to show that it's the photographer that matters, not the equipment. (Although good equipment is nice, let me tell you.)

If you see a photo you particularly like, you can find out who took it by referring to the Photo Credits page located elsewhere in the introductory section of this book. If you peruse these credits, you'll discover that many of the photos were taken by Sherry Elliott, a fine photographer in her own right who also served as the book's photo editor. If you like the way the book looks, it's her doing.

There's More Online...

If you like the photographs in this book and want to view them on your own computer, I urge you to visit my PhotopediaPhotos site on Flickr (www.flickr.com/photos/12150723@N06/). Photos from photo editor Sherry Elliott, myself, and several other contributors are listed in the Photopedia Photos set, while photos from other Flickr members can be found on the Favorites tab. Feel free to download any of these photos for your own purposes; it's also okay to use these photos to experiment with, in terms of photo editing.

I also urge you to visit my personal website, located at www.molehillgroup.com. Here you'll find more information on this book and other books I've written—including an errata page for this book, in the inevitable event that an error or two creeps into this text. (Hey, nobody's perfect!)

And if you have any questions or comments, feel free to email me directly at photopedia@molehillgroup.com. I can't guarantee that I'll respond to every email, but I do guarantee I'll read them all.

Get Ready to Shoot!

With all these preliminaries out of the way, it's now time to get started. While I recommend reading the book in consecutive order, that isn't completely necessary, especially if you're already well-versed in some photographic techniques. It's okay to skip around.

So get ready to turn the page and learn more about creating great digital photographs. If I've done my job right, you'll soon be taking more and better photos than you did before—which will make us both happy

I

Understanding Digital Photography

How Digital Photography Works

Until recently, every family had at least one film camera in the household. When I was growing up, my family had a cute little Kodak Brownie box camera and then a Polaroid SX-70 instant camera. I eventually graduated from the Brownie to a Pentax ME Super 35mm SLR camera, which I owned until just a few years ago.

Today, however, most of those film cameras have been replaced by digital cameras. To the end user, using a point-and-shoot digital camera may be little different from using a similar point and shoot film camera, with the notable exception of how the images are output—on little flash memory cards instead of on film that must be developed. One technology replaces the other in performing the same task, that of photographically documenting people, places, and events.

While a digital camera may outwardly resemble a film camera, there are significant technological differences inside the cases. How exactly does digital photography work? And how does it compare to film photography? Those questions are answered in this chapter, so read on to learn more.

1

Moving from Film to Digital

Photography, whether film-based or digital, is the process of recording images by capturing light on a light-sensitive medium. In digital photography, the light is captured on an electronic sensor. In film photography, the light is captured on light-sensitive film. A camera is simply the device used to capture the light onto the light-sensitive medium.

If you're used to film photography, digital photography is comfortably familiar in general, yet maddeningly different in some of the details. Let's take a quick look to see skills that transfer, and those that don't.

Similarities Between Film and Digital Photography

At its most basic, digital photography is pretty much film photography without the film. That means that the basic principles still apply—there's the same reliance on lens selection, composition, lighting, color, focus, exposure, and the like. There are even the same categories of cameras; if you used a point-and-shoot film camera, you'll be using a similar point-and-shoot digital camera. If you used a single lens reflex (SLR) film camera, you have plenty of similar digital SLR cameras to choose from.

In short, if you can take a good photo with a film camera, you can take similarly appealing photos with a digital camera. The basic techniques transfer.

Differences Between Film and Digital Photography

The fact that a digital camera doesn't use film points out the chief difference between film and digital photography. That is, with a digital camera you don't have to worry about loading and developing the film, or about choosing different film stock. Instead, you have to school yourself on digital technology, including resolution, file formats, file size, storage media, and the like.

In addition, because you're not dealing with different types of film, you have to learn how to achieve similar effects in a different manner. For example, to shoot a black-and-white photograph with a film camera, you used black-and-white film; no color was involved at all. A digital camera, however, shoots everything in color; the image sensor in a digital camera is a color image sensor, pure and simple. So to create a black-and-white photo, you have to convert that color photograph into black-and-white, either in the camera (a feature found on some models) or post-shooting in a photo editing program. And, trust me on this, shooting in color to create a black-and-white photo requires a bit of an adjustment on your part.

Also, if you're used to using different film speeds to get different effects, you again come up against the limitation of using a single digital image sensor for all your photography. Fortunately, some cameras let you adjust a virtual ISO setting, which simulates the effect of different film speeds. But still, it's more different from than similar to the old way of doing things.

Digital editing is what makes digital photography attractive to so many people. It's so important that we'll examine digital editing in its own chapter—turn to Chapter 2, "The Digital Darkroom," to learn more.

And if you happen to take a bad picture that you can't (or don't want to) fix in Photoshop or some similar photo editing program, you can simply delete the file. It's not like the old days, where even your bad photos got printed. With digital photography, you only print the photos you want. It costs you nothing, other than your original time, to toss a bad shot. So go ahead, take a hundred shots to get one keeper—you don't have to pay for the film!

The biggest difference between film and digital photography, however, is that the final product is a digital file—and that file can be easily edited. With film photography, any editing took place in the darkroom and required a skilled hand. (And it wasn't easy—in fact, for casual photographers it wasn't a viable option.) With digital photography, however, making even dramatic changes is relatively simple. Shoot a portrait with bad red eye? Fix it in a photo editing program. Have a shot with poor composition? Crop it after the fact. Have too much or too little lighting, or bad color? Punch it up in post production.

Capturing the Digital Image

In today's world, everything is moving from analog to digital. Analog is the world as it exists in a smooth and continuous flow of information; digital represents the analog world as a series of discrete samples of the original. In the digital domain, the world as we know it is broken down into billions of tiny 1s and 0s—which makes it easy to store, edit, and recreate just about anything.

One of the uses of digital technology is to capture photographic images. Instead of capturing images in an analog fashion on film, images are captured as a series of small picture elements, called *pixels*, in digital files. In the world of digital photography, a digital camera performs many of the same functions as a film camera. Light enters via a lens, moves through a shutter, and strikes a light-sensitive item. But there's no chemically sensitive film inside a digital camera; instead, the image is captured via a light-sensitive electronic sensor. This sensor then transmits an electronic image, stored in a digital file, to some type of storage device, typically a flash memory card. This

digital file can then be copied to a personal computer, edited as necessary, and sent to a printer to create a photo print. There is no film to expose or to develop; everything is done digitally.

How a Digital Camera Works

Figure 1.1 shows a typical digital camera. As in a film camera, light enters through a glass *lens* into the camera body, which is essentially a light-proof box. Light passing through the lens also passes through an *iris* (or diaphragm) and a *shutter* apparatus, ultimately casting an image on a piece of film inside the camera box. The iris controls the size of the *aperture*, and the shutter controls the length of the *exposure*; combined, the aperture and exposure determine how much light strikes the camera's image sensor.

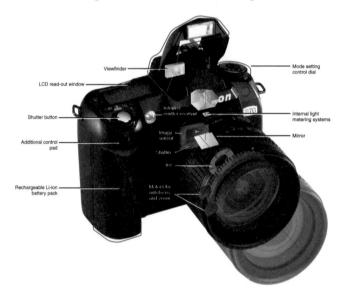

FIGURE 1.1

How a digital camera works.

Because of the principle of *refraction*, the camera's lens bends the rays of light reflected from the subject, so that the rays cross and reappear upside-down on the other side of the lens. The area where the rays re-form an image of the subject is called the *plane of focus*. By adjusting the distance between the lens and the film inside the camera, the photographer or the camera makes the image appear in sharper focus.

Image Factors

The quality of the photographic image depends on several factors—the type and quality of the lens, the length of the exposure (as controlled by the camera's shutter), the size of the hole in which the light enters the camera (the aperture), the ISO or film speed setting, and the distance from the lens to the film (by adjusting the lens's focus ring). To create a photograph, the photographer (or, with an automatic camera, the camera itself) must select the proper ISO, set the lens aperture and length of exposure, and properly focus the lens. And that's in addition to the actual composition of the shot!

In film photography, the film's sensitivity to light is measured via an ISO number; a high ISO number is very light sensitive (or "fast"), while a low ISO number is less light sensitive. (ISO stands for International Standards Organization, an international body that sets various industrial and commercial standards.) While digital cameras don't use film, they do mimic the effect of different film speeds via digital ISO settings.

All this sounds complicated, and it is. While today's digital cameras automate much of this process, there's still a lot of fickle technology at work. The best photographers, film or digital, are masters of measuring light levels, judging proper exposures, and manipulating the ISO setting for the best possible images. For the rest of us, however, simplifying this process is desirable—which most digital cameras today do, via their automatic exposure modes.

Understanding the Digital Image Sensor

The big difference between a film camera and a digital camera is how the image is captured. Instead of using a piece of light-sensitive film, a digital camera uses a light-sensitive image sensor. An image sensor is actually a type of electronic microchip, like the one shown in Figure 1.2. The image sensor is comprised of several different layers, each with its own unique purpose:

- The top layer of the sensor consists of millions of *micro lenses*, which capture the light that enters through the camera's shutter and direct it downward to the next layer.

- On CCD sensors, the next layer is called the *hot mirror* and exists to filter out nonvisible infrared light. (This layer is not necessary in CMOS sensors.)

- The next layer holds a matrix of colored filters arranged to match the photodiodes on the layer below. These red, green, and blue filters provide the color in a color image, as the photodiodes themselves capture only light, not color.

- The bottom layer of the sensor is the layer that actually captures the image. This layer holds millions of individual photodiodes; each photodiode generates a charge when struck by light.

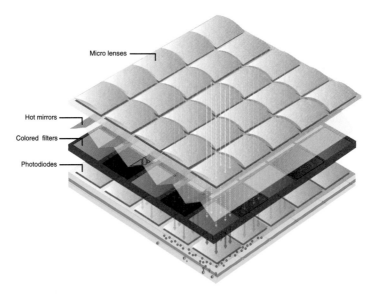

Micro lenses

Hot mirrors

Colored filters

Photodiodes

FIGURE 1.2
The layers of a digital image sensor.

Each photodiode in the image sensor corresponds to a single *pixel* in the final image. A pixel is simply a very small element of the picture; the more pixels, the finer the detail in the image. Today's digital cameras contain image sensors that have anywhere from 3 million to 10 million photodiodes—corresponding to images with 3 to 10 megapixels of information.

The pattern created by the photodiodes duplicates the image reflected by the camera lens. This electronic image is then sent from the image sensor to some sort of storage device, typically a flash memory card, where it is stored in a digital file. The generated image is also sent, in real-time, to the camera's LCD viewfinder; what you see in the electronic viewfinder is the same image seen by the camera's image sensor.

The colored filters in most image sensors are arranged in a *Bayer array* (named after Kodak scientist Dr. Bryce E. Bayer), a specific pattern that includes twice as many green filters as those for red and blue. Other types of filter arrays exist, but the Bayer array is most common because the human eye is more sensitive to green light than it is to the other colors.

A million pixels equals 1 megapixel. Thus a 5-megapixel camera generates images comprised of 5 million pixels.

Different Types of Image Sensors

Two different types of image sensors are used in digital cameras today: *CCD (charge*

coupled device) and *CMOS* (complimentary metal oxide semiconductor). The two types of sensors operate in much the same fashion but have important technical differences. Of particular notice, CCD sensors are sensitive to infrared light and require the separate hot mirror to block infrared rays; for this reason (and others), CCD sensors tend to be a little more costly to produce than similar CMOS sensors. That said, which type of sensor you find in a given camera depends more on the technical preferences of the camera manufacturer than it does on any inherent strength or weakness of that type of chip.

> Learn more about pixels and resolution in the "Resolution" section, later in this chapter.

What is important, however, is the resolution and size of the image sensor. The more pixels generated by the sensor, the higher the resolution of the resulting pictures. In addition, some digital SLR (single lens reflex) cameras use larger sensors than those found in more compact cameras; a larger sensor makes it easier for a camera to use lenses originally designed for 35mm cameras.

Storing the Digital Image

The image reproduced by the image sensor is a temporary thing; it exists on the image sensor only until you take another photo. To store the image permanently, it needs to be sent from the image sensor to some sort of storage medium.

For most digital cameras today, the storage medium of choice is flash memory, in the form of a flash memory card. Several different types of flash memory cards are available, including the SD (Secure Digital), MMC (MultiMedia Card), and CF (Compact Flash) formats. Which type of card you use depends on your camera; you have to use the type of card designed to fit in your camera. Beyond that, however, you can choose from different sizes of cards—that is, different storage capacities. For example, you can find SD cards with anywhere from 256 megabytes (MB) to 2 gigabytes (GB) of storage, and CF cards with up to 8GB storage capacity. The bigger the card, the more photos it will hold.

> Learn more about image storage in Chapter 7, "Managing Batteries and Storage."

1

Understanding Pixels and File Formats

We'll conclude this overview of digital photography by examining the related topics of picture resolution and file format. These two items determine how clear and precise your photos will look and print—and how large the resulting files will be.

Resolution

As noted previously, the camera's image sensor captures an image via millions of photodiodes; each photodiode corresponds to a single pixel in the final image. Naturally, the more pixels in a photographic image, the more accurately that photo captures the original image.

All this talk of photodiodes and pixels begs an important question—how much resolution do you need? Recall that camera resolution is measured in millions of pixels (megapixels); to a point, the more megapixels, the better. But only to a point.

Even the lowest-priced digital cameras sold today deliver 5 megapixel resolution; higher-end consumer cameras go up to 10 megapixels or more, and professional cameras even higher. Depending on what type of picture you're taking—or more accurately, what type of final output you want—you may find that even 5 megapixels is overkill.

For example, if you're taking a photo to upload to a website, that photo will display in a web browser on a computer screen. A typical 15.4-inch notebook PC screen is sized at 1280 pixels wide by 800 pixels tall, so you don't want your photo to exceed those dimensions. (Otherwise, the entire photo won't fit onscreen, and viewers will have to scroll to see the whole thing.) Because a photograph sized at 800 pixels tall comes out at 1,000 pixels wide, that translates into a total of 800,000 pixels—less than 1 megapixel.

On the other hand, if you want to print out an 8×10-inch landscape photo, you'll need more pixels. For the best print quality, you want your photo to have a resolution of 300 pixels per inch (ppi). That translates into a height of 2,640 pixels by

Even if you'll ultimately be displaying your photos in low resolution on the Web, you still might want to shoot at a higher resolution. That's because if you eventually crop your photo to a smaller size, you'll need the excess pixels to be sure that cropped area has sufficient resolution for viewing/printing on its own. In addition, you'll get better results from most photo editing programs when you have more resolution/pixels to work with. That's why I like to shoot at a high resolution, but then reduce the resolution after the fact if I'm moving a photo to the Web.

a width of 3,000 pixels, for a total of 7,920,000 pixels—approximately 8 megapixels.

Learn more about print resolution in Chapter 29, "Printing Your Photos."

Of course, you can print at a lower ppi, but you may notice fuzziness in the picture—especially at large sizes. For smaller-sized prints made with a home inkjet printer, however, you can obtain satisfactory results at 200 ppi. For example, to print a 5×7-inch photo at 200 ppi, you only need a resolution of 1,000 pixels by 1,400 pixels—just 1.4 megapixels in total.

Sound confusing? It's not, really. Table 1.1 details the resolution required for best reproduction of various size photos at different ppi.

Table 1.1 Optimal Resolution for Photos of Different Sizes

Size of Print	150 ppi Resolution (Good)	200 ppi Resolution (Better)	300 ppi Resolution (Best)
2.5×3.5 inches (wallet size)	196,875 pixels (0.2 megapixels)	350,000 pixels (0.4 megapixels)	787,500 pixels (0.8 megapixels)
3×5 inches	337,500 (0.4 megapixels)	600,000 (0.6 megapixels)	1,350,000 pixels (1.4 megapixels)
5×7 inches	787,500 pixels (0.8 megapixels)	1,400,000 pixels (1.4 megapixels)	3,150,000 pixels (3.2 megapixels)
8×10 inches	1,800,000 pixels (1.8 megapixels)	3,200,000 pixels (3.2 megapixels)	7,920,000 pixels (8 megapixels)
11×14 inches (poster)	3,465,000 pixels (3.5 megapixels)	6,160,000 pixels (6.2 megapixels)	13,860,000 pixels (14 megapixels)
16×20 inches (large poster)	7,200,000 pixels (7.2 megapixels)	12,800,000 pixels (13 megapixels)	28,800,000 pixels (29 megapixels)

It's easy enough, using a photo editing program, to reduce the resolution of a photo for web and other low-resolution uses. It's impossible, however, to increase the resolution of a photo beyond that at which it was originally shot. So if you want to create larger prints, you're better off with a higher-resolution camera—even if you end up downsizing your photos for other uses.

Digital File Formats

When a digital camera takes a photo, it stores the information for that photo in digital format. Essentially, each pixel of the image translates into a series of digital instructions for how that pixel should look—its brightness, color saturation, tint, and so forth.

For basic web display or eBay product photos, you never need more than 1 megapixel resolution. Anything more is just overkill.

How that digital information is stored depends on the file format used. As you might suspect, the more information stored, the larger the resulting file size—the larger the image, the larger the file.

JPG and TIF Formats

To this end, most digital image file formats compress the original picture information to some degree. When an image file is compressed, redundant information is extracted from the image. For example, if an image has a large area of blue sky, many of those blue pixels can be extracted from the digital file, and the information for one blue pixel used to create similar areas of blue sky.

That said, some file formats compress the image more than others do. A compressed image might look fine on a relatively low resolution computer screen, but produce unsatisfactory results when printed at large size or in a quality book or magazine; when a compressed image is blown up too large, you'll see compression artifacts in the form of blockiness in the picture, as shown in Figure 1.3.

FIGURE 1.3

A heavily compressed JPG image with noticeable blockiness in the picture.

There are two different types of image compression. *Lossless* compression discards none of the original picture information and instead looks for more efficient ways to describe the image. *Lossy* compression, on the other hand, achieves smaller file sizes by removing less-important pieces of the image; lossy compression results in more picture degradation than does lossless compression.

It's important, then, to understand the different image file formats available and choose those formats that work best for the digital photos you take. The most popular file formats used in digital cameras today are the JPG and TIF formats. The lossy JPG format is okay for web display and printing small prints on home printers, but the lossless TIF format is better if you want to create larger or higher-quality photo prints.

Understanding JPG Compression

If you choose to work with JPG files, you have another factor to consider. The compression used in JPG files is adjustable; you can choose a higher compression to create smaller files, or a lower compression to create better-looking pictures. It's your choice.

Most photo editing programs, and some digital cameras, let you determine the amount of compression you use when creating JPG files. This setting may be labeled JPG Compression or JPG Quality; it adjusts the same setting. (Low quality corresponds to high compression, while high quality corresponds to low compression.)

To create the best-looking JPG photos, choose a low compression/high quality setting—but make sure you have the space to store all those photos, as this setting creates larger files. (This is especially important if you have a low-capacity memory card in your camera.) To fit the most photos on your memory card, choose the high compression/low quality setting—but don't expect these photos to look great if you print them at a larger size. Or, you can do like most people do, and compromise with a mid-quality/mid-size setting. It's your choice.

Raw Format Files

Better than either JPG or TIF is the so-called "raw" format. A raw file is the digital equivalent of a film negative; it contains all the information of the original image with no compression, no processing, and no application of filters or special effects. It's truly a "raw" image that you can then edit and adjust as appropriate.

Raw files, however, are never used as-is; they have to be converted to another format (JPG or TIF) to be printed or viewed online. In addition, there is no single "raw" format; every camera manufacturer uses a slightly different algorithm (and file extension) to create raw files.

There is no single file extension for raw image files; each camera manufacturer uses a different extension. For example, Nikon's raw files are saved with the .NEF extension; Canon's raw files are saved with the .CR2 extension.

Most advanced photo editing programs can import and convert most types of raw files. Some editing is possible during the conversion process; you may be able to adjust the image's exposure, for example, or its levels, curves, color balance, and the like. What's adjustable is dependent on the photo processing program you're using.

That said, the raw format is the format of choice for professional photographers, because raw files retain more of the original image information than do files of other formats. You typically save the photo in raw format in your camera, and then convert the raw file to another format for editing and printing.

Most photo editing programs have their own proprietary file formats you can use when editing your photos. (For example, Photoshop uses the PSD format; Paint Shop Pro uses the PSP format.) While you may use these file formats during the editing process, you'll want to convert the edited file to JPG or TIF format after the editing is completed, for easier printing and distribution.

Choosing the Right File Format

Table 1.2 details these three major image file formats, as well as some other formats you may encounter.

Table 1.2 **Digital Image File Formats**

File Format	Description
BMP	A simple bitmapped graphics format, typically used for Windows desktop backgrounds but not for photographs. It's an extremely inefficient file format, especially with larger images.
GIF	A popular web-based graphics format that can include both transparent backgrounds and simple animations. GIF files are highly compressed and quite lossy (for images with more than 256 colors), which makes them unsuited for photographic images. (It's a good format for line drawings and illustrations, however.)
JPG or JPEG	Perhaps the most widely used graphics format on the Web, JPG files are good for reproducing both black-and-white and color photographic images. The format uses lossy compression, however, which makes it less than ideal for larger or higher-quality photo prints.
PCX	An older, not very efficient graphics format, not widely used today.
PNG	A relatively new graphics format that originally was intended to replace the GIF format—although that hasn't happened. Even though it uses lossless compression, it's nowhere near as popular as the JPG format for photographs.
RAW	One of several manufacturer-specific uncompressed, unedited formats favored by professional photographers and found in higher-end digital cameras. Typically used for in-camera storage; raw files must be converted to another format for editing, viewing, and printing.
TIF or TIFF	A high-resolution graphics format, using lossless compression, that is the best choice when you're creating high-quality or larger-sized photo prints. TIF-format files, however, are larger than comparable JPG files; they're also not viewable in many web browsers.

Which file format should you use? Professional photographers and serious hobbyists save their photos in their camera's native raw format, if their camera offers this feature, and then convert to TIF format for printing. Casual users tend to use the JPG format, because it's the only file format available on most lower-end digital cameras.

In addition, JPG files are better suited for web use and for emailing to friends and family. The TIF format is better if you intend to produce large prints (8×10 inches or larger) or if you're shooting for publication.

WHITHER FILM PHOTOGRAPHY?

The numbers are telling. According to the Photo Marketing Association, 90% of all cameras sold in 2006 were digital. Canon, Konica Minolta, Nikon, and several other manufacturers have largely abandoned the film camera business in favor of digital cameras. Agfa, a major supplier of photographic film, filed for bankruptcy, and Kodak has sharply reduced the numbers of different types of film it offers.

Is film photography dead?

The answer is: Not yet. Even on the downward trend, photographers around the world still use one billion rolls of film a year. But the casual photographer isn't using film anymore; that market has long gone all-digital. The adherents of film photography tend to be professional photographers, typically of the fine-art variety.

In today's digital world, why continue to shoot with film? It's a quality issue; many photographic artists insist that film simply yields a better result than digital. To these professionals, digital photos lack something—depth, saturation, tonal subtlety, whatever it is that the eye of the beholder continues to see in film photographs.

Still, the trends cannot be denied. Just as the digital CD replaced the analog vinyl LP and the digital DVD replaced the analog VHS tape, digital photography is replacing traditional analog film photography. The convenience of the digital format makes it an easy choice for casual photographers, and improving technology is bridging the quality gap for professionals. While film may never disappear entirely (witness the continuing niche market for vinyl LPs), it is becoming a thing of the past for most photographers. It's likely that the next generation of photographers will emerge without ever having set foot in a traditional darkroom; their experience will be all digital, from womb to tomb.

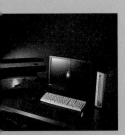

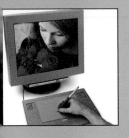

The Digital Darkroom

The digital camera is just the first part of the digital photographic process. After a photograph has been created in the camera, it can be digitally enhanced and edited using special software programs. This post-camera process is colloquially known as the *digital darkroom*; it encompasses the equivalent post-camera techniques used in the physical darkrooms of traditional film photography.

Understanding the Digital Darkroom

In film photography, the light-sensitive negative film must be developed in a totally dark environment. While modern photo processing machines tackle this task inside an enclosed space, professional photographers do their development in darkened rooms, lit only by a dim red safelight.

> Darkrooms are traditional for black-and-white photography. Color film is more light sensitive, so much so as to require a complete absence of light—even a safelight can damage the color image.

(Most photographic films are sensitive only to blue and green light; the red light enables the photographer to actually see what he's developing.)

The traditional darkroom is also a workspace where photo prints can be enhanced and manipulated to special effect. A photo can be cropped to its essential elements, dodged and burned to make the print lighter or darker, or enlarged to make a bigger print.

With digital photography, no film development is necessary. However, other post-camera effects are still possible and even desired. The enhancement and editing of digital photos, however, does not involve the use of chemicals, as is the case with film photography. Instead, digital images can be edited in special photo editing software programs. This digital editing process is referred to as the digital darkroom, in honor of the traditional film darkrooms of the previous era.

Today's digital darkroom is likely to be a desk in an office or cubicle, equipped with a desktop computer, color monitor, photo printer, and the necessary photo editing software, like the one shown in Figure 2.1. The photo files are transferred from the digital camera to the computer, where they are opened from within the photo editing program. The program then manipulates the individual bits and bytes of the digital image, making changes to individual pixels as necessary.

A skilled digital photographer can make good use of the digital darkroom environment. Pictures can be cropped, lightened, darkened, color corrected, and even digitally manipulated to delete or add elements from and to the original image.

In fact, it's much easier to make changes to a digital photograph than it is a film photo; techniques that took years to learn in the film era can be accomplished by rank novices using a program such as Photoshop Elements or iPhoto. That's because a digital photograph is just like any other file on your computer, comprised of millions of digital bits. Editing a bit in a photo is no different from editing a character in a word processing document, or editing a number in a spreadsheet. To a computer, one bit is the same as another.

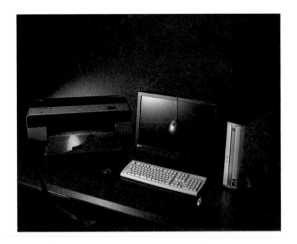

FIGURE 2.1

From Epson Japan, the Digital Darkroom System—complete with computer, monitor, photo printer, and color calibration system.

Have a dark photo you need lightened? Have a poorly composed photo you need to crop? Want to excise an unwanted object from the background of an otherwise perfect picture? Want to create a collage or panorama from two or more photos? You can do all of these things—and more—in your own personal digital darkroom.

Equipping Your Digital Darkroom

What do you need to create a digital darkroom? It's a matter of assembling the right computer hardware and software—and it doesn't have to set you back an arm and a leg.

Desk Space

First, know that you don't need a dedicated room—let alone an actual "dark room"—to create a digital darkroom. All you need is a desk or horizontal surface large enough to hold a computer monitor and a mouse, with space for the actual computer system unit underneath. More elaborate setups might require more space (for example, if you want to use a tablet instead of a mouse, or if you want to add a photo printer), but in general you can get by with a typical computer setup in a small office or cubicle.

Computer

The computer you use to edit your digital photographs can be the same computer you use to surf the Internet, write memos and reports, and play games. That's right, the needs of a digital darkroom aren't much different from your other computing needs—with a few notable exceptions.

You can use either a Windows or Macintosh computer to edit your digital photos. In the early days of digital photography, 10 or more years ago, professional photographers tended to gravitate toward Apple computers for their image editing needs. While the Mac had an early hold on the market, it wasn't a lasting hold; today, both the Windows and Macintosh platforms are more than adequate for even the most demanding photo editing tasks. (And the top photo editing software program, Adobe Photoshop, is available for both operating systems.)

The casual digital photographer can get by with today's bargain PCs, but serious photographers will want something a little more powerful. The more powerful the computer, the faster it will perform most editing tasks. This is especially important if you're editing large photos taken with a high-megapixel camera, or performing complex editing and enhancement in Photoshop. The faster the computer, the less time you'll spend waiting for the computer to finish what it's doing.

How fast is fast? Here's what I currently recommend for serious photo editing:

- For a Windows system, an Intel Pentium 4, Xeon, or Core Duo processor running at 1.8GHz or faster; I also recommend using the new Windows Vista operating system.
- For an Apple system, a Power Mac or iMac with G5 or Intel Core Duo processor, running at 1.8GHz or faster; you'll also want to be running Mac OS X 10.4 or higher.
- A minimum of 1GB RAM, with 2GB preferred.
- A high-end graphics card with at least 64MB video RAM (128MB preferred), capable of 24-bit or higher color depth.
- 200GB hard disk—or, ideally, a separate internal or external 200GB hard drive devoted solely to photo storage.
- CD/DVD read/write drive (to burn photos to CD or DVD).
- Media card reader, either internal or external (optional for transferring image files from your camera's memory card—which can also be done by connecting your camera directly to your computer).
- An adequate number of USB ports, enough that you can connect your camera, an external hard disk drive, a pen tablet, and perhaps an

external media card reader, along with any other peripherals (including your mouse, keyboard, and printer).

- Optionally, a FireWire port for connecting a fast external hard disk.

Reading through these requirements, you're probably wondering whether you need to buy a new PC. The reality, for most casual photographers, is probably no. You can run midrange photo editing programs, such as Adobe Photoshop Elements, on most older PCs (including those running Windows XP), and even a system with 512MB of RAM will perform adequately for most tasks. The only things you may want to upgrade are your storage capacity (by adding an external hard disk) and monitor (move to a larger screen size). Know, however, that a newer computer will be faster when it comes to editing your photos, particularly if you're using the more resource-intensive Photoshop CS or if you're editing large-megapixel photos.

For serious photo editing, I recommend using a desktop PC over a notebook model. As much as I love my notebook, the smaller notebook screen, limited storage space, compact keyboard, and touchpad controller are too much of a hindrance when it comes to editing digital photos. Digital darkroom tasks are easier on a bigger monitor and more expandable system.

Monitor

In a digital darkroom system, the computer monitor is every bit as important as the computer. You want to buy the biggest and best monitor you can afford. Put simply, the better the monitor, the more accurate the images it will reproduce; and the bigger the screen, the easier it will be for you to see the images you're editing.

You can choose from traditional CRT and LCD flat-screen monitors—although the LCD is far and away the market leader today. In fact, it's getting harder and harder to find CRT monitors, especially the high-quality, larger-screen models you want for a sophisticated digital darkroom workstation. In terms of quality, the best LCDs perform every bit as well as the best CRTs, although lower-end LCD displays are sometimes lacking in image fidelity.

As to size, I recommend going with a widescreen model, which makes it easier to edit landscape photos. I consider a 19-inch widescreen the bare minimum for serious photo editing, with larger sizes (22-inch and 24-inch) much preferred. Myself, I use a 22-inch Gateway widescreen LCD, like the one shown in Figure 2.2; it's a significant improvement over my old 18-inch nonwidescreen model, and cost less than $350.

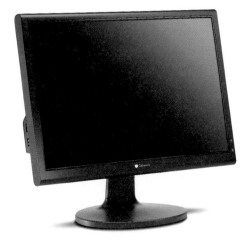

FIGURE 2.2

The Gateway FPD2272W 22-inch LCD monitor.

For serious photo editing, you'll want a higher-end monitor that offers more user-configurable settings. In particular, you want to be able to adjust brightness and contrast separately, adjust all three colors (red, green, and blue) separately, adjust the monitor's gamma setting, and adjust the monitor's color temperature. Equally important are the monitor's contrast ratio and color fidelity. The former can be found in the monitor's specifications; the latter you'll need to trust your eyes and any online reviews you can find.

You can find quality monitors from a variety of suppliers, including

- Apple
- Dell (www.dell.com)
- Eizo (www.eizo.com)
- Gateway (www.gateway.com)
- LaCie (www.lacie.com)
- NEC (www.nec-display-solutions.com)
- Samsung (www.samsung.com)
- Sharp (www.sharpusa.com)
- Viewsonic (www.viewsonic.com)

Of these, Eizo and LaCie specialize in higher-end monitors for photo professionals. For example, the Eizo ColorEdge CG241W, shown in Figure 2.3, is a 24-inch widescreen LCD that offers 1920×1200

> Make sure that monitor adjustments are easy to make. Some touch-activated controls are touchy enough to make adjustment a bit of a pain.

pixel native resolution and built-in color calibration. It's a favorite among professional photo editors, even though it sells for approximately $2,500.

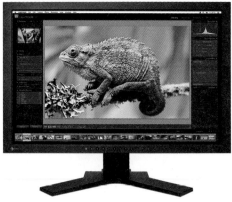

FIGURE 2.3
The Eizo ColorEdge CG241W 24-inch LCD monitor.

Computer Storage Media

The more digital photos you take, the more digital photos you have to store— and the more hard disk space you need for that storage. An active photographer can quickly fill up a smaller 80GB hard drive; larger drives are always better.

A good solution for many photographers is to add a large (200GB+) external hard drive to their system, dedicated exclusively to digital photo storage. With this approach, it's easy enough to connect additional hard drives as your storage needs dictate. If you go this route, I suggest using a drive that connects to your PC via FireWire, which allows for faster transfer rates than similar USB drives.

You can find external hard disk drives from LaCie (www.lacie.com), Seagate (www.seagate.com), Western Digital (www.westerndigital.com), and other manufacturers. As an example, Western Digital's My Book Pro Edition, shown in Figure 2.4, is a 750GB external drive that connects via FireWire 800 (the newest technology), FireWire 400, or USB. It works with Windows and Macintosh computers, and sells for $329.99.

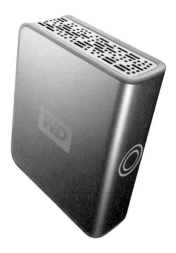

FIGURE 2.4

The Western Digital My Book Pro Edition external hard disk drive—ideal for photo storage.

Media Reader

While we're on the topic of storage media, you may want your system to include a media card reader, so you can easily transfer photos from your camera's memory card. Many computers have built-in media readers, but not all do. (And not all media readers work with all types of memory cards.) If necessary, you may need to connect an external media reader to your computer, like the one shown in Figure 2.5.

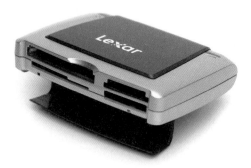

FIGURE 2.5

Lexar's Multi-Card USB 2.0 card reader.

Most external media readers connect via USB and cost less than $40. You can find media readers from Kensington (us.kensington.com), Kinamax (www.kinamax.com), Kingston Technology (www.kingston.com), Lexar (www.lexar.com), Sabrent (www.sabrent.com), and SanDisk (www.sandisk.com).

Note that a media reader isn't a necessity. Some users prefer to connect their cameras directly to their computers, using the camera's included USB connecting cable. To some extent, whether you connect your camera or use a media reader is a matter of personal preference; myself, I find the process of connecting a camera directly to be a tad cumbersome and prefer the media reader approach. Given the low cost of today's external media readers (and the profusion of computers with built-in media readers), why not have the option of going either way?

 STOP Not all media readers accept all types of memory cards. For example, many basic media readers don't accept CompactFlash (CF) cards. Make sure your media reader is compatible with the type of memory card used by your digital camera.

Input Device

Editing a digital photo involves a lot of cursor movement—and, in many cases, extremely *fine* cursor movement. Most casual photographers can get by with a traditional mouse, but for fine detail work a more precise input device makes life a lot easier.

Many professional photo editors prefer to use a tablet device to edit their onscreen images. With this type of device, like the one shown in Figure 2.6, you use a "pen" to draw on the tablet surface; what you draw is translated to the photographic image on your computer monitor. This type of device makes it much easier to trace around the outlines of an area or object, which is a necessary task for selecting portions of your photos for specific editing.

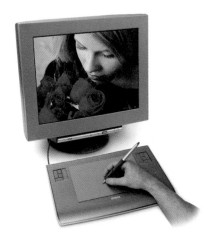

FIGURE 2.6

Wacom's Intuos3 6×8-inch drawing tablet in use.

You can find pen tablets from a variety of manufacturers, including Adesso (www.adesso.com), Aiptek (www.aiptek.com), Genius (www.geniusnetusa.com), and Wacom Technology (www.wacom.com). As you might suspect, larger tablets are easier for editing fine detail as are models with smaller surfaces; a 6×8-inch surface is probably the minimum size for serious photo editing.

Another option, somewhere between a mouse and a tablet in both usability and price, is a trackball. Most mouse manufacturers also offer trackball input devices.

Scanner

If all your photos are taken with a digital camera, they go directly from your camera to your PC, easy as pie. But if you have photo prints or slides from a film camera that you want to edit and store digitally, you need some way of moving those photos from the hard copy into a digital format. That is accomplished via a scanner.

Put simply, a *scanner* is a device that converts images to digital format. A scanner can scan photo prints, slides, or negatives, in the process converting them to TIF- or JPG-format digital files.

You can choose from two different types of scanners, depending on your needs:

 Flatbed scanners. Like the one shown in Figure 2.7, these are the most common type of scanner in the home environment. A low-cost flatbed scanner is typically used to scan photo prints, although some higher-end models come with transparency units that enable them to scan film, as well. You should be able to find a decent flatbed scanner in the $100 to $200 price range—sometimes even less.

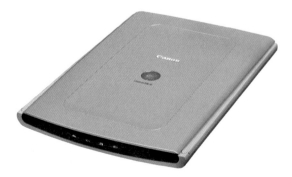

FIGURE 2.7

Canon's CanoScan LiDE 70 photo scanner, for photo prints.

■ **Film scanners.** Like the one shown in Figure 2.8, these are used to scan color film and slides. Models designed for 35mm film and slides run anywhere from $100 to $1,000, depending on features and resolution.

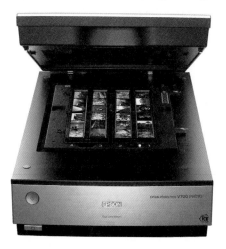

FIGURE 2.8

The Epson Perfection V700 photo scanner, for film and slides.

For most digital photo hobbyists with old prints to scan, a flatbed scanner is the way to go. For best results, look for a model with higher resolution, at least 2400 dpi (dots per inch). For higher-quality scanning needs, you can always deliver your prints or slides to a professional photo center that has its own drum scanner.

The most popular scanner manufacturers today include

■ Canon (www.usa.canon.com)

■ Epson (www.epson.com)

■ Konica Minolta (www.konicaminolta.com)

■ Microtek (www.microtekusa.com)

■ Nikon (www.nikonusa.com)

■ Visioneer (www.visioneer.com)

For higher-quality film scans, professionals turn to *drum scanners*. With this type of scanner the film wraps around a rapidly spinning drum and then passes over a sensitive photomultiplier sensor. You can find drum scanners at most professional photo service centers.

Printer

After you edit your photos, you have a number of choices regarding how you

Learn more about scanners in Chapter 16, "Scanning Print Photos and Slides."

distribute those photos. You can keep them in digital format and burn the image files to a CD or DVD, upload them to a website, or email them to friends and family. If you want a hard copy print, you can always use a photo processing service for that task. Or you can make your own prints, using a photo printer.

Many consumer photo printers let you print directly from your camera's flash memory card, without having to transfer the photos to your computer before printing.

A quality photo printer delivers professional-quality prints on special photo print paper; you can't tell the difference between those prints and the ones you get from a professional photo printing service. A wide range of photo printers are available, priced anywhere from $50 to $1,000. The difference is in the method used to create the prints, the overall quality of the prints, and in the print sizes available.

Today's photo printers fall into three general categories:

- **Photo inkjet printers.** The most consumer-friendly of all photo printers, in terms of both ease of use and price. A photo inkjet, like the one shown in Figure 2.9, creates photo prints when you use special-purpose photo paper but also doubles as a traditional color inkjet printer when used with normal paper. It's a good all-purpose choice for most casual photographers; expect to pay between $100 and $200 for a decent model.

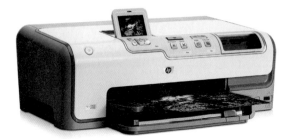

FIGURE 2.9

The HP Photosmart D7160 photo inkjet printer.

- **Dedicated photo printers.** These printers don't offer the option of printing on normal paper; they're limited to printing on special-purpose photo paper. Most of these models, like the one shown in Figure 2.10, print only to relatively small paper sizes, often no more than 4×6 inches. While some dedicated photo printers use inkjet technology, most use thermal-dye printing for better-quality prints. Prices run from $100 to $200 or so.

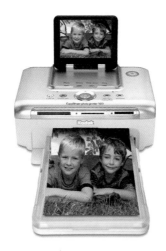

FIGURE 2.10

Kodak's EasyShare Photo Printer 500 dedicated photo printer.

> **Professional photo printers.** Similar to dedicated photo printers but offer printing at larger sizes—8×10 inches or more. Some of these printers use sophisticated inkjet technology (more sophisticated than that in traditional consumer-level inkjets); others use thermal-dye printing. Expect to pay $500 or more (sometimes much more) for a printer of this type.

If your needs are more casual, you can always use a standard color inkjet or laser printer to print lower-quality photo prints. Better quality comes from a photo inkjet printer, optimized to print on special-purpose photo paper. More serious photographers, however, will appreciate the better picture quality that comes from the thermal-dye technology used in dedicated and professional photo printers.

Thermal-dye technology prints each of the printer's primary colors (cyan, yellow, and magenta) in 256 different shades, for a total of approximately 16.7 million colors. This produces prints with more vivid and accurate colors than you get with consumer-grade inkjet printers.

The most popular manufacturers of photo printers include

- Canon (www.usa.canon.com)
- Epson (www.epson.com)
- Hi-Ti (www.hitouchimaging.com)
- HP (www.hp.com)
- Kodak (www.kodak.com)

When choosing a new printer, always ask to see sample prints—and make sure it's a real photo print, not just a color printout of a photo. Choose a model that produces the desired quality.

2

- Olympus (www.olympusamerica.com)
- Sony (www.sonystyle.com)

Learn more about printers in Chapter 29, "Printing Your Photos."

Photo Editing Software

Now we come to the part of the digital darkroom that enables all the digital magic to occur. Photo editing software helps you organize, edit, and enhance your digital photos. These programs run the gamut from the free utilities included with your operating system (Windows Photo Gallery in Windows Vista, iPhoto with the Mac OS) to high-priced, full-featured programs such as the industry-leading Adobe Photoshop CS.

Learn more about photo editing programs in Chapter 17, "Choosing Photo Editing Software."

Photo editing software is so important that I've devoted an entire section of this book (Part VI, "Digital Photo Editing") to the topic. In addition, tips for editing different types of photos are sprinkled liberally throughout the text in Part VII, "Digital Photography Techniques."

Depending on the volume of your photographic library, you may also want to invest in a photo management program, such as Adobe Photoshop Lightroom. Although most photo editing programs include photo management functions, large libraries are easier to manage in separate programs.

Understanding the Digital Workflow

Setting up a digital darkroom is just the first step to obtaining professional-quality photos. You have to learn how to use each component of your digital workstation and master the proper workflow.

Processing a Digital Photo

Processing a digital photo is an all-digital process; you remain in the digital domain from start to finish. (The only exception is the type of output you choose—digital file or analog photo print.) At each step of the process, it's important that you make backups of any newly created files, so that you can return to the image as it was at that point in time.

While editing the image file, you may want to save the image in your photo editor's native format, which typically offers more editing options than the final TIF or JPG format. For example, Photoshop saves files in its proprietary PSD file format.

In a nutshell, here is the workflow involved in processing a digital photograph:

1. **Shoot.** Use your digital camera to shoot the photograph. The photograph should automatically be stored on your camera's memory card.

2. **Transfer.** Transfer the photo from your digital camera to your computer. You can accomplish this by inserting the memory card into a media card reader in your PC, or by connecting a USB cable between your camera and your PC.

3. **Store.** The photo you transferred from your memory card or camera should be saved in a folder on your computer's hard disk. (Many photo editing and management programs automatically save each new batch of photos into separate folders.) You may want to create a separate folder or subfolder for all photos in a given group, or to rename the files with more easily recognizable filenames. In addition, you can use this step to add any necessary metadata to the photo file; this information, such as date, location, exposure, and photographer data, helps you manage all the images in your library.

4. **Convert.** If your camera shot the photo in raw format, you'll need to convert the raw file into another format for editing. (Most photo editing programs convert raw files into TIF or JPG format when you first open or import the file into the program; many digital cameras come with their own utilities for working with raw files.) If your camera shoots in JPG or TIF format, you can skip this step.

5. **Edit.** Use your photo editing program to edit the photo as necessary, performing any appropriate cropping or adjustments to exposure, brightness, contrast, color, or tint.

6. **Enhance.** You can then use your photo editing program to enhance the photo as desired, by applying any appropriate filters or special effects.

7. **Save.** After your photo is in its final format, you should save the photo in either JPG or TIF format—JPG for online distribution, TIF for printing. This is also a good time to make a backup of both your original and edited files, either to a separate hard disk or a CD/DVD.

8. **Resize.** If you intend to distribute the photo online, either on a website or via email, you'll need to downsize the JPG file appropriately.

9. **Print.** If you want hard copy photo prints, you can print the photo on your own photo printer or send the photo to a photo processing service.

10. **Distribute.** If you want to email your photo or post it to a website or blog, do so now, using the appropriate program or service.

Processing a Traditional Film Photo

Working with photos shot with a tradi-
tional film camera requires a slightly dif-
ferent process, especially in converting the
film photo to digital format. After you have
the photo in digital format, however, the rest of the process is the same as with
working with original digital photos.

If you have an existing slide or photo print, skip steps 1-3 and go directly to step 4.

1. **Shoot.** Use your film camera to shoot the photograph.

2. **Develop.** Use a photo developing service or your own darkroom to develop the film negative.

3. **Print.** For best results with minimal hassle, you'll want to print your film to 35mm slides, which are relatively easy to scan into digital format.

4. **Scan.** Use a film scanner or flatbed scanner with transparency unit to scan the slide into a digital file. If you're starting with a photo print, scan the print using a flatbed scanner.

5. **Store.** The file created from the scan should be saved with an easily recognizable filename in a folder on your computer's hard disk. You probably want to create a separate folder or subfolder for all photos scanned at this time. In addition, you can use this step to add any necessary metadata to the photo file; this information, such as date, location, exposure, and photographer data, helps you manage all the images in your library.

6. **Edit.** Use your photo editing program to edit the photo as necessary, performing any appropriate cropping or adjustments to exposure, brightness, contrast, color, or tint. If you've scanned an older photo, you may need to fix scratches and tears, remove dust and speckles, and the like.

7. **Enhance.** You can then use your photo editing program to enhance the photo as desired, by applying any appropriate filters or special effects.

8. **Save.** After your photo is in its final format, save the photo in either JPG or TIF format—JPG for online distribution, TIF for printing. This is also a good time to make a backup of both your original and edited files, either to a separate hard disk or a CD/DVD.

9. **Resize.** If you intend to distribute the photo online, either on a website or via email, you'll need to downsize the JPG file appropriately.

10. **Print.** If you want hard copy photo prints, you can print the photo on your own photo printer or send the photo to a photo processing service.

11. **Distribute.** If you want to email the photo or post it to a website or blog, do so now, using the appropriate program or service.

CALIBRATING YOUR MONITOR

Have you ever edited a digital photo on your computer system, made sure it looked great on your monitor, and then printed it—only to discover that the colors don't look quite the same as they did onscreen? The problem is a common one, and it's often due to a miscalibrated monitor.

Most casual photographers don't realize that the colors they see on their monitors might not always represent the actual colors in a photograph. A computer monitor, just like a television display, can be manually adjusted through a wide range of settings. If you want, you can make greens look red and reds look green, just by tweaking the controls on the monitor.

Obviously, you want your monitor to reflect a natural range of colors. You can try to manually adjust your monitor, eyeballing the colors until they look right to you. But your eyes aren't always an accurate judge of color; it's almost impossible for anyone except a trained professional to manually adjust a monitor to the exact right colors.

A better approach for serious photographers is to use a monitor calibration system. There are several on the market, including the Pantone Huey (www.pantone.com), Gretag Macbeth Eye-One (www. gretagmacbeth.com), X-Rite i1 (www.xrite.com), and ColorVision Spyder2 (www.colorvision.com), shown in Figure 2.11. Basic models run less than $100; professional models, which make more exacting adjustments, run $200 or more.

FIGURE 2.11
The ColorVision Spyder2 colorimeter.

All these systems work similarly. You start by setting your monitor to the factory default settings and making sure that no bright light is glaring on the screen. You then hang the calibration device (called a *colorimeter*) over the monitor screen and start up the calibration software. The software displays a series of test colors and patterns, while the colorimeter takes readings from the screen. Those readings are fed back to the software, which then adjusts your monitor's settings via your computer's operating system. The entire process takes less than 15 minutes, and you end up with a monitor calibrated to professionally accepted settings.

The results can be startling. You might think you have your monitor properly adjusted, but seeing the *correct* settings will tell you just how your eyes can mislead you. With your monitor thusly calibrated, you can be assured that what you see onscreen will be what you print—no more unpleasant surprises.

Of course, it's important that you continue to use your monitor under the same conditions in which it was calibrated. That means using your monitor in subdued indirect lighting, without strong direct light reflecting off the screen. And if you ever decide to tweak the controls on your monitor, you'll need to go through the entire calibration process again.

By the way, if you still see a difference between your monitor and your prints, the problem might lie elsewhere. This book's technical editor notes that she recently had a problem with clogged inkjet heads on a printer which created prints with no yellow ink. (The symptom—blue trees!) It's a good idea to perform regular maintenance on all the components of your digital darkroom system, to ensure the best performance possible.

Digital Camera Essentials

3

Choosing a Digital Camera

Whether you're just starting out with digital photography or are an experienced professional, the big question is what type of digital camera should you buy? There's no single answer to this question because the type of camera you buy depends on how exactly you plan to use it.

You see, there's no such thing as a "typical" digital camera. While a $200 point-and-shoot model and a $1,000 digital SLR (D-SLR) both take digital pictures, they're so different in look, feel, operation, and features that they may as well be creatures from two different planets. The key, then, is determining how you want to use a digital camera and then choosing the right mix of features and performance to get that particular job done.

Read on to learn more.

Different Types of Cameras

Digital cameras today fall into three broad categories. The categories overlap some, and the feature sets are constantly evolving, but it's still beneficial to think of consumer-level digital cameras as belonging to one of the following three categories:

- **Point-and-shoot.** This is the type of camera used by most casual photographers. It's the digital equivalent of the old film point-and-shoot, small and light and with relatively automatic operation. These are also the lowest-cost digital cameras available.

- **Prosumer.** A prosumer camera is like a point-and-shoot model on steroids. This type of camera typically has a better lens with a longer zoom, higher resolution (up to 10 megapixels), and a choice of automatic or manual shooting modes. This is a good camera for those serious about photography but not quite ready to make the jump to D-SLR models. Cost for a good prosumer camera can be twice that of a point-and-shoot, or more.

- **Digital SLR.** A digital single lens reflex (SLR) camera is the same type of camera used by professional photographers. Unlike a point-and-shoot or prosumer camera, a D-SLR features removable and interchangeable lenses, through-the-lens viewfinding, a more accurate (if not necessarily higher-resolution) image sensor, and a raft of manual shooting settings. D-SLRs cost a little more than good prosumer cameras but deliver noticeably superior pictures.

We'll look at each of these types of camera in more depth, but first let's do a brief comparison, as detailed in Table 3.1.

Table 3.1 **Digital Camera Comparison**

	Point-and-Shoot	Prosumer	Digital SLR
Ease of operation	Easy	Easy	Harder
Image quality	Good	Better	Best
Picture resolution (typical)	5–7 megapixels	6–10 megapixels	6–12 megapixels
Auto focus	Yes	Yes	Yes
Manual focus	No	Yes	Yes
Auto exposure	Yes	Yes	Yes
Manual exposure	No	Yes	Yes
Lens quality	Moderate	Good	Superior
Zoom lens range (typical)	3X	12X	Depends on lens

	Point-and-Shoot	Prosumer	Digital SLR
Removable/interchangeable lenses	No	No	Yes
Speed of operation (burst rate)	Slow	Moderate	Fast
File format(s) used	JPG	JPG, TIF, raw	JPG, TIF, raw
Available accessories	Few	Some (lens filters, flash units)	Many (lenses, filters, flash units)
Size	Small	Moderate	Large
Weight	Light	Moderate	Heavy
Price	$100–$400	$300–$600	$600–$2,000

Point-and-Shoot Cameras

3

A point-and-shoot camera is so called because it's easy to use—just point at the subject, press a button, and shoot the shot. Shooting functions are totally automatic, with auto focus, auto exposure, auto everything. The photographer doesn't have to worry about anything other than composition.

Point-and-shoot cameras, like the one shown in Figure 3.1, are compact, which makes them easy to carry around in a purse or a pocket. They're great for casual photographers because they take good snapshots without much effort and don't require bulky cases or awkward accessories.

FIGURE 3.1

The Fujifilm FinePix Z5fd point-and-shoot camera.

Some point-and-shoot cameras have an optical viewfinder, although most users prefer to use the back-of-camera LCD screen. This screen displays what the image sensor sees, as well as the camera's menu functions. Larger point-and-shoot cameras have larger—and sometimes swing-out—LCD displays.

> Even professional photographers sometimes carry point-and-shoot cameras. A point-and-shoot camera is a lot more convenient in some instances than carrying a bulky D-SLR camera and accompanying accessories, and makes for a good "backup" camera for use on family outings and special events.

In terms of picture quality, most point-and-shoot cameras today have resolution in the 5 megapixel range—some even higher. That's more than good enough for creating 5×7-inch prints at the highest possible quality (300 ppi), and even larger prints at slightly diminished quality (200 ppi).

Quality is limited primarily by the lens used; most point-and-shooters don't have the highest-quality lenses. Typical is the 3X zoom lens of moderate quality, which delivers acceptable but not exceptional shots with a large depth of field. Most of today's point-and-shooters save their photos in the JPG format, which is fine for most casual uses.

Even though operation is easy enough for your grandmother to use, don't expect speedy operation. The auto focus on most point-and-shooters takes awhile to do its thing, which means you may have to wait a moment or two between pressing the shutter button and getting the shot. Likewise, the slow speed of operation (burst rate) means that there is noticeable shutter lag; it's often hard to capture rapid movement, such as what you find at sporting events.

In terms of price, point-and-shoot cameras represent the lower end of today's market. You can find basic point-and-shooters as low as $100; even the highest-priced models still come in under $400.

So, in a nutshell, the advantages of a point-and-shoot camera include the following:

- Easy to operate
- Compact size
- Lightweight
- Large depth of field
- Low price

The disadvantages of a point-and-shoot camera include the following:

Learn how to use point-and-shoot and prosumer cameras in Chapter 4, "Operating a Point-and-Shoot Camera."

- Limited manual shooting options
- Limited zoom lens range
- Slow operation with noticeable shutter lag
- Limited expansion options

Prosumer Cameras

Pocket-sized snapshot digital cameras are fine, but when you want really good pictures, you want a camera with a little beef between the bun—what the industry calls a *prosumer* camera.

A prosumer camera, like the one shown in Figure 3.2, looks more like a traditional film camera than does the typical point-and-shooter. The camera body is larger, as is the lens attached to the body. There's slightly more heft to a prosumer camera; it has a good feel in your hand. (Even if it's not quite as easy to tote around as a point-and-shoot camera.)

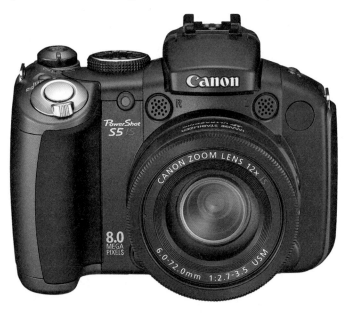

FIGURE 3.2

The Canon PowerShot S5 IS prosumer camera.

3

There are several distinguishing features to a prosumer camera. First, the lens is typically better and longer than that found on a point-and-shoot camera. Instead of a 3X zoom, you can find prosumer models with 12X and 15X zoom lenses, often with image stabilization. This means you'll be able to get a wider range of shots, including those at a longer distance.

The prosumer lens is also a better quality lens. This translates into sharper photos, especially when examining the edges of the shot. (Some point-and-shoot cameras get a tad fuzzy around the edges.)

Speaking of shooting options, prosumer cameras offer more than just automatic shooting. Yes, you still have auto focus and auto exposure, but you also have the option of using manual focus and manual exposure, with either aperture or shutter priority. These manual shooting options let you take a wider range of shots.

In terms of picture quality, today's prosumer cameras offer resolutions up to 7 or even 10 megapixels, big enough for any normal printing need. Most prosumer cameras also feature metal bodies (instead of the plastic bodies found in most point-and-shoot cameras) and intelligent hot shoes to which you can attach external flashes, strobe lights, and the like. Many of these cameras also let you save photos in the raw file format, which is more versatile than JPG or TIF when it comes to post-photo processing in Adobe Photoshop or some similar program.

You'll pay more for all these features, of course—anywhere from $300 to $600, depending on manufacturer and features. In fact, a good prosumer camera can cost as much as (or a little more than) a low-end D-SLR!

The advantages of a prosumer camera include the following:

- More control over shooting options (manual focus, manual exposure)
- Wider zoom lens (for more extreme close-ups)
- Better quality lens (for better picture quality)
- Higher resolution
- Similar quality to D-SLRs, at a smaller size and lower price

The term *prosumer* is somewhat nebulous. I define prosumer in this chapter from a consumer perspective. Many professional photographers, however, would refer to anything short of a D-SLR as a straight consumer camera and would call the $1,000-and-under D-SLRs discussed here prosumer models. More elite professionals would call even these cameras entry-level, reserving the term prosumer for those D-SLRs in the $2,000 to $3,000 range. It's all a matter of perspective.

The disadvantages of a prosumer camera include the following:

- Relatively high price
- Not as compact as a point-and-shoot camera
- Not as versatile as a D-SLR

Digital SLR Cameras

As you probably gathered, point-and-shoot and prosumer digital cameras all use pretty much the same technology inside the camera, although to different degrees. It's when you get to a D-SLR that the technology changes; D-SLRs differ significantly from point-and-shoot and prosumer digital cameras in both operation and performance.

Let's take the typical point-and-shoot or prosumer digital camera. These cameras have their lenses permanently attached and require you to view what you're shooting via either an optical viewfinder (not connected to the lens) or a small LCD display. They typically have small image sensors (less than an inch across) that produce good, but not great, pictures, and they don't offer a lot of operating flexibility.

D-SLR cameras use a reflex mirror apparatus so that, when you look through the optical viewfinder, you're actually viewing through the lens itself. That helps you take better pictures, and it also helps battery life—because you're not powering the LCD display every time you take a picture. (In fact, you can't use the LCD display as a viewfinder; it's only there when you need to make a selection from the camera's menu system.)

You also get the ability to use interchangeable lenses and larger image sensors, often as big as 35mm film, which provide better results in low-light conditions. In addition, these cameras are usually designed by the companies' 35mm camera divisions (instead of their consumer electronics divisions) and provide all the operating flexibility you need to make great photos, fast.

Because the lenses are interchangeable, you can choose what lens or lenses you use with a D-SLR. It's easy enough to switch lenses in and out, to go from a wide-angle to a telephoto to a long zoom and back again with the twist of a lens mount. This also means that lens quality is up to you; spend as much or as little as you want, depending on the quality desired.

Image resolution for today's D-SLRs range from 6 megapixels up to 12 megapixels. While you can save images in JPG format, most D-SLRs offer the preferred raw image format.

In addition to the interchangeable lenses, you also can use all manner of accessories with a D-SLR. Lens filters, hot shoe flash attachments—you name it, you can use it.

You also get manual control over all camera operations—in addition to the normal automatic modes, of course. And operation is much faster than with other types of cameras, which lets you take more photos in a shorter period of time.

D-SLR cameras have been around since the early 1990s, when they used to cost $20,000 or more. Fortunately, the price has come down over the years. Today's most affordable D-SLRs, like the one shown in Figure 3.3, cost around the same price as high-end prosumer cameras; the highest-priced consumer D-SLRs tap out around $2,000 and offer many pro-level features.

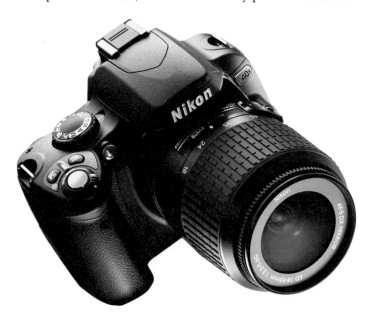

FIGURE 3.3

The Nikon D40X digital SLR camera.

The advantages of using a D-SLR are many, and include

- Superior image quality
- Choice of automatic or fully manual operation
- Faster and more effective auto focus
- Faster operating speed (ability to take multiple photos in a short period of time)

- Wide range of ISO settings
- Choice of lenses—and use of multiple lenses
- Depending on the lens, a shallower depth of focus (so backgrounds can be blurred—which is a good thing)

The disadvantages of a D-SLR include

- Expensive
- Cost of additional lenses
- More complicated to use
- Heavy and bulky

Consumer-level D-SLRs range in price from $600 or so up to around $2,000. Even higher-priced D-SLRs are available, however; these cameras, which can cost up to $10,000, are designed for professional photographers and offer even higher resolution and more sophisticated shooting settings.

Learn how to use D-SLR cameras in Chapter 5, "Operating a Digital SLR Camera."

Bottom line, a D-SLR camera delivers a better picture (no matter what the megapixel rating), lets you use interchangeable lenses, and has more operating flexibility. So, if all you want to do is take quick snapshots, stick with a point-and-shoot or prosumer digital camera. But if you want pro-level performance and flexibility, check out a D-SLR. You'll notice the difference as soon as you pick it up; a D-SLR just *feels* like a real camera.

Specialty Cameras

In addition to the three main types of cameras, several types of specialty cameras also are available. These include the following:

- **Underwater cameras.** Put a normal digital camera underwater, and the electronics fizzle out. Even if the electronics could be protected, the case would soon implode from the pressure as you take it to greater depths. The solution is a specially designed underwater camera, such as those from Bonica (www.bonicadive.com), Sea & Sea (www.seaandsea.com), and SeaLife (www.sealife-cameras.com), shown in Figure 3.4. An underwater camera is designed with a waterproof housing that also protects against high levels of water pressure. It also has special larger controls that are easier for a diver to operate underwater. (Just imagine twiddling the knobs and switches on a typical point-and-shoot camera while you're in the water—not bloody likely!)

3

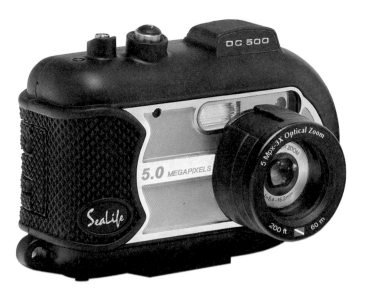

FIGURE 3.4

The SeaLife DC500 underwater digital camera.

- **Weather- and water-resistant cameras.** If you don't plan to dive with your camera but still want to take it with you on the water, consider a water-resistant camera instead. This type of camera is packed into a hard-plastic, water-resistant case—which also makes it great for using outdoors in inclement weather. You can find water-resistant cameras from Bushnell (www.bushnell.com) and Olympus (www.olympusamerica.com).

- **Panoramic cameras.** Want to take wide landscape photos? Or maybe a 360-degree photo of your house, office, or street corner? It's easy enough with a panoramic camera, which records an image over more than one frame. The multiple images are then stitched together to form a single panoramic image. You can find panoramic cameras from Eyescan (www.kst-dresden.de) and Panoscan (www.panoscan.com).

Sorting Through the Features

Whichever type of camera you settle on, you should be aware of some key features. Some of these features can be evaluated by examining the manufacturer's specifications; others can be determined by reading product reviews; still others have to be

Learn more about using specialty cameras in Chapter 28, "Special Shooting Conditions."

examined by using the camera yourself. Let's look at these features in more depth.

Resolution

In a digital camera, *resolution* is a measurement of image density—that is, how much image information is packed into each photo. The higher the resolution—measured in pixels or megapixels—the sharper the picture, especially at large print sizes.

When you're comparing cameras and features, check out Digital Photography Review (www.dpreview.com) and Steve's Digicams (www.steves-digicams.com), two websites that feature a ton of comprehensive digital camera reviews. These sites will help you make a more informed decision.

Why do you need more megapixels? It's simple, really. If you want to create large-size prints, you have to fill up all that space with picture information. The more pixels, the more picture information—and

Learn more about pixels and resolution in Chapter 1, "How Digital Photography Works."

the bigger the prints you can make. With a 5-megapixel camera, you should be able to create good-looking 5×7-inch prints; for 8×10-inch or larger prints, you'll need an 8-megapixel or higher camera.

If you use your camera to shoot eBay product photos or pictures for websites, you don't need nearly that much resolution. In fact, for web photography, anything over 1 megapixel is wasted. That's because the pictures you display in an eBay auction listing or on a typical web page are limited in size to the resolution of a typical computer display—which is much smaller than that of a photo print. So there's no point shooting high-megapixel photos for the Web; you'll only have to reduce the size before you upload the pictures.

That said, having more megapixels provides a lot more options when it comes to cropping your photos. As you know, you don't always properly compose your shots; sometimes the object you want to focus on occupies only a part of the image. You can use photo editing software to crop the image, of course, which is where more megapixels prove handy. Let's say, for example, that you have an image that you crop to a quarter of its original size. If that were a 5 megapixel image to start with, the cropped image is only 1.25 megapixels—big enough for only a 3×5-inch print. However, if you started from a 10 megapixel image, the cropped image is 2.5 megapixels—big enough for a 4×6-inch print, or maybe even a 5×7-inch print. You get the point; the more megapixels you start with, the more options you have in terms of cropping.

For comparison purposes, most point-and-shoot cameras today have at least 5 megapixel resolution; some go as high as 7 megapixels. Prosumer cameras

can go up to 10 megapixel resolution, and some D-SLRs have resolution in the 12 megapixel range.

Lenses

Most digital cameras today have some sort of zoom lens. A zoom lens helps you get up close to distant subjects.

> **STOP** Ignore a camera's *digital zoom* specs; digital zoom is an artificial electronic zooming effect that creates blocky-looking results. Instead, focus on the *optical zoom*, which is what the lens provides.

Point-and-shoot and prosumer cameras have fixed lenses; D-SLRs have removable/interchangeable lenses. That means you have to live with the lens that comes with a point-and-shoot or prosumer camera, while you can swap lenses in and out of a D-SLR.

In terms of zoom range, most low-end point-and-shoot cameras have a 3X zoom; that means the lens can zoom into an image three times as large as its base image. Prosumer cameras have the longest zoom lenses available, some up to 12X or even 15X. D-SLRs let you choose from a variety of lenses, of course, although few freestanding zoom lenses approach the 12X range of a prosumer zoom.

In addition to the zoom features, it pays to examine the lens quality. Most point-and-shoot cameras offer lenses of acceptable quality; they're okay for casual shots, but not for quality photos. You'll get better quality from a prosumer camera lens, or from any of the interchangeable lenses available for a D-SLR camera.

> When you buy a D-SLR chances are it comes in a kit format. (This isn't always the case, of course; some D-SLRs are sold body-only.) The kit should contain the camera body and a default zoom lens. Remember, you don't have to stick with this lens; you can purchase any number and type of lenses, for whatever types of photos you want to shoot.

Image Stabilization

The longer the zoom lens, of course, the more difficult it is to hold the camera steady. For that reason, look for a camera or lens that offers image stabilization or anti-shake technology.

As you've no doubt experienced, it isn't always possible to hold your camera perfectly still when shooting. This is particularly true when shooting in low-light situations. When the light is low, the camera uses a slower shutter speed. This results in a longer exposure, which means that the

> Learn more about camera lenses in Chapter 8, "Using Different Lenses."

camera lens is kept open longer. The longer the lens is open, the more likely that there will be some noticeable camera movement—and when you accidentally move the camera during a shot, the result is a blurry picture. You can manually deal with this problem by better steadying the camera when shooting—typically by using a tripod. But you don't always have a tripod available, which is where image stabilization technology comes in.

One approach to image stabilization utilizes a floating optical element in the lens itself. A camera with image stabilization uses a built-in gyro sensor to detect hand movement and then relay that information to a tiny microcomputer inside the camera. The microcomputer instantly calculates the amount of compensation needed; a linear motor then shifts the optical image stabilizer lens as necessary on the fly, as shown in Figure 3.5. The result is less user-induced jitter and shake. (This approach is used in some Canon, Nikon, Olympus, Panasonic, and Sony cameras.)

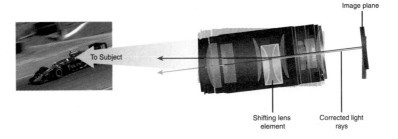

FIGURE 3.5

The movable element inside the lens assembly shifts to correct camera shake.

Another approach is to move the camera's electronic image sensor, instead of the lens, so that it compensates for inadvertent camera movement. The sensor is mounted on a platform that moves in the opposite direction as the movement of the camera, as determined by a series of motion detectors. This type of system is typically called "anti-shake" as opposed to image stabilization; Sony uses it in several of its higher-end digital cameras.

The reason image stabilization is so popular is that it makes it easier to take sharp pictures under all lighting conditions. If your camera features image stabilization technology, you stand a much better chance of shooting sharp pictures at the

In technical terms, image stabilization typically enables you to take hand-held shots two to three stops slower than with a nonstabilized camera. For example, if you would normally need a shutter speed of 1/500th of a second to shoot a particular scene, adding image stabilization would let you shoot the same scene at only 1/125th of a second.

slower shutter speeds used in low-light conditions. In addition, you'll probably notice better sharpness in all your photos, no matter how much light you have.

Learn more about macro shooting in Chapter 26, "Macro Photography."

Macro Capability

Another feature to consider on any camera is its macro or close-up capability. On most cameras, this is accomplished via a special macro mode, typically selected along with the other automatic shooting modes on the camera's settings dial.

Macro mode lets you bring your camera closer to small subjects. Without a macro mode, you can't get any closer than 1.5 to 2 feet from your subject. With a macro mode you can move much closer, thus taking larger close-ups of smaller subjects.

Size and Weight

Many point-and-shoot cameras are little bigger than a credit card and weigh less than half a pound. Prosumer models are bigger and heavier, and D-SLRs even more so. Photo pros actually like the heft of a "real" camera, although most casual snappers prefer something smaller and lighter. This is definitely a personal choice. Choose the camera that feels best to you, for your particular shooting needs. (Know, however, that smaller cameras also have smaller controls—which can be harder to operate, especially by those of us with larger or less agile fingers.)

Viewfinder

Even though most cameras have some sort of optical viewfinder, many casual photographers prefer to preview the picture on the camera's LCD screen, as shown in Figure 3.6. To that end, a bigger screen is better, as is one that offers good contrast in strong lighting. (LCD viewfinders range in size from 1.8 inches to 3.5 inches.) In addition, you may find useful a screen that flips out from the back of the camera, so you can shoot at less comfortable angles.

Professional photographers, however, prefer to use the optical viewfinder—especially if the viewfinder accurately represents what the lens is seeing. This argues for a D-SLR camera, of course, where the mirror apparatus reflects the lens image into the optical viewfinder. The optical viewfinders on non-SLR cameras offer only an approximation of the true lens image.

FIGURE 3.6
The big LCD screen on the back of a Sony DSC-T200 point-and-shoot camera.

Menus

While we're on the topic of the electronic viewfinder, take a moment to check out the camera's menu system. Consider how much effort it takes to reach common settings—macro mode, flash on/off, resolution/file type, exposure adjustments, and the like, as well as how easy it is to review just-taken photographs. If you have to press too many buttons or go through too many menu levels, you're wasting precious time that could be devoted to shooting more photographs.

Operating Speed (Burst Rate)

A camera's operating speed or *burst rate* is the measurement of how long it takes to power up and shoot a picture after you've pressed the auto focus button. Many low-end cameras have a noticeable shutter lag that makes it difficult to take pictures of fast-moving subjects, such as kids at sporting events. Prosumer cameras are a little better at this, but the best performance in this regard comes from D-SLRs. Most D-SLRs turn on practically instantly and can shoot multiple pictures in a single second, without pausing in between. They're the best bet if you shoot a lot of sports photos.

Remember, burst rate is more important if you're shooting fast-moving action. It's less important when shooting portraits, and virtually unimportant when shooting still lifes. But when you are shooting a moving object, you don't

3

want to press the shutter button and then have a five to six second wait before the shot is taken!

Focus

All digital cameras offer some sort of auto focus system. Some auto focus systems work better than others, of course; it depends on how many points the system analyzes, and how fast it does its thing.

It helps if the auto focus system has a focus lock. That is, you point the camera at the object you want in focus, press a button to lock the focus, and then move the camera to create the composition. This way you can focus on an object that isn't front and center in the frame.

This points to the fact that some auto focus systems can be fooled, especially if the closest object to the camera isn't the object you want in focus. To that end, prosumer and D-SLR cameras offer manual focus, which turns off the auto focus system and lets you do the focusing manually. This can sometimes offer more accurate results, if you're good at turning the focus ring.

Automatic Shooting Modes

Most point-and-shoot and prosumer cameras automate the process of taking a photograph via use of shooting or scene modes. Select a specific shooting mode, and the camera automatically selects the aperture and shutter speed to effect the proper exposure. For example, a "sports" mode uses a faster shutter speed to freeze fast action; a "night" mode uses a slower shutter speed to let in more of the available light.

Manual Shooting Modes

These shooting modes aren't perfect, however, which is why professional photographers prefer the manual shooting modes found on some prosumer and all D-SLR cameras. With these cameras, you have the choice of aperture priority or shutter priority; you set one of the two settings, and the other setting is automatically set to create the proper exposure.

You typically choose aperture priority to maintain control over an image's depth of field—to blur the background in a shot, for example. You choose shutter priority to capture fast-moving objects, or for shooting in low-light conditions.

In addition, some cameras let you override the aperture/shutter priority to set both aperture and shutter speed. This lets you create special photographic effects, such as over- or underexposed shots.

Remember, however, that even if a camera offers these manual shooting modes, you still have the option of using automatic shooting modes. And, in most conditions, the automatic modes work just fine and let you start shooting faster (fewer adjustments to make).

 Learn more about exposure, aperture, shutter speed, and ISO in Chapter 13, "Exposure."

Sensitivity

A camera's *sensitivity* refers to how much light it requires to create an acceptable image. In film cameras, this is the ISO measurement. With digital cameras, it's the ISO-equivalent number—what the ISO would be if the digital camera were using film.

The higher the ISO, the better the camera will be shooting in low-light conditions. However, if you crank up the ISO setting, you'll also introduce grain or noise into the image. It's a trade-off.

Some digital cameras (D-SLRs in particular) let you manually adjust the ISO setting. Other cameras adjust the ISO automatically, depending on the shooting mode chosen and the light available. Manual ISO gives you more control over the end result, of course, but does require some knowledge of light and film speed. Again, it's a trade-off.

White Balance Settings

All light isn't equally white. That's why almost all digital cameras offer some sort of white balancing. This is typically accomplished via color presets; choose the setting that corresponds to the type of light you're using. This configures the camera's white balance to compensate for the color vagaries of that type of light.

Some higher-end cameras offer more precise white balance adjustments. While this requires some knowledge of color theory, it's an important option for serious photographers.

Flash Sync

The serious photographer is also apt to use external flash and lighting, instead of the camera's built-in flash. To that end, look for cameras that let you control external flash systems via a sync cable or hot shoe on the camera.

File Types

Most lower-end and some prosumer digital cameras save files in the JPG format. As you learned in Chapter 1, JPG files are compressed to some degree—although most digital cameras use the lowest compression available for the JPG files they create. Some prosumer cameras give you the option of saving in either JPG or the less-compressed TIF format, although the TIF option is becoming less common. More common these days, especially with higher-end prosumer and D-SLRs, is the option to save files in the raw format. Raw files are like film negatives; they provide the best original quality, and thus are preferred by professional photographers.

> If a camera saves files in raw format, you'll need to convert those files to TIF or JPG format for editing. This is typically done when you open or import the files into a photo editing program, or when you use conversion software that comes with some cameras.

Storage Media

All digital cameras store their photos on a flash memory card of some sort. Some cameras come with a blank memory card, typically a low-capacity model; other cameras don't come with any storage by default.

Whichever the case, you'll probably want to spring for a higher-capacity card—or even two, if you plan on shooting a lot of photos all at once. And remember, the higher the resolution of your photos, the more storage space they take.

Which type of storage media a camera uses is a choice made by the manufacturer. The two most popular formats today are Secure Digital (SD) and CompactFlash (CF). A good rule of thumb is that lower-end cameras use SD cards, while higher-end cameras use CF cards, although this doesn't hold universally. (For example, Sony cameras use Sony's proprietary Memory Stick format.) There's not necessarily any reason to choose one type of storage card over another; live with what your camera uses.

Batteries

Digital cameras eat batteries. Lots of them. Go ahead and check the battery specs, but if you're choosing a point-and-shoot or prosumer camera, set aside a few extra bucks for a set of rechargeable batteries and an external battery charger. D-SLRs,

> Learn more about memory cards and batteries in Chapter 7, "Managing Batteries and Storage."

on the other hand, use proprietary internal rechargeable batteries and have extremely long battery life. (Since you set up your shot through the lens itself, a D-SLR doesn't have to constantly power the power-draining back-of-camera LCD display.)

Audio/Video Capability

Believe it or not, many digital cameras (D-SLRs excluded) also let you shoot short video+sound movies. I suppose there's some value to this feature for some people, although it escapes me. (If I want to shoot movies, I'll buy a bloody camcorder!)

If, however, this feature is important to you, look for the video recording specs. Most cameras offer MPEG-4 recording at 480×640 resolution. Moving pictures are smoother at 30 frames per second (fps), although some cameras only offer 15fps recording. And not all digital cameras capture sound and picture together; beware of those that only capture video, with no sound.

Software

Most cameras come with some combination of software programs. Depending on the camera, you might find some or all of the following:

- Proprietary image capture software
- Photoshop plug-in (to import proprietary raw-format files directly into Photoshop)
- Standalone photo editing program, such as Photoshop Elements

If any of these programs are important to you, look for them before you buy. Know, however, that if you're using a third-party photo editor, such as Photoshop, you don't need these programs that come with a camera.

Choosing the Best Camera for Your Needs

So, with all these features and functions floating in your head, how do you decide which camera is the best for you? It all depends on how you intend to use the camera.

To that end, you can break down digital camera users into a handful of main groups, as follows.

The Casual Snapper

The term "casual snapper" describes most consumer digital camera users. You don't take a lot of photos, but when you do you want them to count. You're mainly shooting photos of family get-togethers, vacations, outdoors weekends, and the like—nothing too fancy, but important nonetheless. What you want is a camera that's easy to use, without a lot of complicated features. You probably don't want something big and heavy; if you can slip the camera in your shirt pocket or in a purse, all the better.

The right camera for you is a low-priced, compact, point-and-shoot model. You don't need to spend a lot of money on fancy features or lots of megapixels; a 5 megapixel camera is just fine, thank you. Make sure you like how the camera works and feels in your hands; then choose the one that offers the most useful features for your budget.

The eBay Seller

This is a relatively new category of photographer, a by-product of the eBay online auction revolution. What's important here isn't size or price (although you don't want to spend any more than you have to); instead, you want a camera that shoots quality pictures indoors and close up.

Look for a point-and-shoot model that offers good low-light performance and an easy-to-use macro mode. Again, you don't need to worry too much about the megapixels, as you can only upload low-resolution pictures for use in your auction listings.

The Quality Hobbyist

If you want to create something more than simple snapshots—I'm talking high-quality photo prints, suitable for framing—you need more than just a point-and-shoot camera. You want a camera that lets you manually adjust the focus and exposure, and that offers the highest quality image capture.

The type of camera you want is a prosumer model, one that offers professional-level features in a consumer-friendly package. A good prosumer camera lets you shoot high-resolution pictures, in the 6 to 10 megapixel range, that can be blown up to 8×10-inch or larger print sizes. You'll also get a better-quality lens, typically with a longer zoom (12X to 15X), as well as the ability to bypass the automatic shooting mode and shoot with either aperture- or shutter-priority modes—everything you need to create great-looking photos of all types.

The Aspiring Professional

If photography is something more than a hobby for you, you want a pro-level camera—or as close to pro-level as you can afford. This means a D-SLR camera, one that lets you attach all manner of interchangeable lenses and accessories. There simply is no other choice; not even a high-end prosumer camera offers the image quality and flexibility found in today's D-SLRs.

There are differences between D-SLRs, of course. You'll need to consider resolution (in megapixels), available manual shooting modes, type of image sensor used (larger image sensors introduce less noise into the image), and the number and types of lenses available. It's also a good idea to try before you buy to make sure the camera you choose has the right feel and operability for your personal needs.

What Brand to Buy?

Literally hundreds of different digital cameras are on the market today, sold by dozens of different manufacturers. I won't promote one manufacturer over another; everyone has his or her brand biases. Suffice to say that every major manufacturer makes a quality product, even if some build the occasional lemon.

So who makes what in terms of types of cameras? That's detailed in Table 3.2.

Table 3.2 **Digital Camera Manufacturers**

Manufacturer	Website	Point-and-Shoot Cameras	Prosumer Cameras	Digital SLR Cameras
Canon	www.usa.canon.com	Yes	Yes	Yes
Casio	www.casio.com/products/cameras/	Yes		
Contax	www.contaxusa.com	Yes		Yes
Fujifilm	www.fujifilmusa.com	Yes	Yes	Yes
HP	www.hp.com	Yes		
Kodak	www.kodak.com	Yes	Yes	
Leica	www.leica-camera.com			Yes
Nikon	www.nikonusa.com	Yes	Yes	Yes
Olympus	www.olympusamerica.com	Yes	Yes	Yes
Panasonic	www.panasonic.com/consumer_electronics/digital_cameras/	Yes	Yes	Yes

Continues...

Table 3.2 Continued

Manufacturer	Website	Point-and-Shoot Cameras	Prosumer Cameras	Digital SLR Cameras
Pentax	www.pentax.com	Yes	Yes	Yes
Ricoh	www.ricohzone.com	Yes		
Samsung	www.samsungcamera.com	Yes	Yes	
Sanyo	www.sanyodigital.com	Yes		
Sigma	www.sigmaphoto.com			Yes
Sony	www.sonystyle.com	Yes	Yes	Yes

Where to Buy?

When you want to buy a digital camera, where do you look? There are lots of choices of where to buy a digital camera, including the following:

- **Local camera store.** It's always my preference to buy from a local retailer, and that goes double when shopping for cameras and accessories. Your local camera retailer will have a wide assortment of cameras to choose from, let you try before you buy, help you make an informed decision, and offer service and support after the sale. A dedicated camera store—local or national—is the best place to purchase higher-end cameras, such as D-SLRs. If you have a local camera store nearby, you owe it to yourself to check it out.

- **National camera chain.** Almost as good as a local camera store is a national camera chain, such as Cord Camera and Ritz Camera. Like a local store, you'll find plenty of models on display, as well as a variety of accessories and services.

- **Consumer electronics retailer.** If you're shopping for a point-and-shoot camera, you'll find a good assortment at any consumer electronics retailer, such as Best Buy or Circuit City. Don't expect the same level of support as you get from a dedicated camera store, however—although the prices should be pretty good.

- **Office supply store.** Similarly, most office supply stores (Office Depot, Office Max, Staples, and so on) have a small selection of point-and-shoot cameras. Prices should be similar to what you find at consumer electronics retailers.

- **Wholesale club.** If you're a member of Costco or Sam's Club, you should find a small selection of point-and-shoot cameras available. Prices might be good, if they have a model you want in stock.

- **Online retailer.** Think Amazon.com or Crutchfield, both of which offer a wide variety of camera models at decent (but not necessarily the lowest available) prices. What you get from these retailers is reliability and excellent customer service, as well as a good selection of models.

- **Online/mail order camera outlet.** What we're talking about here are the camera retailers who advertise in the back of photography magazines, typically New York-based retailers. These retailers started out as bricks and mortar stores, migrated to mail order, and now do a big business over the Internet. Most of these retailers offer low prices, but don't always offer the best service. (Some do; some don't. As always, your mileage may vary.)

STOP When shopping at a mail order or online retailer, be on the lookout for bait-and-switch techniques. Also steer clear of sales personnel who try to "up sell" you with unnecessary filters, cases, extended warranties, and the like; don't buy anything you hadn't intended to buy. And beware of so-called gray market goods—that is, products imported from another territory that don't come with the standard U.S. manufacturer's warranty. Not all manufacturers honor the warranty on gray market goods.

Wherever you decide to purchase your camera, don't buy on price alone. Look for a retailer that offers good service and a solid returns policy. If you're purchasing online, also consider the shipping/handling charges in addition to the basic price; a low price with a high shipping charge might not be the best deal.

In any case, make sure you're comfortable with a retailer before you make your purchase. You want to forge a strong relationship with a merchant who will be able to service all your current and future photo-related needs.

Digital Camera Shopping Tips

Want to be sure you get the best camera for your needs? Then consider these digital camera shopping tips, and make sure you think hard before you pull out your credit card.

Do Your Research

Smart shoppers are more satisfied with the cameras they purchase—and find better bargains. To be a smarter shopper, you need to do some homework before you fire up your credit card. That means researching the camera you want to buy—and the retailer you want to buy from.

One of the best ways to find product information is to go straight to the horse's mouth—that is, to the manufacturer's website. Most camera manufacturers offer reams of useful product information on their sites. If you're lucky, you'll find everything from detailed product specs and pictures to warranty information and downloadable instruction manuals.

In addition, many online retailers offer detailed information about the products they sell. For example, both Amazon.com (www.amazon.com) and Crutchfield (www.crutchfield.com) offer detailed information about all products for sale on their sites; Amazon also offers customer reviews of products, which can tell you how others like what they buy.

I find customer reviews particularly useful; your fellow consumers give you the unvarnished pros and cons based on actual use, and tell you whether they think the product is a good deal. Many sites on the Web provide forums for customers' product reviews, including ConsumerReports.org (www.consumerreports. org), ConsumerSearch (www.consumersearch.com), DCViews (www.dcviews. com), Digital Camera Resource Page (www.dcresource.com), Epinions.com (www.epinions.com), The Imaging Resource (www.imaging-resource.com), PhotographyReview.com (www.photographyreview.com), and RateItAll (www.rateitall.com).

Finally, don't forget the two digital photography review sites mentioned previously in this chapter—Digital Photography Review (www.dpreview.com) and Steve's Digicams (www.steves-digicams.com). Both of these sites feature detailed reviews of digital cameras and accessories; I find them invaluable resources when shopping for a new camera.

Try Before You Buy

Two digital cameras might look identical in terms of specs, but look, feel, and perform differently when used in the real world. For this reason, it's important that you give each camera you're considering a personal audition. Judge how it feels in your hands, how intuitive it is to operate, and how easy it is to take various types of pictures. Choose the camera that feels best to you—and takes photos that look the best to your eyes.

Judge the Image Quality

Elaborating on that last point, image quality is in the eye of the beholder. You can't judge a camera's image quality based on its specifications; a camera with a superior image sensor or lens can produce better photos than one with more megapixels. In particular, look at the following aspects of the image:

- **Color accuracy**. The colors in an image might look good in relation to each other, but how accurate are they? Compare the color of the digital image with that of the original subject, and test it against a wide range of colors. Make sure that the camera can accurately reproduce blues, reds, and greens—and everything in-between.

- **Shadows and highlights**. Examine the image to see whether the camera preserves details in both shadowed and highlighted areas. Take test shots in a variety of lighting conditions, and make sure the details don't get lost in dark areas or washed out in bright ones.

- **Color artifacts**. Some image sensors don't do a good job with extreme contrast. If you have an area of high contrast in an image, look for purple fringing or red flares. You want a camera that doesn't introduce these types of color artifacts into the picture.

- **Sharpness**. Most digital cameras perform some digital sharpening of images in an attempt to improve detail and contrast. Too much sharpening, however, results in images with too much contrast and overly sharp edges.

- **Noise**. You'll find some video noise in almost all digital cameras, but some are worse than others. Noise (often seen as graininess in a picture) increases in low lighting conditions and when the camera uses a higher ISO. Examine dark areas of the picture; if you see too many colored speckles, you're dealing with a noisy image sensor.

Match Resolution to Use

Don't get too hung up on multimegapixel cameras. I can tell you, I took a lot of great pictures with my old 2.1 megapixel Olympus digicam; resolution is only one factor in determining the quality of a digital image. In particular, know how you're going to be using your photos, and match the resolution to your needs. For example, shooting for eBay and web use requires less than 1 megapixel resolution, so you don't need to spend the extra bucks for a 7 megapixel camera. On the other hand, if you want to print a lot of 8×10-inch prints or larger posters, you'll need a camera with anywhere from 7 to 10 megapixel resolution. Again, match the resolution to your needs.

Check the Merchant Before You Buy

Buying from a well-known local camera store or a large chain retailer is generally a safe bet, but what about all those camera resellers you find online and in the back pages of photography magazines? Some are more reliable than others; it's possible to end up at a merchant that tries to up sell you

unneeded accessories or ships you gray market merchandise that is without a product warranty.

To protect yourself against less scrupulous direct mail or online merchants, you can check their ratings on the Web, at sites devoted to customer reviews of online retailers. Being able to find out about a retailer before you place your order will help you decide where you want to shop. If you see a lot of negative customer reviews, you know to avoid a particular retailer; if you see a lot of satisfied customers, that's probably a good place to spend your money. And you can tell from the individual reviews just what a specific merchant is good or bad at. You might find one retailer has fast shipping but poor customer service, or another that offers low prices but slow shipping.

The best sites to find merchant reviews include BizRate (www.bizrate.com), ePublicEye (www.epubliceye.com), PlanetFeedback (www.planetfeedback.com), and ResellerRatings.com (www.resellerratings.com). In addition to these sites, most price comparison sites (such as Shopping.com and Google Product search) also offer ratings or customer reviews of the merchants they link to. You can also use these sites to research products before you buy—and find the lowest prices online.

WHAT I USE

After reading through all the advice in this chapter about choosing a digital camera, some readers might wonder what type of camera I use, and where I purchased it. Fair question.

My current camera is a Nikon D70 digital SLR. I have two lenses for the camera, the factory-default 18-88mm zoom and a longer 70-300mm zoom, as well as a Nikon SB-600 speedlight. I purchased all this equipment from Roberts Distributing, a local camera retailer with three locations in the central Indiana area. (They also sell online, at www.robertsimaging.com.)

Before I acquired the Nikon D70, I had an Olympus C-2100 Ultra Zoom prosumer model that I purchased back in 2001; it had a 10X image-stabilized zoom lens that I particularly liked. Before that, in the dark ages of digital photography, I had a primitive Kodak point-and-shoot camera, the model number of which I no longer remember and is no longer relevant. (As you can see, I made the gradual progression from point-and-shoot to prosumer to D-SLR—as well as a progression in resolution from a measly 0.5 megapixels to 2.1 megapixels to 6.1 megapixels.) And before I went digital, I used a Pentax ME Super 35mm film SLR that was a gift for my college graduation.

Operating a Point-and-Shoot Camera

I f you're like most casual photographers, you have a basic point-and-shoot digital camera. This type of camera, while relatively easy to operate, is capable of taking a very good picture—if you know what you're doing.

We'll discuss techniques for taking specific types of photos later in this book; first, however, you need to learn some basic techniques to get the most out of your point-and-shoot camera. While you can just point and shoot, many more useful options are available.

Getting to Know Your Camera's Features

Let's start by taking a quick look at a typical point-and-shoot digital camera. Note that I used the word "typical"; while most point-and-shoot cameras have a similar feature set, they don't put all those features and options in the same place. Operating a new digital camera is like driving a rental car; you know it has all the basic controls, you just don't know where they all are. (And couldn't the auto manufacturers at least standardize where the headlight switch is located?)

In the case of point-and-shoot digital cameras, most cameras have a dozen or so important feature areas:

- Lens (typically in the front center)
- Flash (typically just above the lens)
- Shutter release (the main button on the top right of the camera)
- Zoom control (often a dial around the shutter release button)
- On/off button/switch (often a separate button; sometimes part of the mode selector dial)
- Mode selector (a dial beside the shutter release on top of the camera, or as part of the LCD menu display)
- Optical viewfinder (near the top of the rear of the camera; not present in all models)
- LCD viewfinder and menu controls (on the back of the camera)
- Memory card slot (on the side or bottom of the camera)
- Battery compartment (on the side or bottom of the camera)
- Input/output jacks (on the side or bottom of the camera)—often including a connection for an AC adapter
- Tripod mount (on the bottom, of course)

Prosumer cameras have similar controls to those of point-and-shoot cameras—plus a few more. In particular, prosumer cameras often have a manual focus ring around the lens, as well as manual shooting modes selected from the main menu or a separate dial or switch. To learn more about these advanced features, see Chapter 5, "Operating a Digital SLR Camera."

Some cameras have a front cover that slides to reveal the lens. Others extend the lens when the camera is powered on; the lens is pushed into the camera when it's turned off, to make for more compact carrying.

For example, Figures 4.1 through 4.4 show the front, back, top, and side of a Nikon point-and-shoot camera, and the position of all these controls and features. Remember, the location of these items on your camera may be different from that presented here; every manufacturer has its own way of doing things.

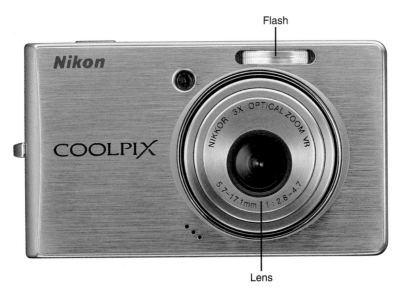

FIGURE 4.1

The front of a point-and-shoot digital camera; the lens is in the middle.

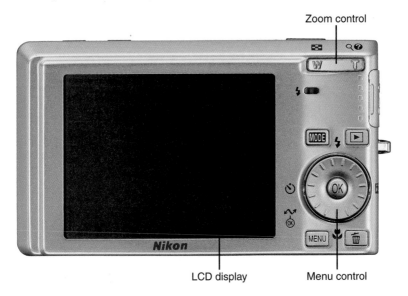

FIGURE 4.2

The back of a point-and-shoot digital camera; the LCD viewfinder is prominent.

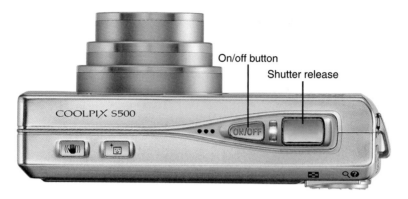

On/off button

Shutter release

COOLPIX S500

ON/OFF

FIGURE 4.3

The top of a point-and-shoot digital camera; note the location of the shutter release button.

Input/output
compartment (closed)

FIGURE 4.4

The side of a point-and-shoot digital camera—note the input/output jack compartment.

You should read your camera's instruction manual to familiarize yourself with the location of your camera's controls and features.

If you don't have the instruction manual for your camera, you should be able to download it (typically in PDF format) from the camera manufacturer's website.

Charging the Batteries

Before you use your digital camera, it has to be charged. More specifically, its batteries need to be charged—or, in the case of nonrechargeable batteries, the batteries need to be fresh.

Learn more about batteries in Chapter 7, "Managing Batteries and Storage."

Most point-and-shoot cameras use two AA batteries. You can use standard AA batteries, but don't expect them to last through a full day of shooting. A better option is to buy one or more sets of rechargeable batteries. When a rechargeable battery runs down, you can bring it back to full power by placing it in its recharger device.

In any case, you want a set of fresh or newly recharged batteries in your camera before you start shooting. (The batteries typically insert into a compartment on the bottom or side of the camera; make sure you insert the batteries in the proper position.) It's also a good idea to keep a set of spare batteries handy, so you can keep shooting if the first pair runs down.

Turning the Camera On and Off

Batteries inserted, you're ready to power up your camera. This is accomplished via an on/off button or switch, typically located on the top or back of the camera.

When you turn on the camera, several things happen. First, the camera's lens may extend from the front of the camera. Second, the LCD viewfinder on the back may display the main menu, or perhaps the last photo shot. (Or the LCD display may do nothing at all; some cameras try to minimize use of the display, as it's a big power drain on the camera's batteries.) Third, some sort of green or red power light may light up, just to let you know the camera is on.

You shouldn't leave the camera turned on when you're not using it; it unnecessarily drains the camera's batteries. It's better (and perfectly acceptable) to turn the camera on and off several times over the course of a shooting day; turn it off between shots, and then power it back up when you're ready to resume shooting. Know, however, that most cameras take several seconds to become fully operational after powering on—so keep it turned on if you think a good shot may pop up soon.

Inserting the Memory Card

The next thing you need to do is insert a memory card into your camera's memory card slot. Few cameras today have built-in

Learn more about memory cards in Chapter 7.

memory; this means that all the photos you take will be stored on the removable memory card.

For most cameras, inserting the memory card is a simple matter of opening a door and sliding the card into the slot. The card should lock into position. To remove the card, simply press the card farther into the slot to unlock it; you should then be able to grab it and remove it.

If no card is inserted, your camera can't take any pictures. In addition, some cameras do not display some menu options if the memory card slot is empty. So insert a card before you proceed.

Configuring Menu Options

After the camera is turned on, you can access all manner of settings via the camera's menu system. You view the menu via the LCD display on the back of the camera; a set of menu controls should be beside the display, typically in the form of a rocker switch. Press the Menu button to display the menu, and then use the rocker control to select menu items.

Most digital cameras have a main menu and a series of submenus, like the one shown in Figure 4.5. (In some cameras the submenus are located on a series of tabs, instead.) It's not uncommon for the available submenus or tabs to change depending on the mode selected; the shoot/record mode menu options are often different from those for playback mode.

FIGURE 4.5

The main menu system on a Nikon camera.

What menu options will you find on your camera? Obviously, this varies from model to model, but you're likely to find some or all the following types of options:

You select your camera's shoot or record mode to shoot photographs. You select the playback mode to view photos that you've previously shot.

- Shooting/record/photo options, which let you configure how pictures are shot—image quality, image size, white balance, ISO sensitivity, auto focus adjustments, flash on/off, red eye reduction on/off, and the like.

The main menu selections may not be named, but instead may be identified by representative icons.

- Scene options, which let you select from various automatic shooting modes. (Used in place of a dedicated mode selection control elsewhere on the camera.)

- Playback options, which let you determine how pictures are displayed on the LCD viewfinder.

- Print options, which let you set up how pictures are printed when the camera is connected directly to a compatible printer.

- Setup/custom options, which let you configure how the camera operates—the internal beep sound, auto power down mode, language, date/time display, file numbering, and the like.

Which of these settings should you pay attention to? Table 4.1 presents a short list of the most important settings.

Table 4.1 Important Camera Settings

Setting	Description
Image size/resolution	Selects the image size for photos (more pixels mean a higher-quality image that requires more storage space)
Image quality/compression	Selects the degree of compression for JPG-format files (the lower the compression, the higher-quality the pictures)
ISO speed/sensitivity	Selects different sensitivity settings, in terms of ISO film equivalents
White balance/color mode	Selects color temperatures for different types of lighting
Auto focus	Turns on or off the auto focus system, or selects different types of auto focus
Red eye	Turns on or off red eye compensation (a brief pre-flash that helps to reduce the red eye effect when using camera flash)
Grid/display overlay	Overlays a horizontal/vertical grid on the LCD display, to help you better compose your photos
Date stamp	Turns on or off a time/date stamp superimposed on your photos

It's not that the other settings aren't important; these are just the most important. It's key that you select the quality level for your photos (image size and compression settings), the ISO level (especially when shooting in low light), and white balance/color mode (to compensate for different types of lighting). It's also important to know how to turn on or off the auto focus and red eye compensation features, along with the LCD display grid and photo time/date stamp.

Using the Viewfinder

Most point-and-shoot cameras have only an LCD display/viewfinder; most prosumer cameras have both the LCD viewfinder and an optical viewfinder. The LCD viewfinder takes up most of the back of the camera, while the optical viewfinder is a small eyehole located near the top of the camera.

Choosing Between the LCD and Optical Viewfinder

The LCD display, of course, does double duty as a viewfinder for composing your photos and a display for the camera's menu system. It reproduces exactly what the image sensor is viewing; what you see on the LCD is what will be captured by your camera.

The optical viewfinder, however, isn't connected to the camera's image finder. Instead, it's pretty much a straight shot from the eyehole in back to the opening in front. Because the optical viewfinder isn't precisely aligned with the camera's lens, what you see is offset by a small degree, as you can see in Figure 4.6.

If your camera has only an LCD display, that's what you use to compose your shots. But if your camera has both an LCD display and an optical viewfinder, which of the two should you use?

Using the LCD viewfinder has the following benefits:

- **Convenience**. Let's face it, for most casual photographers, it's easier to view the shot on the LCD display than it is to hold the camera up to your face to peer through the optical viewfinder. You have a wider range of options for holding and positioning the camera when you use the LCD display as a viewfinder.

Because the optical viewfinder is offset to the left and above the lens, that's how the viewfinder frames the scene. This is called *parallax error* and is more noticeable the closer the camera is to the subject.

Full frame seen through the viewfinder

Actual frame caused
by parallax error

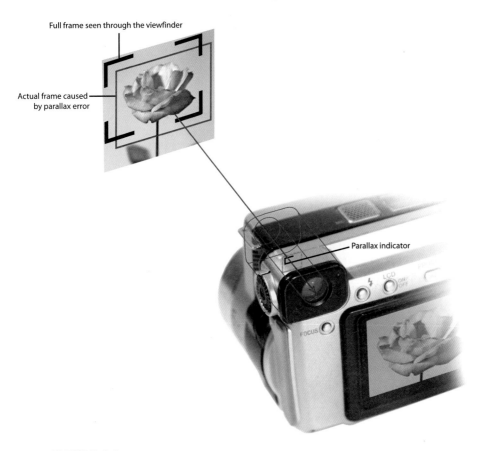

Parallax indicator

FIGURE 4.6
The image seen through the optical viewfinder is slightly offset from what the lens sees.

> **Size**. A 2-inch or more LCD display is a lot bigger than the tiny optical viewfinder. The bigger the display, the easier it is for many photographers to see what they're shooting.

> **Framing accuracy**. It must be said—optical viewfinders don't accurately depict what is seen by the camera lens. Because the optical viewfinder is typically positioned above and to the left of the lens, what it sees isn't quite the same as what the lens sees. Some of what you see through the optical viewfinder will be cut out of the actual photograph. In this regard, the LCD viewfinder is completely accurate—what you see is exactly what the camera captures.

> **Additional information**. Most LCD displays let you overlay additional information when you're shooting a picture. This may include gridlines to help you compose the shot, as well as information about the camera's settings (ISO, resolution, exposure, and so forth).

Of course, using the optical viewfinder has its own benefits:

Some cameras use an electronic viewfinder (EVF) in place of the optical viewfinder. This is a tiny LCD display that you see when you look into the viewfinder. EVFs offer the best of both worlds—you see exactly what the camera sees, plus you don't have to hold the camera out in front of you to see it.

- **Battery life.** Using the LCD viewfinder drains your camera's batteries. When you use the optical viewfinder instead, you'll get longer battery life.

- **Stability/camera shake.** When you hold the camera in front of you with your arms extended, to better see the LCD display, you don't provide enough stability to the camera, which can result in camera shake and blurry photos. Hold the camera with your arms close to your body, as you do when using the optical viewfinder, and you'll have more stable shots.

- **No washout.** Some LCD displays get washed out in bright light, making it hard to see what you're shooting. That isn't a problem when using the optical viewfinder.

While the choice between viewfinders is ultimately a personal one, I find that casual photographers tend to prefer the LCD display. I tend to prefer the optical viewfinder, but I understand the appeal of using the big LCD display to compose casual shots.

Advanced LCD Viewing Options

Given that many casual photographers prefer to work with the LCD viewfinder, let's take a moment to examine the other information you may see displayed on your camera's LCD.

Figure 4.7 shows a typical LCD display. Information about the picture is displayed as a series of text and icons overlaid on the viewfinder image. The information shown on this particular display includes

- Auto flash
- Picture size (in megapixels)
- Number of images remaining on the memory card
- Camera mode
- Exposure compensation (up or down from 0)
- Histogram (analyzes picture brightness)
- Framing marks (to help you compose the picture)

FIGURE 4.7

Information displayed on a Kodak camera's LCD viewfinder.

These aren't the only information bits you're likely to see in your camera's display. Different models display different information at different times; you may, for example, see information or icons for auto focus, ISO setting, white balance, aperture, shutter speed, zoom, self-timer, and low battery. As always, consult your camera's instruction manual for more details.

Positioning the Camera

Before you take your first picture, you have to learn how to hold the camera steady. Steadiness is important; if the camera moves even slightly while you're taking a shot (a phenomenon called *camera shake*), the resulting picture will be blurry. This happens often in low-light conditions, where the camera's shutter is open for longer periods of time; the longer the shutter is open, the more likely it is that you won't be able to hold the camera perfectly still. As most photographers eventually learn, even the smallest movement can result in a blurry picture.

The key to reducing camera shake is to learn how to properly hold your camera—or to use a tripod. We'll examine both approaches.

Holding the Camera

It's an unfortunate fact. Point-and-shoot digital cameras, because of their small size, enable bad photographic technique. In particular, it's tempting to hold the camera in front of you with one hand, as shown in Figure 4.8, so you can clearly see the LCD viewfinder. This one-handed approach is the least stable way to hold a camera and often results in unwanted camera shake.

FIGURE 4.8

The one-handed approach—not recommended.

A slightly better approach, if you insist on straight-arming it, is to do so with both hands, as shown in Figure 4.9. While more stable than the one-armed approach, this still isn't the best way to hold the camera; the farther away you hold the camera from your body, the more chance you have of shaking or swaying when you take your shot.

The best approach, shown in Figure 4.10, is to grip the right side of the camera with your right hand, with the forefinger positioned lightly above the shutter release button and the other three fingers curling around the front of the camera. Position your left hand on the bottom of the camera, so that it fully supports the camera's weight. If you're using the LCD display as a viewfinder, hold the camera a comfortable distance from your body and tuck your elbows into your sides. Even better, use the optical viewfinder and pull the camera against the front of your face; again, keep your elbows tucked into your sides.

FIGURE 4.9
The two-handed straight-arm approach—also not recommended.

FIGURE 4.10
The proper way to hold a point-and-shoot camera.

This last approach offers the most stability for your shots. By bracing your elbows against your body, your body creates a stable foundation that reduces unwanted movement. Make sure you hold your body perfectly still when shooting, and place your feet shoulder width apart to provide the most steady stance.

STOP Take care not to accidentally cover up the lens or the optical viewfinder with your fingers.

Holding your camera in a horizontal position lets you shoot landscape shots—photos that are wider than they are tall. To shoot portrait shots (photos taller than they are wide), turn the camera to your left, so that the end with the shutter button is

You can add extra stability by leaning against a solid object, such as a wall or a tree. Stability is also enhanced when you're sitting or kneeling.

on top, as shown in Figure 4.11. Again, use your left hand to support the weight of the camera, and your right to help steady the camera and press the shutter button.

FIGURE 4.11

Holding a point-and-shoot camera for portrait shots.

Using a Tripod

For even steadier shots, you need a tripod. A *tripod* is a three-legged stand with a screw mount on the top; it screws into the tripod mount on the bottom of your camera, as shown in Figure 4.12.

FIGURE 4.12

A point-and-shoot camera mounted on a tripod.

A tripod is essential for portrait photography, high-quality outdoor landscapes, macro photography, and shooting in low-light conditions. All these shooting conditions require longer exposures, and the longer the shutter is open, the more susceptible the camera is to movement. Using a tripod eliminates all movement—at least that movement that comes from you personally holding the camera. (It's still possible to jiggle the camera/tripod when pressing the shutter release button, but we'll deal with that shortly.)

For increased portability, some photographers prefer a monopod to the larger and more cumbersome tripod. And in a pinch, you can always set the camera on a flat, sturdy surface—such as a table top, brick wall, fence top, or the like.

Learn more about tripods in Chapter 6, "Choosing Camera Accessories."

Composing the Shot

Now that you're holding the camera properly, or mounting it on a tripod, it's time to decide what fits into the image frame. We're talking about composing the shot, which involves placing subjects in position within the confines of the photograph. If you want, most cameras let you overlay a grid on the camera's LCD display.

Composition is so important I've devoted an entire chapter to the topic; learn more in Chapter 10, "Composition."

Zooming Closer

Key to good composition is making sure the main subject fills up as much of the frame as possible. To get the main subject larger, you can get physically closer to the subject by taking a few steps forward, or you can use your camera's zoom lens.

Most point-and-shoot cameras have a 3X zoom lens, which means you can zoom into any item to make it three times larger. (Figures 4.13 and 4.14 show the effect of a 3X zoom lens.) This is good for all types of photography, but especially when you're shooting objects that are farther away, such as athletes at sporting events, landmarks, and the like. It's also good for basic people photography; many casual photographers never get close enough to their subjects.

To operate the zoom on a point-and-shoot camera, you toggle a switch or dial to the right (to zoom in) or to the left (to zoom out). This switch or dial is typically located on the top of the camera, near or surrounding the shutter release button. Experiment with different zoom levels until you get the best composition for your shot.

Learn more about operating zoom lenses in Chapter 8, "Using Different Lenses."

FIGURE 4.13

A subject shot at the normal (1X) zoom setting.

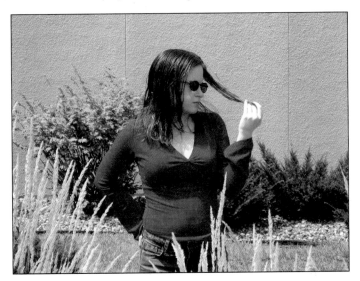

FIGURE 4.14

The same subject shot at 3X zoom.

Using the Camera's Built-In Flash

When you're shooting outdoors in bright sunlight, your camera uses the sunlight to light the photo. When you're shooting indoors, however, there is often

insufficient light to create a bright enough shot. In this type of low-light situation, your camera should automatically switch to its built-in flash mode.

Learn more about flash and other types of lighting in Chapter 11, "Lighting and Flash."

All point-and-shoot cameras have a built-in flash—a small but powerful light that momentarily flashes on to provide light for the pictures you shoot. As I said, most cameras automatically activate the flash when the available light is low enough and turn off the flash when there is sufficient light to create a good photo.

Red eye results when direct light from the camera's flash reflects off the inside of the subject's eyes. The red eye reduction mode pre-lights the flash a microsecond ahead of the regular flash, to contract the subjects' pupils and thus reduce the reflected light from the flash.

There are some instances when you might want to disable the flash in low-light conditions or use the flash even when sufficient natural light is available. To this end, you'll need to access your camera's menu system to turn on or off the automatic flash. (On some cameras, the flash control might be on a separate dial or switch, instead of or in addition to being part of the main menu system.)

Most cameras have multiple flash modes to choose from, typically including the following:

- **Auto.** Flash automatically activates in low-light conditions.
- **On.** Flash is always on, even in strong lighting.
- **Off.** Flash is always off, even in low light.

For example, you may turn off the flash when shooting inside a darkened sporting arena, because the flash from the camera won't reach far enough to light the players on the floor. Or you may turn on the flash when shooting portraits outdoors to provide fill lighting to light up any shadowed areas of people's faces.

Some cameras also feature a red eye reduction mode, which is used in conjunction with the flash. Use this mode to reduce the red eye effect when shooting portraits or people shots with your camera's flash.

Correcting White Balance

If you're shooting indoors, you may need to compensate for the unnatural color generated by different types of artificial lighting. We'll discuss this in more depth

Learn more about white balance and color correction in Chapter 12, "Color."

later in the book; for now know that fluorescent and tungsten lights generate unnatural-looking color casts. With the wrong type of lighting, your picture may look too warm (orange) or cool (blue).

Most point-and-shoot cameras try to compensate for different types of lighting, often through the automatic shooting mode you select. That said, automatic white balance tends to work better under the kind of bright lighting that doesn't require compensation, a nice Catch-22 for that sort of thing.

Fortunately, most point-and-shoot cameras let you manually adjust white balance settings. This is typically done via a setting on the LCD display's menu; you should be able to select a white balance or color or lighting setting that corresponds with the type of lighting in the shot. Make the correct selection, and then proceed to set up the rest of your shot.

Selecting Automatic Shooting Modes

Setting the proper exposure is essential in creating good-looking photographs. You control exposure via the camera's shutter and aperture; unfortunately, most point-and-shoot cameras don't have separate shutter and aperture controls, or those controls are buried somewhere in the camera's menu system. So how do you control the exposure?

The answer is in the camera's automatic shooting modes. Because most users of point-and-shoot cameras want simple operation, manufacturers have preset a limited number of shutter/aperture combinations for different types of shots. Choose the right automatic shooting mode for your particular situation, and the camera properly sets the shutter speed and aperture to provide the optimal exposure.

You typically select your camera's automatic modes via a dial or switch on top of the camera, or via settings on the LCD's menu system. Most cameras indicate modes via a representative icon of some sort; for example, sports mode might be indicated by an icon of a person running, while portrait mode might be indicated by an icon of a person.

Understanding Common Automatic Modes

Different makes and models of cameras feature different automatic shooting modes. Some cameras only have three or four automatic modes; others have close to a dozen. Table 4.2 details some of the more common automatic shooting modes you may encounter.

Most automatic modes also determine the proper ISO sensitivity and white balance for the type of shot selected.

Table 4.2 Common Automatic Shooting Modes

Mode	Typical Icon	Description
Automatic	AUTO	The fully automatic mode makes the most appropriate shutter/aperture adjustments based on available lighting. Provides good (but not necessarily the best) results in most shooting conditions; you can safely use this mode for most shots.
Portrait		Used to shoot a single human subject or inanimate still life. This mode sets a large aperture, which provides a shallow depth of field to keep the background slightly out of focus. Depending on lighting conditions, this mode may also set a faster shutter speed.
Landscape		Used to shoot outdoor landscapes. Almost the exact opposite of portrait mode, this mode sets a small aperture to provide a wide depth of field, so that more of the shot is in focus. Depending on lighting conditions, this mode may also set a slower shutter speed.
Sports/action		Used to shoot fast-moving action, such as that found in most sporting events. This mode sets a fast shutter speed, which helps to freeze the action.
Kids and pets		Similar to sports mode, used to shoot subjects that don't like to pose or even stand still. Uses a combination of a faster shutter speed with some degree of prefocusing.
Snow		Used for shooting in bright snowscapes. Shoots without a blue fringe and boosts the exposure to avoid having people appear dark against the white background.
Beach		Used to shoot bright outdoor scenes. Similar to snow mode in that it boosts the exposure to avoid having people appear dark against water or sand with strong reflected sunlight.
Foliage		Used for shooting brightly colored fall foliage. Boosts saturation to provide bold colors.
Night landscape		Used to shoot in very low-light conditions. Typically sets a wide aperture, slow shutter speed, and (optionally) no flash.
Night portrait		Used to shoot portraits in low-light conditions; lets you capture human subjects against the backdrop of the evening sky. This mode sets a slow shutter speed and wide aperture and activates the flash to light the subject with a foreground light.
Fireworks		Used for shooting fireworks displays. Optimizes exposure to capture fireworks sharply against the night sky.
Indoor		Used for shooting indoors with artificial lighting. Sets a slower shutter speed and appropriate white balance.
Underwater		Used for underwater photography. Adjusts white balance to reduce bluish tones and record images with a more natural hue; also extends the exposure to use as little flash as possible.

Mode	Typical Icon	Description
Macro/close up	🌷	Used to shoot very small objects close up. Introduces different focusing distances for close-up shots; also creates a very narrow depth of field, which makes focusing more sensitive.
Panoramic/stitch assist		Used for taking multiple overlapping shots of a panoramic scene, which can later be joined together as a single image.
Manual	⬛M	Lets you override automatic settings to set manual shutter speed and aperture; not found on all point-and-shoot models.
Movie		For those cameras with video capability, switches the camera to take movies instead of still photos.

Naturally, your camera may have more or fewer modes (or just different modes) than those listed here.

Let's look at some examples of the different shooting modes. Figure 4.15 demonstrates the portrait mode; note the blurry background behind the subject. Figure 4.16 demonstrates the landscape mode, with both the foreground and background in focus. Figure 4.17 shows how you can use the sport mode to freeze movement in the picture (in this instance, to freeze moving water from a fountain). And Figure 4.18 shows night mode, with both the subject and the background properly exposed.

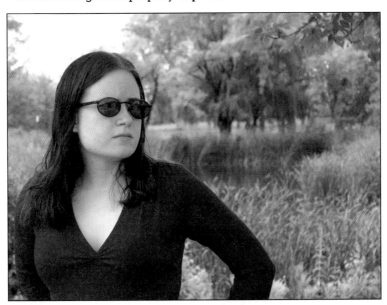

FIGURE 4.15

A picture shot in portrait shooting mode, producing a shallow depth of field.

FIGURE 4.16

A picture shot in landscape shooting mode, producing a wider depth of field.

FIGURE 4.17

A picture shot in sport mode, freezing all movement in the shot.

FIGURE 4.18

A picture shot in night mode, with both the subject and background exposed.

Using Automatic Modes for More Control

Because your point-and-shoot camera probably doesn't have manual shutter and aperture controls, or you don't want to go to the trouble of setting shutter and aperture manually, how do you control exposure for special types of shots? The answer is in selecting the appropriate automatic shooting mode.

Here are some examples of desired effects and the shooting mode that delivers a similar effect:

- To create a shallow depth of field (blurry background), choose **portrait** mode.

- To create a wider depth of field (both foreground and background in focus), choose **landscape** mode.

- To achieve a faster shutter speed (to freeze movement), choose **sport** or **action** mode.

- To achieve a slower shutter speed (to blur the action or shoot in low-light conditions), choose **night** mode but manually deactivate your camera's flash.

Consult your camera's instruction manual for more information about the available automatic modes—or just do some experimenting on your own.

Learn more about manipulating auto focus systems in Chapter 14, "Focus and Depth of Field."

Focusing the Camera

After your shot is composed and zoomed properly, and you've selected the right type of flash and automatic shooting mode, you need to make sure that the main subject is in focus. All point-and-shoot digital cameras use some sort of automatic focus system, which means you shouldn't have to do much to focus the shot.

To activate auto focus, aim your camera at the subject and slightly depress and hold the shutter release button. (Do *not* aim at anything other than the main subject, especially the background behind the subject.) You'll hear the camera make a slight whirring noise; this is the lens focusing on the nearest object. After the object is in focus (you can see for yourself using the camera's LCD display), you can further depress the shutter button to take the shot.

Taking the Shot

You've done a lot of work so far, and yet you still haven't taken a single picture. Not to fear; all that effort is just preparation for creating a great-looking photograph. Now it's time to shoot!

Taking a Single Shot

Taking a single shot, assuming you have everything set up properly, is as easy as pressing the shutter release button. But, as with most things, there's a bit of skill involved in doing it right.

Shooting a camera involves much the same technique as shooting a gun. When you shoot a gun, you don't want to pull sharply on the trigger; instead, you want to gently squeeze the trigger. It's the same thing with a camera. Instead of punching down sharply on the shutter release button, you want to gently push down until the shutter releases.

If your camera has a lens cap, remember to remove it before you take the shot!

The goal is to take a steady picture without unnecessarily jarring the camera—which you can do if you press down too hard or too fast on the shutter release button. The key is to take a breath, hold it, and then exhale as you gently press the shutter release button. Proper breathing helps to steady the shot.

When you press the shutter release button, use the flat part of your finger, as shown in Figure 4.19, not the fingertip. This provides more control over the action and reduces camera shake. Press once and release, and the shot is in the can.

FIGURE 4.19

Gently pressing the shutter release button.

Using Continuous Shooting Mode

Sometimes you want to take more than a single shot. Perhaps you want to capture the continuous action at a sporting event (as shown in Figure 4.20), or take multiple shots of a particular group or setting (as in Figure 4.21).

4

FIGURE 4.20

Capturing continuous action at a sporting event.

FIGURE 4.21

Capturing a range of emotions between a mother and daughter.

Fortunately, you don't have to press-release-press-release-press-release to take multiple shots. Most point-and-shoot cameras offer a continuous shooting mode, sometimes called a *burst mode*, that lets you take multiple shots with a single press and hold of the shutter.

To shoot a burst of photos, you have to put your camera in continuous shooting mode. This mode might be one of the automatic shooting modes, it might be located elsewhere on the camera (sometimes on the same dial that controls the self timer), or it might be an option in the LCD display menu, typically in a "drive mode" submenu. Look for an icon that resembles the one in Figure 4.22; when in doubt, consult your camera's instruction manual.

FIGURE 4.22

A typical continuous shooting mode icon.

When you select continuous shooting mode, the shutter button's operation changes. Instead of shooting a single shot when pressed, it keeps shooting multiple shots until you release the button. To shoot multiple shots, then, follow these steps:

1. Select your camera's continuous shooting mode.
2. Compose the shot and make other necessary adjustments.
3. Press and *hold* the shutter release button; your camera starts capturing a series of successive images.
4. When you're done shooting, release the shutter button.

How many shots your camera takes in how long a period of time differs from camera to camera; it also depends on how full your memory card is and how charged your batteries are. Some cameras might only let you take a half dozen continuous shots; others let you keep shooting until your memory card fills up or your batteries give out, whichever comes first.

Using the Self-Timer

What do you do if you want to capture yourself in a shot? (This is a big issue when you're on vacation and want your entire family posed in front of some landmark or another.) The solution is to use your camera's built-in timer; just set the time, and then rush around in front of the camera to get in the shot.

Some cameras do not save directly to the memory card when in continuous shooting mode. Instead, they save to an internal memory buffer that stores the shots until you finish shooting; at that time, the shots are saved to the memory card.

Most point-and-shoot cameras have a self-timer that either is preset to a specific delay or lets you dial in the amount of delay you want. Look for the timer control somewhere on the top or back of your camera, or perhaps in the LCD display menu; the icon for the self-timer should look like the one shown in Figure 4.23.

Most cameras automatically deactivate self-timer mode after a shot has been taken. If you want to take another self-timed shot, you'll probably have to reenter the self-timer mode.

FIGURE 4.23

A typical self-timer mode icon.

Using the self-timer is a little tricky. Here's how it typically works:

1. Compose and focus the shot—without you in it.
2. Turn on the self-timer or activate the self-timer mode.
3. If offered, select the amount of delay you want for the timer.
4. When everything and everyone is ready, press the shutter release button.
5. Rush to your position in front of the camera.
6. Your camera's self-timer lamp begins to blink; this is your countdown to the actual shot.
7. When the set amount of time has passed, the camera takes the shot.

Reviewing Your Photos

All the photos you take are stored on the camera's memory card. Your camera can access these stored photos and display them on the camera's LCD display. This lets you review the photos you've taken—and, if you like, delete the ones you don't want to keep.

Most point-and-shoot cameras feature separate shoot/record and playback modes. The modes are typically selected via a dial on the top of the camera, somewhere near the shutter release button. Other cameras let you switch modes via a switch or control on the back of the camera, or a setting in the LCD display menu. As always, if you can't find it, look it up in your camera's instruction manual.

When you switch into playback mode, your stored pictures appear on the LCD display; most cameras automatically display the last picture taken. Information about the picture is typically overlaid on the display, as shown in Figure 4.24. You'll probably see information such as when the picture was taken, the image quality or compression, and the number of images currently stored on the memory card. Depending on the camera and the display mode, you may also see information about the shutter speed, aperture, flash, shooting mode, white balance, and the like used to create the photo. Some higher-end cameras also display a histogram of the image's brightness levels.

FIGURE 4.24

The playback display on a Canon camera.

There should be a toggle switch of sorts on the back of your camera; you use this control to move back and forth through the pictures displayed on the LCD. Some cameras offer a zoom mode for pictures displayed on the LCD. Press the zoom button or lever and the picture enlarges so you see only a piece of the image. Use the toggle controls to move left, right, up, or down around the enlarged image.

There may also be an additional zoom mode that displays four or nine picture thumbnails at a time on the LCD display, like that shown in Figure 4.25. Use the toggle controls to move from one thumbnail to the next; select any thumbnail to view it full-screen.

FIGURE 4.25

A typical nine-up thumbnail display.

Deleting Photos

If you find a photo that you decide not to keep, you can delete it from your camera's memory card. Look for a delete or trash can button on the back of your camera; that's what you'll use to delete the selected photo.

To delete a single photo, follow these steps:

1. Enter your camera's playback mode.

2. Navigate to and display the photo you want to delete.

3. Press the delete or trash can button.

4. If prompted, confirm that you want to delete the photo.

If you want, you can delete all the photos on your camera's memory card. In most cameras, this is a setting somewhere in the LCD display menu. Look for a file or photo management submenu; then look for the menu item that says delete or trash. There should be an option to "delete all"; select this option and then confirm the deletion if prompted.

Transferring Photos to Your PC

Of course, you don't want to keep all your photos inside your camera. At some point in time you'll want to transfer those photos to your computer, where you can edit, print, or email them—or just store them permanently.

Learn more about transferring photos in Chapter 15, "Storing and Managing Photos on Your PC."

Most point-and-shoot cameras offer two ways of transferring photos to a PC— via a direct transfer cable or by inserting the memory card into a media card reader on your PC. Either method is equally fast; use the one that works best for you. And after the photos are downloaded to your PC, you can then delete them from your memory card, freeing up all that storage space for new photos.

Cleaning and Maintaining Your Point-and-Shoot Camera

We'll conclude our look at point-and-shoot cameras by talking a little about how to keep your camera in tip-top operating condition. It's a matter of regular cleaning and maintenance, and it's mostly common sense.

First, it's easier to keep your camera clean if you don't use in dirty, dusty, or sandy conditions. This may not always be possible, of course; after all, you really want to take photos of your upcoming oceanfront vacation, and there's lots of sand at the beach. Still, when at all possible, avoid using your camera around the following conditions:

- Water
- Steam
- Excess humidity
- Sand
- Dusty or dirty environments
- Chemicals
- Strong magnetic fields
- Extreme hot temperatures
- Extreme cold temperatures
- Direct sunlight (for prolonged periods)
- Stored inside hot sealed cars

Like I said, pretty much common sense. For example, you don't want to dip your camera in a swimming pool, whip it out during a dust storm, or use it for extended periods when the temperature is below zero. Dust and sand can gum up the internal workings, and extreme temperatures can make everything (mechanical and electronic) work slower, if at all. Again, use common sense.

Even a well-cared for camera still needs some maintenance, however, primarily in the form of cleaning. For proper cleaning, you need three basic tools: a soft lint-free cloth (ideally a microfiber cloth designed specifically for lens cleaning); a "blower brush" (with a bulb you squeeze to blow air, like the one shown in Figure 4.26); and a bottle of lens cleaning fluid.

FIGURE 4.26

Use a blower brush to clean the outside of your camera.

You use the cloth to clean the camera's body and to wipe clean the LCD viewfinder and the front and back of the optical viewfinder. You use the blower brush to wipe dust off the front of the lens and to blow dust from the memory card and battery compartments. You should do this cleaning periodically—once a month or more frequently if your camera is heavily used.

Cleaning the lens is a delicate operation. Start with the blower brush and blow air across the lens to remove any loose dust particles. Next, use the cleaning cloth to wipe dirt and fingerprints off the lens. Stubborn marks can be removed with the lens cleaning solution, wiping the lens dry with the cleaning cloth. Always apply the lens cleaning solution directly to the cloth, not to the lens itself.

 Don't use compressed air with a point-and-shoot digital camera. A can of compressed air blows too hard and can actually blow dust inside the point-and-shoot camera, where it might attach to the image sensor. (Most point-and-shoot cameras are not airtight.)

If your camera accepts lens filters (some do, some don't; check your instruction manual), you should purchase a polarizing or UV filter. This type of filter not only improves the quality of your images, it also protects the front of your lens from dirt and scratches.

 Clean your lens only with a cloth designed for that purpose. Do not clean your lens with paper towels, napkins, facial tissue, and the like, all of which can scratch the lens.

It's also a good idea to periodically clean the battery terminals in the battery compartment and the connectors for the camera's memory card. Use a pencil eraser to wipe clean the contacts.

Beyond these simple steps, any additional cleaning and maintenance should be left to professionals. If your camera needs more work or requires repairs, see your local camera shop for advice.

THE JOYS OF POINT-AND-SHOOT PHOTOGRAPHY

My main camera is a Nikon D70 digital SLR (D-SLR), and I love it. But there are times where it's just too cumbersome, both to carry around and to use. It's nice to be able to adjust manual focus and set shutter speed and aperture, but I don't always have the time or desire to do so.

This is where a point-and-shoot camera is attractive. When you're on a family vacation or casual get-together, it's nice to have a camera small enough that you can pack it in your pocket or purse, without having to lug around a bulky camera bag. And the lack of manual settings isn't a drawback when you just want to snap some quick photos; select the appropriate automatic shooting mode (more often than not, the default "auto" mode works just fine), line up the shot, and press the shutter button. That's it—a near-perfect shot in a matter of seconds.

Granted, a point-and-shoot camera won't deliver the detailed picture quality that you'll get with a D-SLR, but it'll come close—especially with today's 5, 6, and 7 megapixel point-and-shooters, which give you the latitude you need in case you need to do some serious cropping after the fact. (That's some compensation for the typical lack of a long zoom.)

In fact, today's best point-and-shooters give you a lot of latitude in terms of the types of shots you can take. While older models were limited to a handful of automatic shooting modes, today's models offer a dozen or so modes for all sorts of shooting conditions, from nighttime

4

portraits to snaps on the beach. And, if you look hard enough, you may discover that your automatic point-and-shoot camera also lets you manually adjust shutter speed and aperture—just like the big boy cameras do.

In short, if you take the time to read the instruction manual (and if that manual isn't badly translated from the original Japanese), you may find that you have the same type of control over your pictures as you would with a much more expensive D-SLR camera. And that picture quality and control comes at fraction of the cost of a D-SLR in a much more compact package. It's not surprising that point-and-shoot cameras represent the largest segment of the digital camera market; casual photographers benefit from the advancing technology that lets them shoot high-quality pictures with the press of a single button.

4

Operating a Digital SLR Camera

When a point-and-shoot camera just isn't enough, serious photographers graduate to digital SLR (D-SLR) cameras. A D-SLR offers manual control over shutter speed, aperture, and ISO; interchangeable lenses; a larger and more sensitive image sensor; and other advanced features that let you take pro-level pictures.

As you might suspect, using a D-SLR is more involved than using a point-and-shoot model. There are more controls to learn, more options to consider, and more different ways to obtain a variety of photographic effects.

Read on to learn more.

Getting to Know Your Camera's Features

At first glance a typical D-SLR looks a little like a point-and-shoot camera on steroids. The body is bigger, the lens is longer, and there are quite a few more buttons and dials, but they look similar.

There's more there than meets the eye, of course. Look hard, and you'll find some or all of the following features:

For the purposes of this chapter we'll focus on what the industry calls consumer-level D-SLRs—cameras priced in the $1,000 to $2,000 range. There are more expensive D-SLRs, designed for professional photographers, but they're priced well above this range and are beyond the scope of this book.

- Removable lens
- Button to release the removable lens (next to the lens, on the front of the camera)
- Manual/automatic focus switch (on the front or back of the camera)
- Internal flash
- Hot shoe (to mount external flash or speedlight)
- Shutter release button
- On/off button/switch (sometimes a separate button, often on a dial on the outside of the shutter button)
- Mode selector (typically a dial opposite the shutter release button on the top of the camera)
- Selector or command dial (used in conjunction with the exposure/shutter/aperture buttons on the back of the camera, to select specific options)
- Exposure/shutter/aperture controls (typically a set of buttons on the top or back of the camera)
- Optical viewfinder
- LCD status display (located on the top or back of the camera)
- Main LCD menu display and associated menu controls (on the back of the camera)
- Individual buttons for key features (ISO, white balance, and so forth)
- Memory card slot (on the back or side of the camera)
- Battery compartment (on the bottom of the camera)
- Input/output jacks (on the side or bottom of the camera)
- Tripod mount (on the bottom of the camera)

Note that these features are not identical to those found on a point-and-shoot or even a prosumer camera. Indeed, there are many more buttons and switches, assigned to specific manual operations. Most D-SLRs also have a second LCD status display (in addition to the main LCD menu display), which is constantly on to show the status of various camera functions; this display may be on the top of the camera, or on the back, just above the main LCD.

For example, Figures 5.1 through 5.5 show the front, back, top, sides, and bottom of a typical D-SLR, in this case the Nikon D80. Remember, the location of key features on your camera may be different from that presented here; every manufacturer has its own way of doing things.

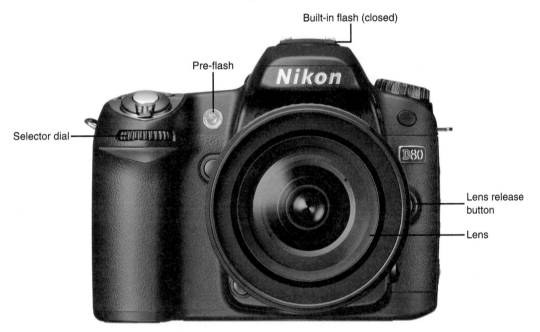

FIGURE 5.1

The front of a D-SLR camera, with the lens attached.

Menu control

Manual setting buttons

LCD display

Memory card compartment (closed)

FIGURE 5.2

The back of a D-SLR camera; note the profusion of individual feature buttons.

Shutter release button

On/off dial

Mode selector

Hot shoe

LCD status display

FIGURE 5.3

The top of a D-SLR; the on/off dial is on the outside of the shutter release button.

Manual/automatic
focus switch

Input/output jacks
(for connecting to a computer)

FIGURE 5.4

The left side of a D-SLR—note the auto/manual focus switch on the side of the lens mount.

Tripod mount

Battery compartment (closed)

FIGURE 5.5

The bottom of a D-SLR.

Obviously, with all the various buttons and switches placed around the body of the camera, you should read the instruction manual to familiarize yourself with the location and function of all these controls and features.

If you don't have the instruction manual for your camera, you should be able to download it (typically in PDF format) from the camera manufacturer's website.

Charging the Camera's Batteries

Learn more about batteries in Chapter 7, "Managing Batteries and Storage."

As with a point-and-shoot camera, you need to charge the batteries for a D-SLR before you use the camera. Unlike the typical point-and-shoot camera, however, most D-SLRs don't use standard batteries. Instead, they have a special battery pack that must be charged in the supplied charging unit.

The good thing about D-SLR batteries is that you don't have to charge them as often. That's because D-SLRs drain batteries much more slowly than do point-and-shoot cameras. The big drain for a point-and-shoot camera is from the LCD display screen, which is constantly on for use as a viewfinder. D-SLRs don't use the LCD display as a viewfinder, however, which means that the LCD is most often off. This reduces the drain on the batteries, which results in longer battery life between charges.

Turning the Camera On and Off

When you insert the camera's battery pack, it's ready to be turned on. With some D-SLRs, this is accomplished via an on/off dial on the outside of the shutter release button on the top of the camera. With other D-SLRs, there's a separate power button somewhere on the body.

Unlike with a point-and-shoot camera, where you want to turn it off when you're not shooting, you can leave a D-SLR turned on for extended periods of time. This is because the LCD display is not automatically lit up when the camera is on. Without the LCD display drawing power, there is little power drain when a D-SLR is turned on.

In fact, the only indication you'll have that a D-SLR is powered up is a green or red light somewhere on the camera body. That little light doesn't put much of a strain on the camera's battery pack!

Inserting the Memory Card

The next thing you need to do is insert a memory card into your camera's memory card slot. For most cameras, inserting the memory card is a simple matter of opening a door and sliding the card into the slot, as shown in Figure 5.6. The card should lock into position. To remove the card, simply press the card farther into the slot to unlock it, or press the supplied card release button. You should then be able to grab it and remove it.

Learn more about memory cards in Chapter 7.

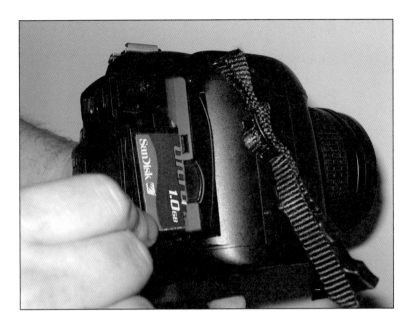

FIGURE 5.6

The memory card compartment of a D-SLR.

Changing Lenses

One unique feature of a D-SLR camera is the removable lens. Most D-SLRs come as part of a kit that includes a factory-supplied lens. You don't have to stick with this lens, however; you can replace it with any compatible lens made by the camera's manufacturer, or made by third parties.

> **STOP** Avoid changing lenses in dirty or dusty conditions. When the lens is off the camera, dust can accumulate on the exposed image sensor; this can affect the quality of future photos. So try to change lenses only in clean, dust-free conditions.

To remove the camera's lens, start by turning off the camera. (This protects the image sensor from a burst of light when the lens is removed; it also turns off the motor used to adjust the lens for auto focus operation.) Now press the lens release button, which is typically located just beside the lens, on the front of the camera. Twist the lens slightly, and then gently pull it from the lens mount, as shown in Figure 5.7.

FIGURE 5.7

Removing a lens from a D-SLR camera.

Inserting a new lens is the opposite of this procedure. Remove the rear lens cap from the new lens, align the lens with the guide on the front of the camera, insert the lens into the camera's lens mount, and then twist it slightly in the direction shown until you hear a click. The lens should now be locked into position.

You should attach the lens cap to both the front and rear of any lens not currently inserted into your camera. This protects both sides of the lens from dust and scratches.

Which lens you choose is a function of what kind of shot you want to take. Use a longer telephoto lens to capture distant shots, a shorter wide-angle lens for closer shots, or a zoom lens to capture a variety of different focal lengths.

Learn more about lenses in Chapter 8, "Using Different Lenses."

Configuring Menu Options

As with point-and-shoot cameras, a D-SLR offers a variety of configuration settings, accessed via the large LCD display at the back of the camera. Unlike a point-and-shoot camera, however, a D-SLR's display is not automatically lit when the camera is powered on. To view the menu on the LCD display, you'll

need to press a dedicated menu or display button, typically located next to the display on the back of the camera.

Most D-SLRs utilize a system of menus and submenus (or sometimes menu tabs), like the one shown in Figure 5.8. Because a D-SLR has more options than the typical point-and-shoot camera, there will probably be more menu items, as well. What menu options will you find on your particular camera? Obviously, this varies from model to model, but you're likely to find some or all the following types of options:

FIGURE 5.8

The main menu system on a Nikon D80 D-SLR.

- Shooting/record/photo options, which let you configure how pictures are shot—image quality, image size, white balance, ISO sensitivity, and the like.

- Playback options, which let you determine how pictures are displayed on the LCD viewfinder. May also let you delete pictures during playback.

- Retouch options, found on some cameras, which enable you to edit photos (remove red eye, crop the image, adjust brightness/contrast, and so on) in the camera.

- Setup/custom options, which let you configure how the camera operates—the internal beep sound, auto power down mode, language, date/time display, file numbering, and the like. On some cameras, this menu may also contain options for configuring the auto focus system.

> The main menu selections may not be named, but instead may be identified by representative icons.

Note that these menus are slightly different from those found on a point-and-shoot camera. You'll also find that the individual menus and submenus typically go deeper (that is, have more options) than those on a point-and-shoot menu; again, this points out the additional features and options found on D-SLR cameras.

Using the Viewfinder

Unlike a point-and-shoot camera, a D-SLR offers only one way to compose your images, through the optical viewfinder. The optical viewfinder on a D-SLR is different from the similar viewfinder on a point-and-shoot camera, however, in that it uses an angled mirror apparatus to reflect the image directly from the camera lens, as shown in Figure 5.9. So what you see through the viewfinder is identical to what the lens sees; you're viewing the image through the lens.

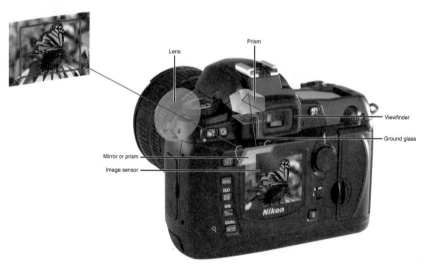

FIGURE 5.9

The lens and viewfinder system of a D-SLR camera.

Positioning the Camera

A D-SLR is both larger and heavier than a point-and-shoot camera, which makes it slightly more difficult to hold the camera steady. Proper technique is important to take blur-free pictures.

Holding the Camera

Because you have to hold a D-SLR up to your face to see through the viewfinder, you need to learn a slightly different method of holding the camera than what you use with a point-and-shoot model.

Start by placing your left hand underneath the camera, so that it supports the camera's weight. Now use your right hand to grip the right side of the camera, with the forefinger positioned lightly above the shutter release button and the other three fingers curling around the front of the camera. (Many D-SLRs have a molded grip on the right side that makes it easy to grab.) Tuck your elbows into your sides, as shown in Figure 5.10, and then pull the camera against the front of your face, so that the viewfinder is directly in front of the desired eye. This stance uses your body to create a stable foundation for the camera, reducing the possibility of unwanted movement. Make sure you hold your body perfectly still when shooting, and place your feet shoulder width apart to provide the most steady stance.

FIGURE 5.10

The proper way to hold a D-SLR camera.

Holding your camera in a horizontal position lets you shoot in landscape orientation—photos that are wider than they are tall. To shoot in portrait orientation (photos taller than they are wide), turn the camera to your left, so that the right side of the camera is on top, as shown in Figure 5.11. Again, use your left hand to support the weight of the camera, and your right to help steady the camera and press the shutter button.

STOP Take care not to accidentally cover up the lens or the optical viewfinder with your fingers.

FIGURE 5.11

Holding a D-SLR in portrait orientation.

Using a Tripod

For even steadier shots, mount your D-SLR on a sturdy tripod. The head of the tripod screws into the mount on the bottom of your camera, as shown in Figure 5.12.

A tripod is essential for any shot that requires longer exposures—portraits, outdoor landscapes, macro photography, and the like. Using a tripod reduces camera movement that can introduce blurriness when you use a slow shutter speed.

Learn more about tripods in Chapter 6, "Choosing Camera Accessories."

FIGURE 5.12

A D-SLR camera mounted on a tripod.

Composing the Shot

It's now time to compose your shot. Composition involves placing subjects in position within the confines of the image frame. This is where your own skill as a photographer comes into play; do your best to frame an interesting composition!

Some newer D-SLRs let you superimpose a grid into the optical viewfinder. This is a good option when precise positioning is important; most viewfinders use a 3×3 grid, which is useful when composing with the rule of thirds.

Using Flash

Most D-SLRs include a built-in flash, as well as the option for using external flash devices, such as speedlights. Flash is useful when shooting in low light situations, or when you need to add a little fill light to remove unwanted shadows.

Learn more about composition and the rule of thirds in Chapter 10, "Composition."

Using the Camera's Built-In Flash

Your D-SLR should include a switch or control that lets you select from several different flash modes. These modes are typically selected by pressing a flash button or using a dial control. (Consult your camera's instruction manual for more detailed instructions.)

> To use the flash in situations where it might not otherwise activate, simply raise the flash unit. When raised, the flash will light whenever the shutter release button is pressed.

Typical modes include the following:

- **Automatic**. The flash lights only when additional light is needed—when ambient light is low, or when the subject is backlit. If there's enough ambient light, the flash won't flash.

- **Red eye reduction**. The flash is immediately preceded by the flash of a red eye reduction light.

- **Slow sync**. Similar to automatic mode, but paired with a slower shutter speed to capture background lighting behind the subject.

- **Rear curtain sync**. Similar to automatic mode, but the flash fires just before the shutter closes. This creates the effect of a stream of light behind a moving subject.

- **Off**. The flash never activates, no matter the available light.

The built-in flash of a D-SLR is "smarter" than the simple flash found on a point-and-shoot camera. With most D-SLRs, range of the flash varies based on aperture and ISO sensitivity.

In addition, most D-SLRs let you adjust the flash beyond the level suggested by the camera. So-called flash exposure compensation lets you increase the amount of flash to make the subject appear brighter, or decrease the amount of flash to prevent unwanted highlights or reflections.

Look for a dedicated flash compensation button or control, or within your camera's main LCD menu. You should be able to press a "+" control to increase the amount of flash or a "-" button to decrease the amount of flash. Return to the normal flash levels by moving the control to the "0" position.

Using a Speedlight

Most D-SLRs include a hot shoe on the top of the body to which you can attach an optional speedlight. When you use a manufacturer-approved speedlight, it is automatically connected to and controlled by your camera, so that it is in sync with the other camera settings.

A speedlight offers better control over both direct and fill lighting than does a simple built-in flash. You can tilt a speedlight to provide bounce flash, or aim it directly at the subject for direct lighting. In addition, you can control the amount of light produced by the speedlight for various lighting effects.

Learn more about flash lighting and speedlights in Chapter 11, "Lighting and Flash."

Consult your camera's instruction manual for how to connect and use a speedlight with your camera. Consult the speedlight's manual for how to get the most out of the speedlight.

Viewing Camera Settings with the Status Display

Now is as good a time as any to discuss the auxiliary display, sometimes called a control panel, found on many D-SLR cameras. This small LCD display, typically located on the top of the camera or on the back, just above the main LCD display, is used to show the status of various camera settings.

The status display is a simple LCD display, showing only text or icons for various camera functions. For example, you'll likely find indicators for shooting mode, shutter speed, aperture, ISO sensitivity, white balance or color temperature, flash mode, auto focus mode, number of shots remaining on the memory card, and the like. As you can see in Figure 5.13, most status displays cram a lot of information into a small space, so you'll need to consult your camera's instruction manual to figure out exactly what's what.

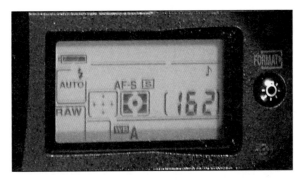

FIGURE 5.13

A typical LCD status display.

The nice thing about this status display is that it's always on but uses very little power. You can use this display to see at a glance how your camera is configured, and to determine which settings you may still need to adjust.

Correcting White Balance

Learn more about white balance and color correction in Chapter 12, "Color."

Now back to your camera's settings. The white balance or color compensation control is used to adjust the color temperature of a shot. This is necessary when shooting indoors with artificial lighting; as you're probably aware, fluorescent and tungsten lights generate unnatural-looking colors, giving your pictures a warm (orange) or cool (blue) cast.

Look for a separate white balance or color temperature control somewhere on the body of your camera, or as part of the main LCD menu system. You may have the option of selecting a particular type of lighting, or of directly setting a particular color temperature or temperature range. Some D-SLRs let you preset the camera's white balance by aiming at a neutral gray or white object. Again, consult your camera's instruction manual to see what options are available.

Setting ISO Sensitivity

The next setting we'll discuss is one not found on many point-and-shoot cameras. ISO sensitivity on a D-SLR is the digital equivalent of film speed on a film camera.

The higher the ISO sensitivity, the less light needed to make an exposure. Set a higher ISO when you're using a fast shutter speed or small aperture, such as with sports or action photography. Use a lower ISO to capture low light images.

Look for a separate ISO button or control on the camera body, or as part of the main LCD menu system. The range of ISO settings varies from camera to camera. Most D-SLRs let you choose values from ISO 100 to ISO 1600; ISO is selected automatically when your camera is using an automatic shooting mode.

Setting the Exposure

Lower ISO settings can introduce noise or grain into the image.

One of the primary benefits of a D-SLR camera is the ability to manually control exposure, by setting the camera's shutter speed and aperture. On a point-and-shoot camera, these settings are made automatically; with a D-SLR, you can set one or both settings manually, or let the camera do it via an automatic shooting mode.

Learn more about ISO sensitivity in Chapter 13, "Exposure."

Most D-SLRs let you select how you set exposure, typically via a top- or back-of-camera mode selector control. For example, Nikon's D-SLRs feature four main exposure modes:

- **Programmed auto.** Enables the camera's preset automatic shooting modes

- **Shutter-priority auto.** Lets you set the shutter speed and then automatically sets the corresponding aperture

- **Aperture-priority auto.** Lets you set the aperture (f/stop) and then automatically sets the corresponding shutter speed

- **Manual.** Lets you set both shutter speed and aperture

We'll look at each of these options separately.

Using the Camera's Programmed Automatic Shooting Modes

You're familiar with automatic shooting modes from their use in point-and-shoot cameras. We're talking about a handful of preprogrammed modes that automatically set shutter speed, aperture, ISO, and (sometimes) white balance for specific types of shots. These modes are great for when you're taking quick snapshots, or don't have the time (or expertise) to set shutter speed and aperture manually.

D-SLRs typically have fewer automatic modes than those found on point-and-shoot cameras. For example, Nikon's D-SLRs offer a grand total of seven automatic modes, as detailed in Table 5.1. (Canon's D-SLRs have one fewer mode, eliminating the night landscape option.)

Table 5.1 Typical Automatic Shooting Modes for D-SLR Cameras

Mode	Typical Icon	Description
Automatic	AUTO	The fully automatic mode makes the most appropriate shutter/aperture adjustments based on available lighting. Provides good (but not necessarily the best) results in most shooting conditions; you can safely use this mode for most shots.
Portrait		Used to shoot a single human subject or inanimate still life. This mode sets a large aperture, which provides a shallow depth of field to keep the background slightly out of focus. Depending on lighting conditions, this mode may also set a faster shutter speed.
Landscape		Used to shoot outdoor landscapes. Almost the exact opposite of portrait mode, this mode sets a small aperture to provide a wide depth of field, so that more of the shot is in focus. Depending on lighting conditions, this mode may also set a slower shutter speed.

continued…

Table 5.1 Continued

Mode	Typical Icon	Description
Sports/action		Used to shoot fast-moving action, such as that found in most sporting events. This mode sets a very fast shutter speed, which helps to freeze the action.
Night landscape		Used to shoot in very low-light conditions. Typically sets a wide aperture, slow shutter speed, and (optionally) no flash.
Night portrait		Used to shoot portraits in low-light conditions; lets you capture human subjects against the backdrop of the evening sky. This mode sets a slow shutter speed and wide aperture and activates the flash to light the subject with a foreground light.
Macro/close up		Used to shoot very small objects quite close up. Introduces different focusing distances for close-up shots; also creates a very narrow depth of field, which makes focusing more sensitive.

Using Shutter-Priority Mode

You can fine-tune your pictures by skipping the automatic modes and manually choosing shutter and aperture settings. Most photographers, however, find it easier to set just one of these two settings and let the camera figure out the corresponding setting. (Setting both shutter and aperture requires some quick calculations on your part, as you'll learn shortly.)

In shutter-priority mode, you select the shutter speed, and the camera sets the corresponding aperture. I like shutter-priority mode when shooting sporting events (set a fast shutter to freeze fast-moving action) or when I want to create deliberate motion blur (set a slow shutter to capture movement in the shot). You set shutter speed in fractions of a second, typically from 1/4000th of a second (fastest) to 15 whole seconds (slowest).

Using Aperture-Priority Mode

In aperture-priority mode, you select the size of the aperture, and the camera sets the corresponding shutter speed—the wider the aperture, the more light that enters the iris. (The shutter speed increases correspondingly.)

Aperture is measured in terms of f/numbers or f/stops. The larger the f/number, the smaller the aperture and the less light entering the camera. A wide aperture (low f/number) creates a shallow depth of field with a blurry background, while a narrow aperture (high f/number) keeps all objects in focus. The number of f/stops available depends on the lens used, not the camera.

Learn more about shutter speed, aperture, and depth of field in Chapter 13.

Manually Setting Both Shutter Speed and Aperture

In fully manual mode, you control both shutter speed and aperture. You may need this manual control when you want to "trick" the camera into achieving shots that can't be imaged via conventional means. For example, you may use manual mode to shoot trailing lights in night shots by opening up the aperture and slowing down the shutter speed.

Many D-SLRs feature a depth-of-field preview button, typically located beside or beneath the lens. Press and hold this button to stop the lens down to the selected aperture value and preview the resulting depth-of-field through the optical viewfinder.

Bracketing the Shot

Professional photographers like to "bracket" their shots. That is, they determine what looks to be the proper exposure, but then shoot successive photos exposed slightly more and less than the center exposure; this gives them a variety of exposures to choose from. Bracketing is typically accomplished by changing the aperture by 1 or more f/stops around the main shot.

For example, if the main exposure is set at f/8, you might bracket that shot with one frame at f/7 and another at f/9, as shown in Figures 5.14 through 5.16. This way, if the original exposure isn't quite right, one of the bracketed shots might be preferred.

FIGURE 5.14

A shot with standard exposure.

FIGURE 5.15

The same shot, bracketed 1 f/stop lower.

FIGURE 5.16

The same shot, bracketed 1 f/stop higher.

Most D-SLRs offer automatic bracketing. When you select this option (via a control or menu option somewhere on the camera), every time you press the shutter release the camera shoots three shots in the following order: standard exposure, decreased exposure, increased exposure. You can then choose from the three shots to keep the one you like best.

Focusing the Camera

D-SLRs let you focus your shots either automatically or manually. The auto focus mode on most D-SLRs is superior to point-and-shoot auto focus; in some cameras, you have your choice of different auto focus methods. Of course, you can also choose to focus the shot yourself by turning off the auto focus and using the manual focus ring on the camera lens.

Using Auto Focus

To turn on the auto focus or select different auto focus modes, look for a focus or AF button somewhere on the body of the camera, or on the main LCD menu system.

In full automatic mode, the camera automatically selects a *focus point*—that is, which part of the frame to focus on, typically based on which subject is nearest to the camera. To activate the auto focus, depress the shutter release button halfway and hold. You'll hear the camera make a slight whirring noise; this is the lens focusing on the nearest object. After the object is in focus (which you'll see in the viewfinder), you can further depress the shutter button to take the shot.

This works more often than not, but when it doesn't, you can select manual AF point mode, which lets you select from one of a half dozen or so focus points, like the ones shown in Figure 5.17. After you enter the manual AF mode, use the camera's selector dial to cycle through the available focus points. (You should be able to view each focus point in the camera's viewfinder.) Find the focus point you want, press the shutter button halfway to lock the focus, and then proceed to compose and make your shot. (This is a great way to keep the focus on a subject in a particular area of the photo, without worrying about another subject being closer to the lens.)

Using Manual Focus

Sometimes the only way to get the right focus is to do it yourself. This is another area in which D-SLRs shine—the ability to manually focus a shot. To use manual focus, you first need to switch off the automatic focus on the camera itself. (This is typically an AF/MF switch near the lens mount.) After you've switched to manual focus mode, you do the focusing from the lens.

Learn more about focusing and auto focus modes in Chapter 14, "Focus and Depth of Field."

FIGURE 5.17

Viewing available focus points on a Canon D-SLR.

All lenses that attach to a D-SLR have a manual focus ring, like the one shown in Figure 5.18. Rotate the focus ring until the subject is in focus; then you're ready to shoot.

FIGURE 5.18

The manual focus ring on a D-SLR lens.

Taking the Shot

When you have everything lined up and in focus, it's time to take the shot. How you take the shot depends on the *drive mode* or shooting mode you've selected.

Most D-SLRs have a drive/shooting mode button, either on the top or the back of the camera. Press the button and use the selector dial to cycle through the available modes: single frame, continuous, self-time, or remote.

Taking a Single Shot

The primary drive/shooting mode is the single frame/single shot mode. In this mode, you get exactly one shot each time you press the shutter release button.

As noted in the previous chapter, shooting a camera is much like shooting a gun. You want to gently squeeze the shutter release button, just as you would squeeze the trigger of a gun. Take a breath, hold it, and then exhale as you gently press the shutter release button, using the flat part of your finger. This releases the shutter without unnecessarily jostling the camera.

Using Continuous Shooting Mode

Continuous shooting or burst mode lets you take multiple shots with a simple press and hold of the shutter release button. Burst mode on a D-SLR is much, much faster than with a point-and-shoot camera; most D-SLRs shoot up to three frames per second, which is plenty darned fast. Just select continuous shooting or burst mode, aim the camera, and then press and hold the shutter release button. The camera continues to shoot until you release the shutter button—or until your memory card fills up, whichever comes first.

Using the Self-Timer

Most D-SLRs offer some sort of self-timer, so you can program the camera to shoot after a short delay. This is great for capturing yourself in a shot; just set the timer, run to the front of the camera, and smile.

When you activate the self-timer, you also should be able to select the length of the delay in seconds. Turn on the timer, set the delay, frame the shot, and then press the

Some cameras save burst shots to an internal memory buffer that stores the shots until you finish shooting; at that time, the shots are saved to the memory card. It's possible to overfill the buffer by shooting too many pictures too fast. When this happens, you'll see a "busy" message on the camera's status display.

shutter release button. The timer starts when you press the shutter button.

Most cameras automatically deactivate self-timer mode after a shot has been taken. If you want to take another self-timed shot, you'll probably have to reenter the self-timer mode.

Shooting via Remote Control

Some D-SLRs also let you operate the camera via an optional remote control. This is even better than using a self-timer, in that you don't have to rush from the back of the camera to the front. Simply activate the remote control mode, frame the shot, and then take your time getting into the shot. When you're perfectly posed, press the shutter release button on the remote control. It's as easy as that.

Reviewing Your Photos

So far, you haven't much used the big LCD display on the back of your D-SLR. Yes, it's used to configure some settings, but other than that it remains off, so as not to draw unnecessary power from your camera's battery pack.

It remains off, that is, until you want to review the photos you've taken. Then it's time to power up the display and take a look at your recent pictures.

Entering Playback Mode

To enter playback mode, press the "play" button on the back of your camera. (This is typically the button with the right arrow icon.) The last image shot should now appear on the LCD display. To cycle through your captured photos, use the left and right toggle buttons on the menu controller.

To zoom in on an image, press the zoom button. You can then use the up, down, right, and left toggle buttons on the menu controller to move around the image on the display. Press the zoom button again to return to normal viewing size.

Viewing Image Information

Your camera can display all sorts of information about any given image—exposure settings, aperture value, shutter speed, ISO speed, white balance settings, and the like. For example, Figure 5.19 shows the detailed information displayed on a Nikon D-SLR.

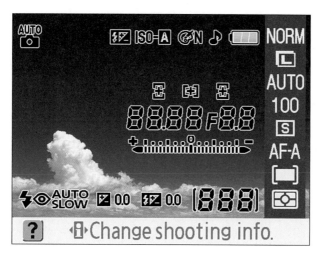

FIGURE 5.19

Detailed image information on a Nikon D-SLR.

To display shooting information for the current image, press the info button on the back of the camera. Some cameras offer several screens worth of shooting information; use the toggle control to cycle through the multiple screens.

Displaying Histograms

Along with the shooting information you can display for any given photo, most D-SLRs also let you display one or more histograms. As you can see in Figure 5.20, a histogram is a graph showing the distribution of tones in an image. The horizontal axis represents pixel brightness, with darker pixels to the left and brighter pixels to the right; the vertical axis represents the number of pixels at each brightness level. Your camera may display a single histogram for image brightness, or may display multiple histograms for the image's red, blue, and green color channels.

You use histograms to analyze brightness and color saturation for an image. The more pixels toward the left of the histogram, the darker the image; the more pixels toward the right, the lighter the image. If there are too many pixels toward the left, the shadow areas of your image will lose detail. If there are too many pixels toward the right, the highlights will be washed out. In most cases, you want to aim for a balance between light and dark, with the histogram fully extended from the left to right edges; this provides the maximum detail and contrast to work with when you later edit the photo in a photo editing program.

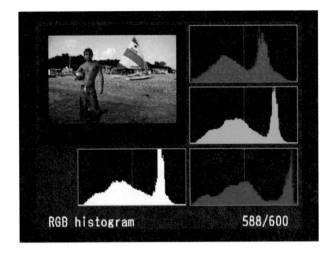

FIGURE 5.20

A histogram display on a Nikon D-SLR.

Deleting Photos

There's one more thing you can do when viewing photos on your D-SLR—delete those photos you don't want to keep. Just navigate to the photo you want to delete and press the delete or trash can button on the back of your camera. If prompted, confirm the deletion, and the shot is erased from the memory card.

Transferring Photos to Your PC

Most D-SLRs offer two different ways to transfer photos from your camera to your computer. If your camera comes with a USB transfer cable, connect this cable between your camera and your computer; when connected, you can easily copy photos from one device to the other. Otherwise, you can insert your camera's memory card into a media card reader connected to or built into your PC. After the card is inserted, your computer can access the files on the memory card just as it can files from any other drive.

Cleaning and Maintaining Your Digital SLR

Maintaining a D-SLR is more involved than maintaining a point-and-shoot

Learn more about transferring photos in Chapter 15, "Storing and Managing Photos on Your PC."

camera. That's because the D-SLR is a more complex device—and because a crucial internal part, the image sensor, is exposed whenever you change lenses.

Basic Maintenance

As with any type of digital camera, it behooves you to keep your D-SLR as free from dust, dirt, and sand as possible—especially when changing lenses. Also, don't get the thing wet; water and electronics don't mix well.

Clean the body of your camera with a soft cloth, and perhaps with a blow brush or can of compressed air. When you clean the camera, make sure that a lens is installed or that you put the lens cover over the empty lens mount; you want to avoid blowing any dust or dirt into the image sensor area.

You should periodically clean the contacts on your camera's hot shoe, battery compartment, and memory card compartment. Use a pencil eraser to gently brush across the contacts, thus cleaning off any lingering residue.

Clean your lenses with a soft microfiber cloth. To remove streaks and fingerprints, use a lens cleaning solution, like that sold in most camera stores; put a few drops of the lens cleaner on your cleaning cloth, and then use the dampened cloth to wipe the lens.

You can, if you're really careful, clean the mirror inside your D-SLR. This may be necessary if you're seeing specs through the viewfinder that don't appear in the finished shot. Remove the camera's lens to expose the mirror assembly, as shown in Figure 5.21, and then use a blow brush to blow off any dust specs. Do not, however, attempt to clean the mirror with a cloth, no matter how soft;, the mirror surface is very fragile and could be easily scratched or damaged.

Cleaning a Dirty Image Sensor

One of the downsides of owning a D-SLR camera is that the image sensor is exposed whenever you remove the lens. This enables minute dust particles to settle on the sensor, which in turn show up as unwanted specs on the photos you take.

How do you know if your image sensor is dirty? It's simple. Look for small dark spots or blotches that appear in the same spot on all your photos. Obviously, these spots will be more noticeable on plain backgrounds than on busy ones. While these spots could be caused by a dirty lens (always something to look for), if they appear with more than one lens, it's a sensor problem.

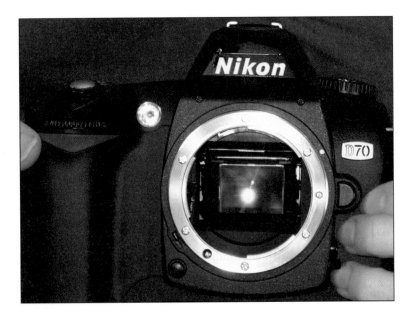

FIGURE 5.21

Remove the camera's lens to clean the mirror assembly.

Even one tiny dust spec can ruin dozens of pictures. You can, of course, try to fix the spot in Photoshop, but it's better to get rid of the problem on the front end.

Some newer D-SLRs incorporate antidust technology. This typically works by rapidly moving the image sensor to "shake" off any dust particles. As crude as this sounds, the solution works surprisingly well. Consult your camera's instruction manual to see whether it offers a "sensor clean" mode, and how to activate it.

In other instances, and on cameras without the antidust technology, you may have to clean the image sensor manually. This is a tricky procedure, which is why many photographers take their cameras into the repair shop to get it done. You can, however, perform the cleaning yourself, if you're extremely careful; one wrong move, however, and you can permanently damage the image sensor.

 STOP Don't used compressed air to clean the camera's mirror. It's too strong and could blow dust into the image sensor.

STOP Use extreme care when cleaning your camera's image sensor. An image sensor is a fragile and expensive electronic part and is easily damaged. If you are uncomfortable working with the image sensor, or not skilled in the procedure, don't do it yourself—take it into a photo store or repair facility for professional cleaning.

To clean your camera's image sensor, you need to remove the lens and flip up the mirror. Some cameras refer to this as sensor cleaning or mirror lock-up mode, and even have a menu item just for this purpose. Consult your camera's manual for instructions on how to do this.

After the mirror is flipped up, you'll need to press and hold the shutter release button to open the shutter. With the lens up and the shutter open, the image sensor should be visible. This is where it gets tricky; there are several ways you can proceed.

At this point, the safest approach is to use a blow brush to gently blow any dust off the image sensor. Do *not* use compressed air for this purpose; you want a gentle breeze, not a stiff wind to blow across the delicate image sensor.

Beyond this simple approach, several companies sell kits and materials specifically for cleaning camera image sensors. These materials include the following:

- **Brushoff** (www.photosol.com). A soft brush designed specifically for sensor cleaning
- **Eclipse** (www.photosol.com). A cleaning solution for both lenses and CCD/CMOS image sensors
- **Pec*Pads** (www.photosol.com). Nonabrasive wipes for both lens and image sensor cleaning
- **Sensor Brush** (www.visibledust.com). A family of ultrasoft brushes designed for safe sensor cleaning
- **Sensor Clean** (www.visibledust.com). A sensor-cleaning kit consisting of soft swabs and a special cleaning solution
- **Sensor Swabs** (www.photosol.com). Sensor cleaning swabs
- **SensorWand** (www.micro-tools.com). A small padded wand designed specifically for cleaning image sensors

5

THE JOYS OF USING A DIGITAL SLR

I love my Nikon D70 D-SLR. I have to admit, I quit taking pictures when the world moved from film to digital; the first digital cameras were just too crude for my tastes, and it turned me off the hobby.

With the introduction of affordable D-SLRs, however, my interest in photography was rekindled. First of all, a D-SLR looks and feels like a real camera to me, where point-and-shoot digicams don't. My D70 has the same substantial feel in my hand that my old Pentax ME Super did; it feels like a real camera, not a toy.

Then there are the pictures. Boy, there is such a difference in what you can do with a D-SLR. Don't get me wrong, a good point-and-shoot, especially a multimegapixel model, can take really good pictures. But a D-SLR can take even better shots, full of subtle detail and variable depth of field, the kinds of shots I grew used to back in the 35mm film SLR world.

Even better, I have total control over how I shoot. Some days I want a shallow depth of field, to blur the background and sharply focus the subject; manually setting the aperture and shutter speed lets me achieve just the effect I was looking for. Other days I want the grainy effect I used to get with high ISO film; my camera's digital ISO control lets me dial in just the right amount of graininess. I can do all that and a lot more just by pressing a few buttons, just like I could with my old Pentax.

And don't get me started on lenses. It's easy to go lens-happy with a D-SLR, spending a small fortune to assemble different lenses for different effects. Plus all the filters you can use—reds and blues and gradients and more. I can tell you now, I really missed my filters.

I understand the appeal of point-and-shoot cameras, especially when on vacation or if you just want something quick and handy. But I'm spoiled by the quality and versatility of my D-SLR, and it's tough for me to give that up. If you own a D-SLR, I'm sure you agree.

Digital Camera Accessories

6

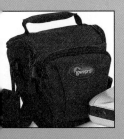

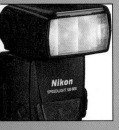

Choosing Camera Accessories

Serious photographers spend a lot of money on camera accessories, and for good reason. When it comes to taking good pictures, they appreciate all the help they can get—as should you. It's amazing how a small investment in an accessory or two can make your life so much easier.

It doesn't matter if you have a low-cost point-and-shoot model or a high-end digital SLR (D-SLR), a few well-chosen accessories can help you shoot better photos, more easily. Read on to discover all the many types of accessories available, and determine which of these accessories make sense for your photographic needs.

Lenses

If you have a D-SLR, you have the option of changing lenses; you don't have to settle for the lens that came packed with your camera. D-SLR owners spend a lot of money on lenses, assembling a collection of different lenses for different shooting situations.

STOP A single manufacturer might make different cameras that don't use the same lens mount system; for example, some Canon cameras use the EF mount system, while others use the EF-S mount system. Make sure you select a lens that uses the right mount system for your specific camera.

We learn more about different types of lenses later in this book; for now, it's important just to know that you can and should invest in a variety of lenses for your D-SLR camera. Of course, you need to make sure that a particular lens is compatible with your particular camera. It's always safe to purchase lenses from your camera's manufacturer, although there are probably third-party companies that also make compatible lenses.

Learn more about camera lenses in Chapter 8, "Using Different Lenses."

Some of the most popular manufacturers of lenses for D-SLR cameras include

- Canon (www.usa.canon.com)
- Lensbabies (www.lensbabies.com)
- Nikon (www.nikonusa.com)
- Olympus/Zuiko Digital (www.olympusamerica.com)
- Opteka (www.opteka.com)
- Pentax (www.pentaximaging.com)
- Promaster (www.promaster.com)
- Sigma (www.sigmaphoto.com)
- Sony (www.sonystyle.com)
- Tamron (www.tamron.com)
- Tokina (www.tokinalens.com)

6

Conversion Lenses

Unlike D-SLR cameras, point-and-shoot and prosumer cameras do not have interchangeable lenses. However, any compact digital camera that has a screw mount on

Some conversion lenses require the use of lens adapters, discussed in the next section of this chapter.

its lens can accept *conversion lenses*. These are lenses that screw onto the front of the existing lens and convert it into a wide angle lens or longer telephoto lens.

Conversion lenses are typically of lower optical quality than dedicated SLR lenses, but they're better than having no lens options at all. You can find conversion lenses of various types from the following manufacturers:

- Bower (www.bowerusa.com)
- Canon (www.usa.canon.com)
- Cokin (www.cokin.com)
- Kenko (www.kenko-tokina.co.jp)
- Merkury (www.merkuryinnovations.com)
- Olympus (www.olympusamerica.com)
- Phoenix (www.phoenixcorp.com)
- Promaster (www.promaster.com)
- Raynox (www.raynox.co.jp)
- Sima Products (www.simaproducts.com)
- Sony (www.sonystyle.com)
- Tiffen (www.tiffen.com)

Lens Adapters

Some point-and-shoot digicams require the use of a lens adapter to use conversion lenses. The lens adapter attaches to the front of the camera and fits over the lens mechanism; it enables the attachment of conversion lenses, lens filters, and other lens accessories.

Lens adapters are often used with so-called step-up and step-down rings so that lenses and filters of other sizes can be attached to the camera. These adapter rings enable you to attach accessories that are a different size than the diameter of your camera's lens.

Lens adapters are also called *lens tubes*, *adapter tubes*, and *lens converters*.

You can find lens adapters from the following manufacturers; make sure that the adapter is designed to work with your specific camera model.

You might need to purchase a new lens cap sized to the diameter of the lens adapter or step-up/down ring.

- Bower (www.bowerusa.com)
- Canon (www.usa.canon.com)
- Fujifilm (www.fujifilm.com)
- Kodak (www.kodak.com)
- Nikon (www.nikonusa.com)
- Olympus (www.olympusamerica.com)
- Phoenix (www.phoenixcorp.com)
- Raynox (www.raynox.co.jp)
- Tiffen (www.tiffen.com)

Lens Filters

Most digital camera lenses of all types accept screw-on lens filters, which is a great option that too few casual photographers avail themselves of. Lens filters can reduce glare and improve color rendition in all your photos; you'd be surprised how big a difference a little filter can make on the pictures you take.

Many different types of filters are available, including ultraviolet, polarizing, light-balancing, color graduated, color conversion, color compensating, and special effects filters. Some of the most popular filter manufacturers include the following:

- B+W (www.schneideroptics.com)
- Canon (www.usa.canon.com)
- Celestron (www.celestron.com)
- Cokin (www.cokin.com)
- Heliopan (www.heliopan.de)
- Hoya (www.hoyafilter.com)
- Kenko (www.kenko-tokina.co.jp/e/)
- Lee Filters (www.leefilters.com)
- Merkury (www.merkuryinnovations.com)
- Nikon (www.nikonusa.com)
- Opteka (www.opteka.com)

Learn more about lens filters in Chapter 9, "Using Filters."

- Promaster (www.promaster.com)
- Sunpak (www.tocad.com)
- Tiffen (www.tiffen.com)

Lens Caps and Covers

Your camera probably came with a lens cap, to protect the lens when you're not using it. But if you're like me that little lens cap is the first thing you lose. Fortunately, several companies make replacement lens caps, including models that have straps that connect to the camera body—so you won't lose it in the future.

You can find replacement lens caps from your camera's manufacturer, as well as from the following companies:

- Kalt (www.bkaphoto.com)
- LensCoat (www.lenscoat.com)
- Op/Tech (www.optechusa.com)
- Schneider (www.schneideroptics.com)
- Sima Products (www.simaproducts.com)

Lens Hoods

A *lens hood*, like the one shown in Figure 6.1, fits over the end of your lens and blocks excess light from entering the sides of the lens. Lens hoods are most necessary when you want to shoot toward a strong light source, such as the sun, without capturing lens flare.

Lens hoods come in a variety of shapes, sizes, and material—rubber, plastic, and metal. Collapsible hoods require less storage space and are easier to carry, whereas plastic and metal hoods offer better protection.

Some lens manufacturers include hoods with their lenses; other companies sell hoods you can add to any lens. You can purchase lens hoods from the following manufacturers:

- Canon (www.usa.canon.com)
- Cokin (www.cokin.com)
- Hoya (www.hoyafilter.com)
- LEE Filters (www.leefilters.com)
- Schneider (www.schneideroptics.com)

 A lens hood can block all or part of the camera flash or auto focus assist lamp, causing shadows in your flash photos. In addition, some lens hoods are large enough to appear in wide angle shots, causing a vignetting effect around the edges of the photo.

FIGURE 6.1

A Nikon lens hood.

Cleaning Kits and Lens Cleaners

An ounce of prevention is worth several hundred dollars of cure, or something like that. That's why you should invest a few dollars to keep your camera free of dust and dirt and extend its working life.

We discussed lens and camera cleaning supplies in previous chapters, so there's no need to go into additional detail here. Instead, look for lens cleaners and cleaning kits from the following companies:

- American Recorder (www.americanrecorder.com)
- DigiPower Solutions (www.digipowersolutions.com)
- Lenspen (www.lenspen.com)
- Nikon (www.nikonusa.com)
- Norazza (www.norazza.com)
- Peca Products (www.pecaproducts.com)
- Sima Products (www.simaproducts.com)

Image Sensor Cleaners

If you have a D-SLR, your image sensor is exposed to the elements whenever you change lenses. While some D-SLRs offer automatic sensor cleaning, many don't—

Learn more about cleaning D-SLR image sensors in Chapter 5, "Operating a Digital SLR Camera."

which means you may have to manually clean dust and dirt off your camera's image sensor.

To that end, consider the sensor cleaning supplies offered by the following companies:

- Micro-Tools (www.micro-tools.com)
- Photographic Solutions (www.photosol.com)
- VisibleDust (www.visibledust.com)

LCD Hoods

Ever have trouble seeing what you're shooting (or what you've just shot) with your digital camera, especially when shooting outdoors? Then you need a hood for your camera's LCD display; this makes it easier to view your camera's monitor, especially in bright sunlight.

An LCD hood, typically made of rubber or plastic, fits over your camera's LCD display and turns your open-to-the-elements display into a hooded viewfinder. You can find LCD hoods from the following manufacturers:

- Cokin (www.cokin.com)
- Delkin Devices (www.delkin.com)
- Hoodman (www.hoodmanusa.com)
- Photodon (www.photodon.com)

Camera Straps

Point-and-shoot digital cameras can fit in your pocket or purse. Prosumer and D-SLR cameras, on the other hand, are too large to be carried in this fashion. Although most prosumer and D-SLR cameras come with basic camera straps, you might want to invest in a third-party strap that provides more support or style, like the one shown in Figure 6.2.

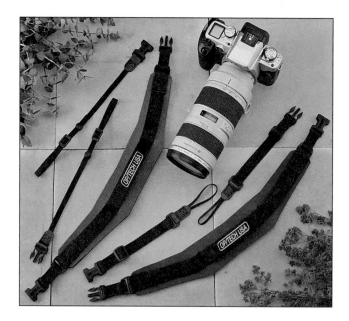

FIGURE 6.2

The Op/Tech Pro Strap, in various colors.

You can find camera straps of all different shapes, sizes, and designs. Look for neck straps, shoulder straps, chest straps, and more from the following companies:

- Domke (www.tiffen.com)
- Digital Pursuits (www.bkaphoto.com)
- Lowepro (www.lowepro.com)
- Op/Tech (www.optechusa.com)
- Promaster (www.promaster.com)
- Tamrac (www.tamrac.com)
- UPstrap (www.upstrap-pro.com)

Camera Bags

When you're carrying around a D-SLR camera, an extra lens or two, an assortment of lens filters, and maybe a spare battery pack or memory card, you need something in which to carry all these items. The solution, of course, is a camera bag, long an essential accessory for the serious photographer.

You want a camera bag that's big enough to hold your particular camera and accessories, but not so big and bulky as to be uncomfortable to carry around. You can find bags of all shapes and sizes, including bags small enough for point-and-shoot cameras (see Figure 6.3), slightly larger ones for larger pro-sumer cameras (see Figure 6.4), and those spacious enough to accommodate all the lenses and filters and such that accompany the typical D-SLR camera (see Figure 6.5). Various manufacturers make traditional shoulder bags, smaller hip bags, backpacks (see Figure 6.6), rigid cases, rolling cases, even photographer's vests with multiple pockets for lenses and accessories (see Figure 6.7).

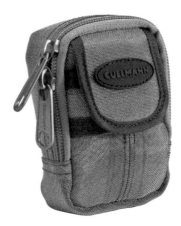

FIGURE 6.3

Cullmann's Mini 110 compact bag for point-and-shoot cameras.

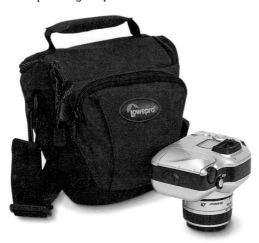

FIGURE 6.4

Lowepro's Topload Zoom Mini midsized bag for prosumer cameras.

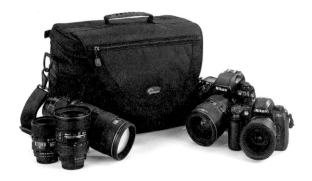

FIGURE 6.5

Lowepro's Nova 5 AW bag for D-SLR cameras and accessories.

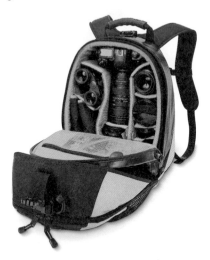

FIGURE 6.6

Lowepro's DryZone 100 camera backpack.

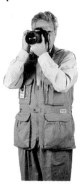

FIGURE 6.7

Domke's PhoTOGS camera vest.

Look for camera bags and cases from the following manufacturers:

- Billingham (www.billingham.co.uk)
- Case Logic (www.caselogic.com)
- Cullmann (www.cullmann-foto.de)
- Domke (www.tiffen.com)
- Kata (www.kata-bags.com)
- Lowepro (www.lowepro.com)
- Omega Satter (www.omegasatter.com)
- Pelican (www.casesbypelican.com)
- Phoenix (www.phoenixcorp.com)
- Promaster (www.promaster.com)
- Seahorse (www.seahorse.net)
- Tamrac (www.tamrac.com)
- Targus (www.targus.com)
- Tenba (www.tenba.com)
- Think Tank Photo (www.thinktankphoto.com)

Tripods

Every serious photographer needs a tripod for her camera, to keep your camera from jittering when you're shooting low-light photos. A tripod is also a necessity for shooting product photos for eBay and other online sites, for macro photography, and for shooting portraits.

For a point-and-shoot camera, a low-cost tripod should be steady enough. But for heavier D-SLRs, you want a tripod with reinforced legs and a versatile three-way pan head, like the one shown in Figure 6.8. Also nice is a quick release platform for the camera mount, as well as some sort of stabilizer or level, to make sure the camera is level.

And when a tripod is too bulky to carry around, consider using a monopod instead. As you can see in Figure 6.9, a *monopod* is a single-legged stand that provides basic support for your camera. Most monopods contract or fold up into a compact carrying package; just whip out the monopod, steady the camera on top, and you're ready to shoot.

6

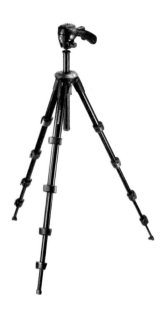

FIGURE 6.8

The Manfrotto MODO tripod from Bogen Imaging.

FIGURE 6.9

Cullmann's collapsible Monofix monopod.

The following manufacturers offer a variety of different tripods and monopods:

- Bogen Imaging (www.bogenimaging.us)
- Cullmann (www.cullmann-foto.de)
- Davis & Sanford (www.tiffen.com)
- Giotto's (www.giottos.com)
- Phoenix (www.phoenixcorp.com)
- Sima Products (www.simaproducts.com)
- Slik (www.slik.com)
- Smith-Victor (www.smithvictor.com)
- Sunpak (www.sunpak.com)
- Tiltall (www.plumeltd.com/tiltall.htm)
- Velbon (www.velbon-tripod.com)
- VidPro (www.vidprousa.com)

Also worth noting is the Joby Gorillapod (www.joby.com), which is a flexible camera mount you can wrap around trees and other objects.

Batteries and Chargers

Digital cameras go through batteries like babies go through diapers. With most point-and-shoot and prosumer cameras, you can use standard-grade batteries (and lots of them) or invest in a set of rechargeable batteries and accompanying battery recharger. Rechargeable batteries and kits are available from the following manufacturers:

- Duracell (www.duracell.com)
- Energizer (www.energizer.com)
- Lenmar (www.lenmar.com)
- Phoenix (www.phoenixcorp.com)
- Rayovac (www.rayovac.com)
- Sanyo (www.sunpak.com)
- Sony (www.sonystyle.com)

Learn more about camera batteries in Chapter 7, "Managing Batteries and Storage."

Memory Cards

The more (and higher-resolution) pictures you take, the more storage space you need. Pictures are stored on flash memory cards, so investing in a

higher-capacity card for your camera is always a good idea. Make sure you choose the right type of card for your camera (CompactFlash, Secure Digital, and so on), and then buy as large a card (in terms of capacity) as you can afford.

Learn more about the different types of memory cards in Chapter 7, "Managing Batteries and Storage."

Memory cards are available from the following manufacturers:

- Delkin Devices (www.delkin.com)
- Kingston (www.kingston.com)
- Lexar (www.lexar.com)
- Phoenix (www.phoenixcorp.com)
- SanDisk (www.sandisk.com)
- Sony (www.memorystick.com)
- Transcend (www.transcendusa.com)
- Viking InterWorks (www.vikingcomponents.com)

USB Media Card Readers

Some computers come with built-in media card readers. If yours does not have a card reader, you can add an external one via USB. The following companies make USB media card readers for your PC:

- Kensington (us.kensington.com)
- Kinamax (www.kinamax.com)
- Lexar (www.lexar.com)
- Phoenix (www.phoenixcorp.com)
- Sabrent (www.sabrent.com)
- SanDisk (www.sandisk.com)

Light Meters

If you have a D-SLR camera and choose to manually set your aperture and shutter speed, it helps to have a light meter handy. Today's light meters, like the one shown in Figure 6.10, feature large, easy-to-read LCD displays that offer the recommended shutter speed and aperture, as well as other pertinent information. Just hold it out, press a button, and let it tell you what settings to use.

FIGURE 6.10

Sekonic's compact Flashmate light meter.

You can find light meters from the following companies:

- Gossen (www.gossen-photo.de)
- JTL (www.jtlcorp.com)
- Sekonic (www.sekonic.com)

External Flash Units

As your light meter will tell you, the more light, the better for your photos—and the built-in flash on most digital cameras is barely adequate, at best. An external flash kit, sometimes called a *speedlight* or *flash gun*, provides much better fill lighting for both indoor and outdoor shots. (Figure 6.11 shows a typical such speedlight.)

The reason an external flash unit produces better results is because the light is generally more powerful and offset from the lens, which reduces both glare and red eye. If your camera has a hot shoe or otherwise accepts external flash units, consider products from the following manufacturers:

- Canon (www.usa.canon.com)
- Cullmann (www.cullmann-foto.de)
- Kodak (www.kodak.com)
- Metz (www.metz.de)
- Nikon (www.nikonusa.com)
- Nissin (www.nissinflash.com)

- Opteka (www.opteka.com)
- Phoenix (www.phoenixcorp.com)
- Sakar (www.sakar.com)
- Sigma (www.sigmaphoto.com)
- Sony (www.sonystyle.com)
- SunBlitz (www.xtri.net/sub_prod_sunblitz.htm)
- Sunpak (www.sunpak.com)

Learn more about flash, speedlights, and lighting kits in Chapter 11, "Lighting and Flash."

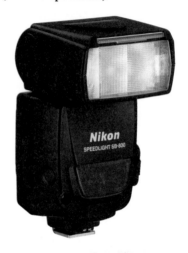

FIGURE 6.11

Nikon's SB-800 speedlight.

Studio Lighting

When you're shooting indoors, flash isn't always the best way to go. Every serious photographer needs studio lighting—whether you're shooting portraits or eBay product shots. The key is to get a lighting kit or combination of individual lights that provides versatility, portability, and adequate lighting power without breaking the bank.

We talk more about studio lighting in Chapter 11, but for now here's a short list of manufacturers that sell what you need:

- AlienBees (www.alienbees.com)
- Bowens (www.bowens.co.uk)
- Interfit (www.interfitphotographic.com)

- JTL (www.jtlcorp.com)
- K5600 (www.k5600.com)
- Lowel (www.lowel.com)
- Novatron (www.novatron.com)
- Photoflex (www.photoflex.com)
- Photogenic (www.photogenicpro.com)
- Savage (www.savagepaper.com)
- Smith-Victor (www.smithvictor.com)

Backgrounds

Whether you're shooting product photos or portraits, it helps to have a nice clean background behind the subject. For example, Figure 6.12 shows a selection of colorful muslin backdrops; many companies offer cloth, muslin, and seamless paper backgrounds.

FIGURE 6.12

A selection of muslin backdrops.

The following companies sell photographic backgrounds, backdrops, and supplies to lend your studio shots a certain polish:

- Interfit (www.interfitphotographic.com)
- Photoflex (www.photoflex.com)
- Savage (www.savagepaper.com)
- Studio Dynamics (www.studiodynamics.com)

You can also find a selection of backgrounds and backdrops at a variety of specialty web retailers, such as Artistic Backgrounds (www.artisticbackgrounds.com), Backdrop Outlet (www.backdropoutlet.com), Backdropsource.com (www.backdropsource.com), and Owen's Originals (www.owens-originals.com).

Light Tents and Boxes

If you're shooting small items, you might want to ditch the lights and background paper and use a light tent. A *light tent* (also known as a *light box*) is a translucent cube or tent into which you place the items to photograph; light comes from outside the box to provide a soft glow around the object. They're ideal for shooting jewelry, crystal, small collectibles, and the like.

You can find light boxes/tents from the following manufacturers:

- American Recorder (www.americanrecorder.com)
- EZCube (www.ezcube.com)
- Interfit (www.interfitphotographic.com)
- Kaiser (www.kaiser-fototechnik.de)
- Photoflex (www.photoflex.com)
- Smith-Victor (www.smithvictor.com)

Monitor Calibration Kits

Most of the accessories we've discussed in this chapter are for your camera. Here's an accessory for your computer system—in particular, your monitor. When working in your digital darkroom, it's essential that your monitor reproduce the exact colors that were shot by your camera and will be printed by your printer. To that end, the following companies offer monitor calibration kits, complete with colorimeter hardware and calibration software:

- ColorVision (www.colorvision.com)
- Gretag Macbeth (www.gretagmacbeth.com)
- Pantone (www.pantone.com)
- X-Rite (www.xrite.com)

Learn more about monitor calibration in Chapter 2, "The Digital Darkroom."

Portable Photo Viewers

A portable photo viewer, like the one shown in Figure 6.13, is a portable device that lets you offload digital photos from your digital camera (either via memory card or USB transfer), and then view those pictures when you're on the go. The device includes a large hard disk with gigabytes of storage and an LCD display for viewing photos. You get the advantage of freeing up storage space on your camera to take more pictures, as well as easily sharing your photos with others via the device's LCD screen.

FIGURE 6.13

Epson's P-5000 portable photo viewer.

When shopping for a portable photo viewer, consider the size of the hard drive (the bigger it is, the more photos it can store) and the size of the LCD display. Also look for a video connector that lets you connect the device to a television or video projector to display your photos to a roomful of people.

You can find portable photo viewers from the following manufacturers:

- Digital Foci (www.digitalfoci.com)
- Epson (www.epson.com)
- Jobo (www.jobodigital.com)
- Kodak (www.kodak.com)
- Sony (www.sonystyle.com)

For all practical purposes, just about any portable video player can be used as a portable photo viewer, as can some portable audio players (those with bigger screens, anyway, such as the Apple iPod and iPod touch).

Digital Picture Frames

Just as a portable photo viewer lets you view photos on the go, a digital picture frame lets you view your digital photos in the comfort of your own home. Most digital photo frames, like the one shown in Figure 6.14, work by inserting a media card full of photos; the photos are then displayed on the picture frame's LCD screen. (The device is nothing more than a small LCD display with memory card reader attached.) Some digital picture frames let you connect to the Internet to find and download even more photos, although you'll pay more for this feature.

FIGURE 6.14

A Kodak EasyShare digital picture frame.

Here are just some of companies currently selling digital picture frames:

- Ceiva (www.ceiva.com)
- Coby (www.cobyusa.com)
- Digital Foci (www.digitalfoci.com)
- Kodak (www.kodak.com)
- Matsunichi (www.matsunichi.com)
- Philips (www.consumer.philips.com)
- PhotoVu (www.photovu.com)
- Sun Group (www.sgmonitor.com)
- Vialta (www.vialta.com)

ESSENTIAL ACCESSORIES

While all photographic accessories are fun to look at, you don't necessarily need (and probably can't afford) all of them. For whatever it's worth, here are the accessories that I personally own and use, in addition to the standard accessories that came with my Nikon D70 D-SLR:

- **Lenses.** In addition to the 18-88mm zoom lens that came with the factory's camera kit, I also use a longer Nikon 70-300mm Nikkor zoom lens for greater telescopic effect.

- **Filters.** I have a Hoya polarizing filter on both of my lenses and use the Cokin Creative System with a variety of colored and effect filters.

- **Cleaning kit.** I use a generic blower brush and cleaning cloth that I purchased from my local camera shop.

- **Image sensor cleaner.** While I own a set of Photographic Solutions Sensor Swabs, I've fortunately never had to use them.

- **Camera strap.** I ditched the generic black Nikon camera strap for a multicolored strap I purchased 20 some years ago (brand unknown), which has followed me from camera to camera over the years.

- **Camera bag.** I use the classic Lowepro Nova 3 AW over-the-shoulder bag, which holds all my equipment and instruction manuals.

- **Tripod.** I use a VidPro TT-250 52-inch tripod.

- **Memory card.** My current memory card is a 1GB SanDisk Ultra II CompactFlash.

- **External flash.** The biggest factor in improving the quality of my pictures over the past few years was the purchase of a Nikon SB-600 speedlight.

- **Lighting kit.** I'm a longtime user of the relatively inexpensive Smith-Victor KT500U lighting kit.

- **Backgrounds.** I use generic seamless gray background paper, mounted on Smith-Victor stands.

- **Monitor calibration kit.** My monitor is properly calibrated with the ColorVision Spyder 2 kit.

- **Digital picture frame.** I love the Kodak digital picture frame that my girlfriend gave me for my birthday. I have it sitting on my desk, loaded up with all my favorite photos, which are set to display in slideshow fashion. It's the perfect way to view the photos I've taken of family and friends.

6

Managing Batteries and Storage

You might wonder what batteries and memory cards have in common, but it's simple—this chapter is all about storage. Power for your camera is stored in batteries; photos are stored on memory cards. Read on to learn how to get the most from a set of batteries and from a flash memory card, both of which are important for efficient digital camera operation.

Working with Digital Camera Batteries

If you've used a digital camera for any period of time, you know that it's somewhat power hungry. That is, digital cameras, especially point-and-shoot and prosumer models, go through sets of batteries very quickly. Seldom will you be able to get through a full day of shooting without replacing batteries.

Why is this? It's simple; it takes juice—and lots of it—to power all the electronics in a digital camera. Think about it. Your camera has to power the motor that focuses and zooms the lens, the big LCD display on the back, the infrared light in the auto focus system, the big light in the camera's flash, and all the other bits and pieces of electronics inside that little case. The more you use your camera—the more buttons you push, the more times you focus, the more pictures you look at on the LCD display—the more you drain the batteries. It shouldn't be a surprise when your camera goes dead in the middle of a shot; those batteries can only last so long.

Using Standard Batteries

Most point-and-shoot and some prosumer cameras use standard AA batteries, either two or four, depending on the camera. How long a set of batteries lasts depends on the type of battery used and on how you use your camera.

As to battery type, alkaline batteries are the lowest-priced way to go. Some newer types of alkalines, such as the Energizer MAX and Titanium lines and the Duracell Ultra line, have a slightly longer life when used to power a digital camera.

Even better, in terms of performance, are lithium batteries. A lithium battery generally lasts three times or more longer than the typical alkaline battery. It also costs two-to-three times as much, so you get what you pay for in terms of battery life.

Using Rechargeable Batteries

The problem with both alkaline and lithium batteries is when they're dead, they're dead. The five, ten, or more dollars you spent on that set of batteries is now gone, and you have to spend another five, ten, or more dollars on another set of batteries to keep going.

If you go the standard battery route, alkaline or lithium, make sure you carry a spare set of batteries with you at all times. When the batteries in your camera go dead (and they will), you want to be able to pop a new set in and resume shooting as quickly as possible.

This is why most serious photographers prefer rechargeable batteries. After its power is drained, a rechargeable battery can be recharged and used again and again and again. You'll pay three to four times as much for a rechargeable battery as you will for an alkaline battery (plus you have to invest in a recharging device), but you'll get hundreds of charges out of that initial investment.

Most rechargeable AA batteries sold today use nickel-metal hydride (NiMH) technology. Not only are NiMH batteries rechargeable, they also last considerably longer on a charge than either alkaline or lithium batteries—up to four times longer than standard alkaline batteries.

Of course, to recharge your rechargeable batteries you'll need a battery charger, like the one shown in Figure 7.1. Place your batteries in the charger, plug the charger into a power outlet, and then go away for eight hours or so. The batteries will then be fully recharged and ready for use again.

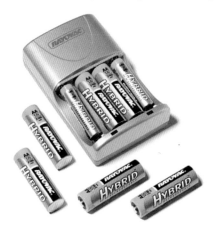

FIGURE 7.1

Rayovac Hybrid rechargeable batteries and charger.

Using Rechargeable Internal Battery Packs

Many digital SLRs (D-SLRs) and prosumer cameras don't use standard AA-sized batteries. Instead, these cameras come with proprietary battery packs, like the one shown in Figure 7.2. These battery packs are rechargeable, and the cameras usually come with a matching charger. Just slide the battery pack out of the camera and into the charger for recharging.

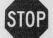 Rechargeable batteries do not long hold their charge when sitting unused. A typical NiMH battery will lose its entire charge in just a few weeks, even if you're not using your camera. For that reason, you want to recharge your batteries immediately before a big shoot.

A battery pack for a D-SLR lasts a lot longer than any type of standard battery in a point-and-shoot or prosumer camera. That's because D-SLRs don't constantly power the back-of-camera LCD display, which is the big power hog on other types of cameras. Because you view your shots through the optical viewfinder, the LCD display stays off, and your camera's batteries last longer—much, much longer. (I've had a fully charged battery pack on my Nikon D70 last for thousands of shots before needing to be recharged.)

The other factor contributing to the life of these proprietary battery packs is the technology used. Many manufacturers use lithium-ion (Li-Ion) technology instead of NiMH technology; Li-Ion batteries last considerably longer on a charge than do other types of batteries.

FIGURE 7.2

A rechargeable lithium-ion battery pack for Nikon D-SLR cameras.

Using a Battery Grip

Another option for powering a D-SLR camera is to use an external battery in the form of a *battery grip*. The battery grip attaches to the bottom of the camera and includes its own grip and shutter release button.

A battery grip houses either NiMH or Li-Ion rechargeable batteries, and several of them, to provide long-lasting power for your camera. For example, the Nikon MB-D100 (shown in Figure 7.3) accepts two Li-Ion batteries and connects directly to the battery compartment on the bottom of all Nikon D-SLRs.

Using an External Battery Pack

Another option, for any type of camera, is to use a freestanding external battery pack. Most battery packs contain multiple NiMH or Li-Ion rechargeable batteries for long-lasting performance. You carry this type of battery pack separate from your camera, and then connect it via a cable to your camera's power connector or battery compartment.

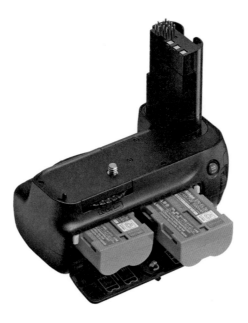

FIGURE 7.3

The MB-D100 battery grip for Nikon D-SLR cameras.

The following manufacturers offer popular external battery packs:

- DigiPower Solutions (www.digipowersolutions.com)
- Digital Camera Battery (www.digitalcamerabattery.com)
- Maha POWERBank and POWEREx (www.nimhbattery.com/maha-powerbank.htm)
- Tekkeon myPower (www.tekkeon.com)

Tips for Extending Battery Life

No matter what type of battery you use with your camera, it's eventually going to run through its charge and leave you unable to take your next shot. That's why it's important to stretch your battery's charge as much as possible; even if you can only get in a few more shots, they may be the ones you want to keep.

With that in mind, here are some practical tips you can use to extend the life of your camera's batteries:

- **Turn off your camera when you're not using it.** Yes, there's a power-up period you need to take into account, especially when you're doing action photography. But every second the camera is on, it's still using

power. Turn it off for a minute or two, and there is that much more charge left in the battery.

- **Remove your batteries for storage.** If you're not going to be using your camera for a month or so, it's advisable to remove the batteries from your camera. This reduces the chance of corrosion and leakage, which can damage your camera's electronics. (Similarly, remove batteries from all your camera accessories, including speedlights, when not in use.)

- **Use the optical viewfinder instead of the LCD display.** Granted, not all point-and-shoot cameras have optical viewfinders, but if your camera does, use it. The LCD display is the thing that pulls the most power from your camera's battery; if you can leave it off (which you do when you use the optical viewfinder) you'll significantly increase your battery life.

- **Don't view photos in the field.** Along the same lines, every minute you spend reviewing photos on your camera's LCD display reduces the amount of charge left in your batteries. Resist the urge to admire your handiwork, and leave the LCD display turned off; you'll have a lot more battery charge left to take even more photos. (Similarly, don't use your camera to display photos to friends and family; that LCD display drains a lot of battery power!)

- **Minimize the flash.** That's right, your camera's flash is also a big power drain. If you can use existing light, all the better as far as your batteries are concerned.

- **Use like batteries.** If your camera uses AA batteries, never swap out just one or two batteries at a time. Always change all the batteries at once, and always insert like-type batteries. Never insert one battery of one type and another battery of another type; mixing batteries can reduce the amount of usable charge and even damage your camera.

- **Cold weather is a big drain.** Batteries hold less of a charge in extremely cold weather. This means that your batteries run out faster when your camera is in the cold. Keep this in mind when doing any outdoor winter shooting, and bring along a spare set.

- **Water is not your friend.** Your camera isn't waterproof, but it should do a good enough job of protecting your batteries in the

> An alkaline battery too weak to run your digital camera still has some power left—just not enough to power your camera. So don't throw those old batteries away; instead, use them in a device that requires less current, such a television remote control.

rain. That said, avoid changing batteries in the rain, or under similarly damp conditions. Water not only corrodes batteries, it can also short out the electrical contacts in your camera.

- **Always bring extra batteries.** It goes without saying, the best protection against running out of battery charge is to bring along an extra set of batteries. There's nothing worse than being stranded high and dry with a dead camera when there are more interesting sights left to shoot.

Working with Digital Photo Storage

Most digital cameras store their photos on some sort of flash memory device. Flash memory isn't like hard disk storage, which uses rapidly spinning magnetic platters. Instead, flash memory devices use solid state technology to store data on tiny, nonvolatile chips. Multiple memory chips are bundled together on compact memory cards (sometimes called media cards) that can easily be transported from one device to another.

The advantages of flash memory include the compact size of these flash storage devices, the small amount of electricity necessary to power the devices, and the total lack of moving parts. These advantages make flash memory technology appealing for a variety of storage tasks—particularly the storage of photo files in digital cameras.

How Flash Memory Works

Unlike the random access memory (RAM) used in personal computers, which is wiped clean when the power is turned off, the contents of a flash memory device don't evaporate when the host unit powers down. Flash memory data is always there, ready to be accessed whenever the power is turned back on.

The nonvolatile nature of flash memory makes it ideal for long-term data storage in portable electronic devices such as digital cameras. When you take a picture with your digital camera, that file is stored on a flash memory device, typically a CompactFlash or Secure Digital card. The data stays on the card even when you turn off your camera or remove the card from the camera. When next you use the cam-

All erasable memory, including flash memory, is limited to a finite number of write/erase cycles. Early designs were good only for a few thousand cycles; today's flash memory can be written to and erased more than a million times without any degradation in data integrity.

era, or when you plug the card into a media card reader (attached to your PC), the digital file is still there, ready to use.

Understanding Storage Capacity

Memory card storage capacity is measured in either megabytes (MB) or gigabytes (GB). One megabyte is equal to roughly a million bytes (1,000,000 bytes); one gigabyte is equal to roughly a thousand megabytes (1,000MB).

Memory cards are typically available in capacities ranging from 128MB to 256MB to 512MB to 1GB, and then in 1GB increments up from there. The largest memory cards (CompactFlash and Secure Digital High Capacity formats) have up to 8GB of storage onboard.

When you're purchasing a new memory card, the primary question is how much capacity do you need. Table 7.1 details the approximate number of photos you can store with a given size memory card. (Numbers assume storage in JPG file format; TIF and RAW format files require more storage space.)

Table 7.1 Memory Card Capacity Versus Photo Storage

Photo Resolution	3 Megapixels	5 Megapixels	8 Megapixels	10 Megapixels
128MB card	120 photos	48 photos	36 photos	26 photos
256MB card	240 photos	95 photos	69 photos	53 photos
512MB card	490 photos	195 photos	143 photos	109 photos
1GB card	996 photos	395 photos	290 photos	221 photos
2GB card	2,000 photos	800 photos	582 photos	444 photos
4GB card	4,000 photos	1,595 photos	1,164 photos	887 photos
8GB card	8,000 photos	3,190 photos	2,328 photos	1,674 photos

As you can see, the higher the resolution of the photos you take, the larger the memory card you need. If you have an 8 megapixel prosumer or D-SLR camera, a basic 128MB memory card holds only 36 photos—not nearly enough. Moving to a 256MB card lets you store 69 photos; a larger 1GB card stores 290 photos.

If you have a lower-resolution point-and-shoot camera, or shoot your photos at a lower resolution, your storage needs are more modest. If you take 3 megapixel photos, for example, a 128MB card stores 120 photos. Upgrade to a 256MB card, and you can store 240 photos. You might not need anything bigger.

Understanding Memory Card Formats

Several different types of digital camera storage media utilize flash memory technology. These memory cards are all small and lightweight, and pack a lot of storage into a small space.

Figure 7.4 shows how the most popular types of flash memory cards compare. The following sections provide a more detailed look at each type of memory card.

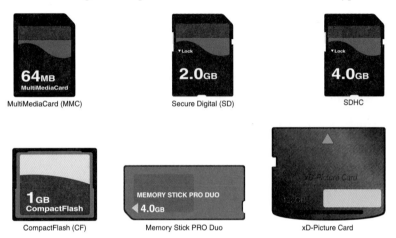

FIGURE 7.4
Different types of digital memory cards.

MultiMediaCard (MMC and MMCmobile)

The MultiMediaCard (MMC) is a postage stamp-sized flash memory card, originally targeted at the mobile phone and pager markets. (It was, in fact, codeveloped by Siemens, one of the world's largest mobile phone manufacturers.) Because of its small size and miserly power consumption, it has found popularity in a variety of other devices, including video camcorders, global positioning systems, portable MP3 players, and PDAs.

The original MMC format has been replaced to some degree by the newer Reduced Size MMC (RS-MMC) format, sometimes referred to as MMCmobile. These cards are slightly smaller than the original MMC cards, but with higher storage capacity (up to 1GB) and much faster transfer rates.

While MMC was used in some early digital cameras, neither the MMC nor the

> The type of memory card you use is dictated by your digital camera. The various memory card formats are physically different and are not interchangeable.

MMCmobile format is widely used in the current generation of digital cameras.

Most cameras that accept SD cards can also accept MMC cards, because they use the same sized slot.

Secure Digital (SD)

The MMC format is important because it led to the development of today's more widely used flash memory format. Secure Digital (SD) cards build on the older MMC format with additional capacity and a digital copyright security scheme. An SD card has the same form factor as an MMC, except that it's a little thicker. (The extra thickness enables the security features.) SD cards are the most popular type of memory card for digital cameras; they're also used in handheld PCs and PDAs.

SD cards can transfer data up to 20MB per second, which is 20 times faster than the original MMC format. Storage capacities run up to 2GB.

Secure Digital High Capacity (SDHC)

A newer version of the SD format is the Secure Digital High Capacity (SDHC) card. SDHC cards are the same physical size as SD cards but use a different file system that theoretically allows larger storage capacity. Current SDHC capacity runs to a whopping 8GB, with future capacity up to 32MB.

CompactFlash (CF)

CompactFlash (CF) cards are squarish flash memory cards used in a variety of digital cameras and other portable electronic devices. CF cards differ from other memory cards in that they're slightly larger and thicker, and they utilize a built-in controller chip.

There are actually two types of CF cards. CF Type I cards are 3.3mm thick, while Type II cards are 5mm thick. Cameras with CF Type II slots can use either Type I or Type II cards; cameras with the thinner Type I slots can accept only Type I cards.

There is also a smaller MiniSD card format, used in mobile phones and some MP3 players. MiniSD cards are not used in digital cameras.

CF cards offer more storage capacity than the popular SD format (up to 8GB) and ultra-fast transfer rates (up to 45MB/s). The large capacity and high transfer rate makes CF the format of choice for higher-end D-SLR cameras and professional photographers.

SD cards work in SDHC slots, but SDHC cards do not work in SD slots.

Memory Stick

Now we come to Sony's Memory Stick format. The Memory Stick is a flash memory device used almost exclusively by Sony in its many different portable digital devices—including Sony's digital camera line. A Memory Stick is more cardlike than sticklike, about the size and shape of a pack of chewing gum.

There are several variations on the basic Memory Stick card. The most common variation used in digital cameras is the Memory Stick Duo, which is half the size of the standard Memory Stick card. The newer Memory Stick PRO Duo is the same form factor but with more storage capacity and higher transfer rates. Capacity for the original Memory Stick (PRO version) ranges up to 2GB; capacity for the Memory Stick PRO Duo goes up to 8GB.

xD-Picture Card (xD)

Smaller and less popular than the other formats discussed here, the xD-Picture Card is an ultra-compact format used primarily by Olympus for the company's small point-and-shoot cameras. (It's also used in some of the company's prosumer cameras.) Capacities run from 64MB to 2GB.

Choosing a Card

With so many flash memory options around, which format is right for your needs? The choice is out of your hands; the type of card you choose is dictated by the digital camera you use. If you have a small point-and-shoot camera, chances are it uses the SD. If you own a larger D-SLR camera, it's likely to use a card with large storage capacity, such as CF or SDHC. And if you own a Sony camera, it probably uses Sony's proprietary Memory Stick format.

That said, Table 7.2 details the various cards available.

Table 7.2 Memory Card Formats

Card Type	Storage Capacity (max)	Transfer Rates (max)	Dimensions (Width×Height×Thickness, in mm)
MultiMediaCard (MMC)	128MB	2.5MB/s	24×32×1.4
Reduced Size MMC (MMCmobile)	1GB	20MB/s	18×24×1.4
Secure Digital (SD)	2GB	20MB/s	24×32×2.1
Secure Digital High Capacity (SDHC)	8GB	20MB/s	24×32×2.1
CompactFlash Type I	8GB	45MB/s	43×36×3.3
CompactFlash Type II	8GB	45MB/s	43×36×5.0
Memory Stick (PRO)	2GB	15MB/s	21.5×50×2.8

Continues…

7

Table 7.2 Continued

Card Type	Storage Capacity (max)	Transfer Rates (max)	Dimensions (Width×Height×Thickness, in mm)
Memory Stick Duo	8GB	20MB/s	20×31×1.6
xD-Picture Card	2GB	4MB/s	20×25×1.7

In digital cameras today, the most common memory card format is the SD card. SD cards are particularly popular in small, lightweight, point-and-shoot digital cameras but are also used in most prosumer cameras and even some lower-priced D-SLRs.

Larger, more professional digital cameras, such as higher-priced D-SLRs, tend to use the larger CompactFlash (CF) cards. Professional photographers like the higher storage capacities offered by CF cards, as well as their higher speed. Data can be read to a CF card much faster than other card formats—which is essential when shooting sporting events and similar pro-level needs.

SPEED MATTERS

When it comes to flash memory cards, storage capacity isn't the only important specification. How fast a card can read/write data is also important.

The data transfer rate of a card can be measured in amount of data transferred per second (megabytes per second, or MB/s) or as a "times" comparison. This comparative rating is based on a 1X rating equal to 15 kilobytes per second (or 0.015 megabytes per second). So a card with a 100X rating has an actual transfer rate of 15MB/s.

The practical application of the transfer rate determines how fast photographs can be read from or written to the memory card. For example, you could transfer four 5MB photographs per second with a 20MB/s SD card, or nine of the same-sized photographs per second with a 45MB/s CF card.

Faster transfer speeds are important if you're shooting in continuous or burst mode; the faster the transfer rate, the more photos you can save on the card before you start backing up into the camera's buffer. Transfer speeds are less important for day-to-day single-shot use.

How fast do you need? For single-shot photography, you can save your money and go with a lower-speed card. (Although, it's important to note, a lower-speed card takes longer to transfer photos to your computer.) For sports and action photography, however, or other situations where you're using continuous shot mode, it's worth the money to go with a higher-speed card.

Using Different Lenses

The lens is the optical component of your digital camera—in other words, your camera's eye. The image that the lens "sees" determines to a large degree what your final picture looks like.

All digital cameras have lenses, of course. Most point-and-shoot and prosumer cameras have zoom lenses, which let you vary the focal length of the lens by some order of magnification; these lenses are not removable. Some digital cameras, however, let you attach conversion lenses that change the nature of the lens. And digital SLR (D-SLR) cameras have interchangeable lenses; you can attach virtually any type of lens to the camera to achieve different effects.

Read on to learn how to best use different types of lenses with your digital camera.

How Lenses Work

At its most basic, a lens is just a curved piece of glass that sits in front of the camera's iris. The lens takes the beams of light that are reflected off an object and redirects them onto the camera's image sensor, thus forming the image that your camera "sees."

A camera lens is convex, or curved outward, to mimic the visual angle of the human eye. When a beam of light strikes the lens, it bends slightly corresponding to the lens surface; this bending of light is called *refraction*. As you can see in Figure 8.1, the multiple rays of light then converge on a single spot, called a *focal point* or *focal plane*. This focal point is directed to the camera's image sensor, thus reforming the image that was originally beamed onto the outside of the lens.

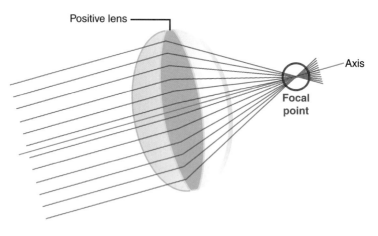

FIGURE 8.1

How a lens bends light onto a single focal point.

That's a simple explanation for what in reality is a much more complex process. For example, most camera lenses actually consist of multiple lenses grouped together into *elements*, as shown in Figure 8.2. This enables the camera lens to focus on multiple objects at multiple distances from the camera. Together, the elements determine the *focal length* of the lens—the distance between the focal plane and the point where the lens is focused at its farthest point.

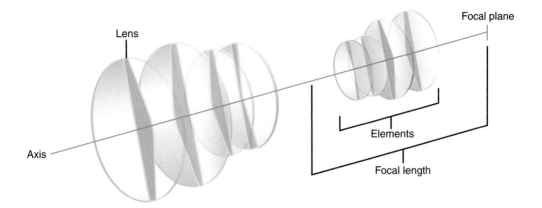

FIGURE 8.2

How multiple lenses work together in a camera lens.

Focusing a lens effectively changes the distance to the focal plane. When an image is in proper focus, the focal plane is the surface of camera's image sensor.

Know, however, that light reflected from objects at different distances have different focal planes. This explains the concept of depth of field, where part of the image is in focus and part isn't. The part that's in focus is the part where the focal plane is aligned with the image sensor. The part that's out of focus has its focal plane either in front of or behind the image sensor.

One interesting effect of how lenses work is that the object re-created at the focal point is actually upside down, as shown in Figure 8.3. To compensate for this, the image sensor in the camera is positioned upside down, so it effectively sees the upside down image as right side up.

With camera lenses, *infinity* is that point where the lens is moved as close as possible to the focal plane. At this point, light is refracted to the least degree, passing through the lens almost straight. All objects at this focal length and beyond appear in focus.

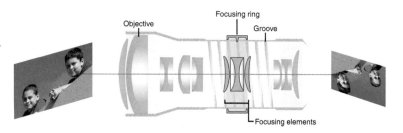

FIGURE 8.3

How a camera lens "flips" the image upside down onto the image sensor.

Different Types of Lenses

The focal length of a lens determines its magnification. A lens with a longer focal length has greater magnification, making far away objects appear closer; a lens with a shorter focal length has less magnification.

Focal length also determines the angle of view, or how much of the scene, in terms of width, is captured by the lens. The shorter the focal length, the wider the angle of view; the longer the focal length, the narrower the angle of view.

Focal lengths are measured in millimeters. A lens with a focal length between 35mm and 65mm is considered a "normal" lens, because it offers little magnification or distortion. A lens with a focal length less than 35mm is called a "short" or *wide-angle* lens; a lens with a focal length more than 65mm or so is called a "long" or *telephoto* lens. (Figure 8.4 compares the three types of lenses.)

There's a fourth type of lens, called a *macro* lens, designed specifically for close-up photography. Learn more about macro lenses in Chapter 26, "Macro Photography."

As a general rule, when you double the focal length of a lens you produce an image twice the original size. For example, a 100mm lens produces an image twice as large as that with a 50mm lens; conversely, the image produced by a 24mm lens will be about half the size as an image from a 50mm lens.

Photographers tend to discuss lens sizes based on focal lengths for a traditional 35mm film camera. To learn about digital equivalents, turn to the "Converting Film Lenses to Digital" section later in this chapter.

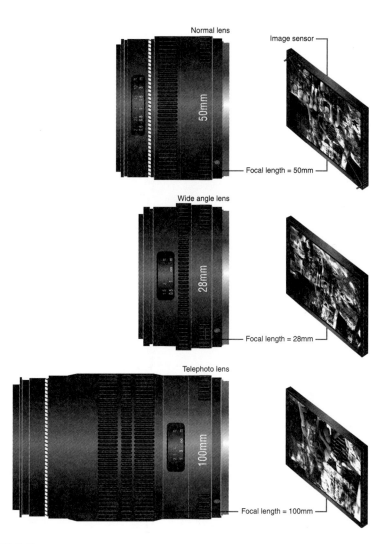

FIGURE 8.4

The three primary types of camera lenses—normal, wide-angle, and telephoto.

Put simply, wide-angle lenses capture a wider expanse of the scene, letting more objects fit into the image. Telephoto lenses magnify the scene, bringing distant objects closer. Obviously, a normal lens presents a compromise between these two extremes. (Figures 8.5, 8.6, and 8.7 show the same scene shot with a normal, wide-angle, and telephoto lens, respectively.)

8

FIGURE 8.5

A scene shot with a normal 50mm lens.

FIGURE 8.6

The same scene shot with a 28mm wide-angle lens.

Which type of lens you use depends on the kind of shot you want to make:

■ Use a wide-angle lens to photograph landscapes, buildings, interiors, street photography, and some group shots.

FIGURE 8.7

The same scene shot with a 100mm telephoto lens.

- Use a telephoto lens to photograph nature scenes, sporting events, and head-and-shoulder portraits.
- Use a normal lens to shoot full-length portraits, still lifes, and other shots that demand minimal image distortion.

We'll look at each type of lens separately.

Normal Lenses

The most common focal length for a normal lens is 50mm. This size lens best approximates the field of vision of the human eye.

The normal lens is the standard setting for most point-and-shoot cameras; what you see with the naked eye is pretty much what the lens captures. This type of lens produces sharp, clear images; the lens itself is compact and light, and offers a large maximum aperture for shooting in low-light situations.

You can use a normal lens for almost any type of shot. It's particularly good for full-length portraits and still life work, because it only minimally distorts the original image.

Lens type also affects depth of field, or how much of the shot stays in focus. Wide-angle lenses have a large depth of field, with most objects in focus. Telephoto lenses have a shallow depth of field, with fewer objects in focus—which makes focusing more critical.

8

Wide-Angle Lenses

A wide-angle lens has a short focal length, which has the visual effect of pushing the subject away from you and making it appear smaller. This lets you fit more of the scene into the frame, without physically moving back from the subject.

A *fisheye lens* is an extreme form of wide-angle lens, typically with a focal length between 8mm and 16mm. It re-creates a full 180-degree field of view with significant curved distortion at the edges.

Wide-angle lenses range in size from 20mm to 35mm or so. They offer a large depth of field, which lets you keep virtually all of the shot in focus. This tends to exaggerate the space between near and far objects, which makes the image captured appear more spacious.

Photographers like to use wide-angle lenses for landscapes, other types of outdoors shots, and architectural interiors. They're also good for fitting many people into a single shot. They're seldom used for individual portraits, however, except for special effect.

You can achieve a dramatic effect by using a wide-angle lens to shoot a subject at very close range, as shown in Figure 8.8. Move in close to the subject so that it's very large in the frame, and the lens's wide angle of view will exaggerate the subject's size relative to the background and other surroundings.

FIGURE 8.8

Use a wide-angle lens to exaggerate the size of a subject.

The main problem with wide-angle lenses is they tend to distort the physical proportion of objects. When you tilt a wide-angle lens up parallel vertical lines converge toward the top of the image, as shown in Figure 8.9; if you tilt the lens down, the lines converge toward the bottom. It's an interesting effect if you're aiming for it, but distracting if you're not.

FIGURE 8.9

Tilt a wide-angle lens up, and vertical lines will converge.

Telephoto Lenses

A telephoto lens has a long focal length, which has the effect of moving the subject closer to you and increasing its size in the frame. This makes them ideal for nature and sports photography, where you can't physically get too close to your subject. A telephoto lens makes it easier to fill the frame with subjects that are at a distance.

Interestingly, telephoto lenses are also good for shooting head-and-shoulder portraits. This is due to the lens's shallow depth of field, which lets you blur the background while keeping the subject in close focus. It also makes precise focusing a tad more difficult.

Moderate telephoto lenses range in size from 65mm to 200mm or so; this is the

STOP Using a wide-angle lens with your camera's flash can result in flash falloff, where subjects farther away from the camera are left in the dark. You can compensate for this effect by using freestanding lights positioned away from the camera.

8

best size to use for portraiture. More extreme telephoto lenses range to 300mm or more, which may be necessary for distant shots. Know, however, that these larger telephoto lenses are also physically larger; some, like the one shown in Figure 8.10, are large enough to include their own tripod mounts.

FIGURE 8.10

Sony's SAL-300F28G 300mm Super Telephoto Lens—the equivalent of a 450mm zoom lens for a 35mm film camera.

Zoom Lenses

Now the reality. Most digital cameras come not with normal, wide-angle, or telephoto lenses, but with a single lens that serves all three functions. A zoom lens offers multiple focal lengths in a single assembly; you rotate the zoom dial (or press the camera's zoom button) to zoom out for wide angle or in for telephoto use.

On point-and-shoot and prosumer cameras, the lens is typically identified by a zoom factor. For example, most point-and-shoots have a 3X zoom, which typically equates to a 35mm to 105mm focal range—plenty wide for most photographers.

Prosumer cameras typically have greater zoom lenses, often with a factor of 10X, 12X, or even 15X. For example, a 12X zoom lens typically equates to an extraordinary 35mm to 430mm focal range.

 Longer telephoto lenses are not easily held steady, especially at slower shutter speeds; even slight camera movement can result in a blurry picture. For best stability, mount the camera (and lens) on a sturdy tripod.

Even the lenses available for D-SLR cameras are, most often, zoom lenses. For example, the stock lens included with a D-SLR kit might offer a focal length of 35mm to 70mm—slightly wide angle at one extreme, and moderately telephoto at the other.

 A non-zoom lens with a single focal point is called a *prime lens*.

Naturally, other types of zoom lenses are available for your D-SLR. For example, a

good complement to the stock zoom lens might be a 70mm to 300mm zoom, which provides a range of telephoto focal lengths. Or you might choose an 18mm to 36mm zoom, which provides a range of wide-angle focal lengths.

By using just a handful of zoom lenses, you cover a wide range of possible focal lengths. Two or three zoom lenses can offer the equivalent of dozens of individual fixed-focal length lenses.

STOP Don't confuse a zoom lens (also called an optical zoom) with a camera's digital zoom feature. Digital zoom uses the camera's electronics to artificially increase the size of an image, but in a way that also reduces image quality. (It can't increase the number of pixels, only enlarge them.) As a result, digital zoom is seldom used by serious photographers; the only zoom that counts is the optical zoom of a zoom lens.

That's not to say that zoom lenses are the perfect solution for all photographic situations. A zoom lens is, by necessity, larger and heavier than a fixed focal-length lens. Most zoom lenses are also "slower" than prime lenses, meaning they have smaller maximum apertures that require slower shutter speeds. And the optical quality of a typical zoom lens may not be as pristine as that of a similar fixed-focus lens. Still, for the average photographer, one good zoom lens with a focal range of 35mm to 70mm can take the place of multiple fixed-focus lenses.

Conversion Lenses

D-SLRs let you change lenses. Point-and-shoot and prosumer cameras don't. So if you have a lower-priced camera, how do you achieve the effect of using multiple lenses?

The answer is to use a *conversion lens*. This is a special lens that screws onto the front of the camera's normal lens. As you can see in Figure 8.11, it doesn't replace the lens but rather augments it.

You can find both wide-angle and telephoto conversion lenses. The first type converts your camera's lens into a wide-angle lens; the second type converts your camera's lens into a telephoto lens.

Conversion lenses are typically measured in terms of conversion factor. For example, a 0.75X wide-angle conversion lens reduces your lens's focal length to 0.75 (75%) of the original. A 2X telephoto conversion lens increases your lens's focal length to 2 times (200%) the original.

If a conversion lens isn't the same physical size as your camera's screw mount, you can use an adapter ring (also called a step-up or step-down ring) to make it fit.

To use a conversion lens, your camera's lens must have a screw mount on the front. You

8

then purchase a conversion lens made specifically to size for your camera's lens. Conversion lenses are available from most major camera manufacturers, including Cokin, Raynox, Tiffen, and other lens and filter manufacturers.

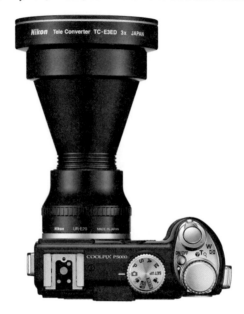

FIGURE 8.11

A Nikon Coolpix point-and-shoot camera with telephoto conversion lens.

Converting Film Lenses to Digital

Now an admission. All the lens numbers discussed so far in this chapter are wrong. That's correct, I've lied to you about focal length—at least when it comes to digital cameras.

This is a confusing topic, so pay attention. The focal length of a lens for a digital camera differs from the focal length of a lens for a 35mm film camera. This is because a digital camera's image sensor is smaller than the size of a 35mm film frame. Because the image size is smaller, the digital camera's focal length is shorter.

So, for example, a particular digital camera might have a 25mm lens, which would seem like an extreme wide angle. But in reality this lens is the equivalent of a 50mm lens on a 35mm film camera—the typical "normal" lens size.

8

The problem comes from the fact that different digital cameras have different sized image sensors. The image sensor on a prosumer camera is typically bigger than that on a point-and-shoot camera, and the sensor on a D-SLR is even bigger than that. With no standard in terms of image sensor size, there can be no standard in terms of digital-to-film lens conversion.

Instead, what you want to look for is the conversion factor, which is between 1.3X and 2X for most digital cameras. To convert from a film lens to the digital equivalent, divide the lens's focal length by the conversion factor.

For example, if you want to achieve the effect of a 100mm lens on a digital camera with a 1.5X conversion factor, divide 100 by 1.5 to get a 67mm lens. That is, the digital camera has an actual 67mm lens that functions as the equivalent of a 100mm film lens. You can also go the other direction; if a digital camera has a 33mm lens with a 1.5X conversion factor, that lens is the equivalent of a 50mm film lens.

To make things simpler, look for the equivalency number on the lens. For example, Nikon advertises that the 55mm to 200mm zoom lens it offers for its D-SLRs is the equivalent of an 82.5mm to 300mm film lens. (That's a 1.5X conversion factor, if you're doing the math.)

Basically, you need to train yourself to convert all those 35mm film lens numbers to corresponding digital lens numbers, or at least do the conversion when necessary. And when you're evaluating lenses, make sure you know what number you're looking at—the actual digital lens size or the 35mm film equivalent. What might appear to be a smallish 100mm digital telephoto could actually be a rather long 200mm film equivalent telephoto!

Lens quality is every bit as important as lens size; a cheap lens can contain imperfections and distortions that may be seen in your finished photographs. The last thing you want to do is invest in an expensive D-SLR camera and then mate it with a cheap zoom lens. Better to do the opposite; a quality name-brand lens will dramatically improve your photographic results.

PUTTING TOGETHER A PRACTICAL LENS COLLECTION

One great thing about a D-SLR camera is that you can put together a collection of lenses that let you take great shots in almost any imaginable situation. Assembling this sort of all-purpose lens collection, however, can set you back a small fortune, especially if you choose quality lenses. (I recently priced a 12mm to 24mm wide-angle lens for my Nikon at just over $1,000—more than I paid for the camera itself!)

If your budget is limited, look for a zoom lens that covers a wide range of shooting situations. For example, a 35mm to 100mm zoom lens (or its digital equivalent) provides a lot of flexibility for most photographers; you get a little bit of wide angle, even more telephoto, and a wide normal range.

You can pick and choose from various zoom lenses to cover an even wider focal range. For example, you might want to mate a 25mm to 70mm zoom with a longer 70mm to 200mm zoom. Together, these two lenses cover a lot of bases.

The key is to plan out your photographic needs and pick the best combination of lenses that fit those needs. It's possible to spend your money wisely on just a few lenses and have most shooting situations covered.

Using Filters

Have you ever seen a photo with a particular effect, and wondered how that effect was achieved? Maybe it was a shot of a bright beach with a darker sky, or a soft-focus portrait, or a shot with a pinpoint light and a starburst effect. Some of these effects can be added in the digital darkroom, of course, but a better approach is to achieve the effect "in the camera"—that is, to create the shot with the effect already in place.

The best way to create special in-camera effects is to use lens filters. A filter attaches to the front of your camera's lens and in some way filters the light. You can use filters that colorize the shot, diffuse the light, or otherwise alter what the camera sees.

9

How Filters Work

A filter is a transparent or translucent optical element that in some fashion modifies the light entering the camera lens. Filters can affect brightness, contrast, sharpness, and color, as well as produce a variety of special effects.

For example, if you have an overly bright scene, you can use a neutral density filter to make it darker. If you have a situation with indoor lighting where your camera is capturing the wrong colors, you can use a color filter to make the photo warmer or cooler. If you want to create a soft-focus glamour effect for a portrait, you can use a diffuser filter to slightly blur the subject.

Filters can be made out of glass (most expensive, best optical quality, longest lasting) or plastic (less expensive, acceptable optical quality, somewhat susceptible to scratching). Professional photographers almost always use glass filters, which are manufactured to a high optical quality.

Filter Systems

Most filters look like shallow lenslike glass or plastic circles, such as the ones shown in Figure 9.1. The filter is sized identical to the camera lens and screws onto the front of the lens.

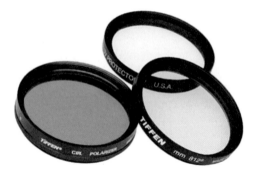

FIGURE 9.1

A selection of Tiffen screw-on lens filters.

Some manufacturers offer versatile interchangeable filter kits. For example, the Cokin Creative Filter System, shown in Figure 9.2, consists of a square filter mount that attaches to the front of the lens; the photographer can then slide different filters into and out of the mount, thus minimizing the time it takes to change filters.

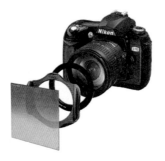

FIGURE 9.2

The Cokin Creative Filter System uses a single lens mount and interchangeable filters.

Attaching a Lens Filter via Mounting Threads

You attach a filter to your camera lens by screwing it into the threads at the end of the lens, as shown in Figure 9.3. You need to obtain the right size filter for your lens; most filter manufacturers make multiple sizes of filters to fit various sizes of lenses. Filters are sized the same as lenses, by diameter, measured in millimeters (mm). So, for example, if you have a 55mm lens, you'll need 55mm filters.

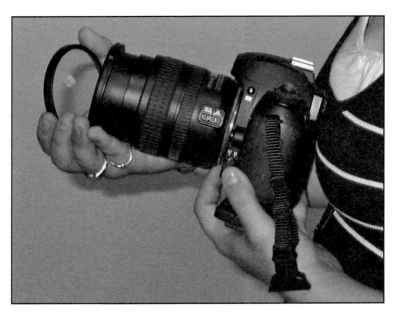

FIGURE 9.3

Attaching a filter to the front of a digital SLR (D-SLR) camera lens.

9

If you have multiple lenses, you can buy filters for each lens, or buy a single filter and mount to each different-sized lens by means of a step-up ring. Buy the filter to fit your largest lens, and then use a step-up ring to attach the filter to your smaller lenses.

> A step-up ring is essentially a converter that fits one size lens on one end and another size lens on the other.

You can also, if you want, stack multiple filters on top of each other. Each new filter attaches to the mounting threads of the previous filter, enabling the application of multiple effects in a single shot.

> **STOP** Avoid using filters smaller than your lens (with a step-down ring), as they can cause vignetting at wider zoom settings. (*Vignetting* is when you can see the edge of the lens in the picture.)

Attaching a Lens Filter via Other Means

Attaching a lens filters is fairly straightforward with D-SLR lenses, but not all point-and-shoot and prosumer cameras make it so easy. In fact, many point-and-shoot cameras do not have screw mounts on their lenses, which means you can't use most screw-on lenses with these cameras.

If your camera lens has mounting threads (most prosumer cameras do; most point-and-shoot cameras don't), you attach the lens filter as described previously. Make sure you purchase the right size filter (or use a step-up ring) and screw the filter onto the lens's mounting threads.

If your camera does not have mounting threads, you can still attach a filter—with a little bit of effort. Some cameras offer an optional *lens adapter*, like the one shown in Figure 9.4 that screws into a bezel at the base of the zoom lens. You can then attach a filter to the outer end of the lens tube. Other cameras accept third-party lens tubes that mount to the camera body magnetically or via glue.

FIGURE 9.4

A lens adapter for Canon point-and-shoot cameras.

Another option is Cokin's Magnefix system, which lets you attach filters to the end of any camera's zoom lens. This system requires you to glue a small metal ring to the end of the camera lens; special lenses affix to the metal ring magnetically.

Lens adapters are also called *lens tubes, adapter tubes,* and *lens converters.*

Using Polarizing Filters

I'll state it flat out: Every digital camera owner should use a polarizing filter.

Why such strong advice? Two reasons, really. First, polarizing filters improve the quality of all your photos. And second, a polarizing filter helps to protect your camera's original lens.

How a Polarizing Filter Works

When we view an object, we're actually viewing the light reflected from the object. This reflected light obtains its color and intensity from the object from which it bounces off. For example, white light from the sun reflecting off a blue object appears blue to us, because all the other colors are absorbed by the object itself; only the blue light is reflected.

That said, a small portion of reflected light bounces off an object without being absorbed. We see this as a white reflection or glare. Too much of this glare washes out the color saturation of the object—even if we don't perceive the glare separately. The effect is most noticeable in direct sunlight when the sun is highest in the sky.

A polarizing filter works the same way that polarizing lenses do in sunglasses. It effectively filters out light traveling in perpendicular directions, thus "polarizing" the light and removing unwanted reflections. Only the true-color light passes through the filter.

Enhancing Color and Contrast

Let's revisit the first benefit of using a polarizing filter with your digital camera. As just noted, a polarizing filter reduces glare and reflections, which increases the apparent contrast and deepens some colors, especially in outdoor shots. When shooting outdoors on a sunny day, a polarizing filter darkens the natural blue sky into a deep, rich blue.

Compare the photo in Figure 9.5 with the one in Figure 9.6. The first photo was shot without a polarizing filter; the second photo used a polarizing filter. Note the deeper blue of the sky in the second photo, which is a direct effect of the polarizing filter.

Because a polarizing filter reduces reflections in water shots, it lets the lens see through the water surface.

Reducing Glare and Reflections

A polarizing filter also keeps your camera's image sensor from "whiting out" when confronted with strong reflections. I'm talking about the type of reflection you might get from water, glass, foliage, and other highly reflective objects. This type of white-out effect cannot be corrected in photo editing programs (there's no original information there to restore), so it's important to attack the problem in the camera, with a polarizing filter.

STOP If you're factoring manual exposure, know that a polarizing lens changes the exposure needed by a shot, by 1 to 2 f/stops. Your camera's automatic exposure mode should compensate, but if you're doing it manually, you'll have to manually compensate.

Know, however, that a polarizing lens reduces slightly the amount of light entering the camera lens. For that reason, you may want to remove the polarizing filter when shooting at night or in low-light conditions.

Protecting the Lens

To the second point, keeping a polarizing filter attached to the front of your lens puts the filter in harm's way, protecting the lens itself. Instead of the expensive lens getting scratched, it's the inexpensive (and easily replaceable) filter that takes the brunt of any careless handling. That's why I have a polarizing filter on each of my lenses, permanently attached.

Considering UV Filters

Similar to polarizing filters are UV, skylight, and haze filters. These types of filters block ultraviolet light, thus theoretically reducing the effect of haze and smog, which contain high amounts of UV light.

That said, the positive effects of UV filters are more noticeable on photographic film than on electronic image sensors. (UV light can cast a bluish tint on color film; it does not have the same effect on digital image sensors.) For that reason, I don't recommend the use of UV filters with digital cameras; there's virtually no bang for your buck.

FIGURE 9.5

An outdoor photo shot without a polarizing filter.

FIGURE 9.6

The same outdoor photo shot with a polarizing filter—note the deeper blue and increased contrast.

9

Using Neutral Density Filters

A neutral density (ND) filter is essentially a darkening filter. It reduces the amount of light passing through to the lens, thus enabling the use of slower shutter speeds or wider apertures in otherwise overly bright conditions.

You can stack multiple ND filters to achieve higher density values. For example, if you stack a 0.6 (2 f/stop) and 0.9 (3 f/stop) filter, you'll get 5 f/stops worth of exposure adjustment.

Standard Neutral Density Filters

A standard neutral density filter cuts the amount of light entering the camera equally across the lens surface, by absorbing light evenly throughout the visible spectrum. When you're having trouble getting a decent exposure with shallow depth of focus (blurred background) in a sunny environment, using a neutral density filter is the preferred solution.

Neutral density filters are available in different levels of brightness absorption, expressed either as a density value or as a compensation value in terms of number of f/stops. A change in density of 0.3 cuts light input by 50%, or 1 f/stop. So, for example, an ND filter with a density value of 0.3 has a compensation value of 1 f/stop. (Table 9.1 details density value, compensation value, and percent of light transmitted.)

Table 9.1 Neutral Density Filter Values

Density Value	Compensation Value (f/stops)	Amount of Light Blocked (%)
0.3	1	50%
0.6	2	75%
0.9	3	87.5%

An ND filter looks, to the naked eye, gray. A filter with more compensation looks darker than one with less.

Graduated Neutral Density Filters

Also useful are graduated ND filters, which reduce brightness in only part of the shot. A graduated ND filter looks dark on one end and clear on the other; the dark side darkens that part of the picture, while the other side retains its original brightness.

It's important to hide the graduation break as much as you can; you want the fade effect to blend in as naturally as possible. In a landscape shot, this can be achieved by positioning the light/dark break at the horizon.

Graduated ND filters are useful when shooting scenes with varying brightness. For example, you might have an outdoor scene, like the one in Figure 9.7, where the ground is dark, but the sky is light. If you expose the shot so that the ground is properly exposed, the sky is overexposed and appears too light.

The solution in this situation is to use a graduated neutral density filter. The dark part of the filter is applied to the sky, and the light part of the filter is positioned over the ground. The sky gets darker, thus solving the overexposure problem, while the ground remains properly exposed, as shown in Figure 9.8.

FIGURE 9.7

A landscape photo shot with no filter.

FIGURE 9.8

A landscape photo shot with a graduated neutral density filter.

9

Graduated ND filters are available with different levels of graduation. With a "soft" filter the fade is gentler, helping to blend the transition from light to dark, while a "hard" filter has a more sudden change in brightness.

Color filters are assigned an industry-standard Wratten number, named after British inventor Frederick Wratten. So if someone says you need an 81A warming filter, that filter (no matter the manufacturer) will have specific color characteristics.

Using Colored Filters

A colored filter is, as the name suggest, a filter that has a translucent color. Color filters can be used to give a specific tint to color scenes, to correct the white balance in color shots, and to enhance contrast in black-and-white photography.

A wide range of colored filters are available, in various shades of blue, green, red, orange, and yellow. There are also special sky filters (blue filters to enhance blue skies), warming filters (yellow filters to "warm" portraits), and sepia filters (for an old-timey sepia tone effect). Figure 9.9 shows just a small selection of the available colored filters.

FIGURE 9.9
A selection of common color filters.

Table 9.2 details some of the more useful color filters, for both color and black-and-white photography.

Table 9.2 Popular Color Filters

Filter	Use (Color or B&W)	Description
6	B&W	Light yellow, darkens blue sky (least noticeable effect)
8	B&W	Medium yellow, darkens blue sky
11	B&W	Yellowish green, darkens blue sky
15	B&W	Deep yellow, darkens blue sky
16	B&W	Yellowish orange, darkens blue sky
22	B&W	Deep orange, darkens blue sky
24	B&W	Red, darkens blue sky (most noticeable effect)
47	B&W	Blue
58	B&W	Green
80	Color	Blue, color balances tungsten lighting
81	Color	Pale orange warming filter; diminishes bluish cast of overcast days
82	Color	Pale blue cooling filter, diminishes reddish or yellow cast of early morning or late afternoon sun
85	Color	Amber warming filter, reduces the cool cast of overcast days

Note that some types of filters, such as the 80+ series, come in different strengths or variations, labeled A, B, C, and the like. For example, an 82A is a cooling filter with a weak effect, while 82B is stronger, and 82C is stronger still.

Color Filters for Color Photography

Light is a tricky thing. Different light sources produce light that appears warmer (more reddish) or cooler (more bluish). Sometimes these tints are desirable; often they're not.

There are many ways to change the color cast in a picture. You can rely on your camera's white balance control, which sometimes works (and sometimes doesn't). You can fix incorrect colors after the fact with photo editing software. Or you can use a color filter to compensate for the color cast or change the colors that the lens sees.

For this reason, color compensating or correction filters are popular with professional photographers. For example, to compensate for the greenish cast of fluorescent lighting, you might want to use a warming filter, which adds a slight yellowish cast to your shots.

Learn more about the color characteristics of various types of lighting in Chapter 12, "Color."

9

Also popular are color effect filters. You use these filters to deliberately alter the color balance in a shot. For example, if you want to give a scene a bluish tint, you'd use a blue filter, as shown in Figure 9.10. Or you may want to make a still life look a little warmer by using a warming filter with an amber tint, as shown in Figure 9.11.

FIGURE 9.10

A still life shot with a blue filter.

FIGURE 9.11

The same still life shot with a warming filter—not the orange cast.

Color Filters for Black-and-White Photography

Believe it or not, color filters are perhaps more important to black-and-white photography than they are to color photography. That's because black-and-white photography registers colors as shades of gray; each color has its own distinct gray value. You can thus alter or enhance the tonal value of a black-and-white shot by enhancing or reducing the saturation for specific colors.

We discuss black-and-white photography in more depth in Chapter 27, "Black-and-White Photography." Turn there for a more detailed discussion of using filters for contrast control when shooting in black and white.

Using Special Effect Filters

Not all filters are used to alter contrast or color. Some filters are designed for specific effects and can be used to produce dramatic shots. We look at some of the most popular special effects filters next.

Diffusion Filters

When you want to create a soft-focus effect, popular in glamour photography, use a diffusion or soft-focus filter. This type of filter diffuses the incoming light, thus producing a gentle blur in the image, as shown in Figure 9.12.

You'll find various degrees of diffusion filters. Softer filters are less noticeable and are often used to soften wrinkles or even out patchy skin. Stronger filters have enough blur to produce a dreamlike effect.

Center Spot Filters

Sometimes you want your subject in clear focus but the background or surrounding area to be slightly blurred; this draws attention to the main subject at the center of the shot, as shown in Figure 9.13.

You achieve this effect with a center spot filter. This filter has a clear central area surrounded by an area with moderate diffusion. Any subject placed in the middle of the shot is held in sharp focus, while the surrounding area is somewhat blurred. (The amount of blur depends on the diffusion of the filter.)

9

FIGURE 9.12
A portrait shot with a soft-focus filter.

FIGURE 9.13
A portrait shot with a center spot filter.

Star Filters

Another popular photographic effect is the starburst. With this effect, points of light become sharply defined "stars," as shown in Figure 9.14.

FIGURE 9.14

A photo shot with a star filter.

This effect is achieved with a star filter. This type of filter is etched with lines in a grid pattern. The etched grid creates the star effect from any point of light; the bigger the light, the more dramatic the star effect.

You'll find different types of star filters, each with different designs—two-point, four-point, eight-point, and the like. The numbers refer to the number of lines produced from each point of light. Most light patterns are symmetrical.

Tips for Using Filters

When using filters with your camera, there are a few tips to keep in mind:

- Most screw-on filters can be stacked, by mounting one in front of another. Stack different types of filters to combine effects.

- All filters reduce the amount of light that passes to the camera lens, by some degree. If you stack too many filters on the front of your lens, you may end up significantly darkening the shot.

- If you're using low-quality filters, you may also notice a degradation in optical quality when you stack lenses. Two low-quality lenses can introduce unwanted distortion or artifacts into your photos.

- Care for your filters the same way you care for your camera lenses. Wipe them clean with a soft cloth, or use a lens cleaning solution as necessary.

- As with lenses, there are many different quality levels of filters. In general, the more expensive the filter, the better the optical quality.

Lens filters aren't the only type of filters you can use. You can also apply filters to light sources, such as studio lights or even speedlights. Light-based filters are used to subtly or significantly change the color of the light, or to produce distinctive special effects. Lighting filters are known as lighting *gels* and are most often sheets of dyed plastic.

FILTERS WON'T SOLVE ALL YOUR PROBLEMS

I like filters, but not all photographers do. Filters are not the be-all, end-all solution to photographic problems—and can, in fact, introduce more problems into the process.

First, note that many of the effects you can achieve with filters can also be achieved in post-processing, using Photoshop or similar photo editing programs. These post-processing effects include color correction, exposure alteration and brightness reduction, soft-focus effects, and starburst effects. For many contemporary digital photographers, it's both easier and more versatile to start with a pristine shot in the camera and then alter it in the digital darkroom.

Second, note that when you put a filter on the front of your camera, you're introducing one more element between the subject and the image sensor. That's one more element that has the potential to degrade the image—by introducing lens flare, distorting the image, attracting dust, dirt, and scratches, and the like. Again, many photographers prefer to capture as "clean" an image as possible, with no alteration or effect.

All that said, I believe that filters can be used judiciously to enhance certain photographs. Plus, I'm a little old school; I prefer to capture as many effects in the camera as possible and rely on the digital darkroom only when necessary.

Photography Essentials

10

Composition

The act of determining what goes where in the image frame is called *composition*. Good composition is one of the keys to taking great photographs.

Composition is essentially an editing process. You decide what to leave in and what to leave out of the shot, and then where to place those things you leave in. When it comes to composition, there are no rights and wrongs, no hard-and-fast rules you must follow; a good composition is one that is pleasing to your eye.

For example, a simple shot of a person standing in front of a house can be composed many different ways: The shot can be horizontal or vertical, you can zoom in close on the person or zoom out to see more of the background, you can place the person in front of or beside the house, you can place the camera at various angles, and on and on. The choices you make determine the final composition.

This chapter doesn't present any cast-in-stone compositional rules. Instead, I offer advice on ways you can approach the composition process—and improve the overall look of your photographs.

Understanding Image Sizes

Before we get to the topic of composition, you need to understand the canvas you have to work with. In digital photography, the canvas is determined by the type of image sensor in your camera, and by the type of printed or online output you're working toward.

Camera Aspect Ratios

The relationship between the sensor's width to its height is called the *aspect ratio*. The aspect ratio of the sensor determines the aspect ratio of its photographic images.

Most point-and-shoot and prosumer cameras generate images with a 4:3 aspect ratio—that is, the image is 4X in the horizontal direction and 3X in the vertical direction. This is the same aspect ratio found in standard definition television displays; it's a relatively but not quite squarish image.

Many digital SLR (D-SLR) cameras, however, have a slightly wider image sensor, with an aspect ratio of 3:2. As you can see in Figure 10.1, this creates a wider image than a typical point-and-shoot camera.

4:3 aspect ratio

3:2 aspect ratio

FIGURE 10.1

Aspect ratios for digital camera images.

As you can see, the widescreen image generated by a D-SLR camera presents a different compositional challenge than the squarer image generated by a point-and-shoot camera. Know what size image your camera creates before you start composing.

To help you better understand these different aspect ratios, as well as the aspect ratios of typical photo prints, it helps to express the aspect ratios in relation to the number 1. For example, the 4:3 aspect ratio can be expressed as 1.33:1, and the

The 3:2 aspect ratio found in D-SLRs is the same aspect ratio found in 35mm film cameras.

3:2 aspect ratio can be expressed as 1.5:1. (That is, a 4:3 image is 1.33 times wider than it is tall; a 3:2 image is 1.5 times wider than it is tall.) The larger the X:1 ratio, the wider the image. Table 10.1 provides more detail.

Table 10.1 Aspect Ratio Comparison

Image/Print Size	Aspect Ratio
8×10-inch print	1.25:1
4:3 image sensor	1.33:1
6×8-inch print	1.33:1
5×7-inch print	1.4:1
3:2 image sensor	1.5:1
4×6-inch print	1.5:1
3×5-inch print	1.67:1

Output Dimensions

As you can see in Table 10.1, the image generated by your camera may not be the same size as the image you want to print or view online. For example, a 4:3 ratio image is the same ratio as a 6×8-inch photo print, but not the same as any other print. A 3:2 ratio image is the same ratio as a 4×6-inch photo print, but not the same as any other sizes.

What if you want to create a 5×7 or 8×10-inch print? Neither a point-and-shoot nor a D-SLR camera generates images that exactly fit these print sizes. You have to use a photo editing program to crop your images to fit these output sizes. But you'll want to keep the output aspect ratio in mind when you're composing your shot, so as not to place any important elements in that part of the frame that will eventually be cut off.

So, for example, if you're using a point-and-shoot camera and want to output to a 3×5-inch print, which is a wider ratio than the camera's 4:3 aspect ratio, know that some of the top and bottom of the image will be cropped off. Likewise, if you're using a D-SLR camera and want to output to an 8×10-inch print, which is squarer than the camera's 3:2 aspect ratio, know that some of the right and left of the image will be cropped off.

To help you visualize how these image sizes compare, Figure 10.2 shows different print sizes overlaid on a 4:3 ratio point-and-shoot image, while Figure 10.3 shows different print sizes overlaid on a 3:2 ratio D-SLR image.

Learn more about cropping images in Chapter 19," Touching Up and Editing Your Photos."

10

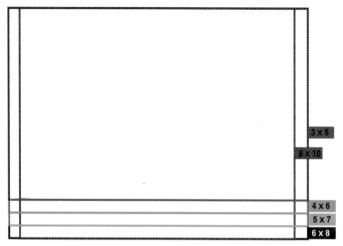

Master Image
4:3

FIGURE 10.2

Comparing print sizes with a 4:3 point-and-shoot image.

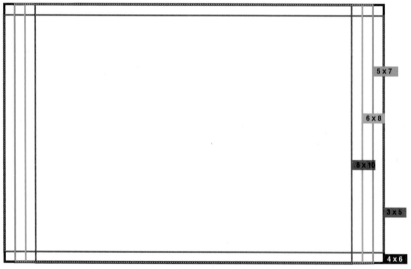

Master Image
3:2

FIGURE 10.3

Comparing print sizes with a 3:2 D-SLR image.

You face similar issues when composing for the computer or television screen. A 4:3 ratio point-and-shoot camera generates images that completely fill a 4:3 ratio standard definition television or computer display, but these images

do not fill the complete width of a 16:9 (1.78:1) widescreen display. A 3:2 ratio D-SLR image fills up more (but not all) of a widescreen TV or computer display, but appears significantly "letterboxed" on a standard 4:3 display. It's your option whether you crop to the display or accept the black bars that appear on the sides of the picture with different ratio displays.

Understanding the Principles of Good Composition

While there are no hard-and-fast rules of composition, there are some general principles you should follow. Following these principles of good composition won't guarantee that you'll create a great photograph, but they will help you move in that direction.

A good photograph has both strength and clarity. Its strength is the ability to capture the viewer's attention; its clarity is the ability to focus and maintain that attention.

You achieve strength and clarity by following a few basic design principles:

- **Tell a story**. Make your photo more than just an isolated snapshot.
- **Focus on a dominant element**. Choose and then draw attention to the main subject of the image.
- **Strive for simplicity**. Select only those elements that are essential to the image.
- **Create an effective eye flow**. Position objects in the scene that guide the viewer's eye through the frame—and to the main subject of interest.
- **Aim for balance**. This can either be symmetrical or asymmetrical, along a vertical, horizontal, or diagonal divide.

The compositional choices you make should be in service to these general design principles. You have many elements at your disposal, both design elements (lines, shapes, patterns, textures, color, and so forth) and photographic elements (horizontal or vertical format, placement of objects in the frame, lens selection, focus, perspective, and the like). These elements are the tools in your photographic toolbox; choose the best tools to use for any given shot.

Telling a Story

The best pictures always tell a story. A photograph without a theme may be visually interesting, but is actually cold and sterile. When someone views your photo, he should sense immediately the story that you're trying to tell, or the feeling you're trying to convey.

What kinds of stories can your photos tell? Sometimes the story is simple, such as "This is Aunt Jane" or "This is Aunt Jane at the zoo." Other times the story is more complex; a photo of a weathered old farmhouse, for example, might tell the story of unrealized hopes or the loss of an older way of living.

Sometimes a photo doesn't tell a story but rather conveys a particular mood or feeling. A photo of a child leaping into the air conveys joy; a photo of a tropical beach conveys tranquility. You get the point.

While it's tempting to get fancy with your compositions, don't let art and technique get in the way of telling a good story. Use your photographic skills as a form of expression, and to inform and maybe even educate your audience. This is how you realize the true power of photography—by using your camera to communicate your point of view.

Even seemingly innocuous photographs tell some sort of story. A photo of a group people might tell the story of a family reunion or business meeting. A photo of a young girl might be one part of the story of the girl's childhood. A photo of a sunset might document where you were on a particular day at a particular time.

So you should begin your composition by determining the story you want to tell or the mood you want to convey. Then, with that story or feeling in mind, visualize how best to tell that story or convey that feeling. Ask yourself what you want the image to say, and then picture the best way to "say" that—visually.

Selecting the Dominant Element

The center of any story is the main character—or, in photographic terms, the main subject of the photograph. Note the emphasis on a main subject, and the implication of a single subject. While a photograph can contain multiple objects, the viewer can focus on just one. As the photographer, you get to choose the main subject for the viewer's focus—and then help to draw the viewer's attention to that subject.

For example, Figure 10.4 shows a garden full of flowers. The flowers are pretty, but no one flower captures your attention; there is no dominant element. Figure 10.5 rectifies the situation by focusing on a single flower, making that flower the focal point of the shot.

The main subject of your composition doesn't have to be centered in the frame (see the "rule of thirds," discussed later in this chapter) or even the object closest to the camera. It merely has to be the dominant element, wherever it appears.

The main subject should become the focal point of the shot. It should be prominent in the composition and be positioned so that the viewer's eye automatically gravitates to it. Of course, position isn't the only way to

draw attention to the main subject; you can also use contrast, color, focus, and the like to subtly guide the viewer's eye.

FIGURE 10.4

A shot with no dominant element.

FIGURE 10.5

The same scene, this time with a single focal point.

10

Note that a photograph's main subject can actually contain multiple objects. For example, if you're shooting a group portrait, the group itself is the subject, not any individual within the group. And two people standing together become a single subject. You get the idea.

While it's possible for a photograph to include a secondary subject, that object must indeed be secondary. It should not detract in any way from the primary focus—and, in fact, should complement the photograph's main subject.

Choosing a Horizontal or Vertical Shot

As you're composing your photograph, give consideration to how the shot should best be presented—horizontally or vertically. Your camera's default position produces a horizontal shot, often referred to as *landscape format*. When you turn the camera on its side it produces a vertical shot, referred to as *portrait format*.

As you can see in Figures 10.6 and 10.7, the same subject can be presented both horizontally and vertically. The orientation you choose, however, determines how much and what kind of background is also included in the shot.

FIGURE 10.6
A shot in horizontal (landscape) orientation.

10

FIGURE 10.7

The same scene, this time in vertical (portrait) orientation.

Of course, sometimes the subjects dictate the type of format you use. A sprawling outdoors landscape cries out for the horizontal landscape format; shoot in a vertical format, and you get too much sky and not enough horizon. Likewise, a standing or sitting person suggests the vertical portrait mode; shoot in a horizontal format and you get too much empty space on either side of the subject.

In general, if the subject is taller than it is wide, shoot in vertical format, as shown in Figure 10.8. Likewise shoot in vertical, if the scene includes long vertical lines, such as trees in a forest or skyscrapers in a cityscape.

Similarly, if the subject is wider than it is tall, shoot in horizontal format, as shown in Figure 10.9. Likewise shoot horizontally, if the scene includes strong horizontal lines, such as an ocean horizon or a series of telephone wires.

All that said, be prepared to break the rules if you can create an interesting composition in the other format. Let your eye decide the best way to frame the shot.

10

FIGURE 10.8

A scene with a strong vertical orientation, shot in portrait format.

FIGURE 10.9

A scene with a strong horizontal orientation, shot in landscape format.

Filling the Frame

Whether you shoot in horizontal or vertical format, you want your main subject to fill the frame. One of the most common mistakes made by amateur photographers is positioning the subject too far away from the camera, as shown in Figure 10.10, which weakens the composition and makes it hard to focus on the subject. When you make the subject large enough to fill the frame, as shown in Figure 10.11, the composition is much stronger and better holds the viewer's interest.

FIGURE 10.10

A weak composition with the subject too small in the frame.

There are many ways to get the subject to fill the frame. You can

- Physically move the camera closer to the subject—or move the subject closer to the camera.
- Use your camera's zoom lens (or a separate telephoto lens) to zoom into the subject.
- Shoot as you will and then later use a photo editing program to crop the photo so that the subject is larger in the frame.

When you fill the frame with the subject, you not only strengthen the composition, you also help to eliminate any distracting background elements. The result is a shot that is much more intimate, with a strong point of focus.

10

FIGURE 10.11

The same subject positioned to fill the frame, creating a stronger composition.

Centering the Subject

When it comes to positioning the subject, many casual photographers instinctively place the subject dead center in the frame. More experienced photographers, however, seldom center their subjects.

Why is this?

The urge to center the subject was imprinted on most of us when we were children. Not only does it play into our sense of symmetry, it was also encouraged by our grade school art teachers as the simplest way to draw a picture.

Unfortunately, a centered subject more often than not creates a boring photograph. There's little interest for the viewer; the eye goes dead center and stops, with no visual flow or excitement.

This desire for visual stimulation is why most serious photographers tend toward off-center compositions, which we'll discuss in the following section. But not all shots have to be off-center; there are actually a few situations where a centered composition is the best approach.

It's okay to use a centered composition when you're photographing a single subject with nothing in the scene that competes with that subject. For example, if you're shooting a single flower that's in sharp focus against an out-of-focus background, it's okay to center the flower in the frame, as shown in Figure 10.12.

10

FIGURE 10.12

A centered composition with a single isolated element.

Some geometrical elements also benefit from a centered composition. For example, Figure 10.13 was shot looking through a long pipe; the symmetry of the circular pipe dictates a centered composition.

FIGURE 10.13

An abstract geometric shot with centered composition.

In addition, if you're shooting a single subject that's too large to fit at a "rule of thirds" intersection point (discussed in the following section) and still dominate the shot, it's okay to center it in the frame. For example, if you're shooting a product photo for eBay, it's okay to get close to the subject and center it in the frame; the artistic rule of thirds approach is trumped by the need to show the subject front and center.

Learn more about composing individual and group portraits in Chapter 21, "Candid Photography."

Finally, when you're shooting a group of people, you may have no other choice but to center the group to fit as many people as possible within the frame. In this situation, it is perhaps helpful to think of the group as a geometrical element that you have to work with.

Beyond these instances, it's better to position the subject of your shot off-center in the frame—which we'll discuss next.

Using Off-Center Composition with the Rule of Thirds

As noted in the previous section, most subjects convey little visual interest when exactly centered in the frame. You want the viewer's eyes to move across the image until they focus on the main subject; when the subject is dead center, there is no eye movement.

To create movement in your photographs, you should position the main subject somewhat off-center. There's actually an accepted way to determine the best placement, called the *rule of thirds*.

With the rule of thirds, you divide the frame into three vertical strips and three horizontal strips, as with a game of tic-tac-toe. You do this by drawing two equidistant vertical lines and two equidistant horizontal lines, as shown in Figure 10.14. This creates nine segments in the frame.

You want to avoid placing the main subject dead center in any of the nine segments. Instead, you want to position the focal point on or close to one of the four points where the vertical and horizontal lines intersect—the colored dots in Figure 10.14. Alternatively, for a little more flexibility, you can position the focal point on one of the grid's horizontal or vertical lines. Figure 10.15 shows how to apply the rule of thirds to an actual photograph; note how the main subject is aligned close to the bottom right intersection point.

10

FIGURE 10.14

The lines and intersection points dictated by the rule of thirds.

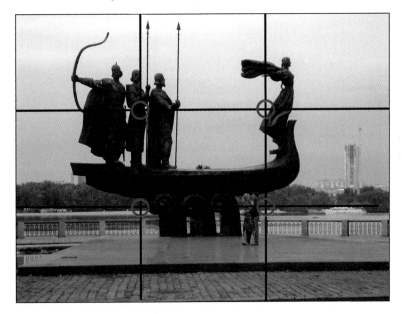

FIGURE 10.15

Applying the rule of thirds to a real photograph.

10

By the way, the rule of thirds applies to both horizontal and vertical format shots; Figure 10.16 shows the 3×3 grid in portrait format.

FIGURE 10.16

The rule of thirds in the vertical orientation.

Which intersection point you choose is entirely up to you. For example, Figure 10.17 shows a shot with the subject centered (bad), while Figures 10.18 and 10.19 show the same subject aligned to the top-left and bottom-right focal points, respectively. Both of the subsequent shots are much more interesting than the centered original.

To help you compose shots using the rule of thirds, most digital cameras let you superimpose a 3×3 grid onto the optical viewfinder or LCD display.

10

FIGURE 10.17

A shot with a centered subject—less than ideal.

FIGURE 10.18

The same shot with the subject aligned via the rule of thirds to the top-left intersection point.

FIGURE 10.19

The same shot with the subject aligned to the bottom-right intersection point.

10

When you use the rule of thirds you avoid a centered or symmetrical composition, which can result in a boring picture. Instead, you create a pleasing proportion of space around the main subject and help to lead the viewer's eyes across the frame to the focal point.

If your photograph has both a main and a subsidiary subject, align both of them to asymmetrical intersection points via the rule of thirds.

The rule of thirds should also guide you in positioning the horizon in outdoors shots. As you can see in Figure 10.20, a horizon that bisects the frame presents an uneasy ambivalence as to whether the focus is on the land or the sky. Place the horizon across the lower horizontal line, as shown in Figure 10.21, and the viewer knows it's a sky shot, because the sky is now two-thirds of the frame; position the horizon across the upper horizontal line, as shown in Figure 10.22, and the focus becomes the land instead.

STOP There's nothing more unnerving than a landscape shot with a horizon that's just a little tilted. Use your camera's grid feature and the rule of thirds to keep your horizons straight.

FIGURE 10.20

A landscape shot with the horizon dead center in the frame—an ambivalent composition.

FIGURE 10.21

The same shot with the horizon located on the lower horizontal line turns this into a shot of the sky.

FIGURE 10.22

The same shot with the horizon located on the upper horizontal line directs the focus to the land.

All this said, you shouldn't slavishly locate every single subject precisely at a rule of thirds intersection point; it's okay if you're *near* one of the intersection points, or even near one of the horizontal or vertical lines. I like to think of the rule of thirds as more the *guideline* of thirds. Use the 3×3 grid as a guide, but let your eye be the ultimate determiner of where you place your subjects in the frame.

Striving for Balance

One thing the rule of thirds can help you do is balance your photograph, especially when shooting in the wider 3:2 aspect ratio of a D-SLR camera. When your subject is on one side of the frame, aligned with one of the rule of thirds vertical gridlines, you have two-thirds of the frame left to deal with. You need to put something on the other side of the frame to balance the shot and achieve some degree of symmetry.

Balance doesn't necessarily mean symmetry, however. You don't have to balance the main subject with a like-sized subsidiary subject on the other side of the frame. Instead, you can use empty space to provide the balance, as shown in Figure 10.23; the composition is asymmetrical but balanced.

FIGURE 10.23

An asymmetrical composition with the main subject balanced by white space (literally, in this case).

Isolating the Subject

It's important that your main subject be the most important and most noticed element in the shot. To that end, you may want to isolate the subject from other objects in the shot, and from the shot's background. There are many ways to do this, including

STOP Avoid unnecessary bright spots in the background of a shot. These lighter areas draw the viewer's eyes away from the main subject.

- **Contrast**. If the subject and background have the same tonal value (the same gray shades), the subject simply fades into the background. Better to accentuate the contrast between the two, as shown in Figure 10.24. If you have a dark subject, use a light background; if the subject is lighter, use a dark background. (This is an essential technique for black-and-white photography but also works in color shots.) And, while we're talking about contrast, know that light tones advance while dark tones retreat. This means that most people naturally are drawn to the lighter sections of a photograph. For this reason, it helps to clothe your subjects lighter than the background.

- **Color**. Another way to provide contrast between the subject and the background is to use contrasting colors, as shown in Figure 10.25. As you can see, this also works when there are multiple objects in the shot; a single red subject stands out against a sea of blue or green.

- **Simplicity**. Even better, focus the viewer's attention by eliminating competing elements; a simple shot makes it clear where the viewer's eyes should focus. For best effect, remove all competing elements from the scene, including subsidiary objects and background elements.

- **Depth of field**. You can also use selective focus to focus attention. That is, work with aperture and shutter settings to create a shallow depth of focus; as you can see in Figure 10.26, this puts the main subject in sharp focus while the background and other elements are blurred.

10

FIGURE 10.24
Using contrast to isolate the main subject.

FIGURE 10.25
Using color to isolate the main subject.

10

FIGURE 10.26

Using depth of field (selective focus) to isolate the main subject.

Along similar lines, look for any object in the background that might be perceived as part of the subject. For example, Figure 10.27 is a photo of me standing in front of a tree; as composed, it almost looks as if the tree is growing out of my head! If you see such foreground/background interference, either move the camera, the subject, or (if possible) the item in the background so that the background object doesn't interfere with the foreground subject.

Learn more about depth of field in Chapter 14, "Focus and Depth of Field."

FIGURE 10.27

Does the author have a tree growing out of his head—or is the picture just poorly composed?

Determining How Much of the Subject to Show

When you're shooting a person or object, should you show the complete subject in your shot? Should you only see the person's face, or face and shoulders, or upper body, or complete body?

How much of the subject you show is an artistic choice; a head and shoulders shot is substantially different from a full body shot. That said, when you do crop part of the subject out of the shot, make sure you do so intelligently. A poorly cropped subject just looks wrong and draws unwanted attention to the part that's not there.

In other words, don't unthinkingly amputate your subject. If you're going to crop a person or object, don't place the crop mark at a limb or joint. Cut the shot in the middle of an arm of leg rather than at an elbow or knee.

And don't crop anything important to the shot. You never want to drop a person's eyes, and seldom want to cut off the top of his head. (Figure 10.28 shows a poorly cropped portrait; Figure 10.29 shows a better cropping.)

FIGURE 10.28

A portrait with too much of the subject cropped out of the shot.

FIGURE 10.29

Better cropping of the same portrait—nothing important is amputated.

This goes for items subsidiary to the main subject, as well. You don't want to crop a subject's shadow, nor do you want to carelessly crop objects in the background. A bad crop anywhere in the shot draws attention to itself—and away from the main subject.

Changing Angles

One compositional element that's often overlooked by casual photographer is the angle of the shot. The natural tendency is to shoot most shots straight on, at or near eye level. While the head-on approach is good for many shots, it's not the only angle available.

For example, Figure 10.30 shows a subject shot straight on, which is fine but a little boring. Figure 10.31 adds interest by shooting the same subject from a low angle, with the camera positioned slightly below the subject. Figure 10.32 takes the opposite approach, shooting from a high angle with the camera positioned above the subject. Both angles are much more dramatic than the original head-on shot.

FIGURE 10.30

A subject shot with the camera positioned at eye level.

FIGURE 10.31

The same subject shot from a more dramatic low angle.

FIGURE 10.32

The same subject shot from above.

10

And you're not limited to shooting from above or below. You can tilt your camera to the side to position the subject diagonally in the frame; the more the tilt, the wilder the effect. It's amazing how changing the angle of the camera can make such a big impact on how the subject appears.

If your shot includes a lot of long lines, it's better to position them diagonally than either horizontally or vertically. Breaking up an image into long horizontal or vertical lines can be visually boring; the image is too static. Tilting the camera to create diagonal lines, on the other hand, adds visual energy to the shot.

Framing the Subject—Naturally

Here's an interesting effect. Whenever possible, take advantage of existing objects to frame your main subject. There are many objects you can use as frames—doorways, foliage, rock arches, you name it. As you can see in Figure 10.33, the natural frame helps to draw attention to the main subject of the photo.

FIGURE 10.33

A subject naturally framed by existing objects.

Using Leading Lines and Patterns

Another way to focus attention on the main subject is to use leading lines. As you can see in Figure 10.34, these lines create energy and movement in the shot, and they lead the viewer's eyes to the focal point.

FIGURE 10.34

Using leading lines to point to the main subject.

The best leading lines result from natural elements. These may be separate objects that create a linear pattern, or literal lines in the background of the shot. It's better if the lines move diagonally and are directed toward one of the rule of third intersection points.

Also interesting are patterns—especially naturally occurring patterns. A repetition of shapes, textures, or colors can work to suggest leading lines, or they can merge to become the main subject of a photograph. The best patterns create rhythm and motion in a composition and lend the shot a dynamic energy.

According to some design experts, diagonal lines express dynamic energy, vertical lines express power and strength, horizontal lines express stability, and curving lines express sensuality.

10

KEEP IT SIMPLE

Earlier in this chapter we discussed the need to simplify the background of a shot to help isolate the main subject. It's also important to keep your entire shot simple to create a stronger composition.

A simple composition presents a clear message. The fewer elements in the shot, the easier it is to create a composition that controls the viewer's eye movement.

A cluttered composition, on the other hand, is both difficult to work with and difficult to view. In most instances, a few dominant elements are much more striking than a complex combination of objects.

While it's possible to create stunning complex compositions, give me a few bold elements any day. To my eyes, simplicity makes a big impact.

Lighting and Flash

How much light your camera sees determines the quality of a shot. Too much light results in overexposure, and your subjects look washed out. Too little light causes underexposure, with muddy colors and too many shadows. Then there's the issue of what kind of light you have; certain types of light imbue your photos with an unwanted color cast.

As you can see, lighting is important and it's tricky; it's not just a matter of popping up your camera's flash and hoping for the best. No, you have to learn to see light the way your camera does and manipulate that light to best effect.

Fortunately, there are many ways to do this—as you'll soon learn.

11

Positioning the Light Source

Light can hit your subject from any possible angle. You want, as much as possible, to control the direction of the light source to best light your subject. Of course, there are many ways to change the direction of the light source—you can move the light itself (in some instances), the subject, the camera, or any combination of these. You can even supplement the main light source with a secondary light source, to fill in existing shadows and create other photographic effects.

There are five main positions for your primary light source—overhead, directly in front, to the side, at a 45-degree angle, and behind. Figure 11.1 shows all these positions, which we'll examine separately.

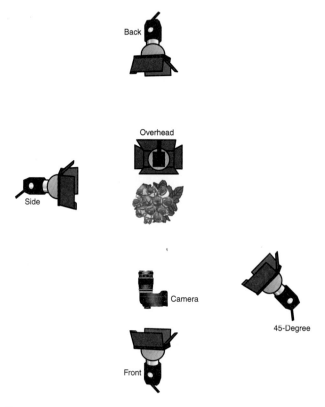

FIGURE 11.1

Five different positions for lighting.

Overhead Lighting

When you're outdoors at noon on a sunny day, you have high overhead lighting. When the light source hits the scene from directly above or even a slight

overhead angle, your subject and all other objects in the frame are well lit and equally lit, as you can see in Figure 11.2. However, overhead lighting can also create unwanted shadows, especially under a person's eyes, nose, and chin, or under any overhanging part of a still life. As such, it's not the most flattering type of lighting for portraits—although it's not bad for some still life photos.

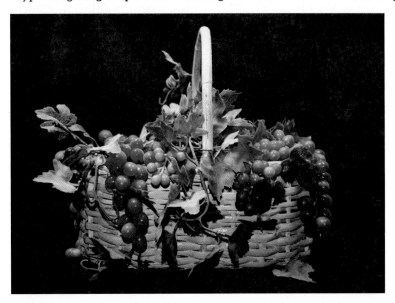

FIGURE 11.2

Direct overhead lighting—note the harsh shadows.

Front Lighting

Front lighting positions the light source directly in front of the subject. This is the position of the light source when you use your camera's built-in flash, and illuminates that portion of the subject that's facing the camera.

This type of lighting does a good job of exposing the front side of the subject, with no distracting shadows. However, the lack of shadows results in a lack of depth; the photo tends to look a little flat, as you can see in Figure 11.3.

Side Lighting

Side lighting results when you position the light source to the right or left side of the subject. It's a more dramatic lighting, good for emphasizing texture, shapes, and patterns. As you can see in Figure 11.4, this type of lighting tends to sculpt a subject, using selective shadows to exaggerate dimension and depth.

11

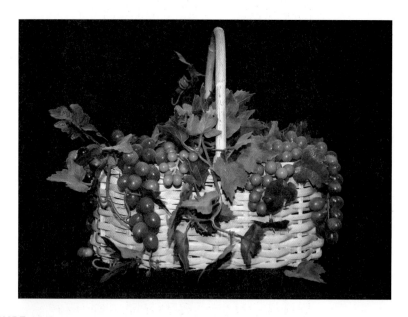

FIGURE 11.3

Front lighting—no shadows, somewhat flat looking.

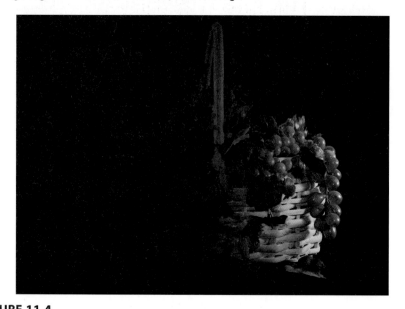

FIGURE 11.4

The result of side lighting—a dramatic half-lit effect.

On the downside, a light positioned 90 degrees from the front of the subject may be too severe for some subjects. At its most extreme, it highlights only

half the subject, leaving the other half in darkness. (Which may be a desired effect for some shots.)

Ninety-degree side lighting is sometimes called *split lighting*. Forty-five-degree lighting is sometimes called *Rembrandt lighting*.

Forty-Five-Degree Lighting

A compromise between front and side lighting is to position the light source 45 degrees from the front of the subject—in front and to the side. As you can see in Figure 11.5, this type of angled side lighting provides a nice mix of highlights and shadows, and is perhaps the most flattering type of lighting for portraits.

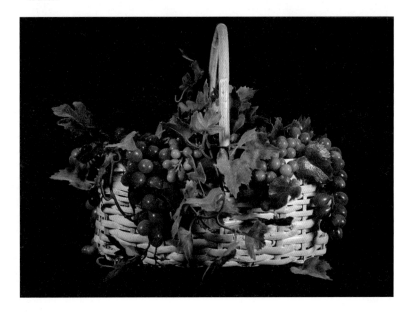

FIGURE 11.5
Forty-five-degree lighting—a flattering mix of highlights and shadows.

Backlighting

Positioning the light source directly behind the subject results in a backlighting effect. As you can see in Figure 11.6, backlighting leaves the front of the subject in shadow and creates a ring of light around the edge of the subject, for a silhouette effect.

If you have only one light in a studio, use the 45-degree positioning for best effect.

11

FIGURE 11.6

Backlighting—the front of the subject is totally in shadow.

This type of lighting is the most difficult to use properly, simply for the reason that the most interesting part of the subject—the side facing the camera—is not lit well enough to allow for proper exposure or to show details. And if you try to compensate for the backlighting to adequately expose the face of the subject, you may end up with a too-bright background.

Working with Available Light

Whatever the position of the light source, working with the available light is the easiest way to shoot. That means utilizing the sunlight outdoors or lighting fixtures indoors, and not using your camera's flash or other lighting accessories.

Outdoor Lighting

Perhaps the best type of light to work with is natural light—the light from the sun. This is a relatively pure white light, without unnecessary coloration. Outdoor lighting can be direct (in the sunlight of a cloudless day) or indirect (in a shadowed area or under clouds).

One way to compensate for the backlighting effect is to use additional fill lighting in front of the subject to fill in the dark areas. You can also use a white reflector card to reflect the backlighting onto the front of the subject, thus lighting both sides of the subject with the same light source.

With outdoor lighting, the time of day you shoot has a big effect. When you shoot mid-day or early afternoon, the sun is high in the sky and gives a harsh direct light. The result is a brightly lit scene with washed out colors and harsh overhead shadows, as shown in Figure 11.7. In addition, if you're shooting people they'll probably be squinting from the sun (or wearing sunglasses, which is even worse); the overhead sun also puts the subjects' eyes in deep shadow, which is not a pleasant effect.

FIGURE 11.7

A shot made with the harsh midday sun.

If you must shoot at midday, experiment with your camera's exposure settings. You'll often get better results by using a darker exposure, which minimizes somewhat the harshness of the direct overhead lighting. Also make sure you're exposing for the subject, not the bright background; it's better to have a properly exposed subject with a blown-out background than a visible background with a too-dark subject.

A better approach is to shoot earlier in the morning or later in the day, when the sun is at more of an angle to the subject. This results in a warmer, more pleasing light with flattering long shadows, as shown in Figure 11.8.

When shooting outdoors in bright lighting, a polarizing filter is essential to darken the sky and enhance available colors. Learn more in Chapter 9, "Using Filters."

11

FIGURE 11.8

A shot made with the more pleasing late afternoon light.

When you shoot in sunlight, it's best to lay out the scene so that the sun hits the subject from the side, not from the front or back. Shooting with the sun in front of the subject (behind the camera) results in too few shadows, as well as squinting subjects; shooting with the sun behind the subject makes exposure difficult and can result in unwanted backlighting and lens flare. Side lighting creates shape-defining shadows, which give your subject a three-dimensional effect, as shown in Figure 11.9.

Even better, move your subjects into a shady area, away from the direct sunlight. You'll still have plenty of light for a good exposure (it is a sunny day, after all), but you'll avoid the problems commensurate with bright direct lighting; the lighting is more uniform, and you avoid unwanted facial shadows.

That said, cloudy days are often better for shooting people—even if they're not that great for shooting landscapes. While it's nice to have a clear blue sky in your out-doors shots, clouds create a diffuse lighting effect that enhances portraiture.

The so-called "golden hours" for photography are the first and last hours of sunlight during the day. The quality of light during golden hour is soft and warm with pronounced shadows and enhanced colors, making for some beautiful shots.

FIGURE 11.9

A flattering outdoors portrait, made with the sun to the side of the subject.

Indoor Lighting

The nice thing about shooting outdoors, no matter what kind of day it is, is that you get a surplus of light; you don't have to worry about underexposing your shots. Shooting indoors, however, is more problematic.

Unless you happen to live in a television studio, your house is probably underlit. And what light you have is artificial, which doesn't have the same color as natural light.

Of course, one solution to shooting indoors is to use your camera's flash, which we'll discuss in the following section. But it's also possible, and often desirable, to shoot with the existing light. You just have to know what you're getting into.

The key to shooting with indoor lighting is to let as much of that light as possible into the camera. There are several ways to do this; you should employ some or all of the following techniques:

- Use a slow shutter speed to let in all available light. Of course, this means you should consider using a tripod to hold the camera steady. (Handheld shooting in low light often results in blurry shots.)

■ Set your camera's ISO to a fast set-
ting, 400, 800, or even 1600. Fast
ISO/film speeds respond quickly to
the available light and work best in
low-light situations—although they
also introduce some amount of grain
into the photograph.

Learn more about the
effect of different types of
lighting on color in Chapter
12, "Color."

■ Adjust your camera's white balance controls to compensate for the
color cast of the particular type of light in the room.

You'll also need to be creative with the light that's available. For example, you
might position your subject near a window to take advantage of the light fil-
tering in from outdoors; the effect can be striking, as you can see in Figure
11.10. Similar effect can be had by positioning your subject near a shaded
desk lamp, flickering candle, or other interesting source of light.

FIGURE 11.10

A creative use of indoor lighting: Lighting the subject with light from a nearby window.

Working with Your Camera's Flash

Most casual photographers deal with a lack of available light by doing one
thing—using the camera's built-in flash. That's a good solution, but not
always a great one, as you'll soon learn.

Understanding How Flash Works

All digital cameras today come with a built-in flash, positioned either to the side of or above the lens. The flash shines a relatively harsh direct light on nearby subjects.

When you activate the flash on your camera, it fires in conjunction with the opening of your camera's shutter. It doesn't fire precisely simultaneously, however. Instead, it works like this: The shutter opens, the flash fires, and then the shutter closes. This permits both ambient light and light from the flash to contribute to the photographic image.

Most flashes can light subjects 10 feet or so away; they have little or no effect on distant objects. A phenomenon known as *flash falloff* concerns the fact that the flash illumination is cut in half when the distance to the subject increases by a factor of 1.4. This can result in odd effects if you're shooting a deep subject. For example, if you're shooting a group of people in several rows, where the people in the first row are 10 feet away and the people in the last row are 14 feet away, those folks in the last row will get only half the flash illumination as their first-row colleagues. This is why you need to take flash falloff and distance from the camera into account when using your camera's flash.

11

When to Use Flash—And When Not To

Flash photography is good for lighting certain types of scenes, but less than ideal for others. It's important to remember that flash units have a relatively short range (10 feet, as discussed previously) and emit a somewhat harsh light.

The first rule, then, concerns distance. If your subject is 10 feet or less away, your camera's built-in flash will work fine. If the subject is between 10 and 15 feet away, the flash will have less effect. And if the subject is more than 15 feet away, you're wasting the light; the flash simply won't illuminate distant subjects.

The second rule concerns convenience. Your camera's built-in flash is nothing if not convenient. When you don't have the time or inclination to use a speedlight or other types of external lighting—for most candid shots, that is—use the camera's flash.

The third rule concerns available lighting. If natural lighting is plentiful, use it—and don't use your flash, except perhaps for fill lighting, which we'll discuss shortly. If the light is too low, or too colored (as with most artificial indoor lighting), use the flash to generate enough light for a decent exposure, or to balance the color cast from artificial lighting.

Finally, if you try using your camera's flash and find the results too harsh in any way, it's time to consider using an external flash unit or speedlight—which we'll also discuss later in this chapter.

Selecting Flash Modes

Simple point-and-shoot cameras tend to automate the use of the built-in flash; you can turn it on or turn it off, but not much more.

More sophisticated cameras, however, including most prosumer and digital SLR (D-SLR) models, offer a variety of flash modes. You can select different modes for different lighting effects.

The most common flash modes include the following:

- **Automatic**. The flash lights automatically when ambient light reaches a low-enough level, or when the subject is backlit. The camera determines how much flash to provide in the given situation.

- **Slow sync**. In this mode, sometimes called "fill in" mode, a small dose of flash is paired with a slower shutter speed. This keeps the shutter open longer than the flash fires, letting in more natural lighting. The effect is to expose both the subject and the background behind the subject. It's also used when you need fill flash to remove unwanted shadows from the subject.

- **Rear curtain sync**. In this mode, the timing of the flash is slightly different than normal; the flash fires near the end of the exposure, just before the shutter closes. The effect is to freeze a moving subject, creating a stream of light *behind* the subject. Use this mode when shooting action photography, to create a sense of forward movement.

- **Front curtain sync**. This mode also deals with the timing of the flash; the flash fires at the beginning of the exposure, just after the shutter opens. The effect is to create a stream of light *ahead of* a moving subject, which is a somewhat unrealistic effect. (This mode is less useful than rear curtain sync, and is in fact not found on all cameras.)

Naturally, you also have the option of manually turning off the flash, so that it doesn't fire, even in low-light situations. You should also have the option of manually turning on the flash, so that it fires even if there is sufficient natural light.

Some cameras also offer flash output compensation. This is similar to exposure compensation in that it enables you to manually adjust the power of the flash output. For example, you may be able to adjust the flash output by 1 or 2 stops, in moderate steps; some cameras may offer only high, normal, and

low flash output settings. However it's accomplished, being able to adjust the level of flash helps you achieve the correct exposure in tricky lighting situations—or provide just a bit more light to soften shadows in a shot.

Avoiding Back Shadows

When light from a flash falls on a subject, a shadow is cast behind the subject. That's not a problem if the subject is in the middle of a room, but if the subject is positioned directly in front of a wall or other solid object, you get distracting shadows, as shown in Figure 11.11. The simplest solution, of course, is to move the subject away from the wall. This type of situation also calls for something other than the camera's built-in flash; using a speedlight aimed above or behind the camera produces a more diffuse light that is less likely to cast harsh shadows.

FIGURE 11.11

An unwanted back shadow created when the subject is positioned too close to a wall.

Avoiding the Red Eye Effect

Flash, especially that on low-end point-and-shoot cameras, can also create the dreaded red eye effect when shooting people and animals. You know the effect: You shoot with a flash, and your subjects end up with glowing red eyes, like the girls in Figure 11.12. Unless your friends or family members actually

have glowing red eyes (in which case you have bigger problems than just a bad picture), you need to eliminate the effect to achieve a realistic photo.

FIGURE 11.12

The dreaded red eye effect—not desirable, unless your subjects are actually the spawn of the devil.

The red eye effect results from the light from a camera's flash reflecting off the subject's retina, which is sensitive to red light. As a result, a trace (or more) of red appears in the eyes of the subject in your photograph. The closer the flash is to the camera lens, the worse the effect, because this shoots the light from the flash directly into the back of the subject's eyes.

Even worse than red eye on people is red eye on animals—which is often green or yellow, not red. You get more of this effect when you photograph your pets because animals' eyes reflect more light than those of humans, to enhance their night vision.

Whether we're talking humans or animals, the easiest way to avoid red eye is simply to not use your camera's flash; you'll seldom get red eye when shooting under natural light. You can also minimize red eye by reducing the amount of flash, therefore using more ambient light in the shot.

The color of the reflective layer in an animal's eyes somewhat depends on the color of the animal's coat. For example, black dogs tend to have a green reflective layer, resulting in a vivid "green eye" effect; tan-colored dogs have a light blue reflective layer that creates "blue eye."

The red eye effect can also be overcome by moving closer to your subject and positioning the camera a little off to the side—that is, not shooting directly at the subject. The more off-angle to the center of the eye you can get the flash, the less the effect.

You can remove most red eye after the fact by using the red eye removal tool found in most photo editing programs. Learn more in Chapter 19, "Touching Up and Editing Your Photos."

Another solution is to use an external flash or lighting kit instead of your camera's built-in flash. Consider using a speedlight that angles or bounces its flash, or flood lights positioned off-angle to the subject. The goal is to light the subject without sending a beam of light directly into the back of her eyes.

Finally, many digital cameras today offer a red eye reduction feature, which fires a pre-flash about a second before the normal flash. This forces the subject's pupils to contract, which lessens the amount of light reflecting off the back of the eye. Although this feature doesn't totally eliminate red eye, it does serve to minimize the effect—although the effectiveness varies from model to model.

Using Fill Flash

Shadows are tricky things. Too little shadow and your subject lacks detail and appears two dimensional. Too much shadow and your subject appears too dark with too many details lost in the shadows, as you can see in Figure 11.13. Ideally, you want to achieve a balance between too much and too little shadow—which isn't always possible using the available light.

The solution to this problem is to use your flash to fill in and lighten the shadows, as shown in Figure 11.14. This effect, called *fill flash*, is both effective and easy to accomplish. All you have to do is set your camera's flash to fire manually, even though there's enough light for it to stay off in automatic mode.

Fill flash can be used in any situation where there's adequate light for a good exposure, but all or part of the subject is still too dark. For example, you can use fill flash when your subject is outdoors in the shade, or has too much backlighting, or even in an otherwise good shot where you need just a little more light on the subject. It's also good in portrait photography, when you want to eliminate shadows under the eyes, nose, or chin of the subject.

STOP Believe it or not, the problem of too much shadow is particularly acute when shooting in bright sunlight. The bright light brightens most of the subject, leaving the shadowed areas so dark in contrast that they show little or no detail. The effect is both unattractive and somewhat distracting.

11

FIGURE 11.13

A person shot outdoors with too much shadow.

FIGURE 11.14

The same person shot outdoors, with fill flash used to fill in the shadows.

If you're using a D-SLR camera, you may
have the option of adjusting the amount
of flash used. If so, try shooting your fill
flash at less than full output—down any-
where from 2/3 to 1 1/3 f/stops. This same
advice holds when using a speedlight for
fill flash; shoot at less than full flash power, or by bouncing the light from the
speedlight so that it's more diffused than direct.

Fill flash also adds a little
sparkle to the eyes of
any person you're photo-
graphing.

Working with a Speedlight

If your camera has a hot shoe on the top, you can attach an external flash
device, like the one shown in Figure 11.15. This device, sometimes called a
speedlight or *flashgun*, offers both more power and more flexibility than your
camera's built-in flash.

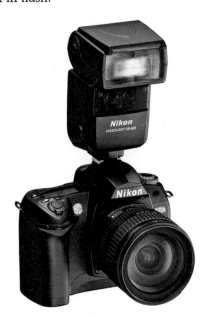

FIGURE 11.15

A Nikon D-SLR with SB-600 speedlight attached.

The advantages of using a speedlight over the built-in flash are several. First,
a speedlight has a longer throw, meaning you can get more consistent light
over a longer distance. Second, the speedlight's power can be dialed down,
providing more subtle lighting. And third, the speedlight's head can be
swiveled or angled up or down, providing bounce lighting instead of direct

lighting, which results in less harsh lighting effects. (Bounce lighting also reduces the red eye effect.)

Most speedlights, when connected to your camera's hot shoe, are controlled by your camera. That is, the same automatic metering system that your camera uses to adjust the amount of traditional flash is applied to the speedlight. The camera determines how much light the speedlight should produce for any given shot.

In addition, many speedlights have their own light sensors and controls. This lets you manually adjust the amount of light produced, separate from what your camera might determine. Make sure you read the speedlight's instruction manual to learn all the available adjustments.

Using Bounce Flash

A chief benefit of using a speedlight is the ability to use bounce flash or bounce lighting. In essence, bounce flash is indirect lighting that is first bounced off another object (a wall or ceiling, typically) before it hits your main subject. This is distinguished from direct flash, where the light from the flash shines directly on the subject.

Direct flash can be a harsh light. It can overpower and often overexpose the subject, as you can see in Figure 11.16, creating unwanted highlights and reflections as well as hard shadows behind the subject. Bounce flash, on the other hand is a subtler, more diffused light. As you can see in Figure 11.17, bounce lighting gently eliminates glare and shadows on the subject, flattering the surface and avoiding unwanted background shadows. That's because bounce lighting is diffused by first bouncing off another surface.

It's easy to use bounce flash if you have a speedlight. All you have to do is swivel or angle the head of the speedlight so that it's not pointing directly at the subject. You can aim the speedlight at any convenient surface; ceilings are good, as are side and back walls. In fact, many photographers achieve good results by aiming the speedlight behind them, thus creating a very diffused lighting effect.

You'll need to experiment with the angle and position of the speedlight. Ceiling height plays a big factor; tall ceilings are better for bounce flash than shorter ones, as they provide more diffusion with less chance for direct reflections onto the subject.

FIGURE 11.16
A subject shot with hard direct flash—okay, but not great.

FIGURE 11.17
The same subject shot with gentler bounce flash from a speedlight—a much better portrait.

Know, however, that when you bounce the light from your speedlight, you double or even triple the distance the light travels, which increases the risk of underexposing the subject. To compensate for this, you can increase the flash power or flash exposure compensation on your camera or speedlight by 2 or 3 stops. Again, this is something you may need to experiment with, as the effect depends on the distance between your speedlight and the bounce surface, and the bounce surface and your subject.

Positioning the Speedlight Off-Camera

Many speedlights come with connecting cables that let you use the speedlight in a handheld fashion. You connect one end of the cable to the camera's hot shoe and the other end to the speedlight itself. In this fashion you can position the speedlight away from the camera, to provide lighting from a different angle.

Moving the speedlight off-camera has many benefits. First, when the angle of the light is different from the angle of the camera, you're less likely to get a red eye effect. Second, light coming at an angle creates more interesting and defining shadows than you get with light aligned with the camera lens.

If your speedlight can be used off-camera, it's worth experimenting with it. In this situation you can hold the speedlight in one hand and the camera in the other (awkward), have someone else hold the speedlight (better), or set the speedlight on a hard surface or tripod to the side of the camera (best).

Working with Studio Lights

As you get more serious with your photography you'll want to expand your lighting options beyond built-in and accessory flash units. This is especially true if you're into portrait, still life, or product photography.

For the best control over the lighting of your subjects, you want to invest in a set of studio lights. These are freestanding lighting enclosures that you position in front of, to the sides, or behind the subjects you photograph. Different types of lights provide different lighting effects; you can further customize the effects by using various accessories, such as soft boxes, umbrellas, or color filters.

For beginning photographers, the best way to experiment with studio lighting is to purchase a prepackaged lighting kit. These kits typically contain two or three photofloods, stands to hold the lights, and some sort of diffuser for each light. Different kits are available at different price points, depending on the power and quality of the lights themselves, as well as the provided accessories.

Types of Studio Lighting

There are two main types of studio lighting: *continuous* and *flash*. As the name implies, continuous lighting stays lit continuously, before, during, and after the shot. Studio flash lighting, sometimes called *strobe* lighting, is like the flash built into your camera; it lights only during the shot.

A continuous lighting unit, like the one shown in Figure 11.18, can contain one of several different types of bulbs. The lowest priced units, called *photofloods*, use simple incandescent bulbs, similar to the light bulbs found in a typical home but with brighter output. More expensive units use fluorescent, quartz halogen, or tungsten lights, which are more powerful for brighter lighting. Studio flash units, like the one shown in Figure 11.19, typically use quartz halogen bulbs, but with a higher color temperature for a cooler cast.

FIGURE 11.18

A quartz continuous lighting unit from Smith-Victor.

FIGURE 11.19

A studio flash head from Bowens.

11

Both types of studio lighting have their pros and cons. Continuous lighting, for example, is less expensive than studio flash and, because it's always on, makes it easy for you to see the effect of the lighting. On the other hand, continuous lighting produces a lot of heat, because the lights are always on, which can make the studio and your models warm. In addition, when you're shooting portraits continuous lighting will make the irises in your subject's eyes narrow, and the light you get isn't always white balanced to daylight.

Learn more about the color temperature of different types of studio lighting in Chapter 12.

In addition to the type of lighting, you can choose from different levels of output, measured in watts. The higher the wattage, the brighter the light. For example, a 500-watt light burns twice as bright as a 250-watt light.

Studio flash, although more expensive than continuous lighting, has a few advantages. First, studio flash units generate huge amounts of light released in a fraction of a second, providing much more power lighting than what you get with the typical continuous lighting setup. This extra power lets you use smaller apertures and faster shutter speeds, which creates a larger depth of field. And all that light is relatively cool, temperature-wise, because it strobes on only while you're taking a shot; the lights aren't on continuously, heating up your studio. In addition, studio flash units provide a lot of control over your shot's lighting; you can dial the flash power up or down in small increments, which lets you create subtle lighting effects.

Which type of studio lighting should you use? If you're just starting out, go with an inexpensive photoflood continuous lighting kit. For more professional product and still life photography, go with higher-priced quartz halogen continuous lighting. For professional portrait photography, studio flash is the way to go.

Lighting Accessories

Beyond the lights themselves, a typical studio lighting setup includes a variety of important accessories. In addition to the expected stands for the lights, you can choose from accessories that help you position, diffuse, and bounce your studio lighting, including the following:

Most studio flash units are fitted with a low-powered continuous lamp, called a *modeling lamp*, which helps you see the effect you'll get when the flash lights. This modeling lamp generates less light and heat than traditional continuous lighting.

- **Reflector**. This is a polished metal bowl that attaches around the light source, redirecting light from the sides of the bulb forward onto the subject. (Most continuous lighting units come with their own reflectors.)

- **Diffusers**. This is a translucent piece of glass or plastic that fits over the light source. Without a diffuser, the light from a bare bulb is stronger at the center and gets softer closer to the edges. The diffuser spreads the light more evenly across the subject and also serves to soften the light.

- **Soft boxes**. This is a translucent fabric "box" that attaches directly to a strobe head, as shown in Figure 11.20, serving to diffuse or soften the source light.

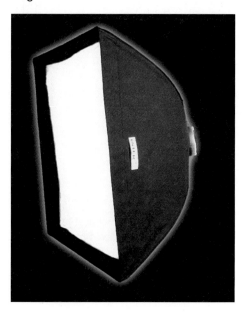

FIGURE 11.20

The Interfit Pro rectangular soft box from Interfit Photographic.

- **Umbrellas**. Shaped like a conventional rain umbrella, a lighting umbrella functions as a reflector for studio lighting, as you can see in Figure 11.21. Light is bounced off the inside of the umbrella onto the subject, resulting in a more diffused lighting effect. Different colored umbrellas are available, depending on how warm you want the reflected light.

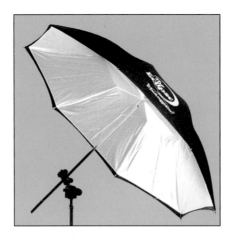

FIGURE 11.21

An Eclipse umbrella from Photogenic Professional Lighting.

- **Scrims**. These are translucent diffusion panels that are placed in front of the light source to soften the light. Scrims are typically attached to a frame support, often mounted on the same stand as the light itself. You control contrast by moving the scrim closer to or farther from the light source.

Some umbrellas are translucent, which lets you use them as diffusers as well as reflectors.

- **Barndoors**. These are hinged flaps that attach to the light's reflector, as shown in Figure 11.22, and are used to direct the light and control how wide or narrow an area the light covers.

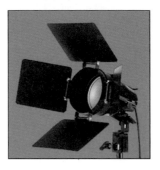

FIGURE 11.22

Four-panel barndoors from Smith-Victor.

- **Cones and snoots.** These devices attach to the reflector and serve to narrow the light symmetrically to produce a round patch of light.

- **Reflector cards.** In essence, this is a large card that serves to reflect light from the light source onto the subject or background, as shown in Figure 11.23. Reflector cards come in many shapes and sizes and are made from many different types of materials—cardboard, fabric, or metal. A reflector card is not attached to the light source, but positioned between the light and the subject to bounce the projected light.

FIGURE 11.23

The Chameleon Kit reflector card and stand from Photogenic Professional Lighting.

- **Gobos.** Derived from the phrase "go between," a gobo is a black card placed in front of the light source to block light. You use gobos to keep light from hitting a particular spot on the subject, or to cast a shadow on the background.

- **Gels.** This is a colored gelatin filter used to correct white balance, change the color of the background, or create dramatic lighting effects.

You use these accessories to gain more control over the lighting in your studio. You don't need all these accessories for each shot, but having several of them available lets you fine-tune the lighting of your studio photos.

If you have more than one person or object in the shot, you may need to light each item separately, with its own light or set of lights. Don't expect a single light to effectively light two different objects.

11

EMBRACING SHADOWS

I like shadows. The more dramatic, the better.

But then I'm a fan of black-and-white photography, which relies on shadow and contrast for effect. In fact, my favorite effect is the film noir look, with faces in heavy shadow—so heavy that half the face disappears into the dark background. That's what I get for watching too many black-and-white movies.

Deep shadows aren't just for black-and-white photography, however. You can also use heavy side lighting to create dramatic color portraits, as demonstrated in Figure 11.24. It's not quite the same effect as with black and white, but it's still striking.

FIGURE 11.24

Heavy shadows create a dramatic portrait.

Of course, shadows don't have to be this dramatic to be of use in your photographs. For example, compare a shot with direct front lighting with one using 45-degree lighting. The slight angle of the light puts enough shadow on the subject to bring out contour and texture. Without the shadow, the photo is flat and uninteresting; with the shadows, the subject looks three dimensional. It's the shadows that make the difference.

12

Color

U nless you're shooting in black and white, which is a totally different beast, color is an important part of any photograph. What colors you use and how you use them determine the look and feel of the photographic image; the right use of color can turn an average shot into a superior one.

Color is about more than just red, blue, and yellow, however; the type of lighting you use affects the way colors appear in your image. In this chapter we'll examine all these aspects of color, from simple color theory to determining the color temperature of your light source.

Understanding Color

Color is a part of light. Specifically, light at different wavelengths delivers different colors to your eyes. And all the wavelengths mixed together create the white light that we view as "normal" light.

The Color Spectrum

The wide array of colors that we use in photography results from the mix of just three primary colors—red, green, and blue (RGB). As you can see in Figure 12.1, when red and green light are mixed together, you get yellow; when green and blue light are mixed together, you get cyan; when blue and red light are mixed together, you get magenta; and when all three colors are mixed together, you get pure white light.

> Red, blue, and green are the primary colors of light, in what is called the *additive color* process used for transmissive light. Different primary colors are used when mixing inks for printing; in this *subtractive color* process used for reflected light, cyan, magenta, and yellow (CMY) are the three primaries, and when they're layered together you get black.

FIGURE 12.1
The additive properties of colored light.

All the possible colors that result from this mixing of the three primary colors create what we call the color spectrum, as shown in Figure 12.2.

FIGURE 12.2

The color spectrum.

The color spectrum breaks into three levels or orders of colors. The first level of colors are the three primary colors (red, green, and blue); these are pure colors not created through the mixing of any other colors. The three colors created from the direct mixing of the primary colors are called *secondary* colors and include magenta, yellow, and cyan. When you mix one primary color with one secondary color, you create one of the six *tertiary* colors—orange, chartreuse, spring green, azure, violet, and rose.

Primary Colors

You use the three primary colors to create the most colorful photographs. Of these colors, red is the hottest, blue is the coolest, and green is somewhere in between.

■ Red is an intense color, particularly so when placed against a dark background. As such, it should be used sparingly; a little red goes a long way. Red is used to convey a range of intense emotions, including passion, strength, energy, excitement, speed, sex, and power.

- Blue is a soothing color. It's the color of the sky and of the water, which derives its color by reflecting the blue of the sky. Blue is also somewhat retiring, and generally best used as a background rather than a foreground color. It is used to convey a range of less intense emotions, including peace, harmony, tranquility, and loyalty; it can also be used to convey coldness and depression.

- Green is a more versatile color than either red or blue. It's capable of a wide range of tonalities, as you can see from the variety of green displayed by earth's vegetation. As you might suspect, green is the dominant color in most landscape photographs. It is used to convey a mix of emotions, from nature and fertility to money and aggression.

Secondary Colors

Secondary colors provide more subtle coloring for your photographs. Of these colors, yellow is the brightest, violet is the coolest, and orange is in the warm middle.

- Yellow is a dominant color; it does not recede on the page. It screams for your attention, which is why it's frequently used in caution signs and the like. In spite of its harshness, however, it's a happy color; you don't use yellow when you're trying to convey a sad mood. Instead, yellow is typically used to convey joy, optimism, and idealism—as well as hazard, greed, and deceit.

- Orange is less dominant than yellow; in fact, it can be either dominant or receding in a scene. Its various shadings allow for a broad range of possible tonalities. Orange is often used to convey enthusiasm, playfulness, desire, and danger.

- Violet is one of the warmest of the cool colors and mixes well with both warm and cool colors. It is typically used to convey sensuality, spirituality, wealth, royalty, and nobility.

Tertiary Colors

As they exist "between" the six primary and secondary colors, the tertiary colors are used to provide subtlety in your compositions. They're weaker colors than the main colors, and thus better used in more understated ways. Use tertiary colors as backgrounds or to complement stronger colors.

Using Color for Composition and Mood

Knowing the qualities of the various colors helps you to better use those colors in your photographs. If you want to convey a cool and calming mood, for example, you know to use a cool and calming color, such as blue or deep green. If want to convey heat or passion, you know to use an intense color, such as red or bright yellow.

How colors relate to each other should also inform how you compose your photographs. Read on to learn more.

Contrasting Colors

Color is one way to achieve contrast in a photograph. And when you want the most contrast, go with two or more of the primary colors; pitting one primary color against another creates a significant contrast, no matter the size or shape of the colored objects.

Of course, there are other colors that contrast with each other. Look for those colors that are opposite each other in the color spectrum. Obviously, the three primaries are never adjacent, so they're good choices. But there are other color contrasts you can use to good effect, such as blue and orange, blue and yellow, red and green, and violet and yellow.

You can use contrasting colors to make a subject stand out from the background. For example, note how the red liquid in Figure 12.3 stands out from the blue background; that's the power of two primary colors contrasting with each other. Your eye is drawn to the more brightly colored object, which is highlighted by the color contrast.

Harmonizing Colors

Colors can also be used to complement objects in your photos. In this instance, you want to use *harmonizing* colors—those colors located adjacent to each other on the color spectrum. By using like colors, you create more of a singular mood, as you can see in Figure 12.4.

12

FIGURE 12.3

Achieve contrast with competing primary colors.

FIGURE 12.4

Harmonize your color composition with adjacent colors.

In addition to using adjacent colors, you can also use different shades of the same color. This type of monochromatic shot, like the one in Figure 12.5, works best when there are subtle color variations. In the best instances, monochromatic photographs impart a sense of quiet drama or tranquility.

FIGURE 12.5

Achieve a unified mood with subtle variations on a single color.

Expressing Mood with Color

When it comes to expressing mood, the colors you choose have a big effect. Different colors have a different psychological impact; for example, blues and green are somewhat calming, while reds and orange are more exciting. You can see what I mean in Figures 12.6 and 12.7; the first photo is soothing, while the second is much more passionate.

FIGURE 12.6

A photo with soothing blue colors.

FIGURE 12.7

A photo with more exciting tones.

The intensity of the color also affects mood. Figure 12.8, with its bright primary and secondary colors, is a more intense photo than the one in Figure 12.9, which uses more subtle pastels. The more intense the colors, the more intense the mood.

FIGURE 12.8

Bright colors create intensity.

FIGURE 12.9

Pastels are more soothing.

In short, use color as an important tool in your photographic toolbox. Whether to convey a mood or draw attention to the main subject, the choice of colors matters a great deal.

Different Lights, Different Whites

Another aspect of color that we've touched on throughout this book needs further illumination. (No pun intended.) That's the topic of the color of different types of lighting, and the goal of achieving the proper white balance.

Here's the reality. So-called "white light" isn't always white. The color of white varies from light source to light source. Some types of lighting produce a cooler (bluer) white; others produce a warmer (redder) white. And when the light itself is colored, it affects all the other colors in a photograph.

The color of white light is measured in terms of color temperature, which itself is measured in degrees Kelvin. In somewhat confusing fashion, the higher the color temperature the cooler the color, and the cooler the temperature the warmer the color. Figure 12.10 shows how this works. (As you can see, there's not even a single "daylight" color; the temperature of sunlight differs from one time of day to another.)

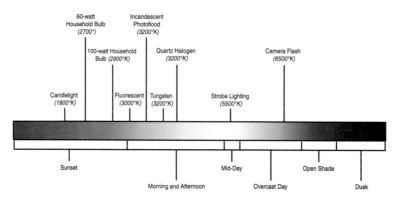

FIGURE 12.10

Comparison of different types of lighting.

More important than measuring color temperature is knowing how a shot will come out in various types of lighting. To that end, Figure 12.11 shows the same shot in different lighting conditions; as you can see, there's a wide variation as to the color of the light.

For reference, midday sunlight has a temperature of about 5500°K, while "golden hour" sunlight has a warmer 3500°K temperature.

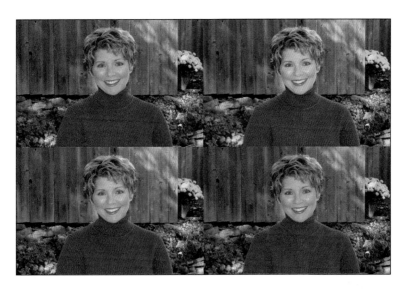

FIGURE 12.11

Same photograph, different lighting—clockwise from top left, normal midday daylight/tung-sten lighting, greenish fluorescent lighting, warm late afternoon sun, and cool camera flash.

While some color variations are more appealing than others, you don't have to live with these color differences. There are many ways to affect the color cast of different types of lighting and achieve a proper white balance.

As discussed in Chapter 4, "Operating a Point-and-Shoot Camera," and Chapter 5, "Operating a Digital SLR Camera," most digital cameras have a white balance or color compensation control. You may have the option of selecting a white balance for a particular type of lighting, or of directly setting a particular color temperature or temperature range. Even better, some digital SLRs (D-SLRs) and prosumer cameras let you present an exact white balance under any lighting condition, simply by aiming the camera at a neutral gray or white object. (Ideally, you aim at a white card.)

Optionally, you can use a color compensating or light balancing filter to white balance a shot. For example, to compensate for the greenish cast of fluorescent lighting, use a yellowish warming filter. To compensate for the orange tone of low-wattage incandescent lighting, use a bluish cooling filter. And so on.

Finally, you can always color correct a photograph after the fact in any photo editing program. Most of these programs,

In addition to the differences in color temperature, some types of lighting have peaks in certain spots of the color spectrum. For example, fluorescent light has a higher proportion of green light, which gives photographs a greenish tint.

such as Adobe Photoshop, let you adjust the overall tint of a photo to add or remove a color cast. Although I prefer white balancing in the camera, it's always good to have this method as a backup.

Learn more about color compensating filters in Chapter 9, "Using Filters."

COLOR BACKGROUNDS

In most instances, color is best used to accentuate objects in the foreground—that is, to make the main subject stand out from the background. To that end, the background color should not draw attention to itself; muted colors are better than brighter ones.

But that's a generalization, of course. There will always be instances where bright background colors add interest to a shot, or even help the foreground objects better pop from the background.

Figure 12.12 is one of those exceptions. I snapped this photo when I was on vacation with my two nephews in Memphis. We were walking down Beale Street, taking the normal touristy candids, when I spotted the brightly colored door and wall. I had two subjects, and the split-color background seemed ideal to highlight them both. The result is a shot made more interesting by its brightly colored background; without that background, it would be a fairly standard vacation pose.

FIGURE 12.12

Interesting background colors make an ordinary shot more memorable.

Exposure

*E*xposure is the total light reaching your digital camera's image sensor. If too much light reaches the sensor, the image is overexposed—too bright and washed out. If not enough light reaches the sensor, the image is underexposed—too dark and muddy.

You control exposure by means of your camera's aperture (f/stop) and shutter speed. To some degree, your camera's ISO setting (film speed equivalent) also impacts the exposure. Control all three of these settings, and you control not only the final exposure but also how that exposure is achieved.

But, I hear you. You're saying your camera has automatic exposure. Why do you need to concern yourself with all this? It's all a matter of how good you want your pictures to look—and whether and when you can trust your camera's automatic exposure system.

How Exposure Works

Exposure is a function of the luminance of the subject (the amount of light reflected off its surface), your camera's aperture setting, its shutter speed, and the ISO (film speed) setting. Change one of these items, and the others change in response.

Why Proper Exposure Is Important

Before we get into the nuts and bolts of creating an exposure, know that proper exposure is extremely important for quality photos.

Your photo needs to include as much information about the scene as possible; this information is recorded by the image sensor. As with most things, the devil is indeed in the details, in both the shadowed and highlighted areas of the photograph.

The challenge is capturing details in both the shadows and highlights. Make the photo bright enough to capture details in the shadows, and you lose detail in the highlights. Darken the photo to capture details in the highlights, and you lose detail in the shadows. There's a narrow range of exposure that captures detail in both the shadowed and highlighted areas; this is proper exposure for the photograph.

Of course, you can change some aspects of exposure after the fact in a photo editing program. Some, that is, but not all. If a picture is slightly underexposed (too dark), you can lighten it to some degree; likewise, if a picture is slightly overexposed (too light), you can darken it to some degree. However, you can't add back to the picture details that weren't captured by the image sensor. For example, if the original picture was underexposed to the point of shadows turning black, you can't add back in details that were lost in the black. The same goes for extreme overexposure; areas of the picture that blow out into white can't have lost details retrieved, because the details aren't there. In short, it's best to aim for the proper exposure in the camera than it is to try to fix it in a software program.

Understanding Overexposure and Underexposure

If proper exposure captures the detail in both shadowed and highlighted areas, what is *improper* exposure? Well, there are two types of improper exposure, on either side of the proper one, as you can see in Figure 13.1.

FIGURE 13.1

An image overexposed (top), properly exposed (middle), and underexposed (bottom).

Overexposure happens when too much light enters the camera and results in an image that is too bright. With a slight overexposure, colors become washed out, and light areas become too bright. With extreme overexposure, high-lighted areas turn to complete white, thus erasing the details of those areas.

Underexposure happens when not enough light enters the camera and results in an image that is too dark. With a slight underexposure, colors become muddy, and dark areas dim and lose contrast. With extreme underexposure, shadowed areas turn to complete black, thus losing details into the blackness.

Creating an Exposure

There are two primary ways to control the amount of light that hits your cam-era's image sensor—the size of the iris's aperture and the speed of the cam-era's shutter. (Film speed or ISO sensitivity affects the exposure by setting parameters for aperture and shutter speed, but doesn't change the amount of light that enters the camera.) Aperture and shutter speed are interrelated, of course; changing one changes the other.

For example, if you open the aperture wider to let more light into the camera, you have to use a faster shutter speed to hold the same exposure. Likewise, if you use a smaller aperture you have to use a slower shutter speed. Read on to learn why this is.

Understanding Aperture

After passing through the lens, light enters your camera through a small opening called an *iris* or *aperture*. The iris itself is of variable size, controlled by a ring of overlapping metal leaves. When the leaves close in, the aperture is narrowed; when the leaves open out, the aperture is widened.

The size of the aperture opening is measured in terms of *f/stops*. The smaller the f/number, the larger the aperture and the more light that enters the camera; the larger the f/number, the smaller the aperture and the less light that enters the camera , as illustrated in Figure 13.2.

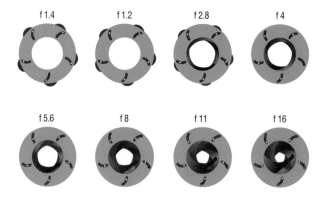

FIGURE 13.2

F/stops and apertures.

F/stops are sequenced in multiples of the square root of two: 1, 1.4, 2, 2.8, 4, 5.6, 8, 11, 16, and so on. Increasing the f/stop by one step halves the amount of light reaching the film; decreasing the f/stop by one step doubles the amount of light.

Understanding Shutter Speed

The second way to control the amount of light entering the camera is to regulate the length of time the aperture remains open. This is done by controlling the shutter speed—literally, the speed of the camera's shutter.

The f/stop is defined as a lens's focal length divided by the diameter of the aperture.

As you can see in Figure 13.3, the camera's shutter consists of an upper and lower curtain that open and close together. The shutter is closed by default; when you press your camera's shutter release button, the curtains slide apart to open the shutter. After the proper exposure time, the curtains slide shut again to close the shutter.

"Opening up" or increasing the aperture means admitting more light by reducing the f/stop. "Stopping down" or decreasing the aperture means admitting less light by increasing the f/stop.

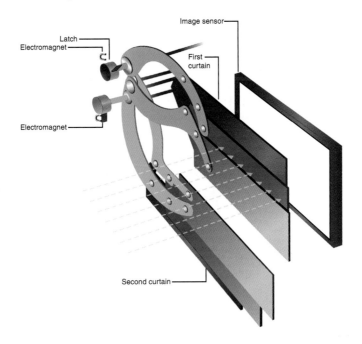

Latch
Electromagnet
Image sensor
First curtain
Electromagnet
Second curtain

FIGURE 13.3
How a shutter works.

The amount of time that the shutter stays open is measured in seconds or fractions of a second. The longer the shutter is open, the longer the exposure and the more light that enters the camera. The shorter the shutter is open, the shorter the exposure and the less light that enters the camera.

Shutter speed is sequenced in a 2:1 ratio, each setting twice that of the previous: 1/8000, 1/4000, 1/2000, 1/1000, 1/500, 1/250, 1/125, 1/60, 1/30, 1/15, 1/8, 1/4, 1/2, 1, 2, 4, and so on. Moving from 1/60 to 1/30, for example, doubles the time the shutter is open.

Speeds above 1/500 allow very little time to expose the picture, thus typically freezing the image, such as in a sports or action shot. Speeds that fast require high levels of light (or higher ISO settings.)

Speeds below 1/30 often result in blurry pictures, as the shutter is open so long that it's difficult to avoid shaking a handheld camera. When shooting at 1/30 or below, it's best to mount the camera on a tripod to avoid resultant blurry pictures.

This relationship between aperture and shutter speed is called the *Law of Reciprocity*.

This leaves the range of 1/60 to 1/250 as "normal" shutter speeds. Set your camera for speeds in this range and you'll stand a good chance of capturing a good-looking picture without blur or unwanted frozen movement.

Understanding the Relationship Between Aperture and Shutter Speed

If you're good with math, you may have noticed that both f/stops and shutter speeds are sequenced in a series of 2:1 ratios. Take the math to the next step and you discover that you can maintain the same amount of light entering the camera by halving one setting (either the f/stop or shutter speed) and doubling the other.

So, for example, a setting of f/11 at 1/60 lets the same amount of light into the camera as a setting of f/8 at 1/125. This second setting is one f/stop lower and one shutter speed higher than the original; move one setting in one direction and the other setting in the other by the same number of settings.

Understanding ISO Speed

The correct exposure for a photograph is also affected by the sensitivity of the image sensor. The more sensitive the sensor, the less exposure (less light) necessary; the less sensitive the sensor, the more exposure (more light) necessary.

In film cameras, the sensitivity of the film mattered, referred to as the *film speed*, as measured on a scale published by the International Organization for Standardization (ISO). Faster film (higher ISO) requires less exposure; slower film (lower ISO) requires more exposure.

Even though digital cameras don't use film, the digital camera industry has retained the ISO setting and applied it to the sensitivity of the camera's image sensor. Most digital cameras let you adjust the image sensor's sensitivity by dialing in different ISO settings—more appropriately called ISO equivalents.

The practical use of your camera's ISO setting is this: If you use a lower ISO setting, you need more light in your shot—that is, a higher exposure, affected by either a larger aperture (lower f/stop) or slower shutter speed, or both. If you use a higher ISO setting you don't need as much light in your shot—that is, a lower exposure, affected by either a smaller aperture (higher f/stop) or faster shutter speed, or both.

Calculating the Correct Exposure

As stated earlier, exposure is a result of aperture, shutter speed, ISO setting, and amount of light in the scene. If the scene is darker, you need to let more light into the camera by increasing the exposure. If the scene is lighter, you need to let less light into the camera by decreasing the exposure. Because exposure is controlled by aperture, shutter speed, and ISO setting, there are many ways to deal with any specific lighting situation.

When in doubt, you can always fall back on the *Sunny 16 Rule*. For the approximately correct exposure on a sunny day, use an aperture of f/16, a shutter speed of 1/100 (or the closest speed on today's cameras, which is 1/125), and an ISO setting of 100.

All of which means that there is no such thing as a single "correct" exposure. Any given scene can be exposed in any number of ways, using the controls available to you. And, if you want, you can even choose to underexpose or overexpose a shot to let in more or less light than you might do otherwise.

You measure exposure by means of *exposure value* (EV), which denotes all the combinations of aperture and shutter speed that give you the same exposure. A value of 1 EV corresponds to the difference of one f/stop.

Figure 13.4 shows a table of EV values, with corresponding aperture (f/stop) and shutter speed settings. Any combination of aperture and shutter speed that meets on the yellow line is a normal exposure value; any combination that meets on the blue line is an exposure calculated for larger depth of field; any combination that meets on the green line is an exposure calculated for a faster shutter speed.

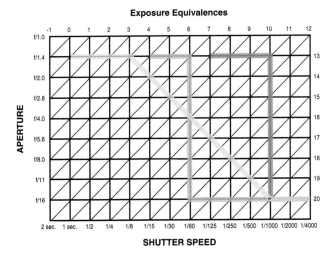

FIGURE 13.4

Calculating exposure value (EV).

Your camera's automatic exposure system will try to use a given range of settings for any given lighting situation. In Figure 13.4, the yellow line represents the range of EV settings used for an "average" photograph, where neither aperture nor shutter

Your camera's light meter doesn't measure color, only how dark or light a scene is.

speed has priority. The blue line represents the EV settings used when aperture priority is selected to achieve a greater depth of field. The green line represents the EV settings used when shutter priority is selected to freeze the frame in action shots.

Understanding Automatic Exposure

As you can see, calculating exposure can be a tricky business. This is why all digital cameras include some sort of automatic exposure system, to do the figuring for you. The camera measures the available light and then sets the correct shutter speed and aperture to obtain a proper exposure.

How Automatic Exposure Systems Work

All automatic exposure systems work by using a built-in light meter. This light meter is similar to the handheld meters used by professional photographers; it measures the intensity of light reflected from the objects in your shot.

Note that I said objects, plural. Each object in the scene reflects light differently; some objects are lighter, and some are darker. Your camera's light meter records the light from all objects and calculates an average brightness level. Thus if you have one black object and one white one, the light meter records the scene as medium gray.

In fact, most automatic exposure systems strive for a medium gray light reading. If the scene is brighter than medium gray, the auto exposure system uses a lower exposure to darken it; if the scene is darker than medium gray, the auto exposure system uses a higher exposure to lighten it.

Different cameras include different types of light meters. Some built-in light meters offer multiple types of metering, typically selected from the camera's LCD menu system. The most popular of these metering systems include the following:

Matrix. Divides the image area into a grid and compares the measurements against a library of typical compositions to select the most likely exposure.

Medium gray is typically defined as 18% gray. That is, it reflects 18% of the light that falls on it.

- **Center-weighted.** Measures the entire scene but assigns the most importance to the center part of the frame, where the most important objects are typically located.

- **Bottom-weighted.** Measures the entire scene but assigns the most importance to the bottom part of the frame.

- **Spot.** Measures only that part of the scene within a small area in the middle of the frame. This lets you meter a specific part of the scene only, instead of relying on an average reading.

For most shots, matrix metering or center-weighted metering is best. If you're shooting an extremely dark subject against an extremely bright background, however (or vice versa), spot metering might provide better results.

Automatic Versus Manual Exposure: When to Use Each

Most of the time these automatic metering systems work fine; the average brightness level, however measured, exposes both the dark and light areas adequately. However, the average brightness level of some scenes can be confusing to the light meter, especially when extreme dark or light objects are in the scene. In these situations, you have to manually adjust the exposure to lighten or darken the picture as necessary.

When might the automatic exposure system *not* provide acceptable results? Here's a short list of problematic shots:

- **Scenes lighter than medium gray.** The automatic exposure system is designed to achieve a medium gray (18%) reading. If the scene is lighter than that—that is, if it reflects more than 18% of the light falling on it—the auto exposure system thinks the scene shouldn't look that bright and produces an image that's too dark. Examples include beach scenes, or shots with bright sand or snow. In these scenes, you want to manually increase the exposure.

- **Scenes darker than medium gray.** The opposite happens when you have a naturally dark scene, one that reflects less than 18% of the light falling on it. The auto exposure system thinks the scene shouldn't look that dark and produces an image that's too light. Examples include scenes in dark rooms, outdoors in the woods, or with really dark subjects. In these scenes, you want to manually decrease the exposure.

- **Main subject against very light background.** In this situation, the brightness of the background confuses the auto exposure system into thinking the scene is too light; the camera decreases the exposure and thus underexposes the subject. In these scenes, you want to manually increase the exposure.

- **Main subject against very dark background.** This is the opposite of the previous situation, where the darkness of the background confuses the auto exposure system into the thinking the scene is too dark; the camera increases the exposure and thus overexposes the subject. In these scenes, you want to manually decrease the exposure.

- **Scenes with high contrast.** When a scene has extremely dark darks and extremely bright brights, an average reading doesn't do either area justice. In this situation, you have to decide which is most important, the shadows or the highlights, and expose for that area.

- **Scenes with unusual lighting.** Light meters don't work well when the light is unusual. For example, night scenes with neon street signs or fireworks are pretty much impossible to meter; the small amount of often transitory light doesn't play to the meter's strengths. In these situations, it's probably best to experiment with different exposures, and see which one works best.

- **Special effects.** Then there are those shots that you don't want to look "normal." Different moods require different types of lighting; maybe you want a particular shot to be over- or underexposed. In these situations you'll need to switch off the automatic exposure system to manually achieve the effect you want.

Mastering Manual Exposure

Casual photographers tend to rely on the automatic exposure system for most of their shots. More serious photographers, however, prefer to manually control exposure, the better to both deal with tricky lighting and achieve interesting effects.

How you control exposure varies from camera to camera, however. Some point-and-shoot cameras offer no manual exposure control; others offer simple exposure compensation, which lets you increase or decrease the exposure by a stop or two; still others offer preset exposure adjustments in the form of automatic scene settings. In the prosumer and digital SLR (D-SLR) camera world, you may have any or all of these simple settings, as well as the ability to set

If you're calculating a manual exposure, it helps to know the light in different parts of the scene. This can be done with a handheld light meter, such as those discussed in Chapter 6, "Choosing Camera Accessories," or with the through-the-lens (TTL) spot metering systems offered by many of today's digital cameras. To use TTL spot metering, press the shutter release button half-way and observe the f/stop and shutter speed shown on your camera's display; focusing on lighter or darker parts of the image will result in different exposure settings.

exposure via aperture priority or shutter
priority, or by adjusting both aperture and
shutter separately. Read on to learn about
each method.

Learn more about pre-
programmed scene set-
tings in Chapter 4,
"Operating a Point-and-Shoot
Camera."

Using Preprogrammed Scene Settings

For many photographers, especially those with automatic point-and-shoot
cameras, an even easier way to adjust exposure is to use preprogrammed
scene settings. These settings include preset combinations of aperture and
shutter speed (and, in some instances, ISO speed) that work best for specific
types of shots. For example, the action or sports setting uses a fast shutter
speed to freeze fast action; the night setting uses a wider aperture and slower
shutter speed to let in all available light in night shots. It's not a totally flexi-
ble solution, but it's better than nothing.

Using Exposure Compensation

A better option for many photographers is to use exposure compensation. This
control, found on many point-and-shoot and prosumer cameras, lets you
lighten or darken the photograph as necessary. You don't have manual control
over aperture or shutter speed separately; the camera adjusts both of these set-
tings to increase or decrease the overall exposure.

The amount you increase or decrease the exposure is specified in the number of
stops. Selecting a value of +1 exposure compensation, for example, increases the
exposure one stop. (This is accomplished by either opening the aperture or slow-
ing down the shutter speed, whichever the camera thinks will work best.) Most
cameras let you go up or down two full stops, in one-third stop increments.

In general, you increase the exposure (+ settings) when the subject is bright
and decrease the exposure (- settings) when the subject is darker. Table 13.1
details some common exposure compensation settings.

Table 13.1 Exposure Compensation Settings

Exposure Compensation Value	Typical Uses
-2	Scenes with large areas of dark background
-1	Scenes where the background is much darker than the subject; also good for very dark subjects
0	Default setting; best for scenes that are evenly lit and without extreme foreground/ background contrast
+1	Scenes that are heavily side lit or backlit, scenes with bright backgrounds (snow or sand), scenes with a bright light source (sunsets or sunrises), and scenes with very light objects
+2	Scenes with brightly lit areas and shadowed areas much darker than the background

Using Aperture Priority

All D-SLR cameras, most prosumer cameras, and some higher-end point-and-shoot cameras let you adjust aperture and shutter speed manually. While you can adjust each separately, an easier approach is to adjust just one of these settings and let the camera calculate the other setting automatically.

Aperture priority is when you set the aperture yourself and let the camera set the shutter speed. In other words, you determine the f/stop for the shot, and the camera sets the corresponding shutter speed.

The primary benefit of using aperture priority mode is to control the depth of field of the photograph. As we'll discuss later in this chapter, the smaller the aperture (the higher the f/stop), the greater the depth of field—the more of the scene that stays in focus. Set a larger aperture (lower f/stop), and you get a smaller depth of field, with the main subject in focus and the background out of focus.

Controlling depth of field is desirable when you're shooting portraits, product shots, and other scenes where you have a main subject you want to keep separate from the background. In these instances, you want to dial in a lower f/stop setting to blur the background and focus exclusively on the main subject. Otherwise, dial in a higher f/stop setting to keep the entire scene in focus.

Using Shutter Priority

Shutter priority is when you set the shutter speed yourself and let the camera set the aperture. You use shutter priority mode in one of two scenarios—in low-light conditions and when shooting fast-moving action.

In the case of shooting in extreme low-light conditions, you're likely to end up with an underexposed shot if you use the camera's automatic exposure mode; there's only so much light the auto exposure system lets into the camera on its own. So when the light is super low, override the manual system by manually setting a lower shutter speed. (Of course, you'll want to steady the camera on a tripod when shooting at so slow a shutter speed; otherwise, you'll get camera movement and blurry results.)

The situation is just the opposite when you want to freeze an action shot. To avoid blurring any moving subjects, manually select a fast shutter speed.

Setting Both Aperture and Shutter Speed

Most higher-end cameras also let you bypass the priority modes and instead set both aperture and shutter speed manually. You use the total manual setting when you want to deliberately under- or overexpose a shot.

For example, if you're shooting an expanse of snow on a sunny day, any of your camera's automatic or semiautomatic modes is likely to result in underexposure; the expanse of bright white throws off all the settings. The solution is to manually set a small aperture (high f/stop) and fast shutter—a combination that your camera won't make automatically.

Likewise, if you're trying to capture moving lights at night; the automatic and semiautomatic modes tend to overexpose the shot, overbrightening the dark areas. The solution is to manually set a large aperture (low f/stop) and slow shutter—another combination that your camera won't normally make.

> When using manual exposure controls, most professional photographers learn to *bracket* their shots. That is, they calculate what appears to be the right exposure but then shoot three shots—at the desired exposure, at one f/stop larger, and at one f/stop smaller. This way if their calculations were off a little, one of the shots that bracketed that exposure will probably be spot on.

Exposure Techniques

We've talked a lot about exposure in this chapter, but haven't shown a lot of examples. That's because the goal, in most instances, is a properly exposed shot—and most of the examples elsewhere in this book are properly exposed.

That said, you can achieve some interesting effects by playing around with your camera's aperture and shutter settings—that is, by deliberately over- or underexposing the shot. Let's look at a few examples.

Overexposing for Effect

The primary reason to overexpose a shot is to brighten what would otherwise be a too-dark subject. It's a good approach only when you don't care about blowing out the background details by making them too bright.

For example, if you have a shot where the main subject is in shadow with a lighter background, you can overexpose the shot to lighten the shadows. The background gets blown out, of course, but you don't care about the background; you only care about making the main subject visible.

Overexposure can also be used artistically to create a dreamy, impressionistic effect, as demonstrated with Figure 13.5. This photo of flowers against a light background was overexposed to the extent that the edges of the flowers blur, colors leading into the light soften, and the normal background fades into white. It looks as if the flowers are enveloped by light.

FIGURE 13.5

A dreamlike effect caused by overexposing a group of flowers against a light background.

The technique to create this type of shot is simple. Properly expose the darker areas of the shot, thus overexposing the background and remaining areas.

Underexposing for Effect

Underexposure works when you want to silhouette an object against a brighter background. A normal exposure would blow out the background and keep the subject light enough to see detail; by underexposing, the background gains detail, colors become richer, and the foreground subject darkens for effect.

Figure 13.6 shows just this effect. Normally exposed, the boy in the foreground was fully visible, and the ocean in the background was washed out. By underexposing the shot, dramatic shadows fill in the foreground subject, while the ocean in the background gains deep color and detail.

Even more dramatic is the underexposed shot in Figure 13.7. By dialing down the exposure, this shot silhouettes the docks and the boats in the foreground against the setting sun; at normal exposure, the sun would have been too bright, the colors would have washed out, and the subjects' details would have been visible to distraction. By underexposing the shot, the details fade into black, the colors get richer, and the sunset appears just right.

FIGURE 13.6

A pensive shot made more dramatic via underexposure.

FIGURE 13.7

A sunset shot underexposed to create striking silhouettes.

Manipulating Shutter Speed for Effect

Another thing you can do with manual exposure controls is manipulate the shutter speed to either freeze or blur objects in motion. This is well illustrated by shooting the moving water in a waterfall. When you choose a faster shutter speed, as in Figure 13.8, the water freezes in midair; the shot is full of spray and bubbles forever fixed in place. When you choose a slower shutter speed, as in Figure 13.9, the water blurs to impart a real sense of the flowing water.

FIGURE 13.8

A waterfall frozen with a fast shutter speed.

FIGURE 13.9

A waterfall blurred with a slow shutter speed.

Manipulating Exposure for Depth of Field

The final effect you can achieve by manu-
ally manipulating exposure is depth of
field. We'll talk about this more in Chapter
14, "Focus and Depth of Field"; for now,
know that you use the aperture setting to
control how much of the shot is in focus.

Depth of field can be confusing. Just remember this: Set a small f/stop for small depth of field, or a high f/stop for large depth of field.

For a deep-focus shot, set a small aperture (high f/stop); this lets in light from
both the foreground and the background to keep both in focus. For a shot
with selective focus, set a large aperture (low f/stop); this lets in light primarily
from the foreground, thus blurring the background of the shot.

EXPOSING WITH THE ZONE SYSTEM

I love the photography of Ansel Adams. His black-and-white land-
scapes reproduce a range of tonal values that must be seen to be
believed. He captured subtle changes of tone and light via a complete
mastery of exposure.

The secret to Adams's wide-tonality photographs is the Zone System,
which he formulated (along with fellow photographer Fred Archer) in
1941. The Zone System is based on an 11-segment chart of tonal values,
as shown in Figure 13.10, that ranges in value from pure black to pure
white. Zone 5, in the middle, is the equivalent of medium gray (18%).

Zone	% black	RGB
0	100%	0
1	90%	30
2	80%	55
3	70%	80
4	60%	105
5	50%	128
6	40%	155
7	30%	180
8	20%	205
9	10%	230
10	0%	256

FIGURE 13.10
Zone values.

Continues...

The Zone System, if used correctly, requires a considerable amount of planning for each shot. To use the Zone System, start by visualizing the scene in shades of black and white. Use a light meter to read the value of each target area in the frame and assign each area its own value, as shown in Figure 13.11.

FIGURE 13.11

Assigning zone values to a color scene.

Now select an area of the photograph that you want to place at a specific zone value, and then adjust the exposure by the difference between the metered value and zone 5. For example, if you want to place a particular area as zone 7, you increase the shot's exposure by 2 f/stops (zone 7 minus zone 5).

A full discussion of the Zone System can fill a book of its own—and has. To learn more about the Zone System, I recommend reading *The Practical Zone System: For Film and Digital Photography* (Chris Johnson, Focal Press, fourth edition, 2006). And to learn more about Ansel Adams, which I encourage you to do, visit the Ansel Adams Gallery online (www.anseladams.com). His work is truly astounding and an inspiration to any serious photographer.

Focus and Depth of Field

S ome of my potentially best photographs have been ruined by focus problems. Either I focused on the wrong object or my camera did; whatever the cause, the effect is an out-of-focus or poorly focused shot, which is one of the few types of bad photographs you can't fix in Photoshop.

Achieving proper focus involves more than just pointing at a subject and relying on your camera's auto focus system. It's also about choosing the right object on which to focus—which isn't always as simple as you might think.

Deciding on What to Focus

When you're photographing a single subject against a neutral background, your choice of focus is simple—you focus on the main subject. But what do you do when two or more subjects are in the shot? Or, even worse, when you're shooting some sort of geometric pattern with no clear focal point?

Focusing on Multiple Subjects

Consider a situation where you have one object positioned close to the camera and a second object positioned farther away. Which object should be the focal point of the shot?

Some digital camera manufacturers are now incorporating face recognition technology into their auto focus systems. This technology looks for faces in the frame and makes them the focal point of the picture.

Figure 14.1 shows the most common approach, with the object closest to the camera in sharp focus and the other object not. That's fine—if that object is the main subject. But what if it's not?

An alternative approach is shown in Figure 14.2. In this shot, the object farthest from the camera is the one in focus. It's a different approach, and one that the eye might not immediately accept, but the use of selective focus eventually tells the viewer that the object in the distance is the most important object.

Yet another alternative is to keep *both* objects in focus, as shown in Figure 14.3. This sort of deep focus (otherwise known as a large depth of focus) puts attention on both objects and makes the viewer decide which is the most important.

Which of these approaches should you adopt? That's up to you—there's no single "right" approach. Decide which object is the most important, and put the focus there. If the objects are of equal importance, expand the depth of field to put both objects in equal focus.

Focusing on Foreground or Background Patterns

Sometimes it's unclear where the focus should be in the frame. This is more often a problem when you're shooting patterns that form some sort of geometric pattern, or when shooting *through* one object to another.

FIGURE 14.1

Focusing on the object nearest to the camera.

FIGURE 14.2

Focusing on the object farthest from the camera.

14

FIGURE 14.3

Focusing on both objects equally with deep focus.

For example, let's say you have a shot of an iron fence with a building behind it. Figure 14.4 shows one option, focusing on the building, so that the fence goes out of focus. Figure 14.5 shows the other option, focusing on the fence in the foreground, with the building blurring in the background.

FIGURE 14.4
Focusing through the fence on the building in the background.

FIGURE 14.5
Focusing on the fence in the foreground, with the building in the background blurred.

Again, whether you focus on the foreground or background is your artistic choice. But you will need to manipulate your camera to achieve the desired focus—which we discuss in the following sections.

Working with Auto Focus Systems

All this discussion of what to focus on might seem academic to some readers. After all, you may be thinking, my camera has an automatic focus system; it does the focusing for me.

That's true—to a point. All digital cameras use some sort of automatic focus system, which means you shouldn't have to do much to focus the shot. The operative word here is "shouldn't"; in reality, you need to know a lot about how your camera handles focus.

How Auto Focus Works

First, it's important to know how your camera's auto focus system works. Most auto focus systems work by shooting out a beam of infrared light. When the beam of light hits the closest object, it bounces back to a sensor in the camera. The camera's auto focus system then adjusts the lens to focus on this object, using the reflected light to calculate the correct distance to the object.

Auto focus in some prosumer and digital SLR (D-SLR) cameras is slightly more sophisticated, in that the system can focus on more than one point in the frame. That is, you can set the camera to focus on a part of the frame—the center, or bottom right, or top left, or whatever. Your camera might have seven or nine different auto focus "zones" you can select. This lets you direct the focus to those objects located in a particular position. For example, if your subject is standing in the lower right of the frame, select that zone for auto focus; thus selected, your camera won't try to focus on objects in other parts of the frame.

To activate auto focus, aim your camera at an object and slightly depress and hold the shutter release button. You'll hear the camera make a slight whirring noise; this is the lens focusing on the target object. After the object is in focus, you can further depress the shutter button to take the shot.

"Tricking" Your Auto Focus System with Focus Lock

Most auto focus systems work by automatically focusing on the object nearest the camera, or the nearest object in a particular part of the frame. This is great, unless the thing you want to focus on isn't the nearest object.

14

For example, a subject standing to the side of the frame may not be hit with the infrared beam; the camera may instead focus on the wall behind the subject, as shown in Figure 14.6. Likewise, if the main subject is positioned slightly past a larger object, such as a post or column, the camera may focus on the post or column and put the subject out of focus.

Fortunately, there's a way to "trick" your camera's auto focus system into focusing on what you want it to focus on. The workaround is called *focus lock* or *focal lock*, and it works by letting you prefocus on a given object, locking that focus as you continue to compose and shoot your photo—even if the object is no longer front and center in the frame, as shown in Figure 14.7.

To use focus lock on most digital cameras, start by posing your subject—but don't compose the final shot just yet. Instead, aim your camera at the person or object that you want to be in focus; put that person or object temporarily in the center of the frame.

Now depress the shutter button halfway and hold it there. This activates the focus lock and tells the camera to focus on the person or object in the center of the frame. With the shutter button still half-depressed, go ahead and move the camera to compose the image as you want to shoot it; the main subject can be positioned off-center if you choose, as it retains its original focus.

When the shot is composed as you like, fully press the shutter button to take the shot. The subject you initially focused on will remain in focus for the final shot.

Other Uses of Focus Lock

Focus lock is useful when you're shooting action or sports shots, where you might not otherwise have time to properly focus the camera. What you want to do is find an object approximately the same distance from the camera as the subject you intend to photograph. Lock the focus on this substitute object, and then move your camera back to frame the ongoing action. When the subject is in the right position for the shot, fully depress the shutter release button. The focus will hold from the object you initially focused on, thus properly focusing the moving subject.

 Some digital cameras lock the exposure at the same time they lock the focus. Be careful when shooting in tricky lighting, because the first object you focus on defines the exposure for the final shot.

FIGURE 14.6

A subject not properly captured by the camera's auto focus system.

FIGURE 14.7

The same subject properly focused, thanks to focus lock.

For example, let's say you're photographing the action at an auto race. The cars come down the track too fast for you to properly focus, so what do you do? The answer is focus lock, of course. Find an object the same distance away as the cars (or close; it's okay to focus on the track itself at that point), activate the focus lock, and wait for the cars to come around again. When you snap the shot, the focus is already where it should be.

Manually Focusing Your Camera

Of course, a better approach might be to simply focus the camera yourself. This is especially useful if the scene is complex enough that the auto focus system can't find a focal point, or if the subject is too close to the camera to activate the auto focus system.

If your camera features a manual focus ring on the lens (or if your D-SLR lens has a manual focus ring), all you have to is move your camera into manual focus mode (typically via an Auto/Manual focus switch somewhere on the body) and turn the focus ring until the shot is in focus. Other cameras have focus "in" and "out" buttons that accomplish the same task.

Controlling Depth of Field

Here's a challenge. You have multiple people grouped candidly together. They're all important, so you want them all in focus in the shot. What you want is a deep focus, as illustrated in Figure 14.8, where the focus is equally sharp for the foreground and background of the frame.

Another challenge: You want all the attention on a single subject, not on the background or other objects in the frame. In fact, if the other objects were in focus, they might distract from the subject. What you want for this shot is a selective focus, as illustrated in Figure 14.9.

How much of the shot is in focus is called *depth of field* or *depth of focus*. A shallow depth of field provides a selective focus, with just part of the shot in focus and the rest out of focus or blurred. A large depth of field keeps all of the shot in focus, foreground and background equally.

Some cameras don't include manual focus capabilities; others do. As a general rule, the more expensive the camera, the more likely it is to offer manual focusing. (Expect manual focus on most prosumer and D-SLR cameras.)

FIGURE 14.8

A group shot with all subjects in equal focus, thanks to a large depth of field.

FIGURE 14.9

A subject isolated from the background via a shallow depth of field.

The depth of field is a function of the size of the aperture. The larger the aperture, the shallower the depth of field; the smaller the aperture, the deeper the focus.

 Learn more about aperture settings in Chapter 13, "Exposure."

It's this simple:

- For a large depth of field (both foreground and background in focus), use a small aperture (higher f/stop number).
- For a shallow depth of field (only the foreground in focus), use a large aperture (lower f/stop number).

In other words, step up the f/stop to a higher number to keep all objects in focus, or step down the f/stop to a lower number to focus only on a single object. Naturally, you'll need to experiment with different aperture settings to achieve precisely the effect you want.

WHY YOU CAN'T FIX FOCUS IN PHOTOSHOP

Most photographers today have become accustomed to fixing their mistakes after the fact, using Photoshop or some similar photo editing program. "Don't worry about it," I often hear, "I can fix it in Photoshop."

Except that you can't always do that. In particular, problems with focus are almost impossible to fix in the digital darkroom.

How might you try to fix an out-of-focus picture? The most common approach is to use the program's "sharpening" controls. Unfortunately, sharpening a picture only increases the contrast between sharp edges. With a blurry pictures, there are no hard edges to sharpen; all you do is make the blurriness more pronounced.

No, there's no fix for out-of-focus pictures, which means there's no substitute for achieving proper focus in the camera. You have to learn how to manipulate your camera's auto focus system—and learn when not to trust that it will deliver the right results. And, if your camera so allows, you also need to learn that ancient art of manual focusing. Sometimes there's no better way than to do it yourself.

14

Transferring and Managing Photos

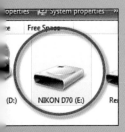

Storing and Managing Photos on Your PC

You've absorbed the techniques presented so far in this book and taken what you think are some promising pictures. Now those photos are stored on your digital camera's memory card. How do you transfer the photos from your camera to your computer—and, once transferred, how do you manage all the photos you've taken?

The answers to these questions involve photo transfer, storage, and management—which is what we discuss in this chapter.

Transferring Photos from Your Camera to Your PC

There are several different ways to get your photos from your digital camera to your computer. Which method you use depends on the equipment you have and how you want to go about it.

Transferring via USB Cable

The most common way to transfer photos from your camera to your PC is to simply connect your camera to your computer, using the USB cable that came with your camera. (If your camera didn't come with such a cable, you can purchase one at your local camera or electronics store.) This cable, like the one shown in Figure 15.1, has a mini USB connector on the camera end and a regular USB connector on the end that connects to your PC. You probably have to turn on your camera to make the transfer, and perhaps enable the camera's picture transfer mode.

FIGURE 15.1

Use a USB cable to connect your digital camera to a personal computer.

When you connect a USB cable between your camera and your PC, one of several things is likely to happen:

- If your computer is running the Windows Vista operating system, it should recognize when your camera is connected and automatically download the pictures in your camera, while displaying a dialog box that notifies you of what it's doing.

- If your computer is running Windows XP, connecting your camera may open the Removable Disk dialog box. Select Copy Pictures to a Folder on My Computer Using

> Some digital cameras use a FireWire cable instead of a USB cable to connect to your PC. Connect this cable in the same fashion, except to your computer's FireWire (IEEE1394) port.

Microsoft Scanner and Camera Wizard, and you'll launch the Scanner and Camera Wizard. Use this wizard to select which photos you want to download and tell Windows where to save them. (Alternately, select the Open Folder to View Files Using Windows Explorer option to copy the files manually.)

- If your computer is an Apple Macintosh, connecting your camera may launch the iPhoto program, in import mode. Select your camera from the Source list, enter a name and description for the group of photos you're importing, and then click the Import button.

- A Mac might also display your newly connected camera on the desktop, as an external drive. If so, open the camera icon as you would an external hard drive, and then copy the photos to your Mac.

- If you've installed a proprietary picture management program that comes with your digital camera, it may launch when you connect your camera and ask to download your camera's pictures. Follow the onscreen instructions to proceed.

- If you've installed a third-party photo editing program, such as Adobe Photoshop, it may launch and ask to download the pictures from your camera. Follow the onscreen instructions to proceed.

- If nothing happens when you connect your camera, use My Computer (Windows XP), Computer Explorer (Windows Vista), or the Mac Finder to locate the icon for your camera; it should appear as if it's another disk drive on your computer. Double-click this icon to view the current contents of your camera and to copy files from your camera to a location on your computer's hard drive.

In essence, all the photos on your camera are individual files (typically stored in the DCIM subfolder) and can thus be copied in the same way you copy other computer files. When you're done copying the files to your computer's hard drive, you can then delete those files from your digital camera.

Transferring via Memory Card Reader

Connecting a camera to your computer is easy enough, but you do have to deal with that darned cable. For many users, an easier approach is to transfer photos using your camera's memory card.

With this method, you remove the memory card from your camera and then insert it into a memory card reader. Your computer may have a memory card reader built-in, or you can always connect an external memory card reader. Several manufacturers make low-cost ($10-$20) memory card readers that connect to your computer via USB.

15

When you insert the memory card into the memory card reader, your computer recognizes the card as if it were another hard disk. You can then use Computer Explorer (in Windows Vista), My Computer (in Windows XP), or the Mac Finder (on an Apple computer) to copy files from the memory card to your computer.

Learn more about memory card readers, also known as media readers, in Chapter 2, "The Digital Darkroom."

For example, if you're using Windows Vista, open the Start menu, select Computer, and then double-click the drive icon for the memory card, as shown in Figure 15.2. When you open this icon you see the card's contents, typically in a subfolder labeled DCIM. You can then move, copy, and delete the photos stored on the card, as you would with any other type of file on your computer.

Some newer cameras are coming with wireless connectivity built in, either via Bluetooth or WiFi. If your camera offers this functionality, you can transfer photo files to your computer without using a cable or card reader.

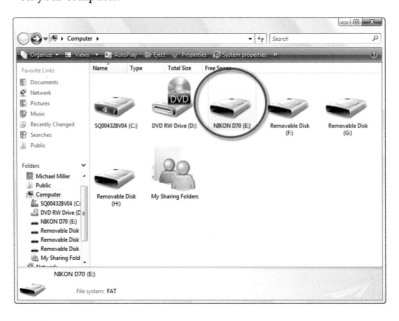

FIGURE 15.2

Viewing a digital camera's memory card as another drive in Vista's Computer Explorer.

Storing and Managing Photos on Your PC

After you've transferred digital photos from your camera to your computer, you have a lot of options. A digital picture file is just like any computer file, which means that you can copy it, move it, delete it, or whatever. You can also use special photo organizer software to better organize your photos, or photo editing programs to touch up or edit your photos.

Where Your Photos Are Stored

You may be wondering just where your photos are stored after they've been downloaded from your digital camera. It all depends on which operating system you're using:

- **Windows Vista.** By default, Windows Vista stores all your pictures in the Pictures folder, which is located along the path c:\Users*username*\Pictures.

- **Windows XP.** In Windows XP, your pictures are stored by default in the My Pictures folder, which is located along the path c:\Documents and Settings*username*\My Documents\My Pictures.

- **Mac OS.** On Apple computers, your photos are automatically stored in the Pictures folder—although you can store photos in any folder of your choosing, even folders on your desktop.

If you're using a photo downloading program, your photos may be stored in a subfolder within the Pictures or My Pictures folder. For example, Adobe Photoshop and Photoshop Elements create an Adobe subfolder within the Pictures or My Pictures folder, then a Digital Camera Photos subfolders within that, and then additional subfolders within that one, labeled by date.

Organizing Your Photos

If you only have a few hundred photos, it may be okay to just dump them in the Pictures/My Pictures folder. However, if you have several thousand photos, this sort of disorganized batch approach is somewhat unwieldy; it makes it difficult to find any particular photo.

A better approach is to organize your photos by some criteria. I like to organize my photos by occasion—vacations, special events, and the like. Other users prefer to organize by year, month, or even date. The key is to create subfolders within the Pictures/My Pictures folder and place your

If you can't find the photos on your computer's hard drive, you can use your operating system's search function (or the search function in the Google Desktop software) to locate them for you.

photos in those subfolders, using the appropriate criteria.

You can also use a photo organizer program to help you organize your photos. Many such programs are available, such as Adobe Photoshop Album, Picasa, and PicaJet; in addition, many photo editing programs also offer photo organization features. These programs let you organize your photos by various criteria, including date taken, subject, size, and the like, and are easy to use.

Learn more about photo organization programs in Chapter 17, "Choosing Photo Editing Software."

Archiving Your Photos

Your digital photos are your family's memories. To this end, you want to protect these memories by backing up or archiving your photos regularly. This way you'll have a backup copy of any photo, in case it gets lost or deleted.

There are many ways to do this, including the following:

- **Archive to external hard drive.** This is my preferred method. External hard drives are relatively low cost these days (under $100) and connect easily to any computer via USB or FireWire. Simply connect the external drive to your computer and then copy all your digital photo files to the external drive. Make sure you purchase a drive large enough to hold all your current and anticipated future photos.

- **Archive to CD or DVD.** With this approach, you copy all the photos for a particular time frame to a specific data CD or DVD. If you do so yearly, for example, you end up with a library of archive CDs or DVDs, one for each year of photo taking. (A blank DVD can hold up to 4.7GB of pictures; a blank CD can only hold 700MB.)

- **Archive to online photo storage service.** Another approach is to archive your photos offsite, using an online photo storage service. Most of these services offer large volumes of storage, either free or for a reasonable cost. (You may get some storage free but have to pay for additional capacity.) The advantage of this approach is that your photos are safe if your house happens to burn down or get flooded, circumstances that might destroy hard drive or CD/DVD backups.

However you decide to archive your photos, you should do so at regular periods of time. Some people like to archive once a year, but that's not frequently enough for me. A

If you edit your digital photos, I recommend storing a copy of each original, pre-edited file. This way you can always return to the original file if you need to re-edit the photo at a future date—you won't be forced to edit an already-edited photo.

monthly backup is probably good enough for
most folks, although you should do a manual
back up anytime you transfer a large number
of photos from your camera to your PC.

Learn more about online
photo services in Chapter
30, "Sharing Photos Online."

Displaying EXIF Photo Data

Most file organizer programs, as well as your computer's operating system, let
you display your photos in thumbnail form. Many also display detailed infor-
mation about each photo. This metadata may include the make and model of
the camera used to take the photo; the date and time the photo was taken; the
aperture, shutter speed, focal length, and film speed settings; and other similar
information.

The standard for storing this type of photo information is called the
Exchangeable Image File Format, or EXIF. Most digital cameras record EXIF
data when the photo is taken; the data is embedded into the photo file. It's this
information that your photo software reads.

Viewing EXIF Data

For example, in Windows Vista, you can view EXIF data by right-clicking any
photo file and selecting Properties from the pop-up menu. When the Properties
dialog box appears, select the Details tab and scroll down to the Camera and
Advanced Photo sections. As you can see in Figure 15.3, a wide variety of infor-
mation is now displayed, including some or all of the following:

FIGURE 15.3

Viewing a photo's EXIF metadata in Windows Vista.

- Camera maker
- Camera model
- F/stop (aperture)
- Exposure time (shutter speed)
- ISO speed
- Exposure program
- Exposure bias
- Focal length
- Maximum aperture
- Metering mode
- Subject distance
- Flash mode
- Flash energy
- 35mm focal length
- Orientation
- Lens maker
- Lens model
- Flash maker
- Flash model
- Camera serial number
- Audio
- Contrast
- Brightness
- Light source
- Program mode
- Saturation
- Sharpness
- White balance
- Photometric interpretation
- Digital zoom

You can use this EXIF data to learn more about when and how a photo was created. It's particularly useful when examining photos shot by other photographers; everything you need to know is there, from exposure settings to lens choices.

Editing EXIF Data

Some photo organizer and editing programs let you edit EXIF data. Some programs let you augment EXIF data by adding further information about the photo. For example, Adobe Photoshop Elements lets you add a title and description to any photo; this additional information provides further criteria you can use to organize your photos.

To edit EXIF data, I recommend using a dedicated EXIF editing program. Some of the most popular of these programs include

- Exif Pilot (www.colorpilot.com/exif.html)
- Exifer for Windows (www.exifer.friedemann.info)
- PowerExif (www.opanda.com)

Not all cameras encode all EXIF data; some point-and-shoot cameras don't encode any data. The more advanced your camera, the more likely it is to register this information and encode it onto your photos.

MEMORIES LOST

Let me relate a cautionary tale. Several years ago my brother and I were installing a new computer in his home office and in the process transferred his entire collection of digital photographs from the old PC to the new one. Or rather, we *thought* we transferred the photos. It was only after we deleted the photos from the old PC that we realized the photos had not been transferred to the new one; his entire library of photographs had just been erased.

That was tragic, as many of those photos were irreplaceable. I'm not sure his wife has fully forgiven him yet, either—and that was almost five years ago!

Of course, it was our own stupidity that resulted in the loss of his photo library; we should have confirmed that the photos had been transferred before we deleted them from the original PC. But even smart people do stupid things from time to time—and there's always the possibility of computer failure, as well.

The moral to this story, of course, is that you need to back up all your invaluable digital photos, in some sort of digital photo archive. If or when your original photo files get lost or damaged or accidentally deleted, you'll have that archive from which to restore your photos to a new computer.

As important as your photos are, they deserve as much protection as possible. You don't want to lose those precious memories—so back up your photo files on a regular basis, and keep your photo archives in a safe place.

15

Scanning Print Photos and Slides

I deally, digital photography and the digital darkroom deal with photographs in an all-digital path; the photo is shot digitally, edited digitally, and then sent to some sort of digital display or printing device. This is fine when you're taking fresh photos with a digital camera, but what about all those old photos you may have taken with a film camera?

Fortunately, you can import film photos into the digital domain by using a photo scanner. The scanner converts the analog images from a film slide, negative, or print into the same type of digital bits created with a digital camera. The result is a digital photo file of the scanned photo that you can edit in any photo editing program and print on a color printer.

How Scanners Work

There are several different types of scanners—flatbed scanners, film scanners, and drum scanners. While the mechanism is a bit different with each type, the scanning process itself is similar.

Understanding the Scan Process

In essence, a lamp or similar light source moves across the image being scanned (or the image moves across the light source, depending on the type of scanner). The image is reflected onto a lens, which focuses the image on a digital image sensor—typically a CCD, like that used in digital cameras. The CCD registers the image and converts it into a digital file, just like the kind created by your digital camera.

The bottom line is that the scanner uses a digital image sensor to "photograph" your print or film image. It's essentially the same process used to capture images with a digital camera—it's just that the image is already processed in the form of a photo negative, slide, or print.

Different Types of Scanners

Even though the underlying scan technology is the same, not all scanners work the same way. For example, some scanners register all colors in a single pass, while other scanners make separate passes for the three primary colors (red, green, and blue). This multiple-pass scanner typically produces more accurate and vivid colors than the single-pass models.

Then there's the issue of how the image and the light source intersect. *Flatbed* scanners keep the image still and move the light source, typically as a scan head mounted on a moving arm. *Drum* scanners keep the light source still and move (rotate) the image. Drum scanners are typically more accurate (and higher priced) than the flatbed scanners available for home use.

In addition, some scanners are *reflective* scanners, designed to scan photo prints and other reflective media. Others are *transparent* scanners, designed to scan slides, negatives, and other transparent media. And some scanners can handle both reflective and transparent media—often via transparency adapters that let them scan slides, transparencies, and the like.

When I said drum scanners are higher priced, I meant it. Prices tend to start in the $30,000 range, which makes them suitable for professional use only.

Most low-cost home scanners are single-pass or multiple-pass flatbed reflective scanners; many offer optional transparency adapters. Some transparent scanners are available for home use but cost a bit more than their simpler brethren.

 Learn more about choosing a scanner in Chapter 2, "The Digital Darkroom."

Resolution, Dynamic Range, and Color Depth

One other difference between scanners is the *resolution* of the scanner—how sharp an image it can create. Scanner resolution is measured in either dots per inch (dpi) or pixels per inch (ppi); both measurements are the same, and the more of either is better, especially for high-quality photo work.

Also important is the scanner's *dynamic range*. This is the measurement of how well the scanner captures extremes of light and dark. The scanner's dynamic range is given as a set of light and dark numbers. Pure white is measured as 0.0, while pure black is measured as 4.0; you'll typically see values that look like "0.0 to 3.0," or something similar. Naturally, the wider the dynamic range, the better the scans represent the tonal values of the original image.

The third important measurement is the scanner's *color depth*. This refers to how many bits are assigned to each pixel in an image. The best pixels have a 36-bit color depth (12 each for red, blue, and green); these scanners can reproduce a total of 6.8 trillion colors. Lower-priced scanners may have a lower color depth of 24-bit or even 16-bit; again, bigger is better.

Understanding TWAIN

The last piece of technology you may be exposed to is something called *TWAIN*. This is that rare technology name that isn't an acronym; the letters TWAIN don't stand for anything.

TWAIN is the software standard used by all scanner manufacturers. When you first install your scanner, you also install a TWAIN driver on your computer; this driver is necessary to operate the scanner and serves as the interface between your computer (and any installed graphics programs) and the scanner hardware. The TWAIN driver provides the controls you use to specify the type and quality of a scan.

Making a Scan

The scanner doesn't work totally on its own. The scan process is facilitated by some sort of scanning software. This can be a freestanding program supplied

16

by the scanner manufacturer, the scan function of a photo editing program, or the scan function in your computer's operating system. For example, Adobe Photoshop has a built-in scan feature, as do the Windows XP and Windows Vista operating systems.

When you power up the scanner, place the image on the flatbed screen, and press the "Scan" button on the scanner, your default scanning program should launch automatically. If the program doesn't start automatically, launch it, and then select the appropriate menu option to launch the scan. (For example, in Photoshop Elements you select File, Import, [*scanner name*].)

Most programs let you specify different aspects of the scan, either on a scan-by-scan basis or as default settings for all your scans. These settings typically include some or all of the following:

- Mode (color image, grayscale image, black-and-white line art, or character recognition)
- Resolution (in dpi or ppi)
- Brightness
- Contrast

To scan color photographic images, select the color image mode and the highest possible resolution. To scan black-and-white images, you can select either the color or grayscale image mode; you actually have more editing options available in your photo editing program if you scan black-and-white images via the color setting.

The scanner starts by making a low-resolution preliminary scan of the image and displays a preview image onscreen, as shown in Figure 16.1. (You may have to click a "preview" button first, depending on your software.) You have the option of okaying this image or of cropping the image to scan only a portion of the image. (Cropping is probably necessary when scanning a photo print, as most flatbed scanners have an 8.5" × 11" or 14" surface.)

The software scan function may be labeled Scan, Acquire, or Import, depending on the program.

Click the Scan button displayed by your software, and the scanner now makes the full-resolution scan, in either one (all-color) or three (red, blue, green) passes. A typical scan might take a minute or more to complete, depending on the size of the original image and the resolution of the scan.

Learn more about file formats in Chapter 1, "How Digital Photography Works."

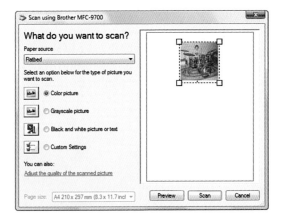

FIGURE 16.1

Displaying a prescan image in Photoshop Elements.

The scanned image is converted into a digital file, in either JPG or TIF format (your choice, if a choice is available), and saved to your computer's hard disk. You can then open the image file in any photo editing program, or send it to your printer.

Tips for Better Scans

Not all scans are created equal. To create the best possible scans of your prints and slides, consider these tips:

- Make sure the scanner glass is free from dust and streaks. Use a little Windex before you make the scan, or you'll end up scanning dust particles as well as your prints.

- Along the same lines, clean off the print or slide before you scan. Gently remove surface dust and dirt with a soft cloth, and tape over any tears (from the back of the photo—you don't want the tape showing in the scan).

- Scan at the highest possible resolution: 300 dpi is good, but 600 dpi is better. You can decrease the size of the scanned file in a photo editing program after the fact, but you can't add resolution beyond that of the original scan.

- That said, scanning a big picture at a high resolution can result in an unwieldy large file. Take file size into account when setting the scan resolution.

16

■ Square up the photo on the glass. The last thing you want is a crooked photo, like the one in Figure 16.2; make sure that the edge of the photo is parallel to the top or bottom edge of the scanner glass. (Although you can correct image tilt in Photoshop and similar programs, it's a lot easier to eliminate the problem in the scanner itself.)

FIGURE 16.2

If you don't align your photo on the scanner, you'll get a crooked scan—like this one.

■ At the same time, make sure you're not cutting off any part of the photo. Most flatbed scanners have some sort of alignment guide along the side of the bed; don't position the photo past the outside guide.

■ Most scanned images need sharpening after the fact. That's because when the image is scanned, pixels in the image often overlap. Use the sharpening or unsharp mask tool in your photo editing program to clean up the boundaries between colors and make edges appear sharper.

■ If you scan images from magazines, newspapers, catalogs, CD covers, or other printed materials, know that you're not scanning a continu-

ous image, as you would a photo print. Instead, these images are composed of tens of thousands of tiny dots in what is called a *halftone pattern*. Scanning a halftone image often results in a moiré pattern on the scanned image, like the one shown in Figure 16.3. You can minimize the moiré pattern by placing the original image at a slight angle on the scanner bed, or by applying a Gaussian blur filter after the fact in a photo editing program.

FIGURE 16.3

Scan a halftone image and you may end up with a moiré pattern on your scan—not desirable.

One thing to remember, whether you're scanning prints or slides, the image in your scan will be no better than the original image. So, for example, if you're scanning a faded old print that's torn and scratched, the scan will include the tears and scratches—and be just as faded. You can, of course, touch up these scans in a photo editing program, but most scans of old photos won't look quite as good as the new photos you take with a digital camera.

Learn how to touch up scanned photos in Chapter 19, "Touching Up and Editing Your Photos."

16

SCANNING OLD PHOTOS

Scanning your precious old photos is a lot of work, but it's worth it to have digital copies of those photos alongside your newer digital photos. This requires an investment in a photo scanner, of course, but that investment is minimal.

Most home scanners are of the flatbed type, optimized for scanning snapshot-sized photo prints. These scanners do a decent job, especially if you choose a model with a relatively high resolution. It pays to shop around.

Know, however, that scanning a print doesn't deliver the same output quality as scanning a slide or negative; the print itself is already a generation removed from the original negative film. For this reason, serious photographers always scan from the original negative or slide.

To do this, of course, you need a scanner that can scan transparent media. Many flatbed scanners come with optional transparency adapters that let you do just that. You'll probably have to insert the slide or film into a transparency holder; these devices let you mount multiple slides/frames and scan them in one at a time.

For higher-quality scans, consider taking your prints to a photo processing service for professional scanning. These services typically have high-speed drum scanners that deliver much higher resolution than home flatbeds. The service is typically costly, but the results can be impressive.

Digital Photo Editing

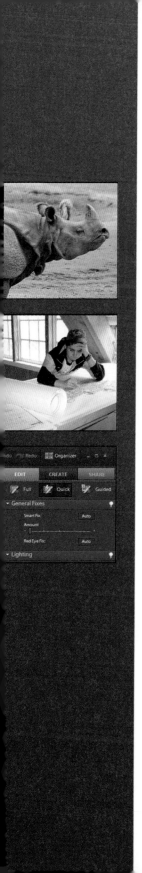

Choosing Photo Editing Software

I am a firm believer that the best digital photos are created that way in the camera, no editing necessary. That said, not all photos are perfect as shot—and even the best photos can benefit from a little "digital enhancement" after the fact.

When it comes to editing your digital photos, you can use one of many different photo editing programs. The most well-known of these programs is the relatively high-priced Adobe Photoshop CS, but many lower-priced alternatives are available.

In addition, several software manufacturers offer photo management software. These are programs that help you organize large photo collections on your computer system; most also offer basic image editing features.

Read on to learn more about all these programs—and decide which ones are right for your personal and professional needs.

17

Choosing a Photo Management Program

Even the most casual photographer will soon amass a collection of thousands of digital photographs. Organizing these photos so that it's easy to find the ones you want at any given time used to be a challenge, involving manual shuffling of individual files into separate folders on your hard disk.

Recognizing the need for easier and more effective photo organization, several software manufacturers now offer photo management programs. These programs let you organize your photo collection into virtual folders; many let you "tag" photos with descriptive keywords, and then sort your collection by tag. You can then view your photos either full-screen or in thumbnail view, and send your photos to your printer or to an online photo sharing service.

There are two classes of photo management programs. Consumer programs, priced under $100, are relatively easy to use but somewhat limited in their organizational functionality. These programs tend to include basic photo editing functions, so you could use them as a one-stop-shop—assuming that your photo editing needs are on the minimal side, of course.

Professional photo management programs tend to be more powerful than consumer programs—and correspondingly higher priced. These pro-level organization programs are designed to mimic the workflow of a professional photographer—from importing to editing to organizing to printing. You'll also find that these higher-end programs are fully compatible with raw-format files, in many cases working in raw from start to finish.

When you're shopping for a photo management program, consider the following features:

- File formats supported
- Ability to add tags to each photo
- Ability to organize photos in virtual folders
- Ability to edit photo metadata
- Search capabilities
- Thumbnail or contact sheet views
- Slideshow capability
- TWAIN importing from scanners
- Image editing tools
- Batch processing capabilities—to rename, resize, convert, and so on

You may not need a separate photo management program—especially if you're using a fully featured photo editing program. Most of the major photo editors, including both Adobe Photoshop Elements and Adobe Photoshop CS, have photo management features built-in. In most instances, you don't need both a photo editing and a photo management program.

Consumer Photo Management Programs

Consumer photo management programs tend to be priced under $100 (or free, in some instances) and offer both photo organization and basic image editing. The most popular of these programs include the following:

- **ACDSee Photo Manager** (www.acdsee.com; Windows; $39.99). Photo viewing, organization, and basic editing.

- **Adobe Photoshop Album** (www.adobe.com; Windows; free). Photoshop Album is a popular choice for casual photographers; it's easy to learn and easy to use. In addition to photo organization, it also offers basic photo editing features.

- **Apple iPhoto** (www.apple.com/ilife/iphoto/; Mac; free). Comes free with Mac OS X. Photo organization by event. Also offers basic photo editing features.

- **Cerious ThumbsPlus** (www.cerious.com; Windows; $49.95). Excellent photo organizer for large image collections; includes basic photo editing functions. Also available in a Professional version with raw file support ($89.95).

- **Corel Photo Album** (www.corel.com; Windows; $29). Basic photo organization and image editing.

- **IrfanView** (www.irfanview.com; Windows; free). Basic image management, viewing, and editing.

- **Photodex CompuPic Pro** (www.photodex.com; Windows; $79.95). Image organization viewing. Includes automated batch conversion to edit multiple photos simultaneously.

- **PicaJet Photo Organizer** (www.picajet.com; Windows; free/$59.95). Lets you organize pictures into more than one category simultaneously; also offers dynamic categories. Includes automated import and batch conversion utilities, and offers basic photo editing features and raw conversion. Comes in a free version and a more robust FX version ($59.95).

- **Picasa** (picasa.google.com; Windows; free). Picasa, shown in Figure 17.1, organizes photos into user-defined albums; a single photo can reside in more than one album. Combines photo organization with basic photo editing.

- **Preclick Gold Photo Organizer** (www.preclick.com; Windows; free). Very basic, very fast, small-footprint photo organizer program. Includes limited image editing tools.

- **Ulead Photo Explorer** (www.corel.com; Windows; $29.99). Basic photo organization and enhancement.

- **Windows Photo Gallery** (www.microsoft.com; Windows; free). Comes free with most editions of Windows Vista. Organize photos by folder, date, or tag. Also offers basic photo editing features.

FIGURE 17.1

The Picasa photo management/editing program, from Google.

Which of these tools should you use? For many users, the one that came with your operating system (iPhoto with the Mac or Windows Photo Gallery with Windows Vista) is more than good enough. Beyond these programs, I also like the free Adobe Photoshop Album and Picasa (from the good folks at Google); both offer a nice combination of photo organization and basic image editing.

Professional Photo Management Programs

Professional photo management programs tend to be higher-priced than their consumer cousins. Most of these programs work with raw-format files and have a professional workflow orientation; they help you import, sort, catalog, edit, present, and print your digital images. These are the programs you want to use if you're managing extremely large (10,000+) photo collections.

The most popular of these pro-level photo management programs include the following:

- **ACDSee Pro Photo Manager** (www.acdsee.com; Windows; $129.99). Workflow-oriented program with more sophisticated and flexible

organization than the consumer version. Fully compatible with raw-format files.

- **Adobe Photoshop Lightroom** (www.adobe.com; Mac and Windows; $299). Lightroom, shown in Figure 17.2, is an interesting supplement to Photoshop CS and other high-end photo editing programs. Lightroom is organized around a digital photographer's workflow— importing, managing, editing, and outputting digital photos. Works primarily (but not exclusively) with raw-format files. Offers nondestructive photo editing with a variety of professional-level editing tools.

- **Apple Aperture** (www.apple.com/aperture/; Mac; $299). A Mac-only photo management program aimed at professional photographers. Includes full raw support for all major digital camera manufacturers.

- **FotoWare FotoStation Pro** (www.fotoware.com; Mac and Windows; $599). Advanced image management with workflow-oriented interface. Also offers select photo editing tools.

- **Microsoft Expression Media** (www.microsoft.com/Expression/; Windows; $299). Workflow-oriented media management. Includes image editing tools.

- **Photools IMatch** (www.photools.com; Windows; $59.95). Despite the low price, offers powerful image management tools that rival those in high-end database programs. Workflow-oriented interface that natively supports all major raw file formats.

FIGURE 17.2

Adobe Photoshop Lightroom, a professional photo management program.

17

Do you need a professional-level photo management program? Maybe, maybe not. Most casual photographers can probably do without, as can low-volume professionals. But if you have a heavy workload, these programs are worth your consideration. I like Photoshop Lightroom for many reasons, not the least of which is that it integrates seamlessly with Photoshop CS. But these are relatively expensive programs, and you should definitely do your research before you make an investment.

Choosing a Photo Editing Program

Not every photographer needs a dedicated photo management program. Virtually every photographer today, however, uses a photo editing program. These programs are essential for enhancing, editing, and fixing digital photos—from candid holiday snaps to commercial and artistic images.

What can you do with a photo editing program? The list is almost endless; you can crop and rotate your photos, color correct them, fix the red eye effect, remove dust and scratches, adjust levels and contrast and brightness, apply digital filters, even stitch together multiple photos into a larger panorama.

Even the most basic photo editing programs let you perform most (but not necessarily all) of these operations. In fact, the lower-priced the program, the more likely it is that most of these fixes are of the "one-step" variety.

The more advanced programs go beyond quick fixes to offer fine-tuning of levels and channels and such. Editing in these programs can be nondestructive, via the use of layers; instead of editing the picture itself, you apply your edits and enhancements in layers positioned on top of the original.

Free Photo Editing Programs

The short list of free photo editing programs mirrors the list of free photo management programs. That's because these programs do double duty; they offer basic image editing tools combined with photo organization capability. These programs include

- **Apple iPhoto** (www.apple.com/ilife/iphoto/; Mac; free). Comes free with Mac OS X. Basic photo editing tools integrated with photo management.

- **Picasa** (picasa.google.com; Windows; free). Organizes photos into user-defined albums; a single photo can reside in more than one album. Combines photo organization with basic photo editing.

- **Windows Photo Gallery** (www.microsoft.com; Windows; free). Photo Gallery, shown in Figure 17.3, comes free with most editions of

Windows Vista. It lets you view and organize photos by folder, date, or tag. Also offers basic photo editing features.

FIGURE 17.3

Windows Photo Gallery (in editing mode), included free with most versions of Windows Vista.

Low-Cost Consumer Photo Editing Programs

Free photo editing programs are nice, but they're not nearly as full-featured as this next category of program. The consumer photo editing programs presented here offer much more sophisticated editing, above and beyond the "one click" editing found in the free programs.

That's not to say that these programs are difficult to use. They're not. That's because most of these programs provide a mix of casual and power-user features.

If you're a casual user, look for the automatic fix or "quick fix" features. Instead of twiddling with multiple controls, just click a single button to fix the color or contrast or sharpness. The auto fix feature doesn't get it right all the time, but it's a good place to start.

If you're a more experienced or demanding user, look for the more sophisticated tools and controls. Many of these programs let you apply your enhancements via nondestructive layers; depending on the program, you may be able to go beyond simple brightness, contrast, and color adjustments to fine-tune a photo's levels and curves.

If you have a Mac, you have iPhoto installed and ready to use. If you have a Windows Vista PC, you have a copy of Windows Photo Gallery installed. However, you might want to think about downloading Google's Picasa, which offers more robust photo editing tools than either of the other two programs.

17

The most popular of these programs include the following:

- **ACDSee Photo Editor** (www.acdsee.com; Windows; $49.99). Basic image editing tools combined with step-by-step "How-Tos" for common photo fixes.

- **Adobe Photoshop Elements** (www.adobe.com; Mac and Windows; $79.99-$99.99). A powerful subset of the Photoshop CS software, with added "quick fix" features for casual photographers—like the Quick Fix pane shown in Figure 17.4.

- **Corel Paint Shop Pro Photo** (www.corel.com; Windows; $79.99). Semipro image editing tools; more powerful than Photoshop Elements but slightly less than Photoshop CS. Includes "one-step" photo fixes and image organization features.

- **FotoFinish Studio** (www.fotofinish.com; Windows; $99). Features intuitive "Photo Wizard" for basic image touch-ups, as well as advanced layer editing.

- **Noromis Photolab** (www.noromis.com; Windows; $49.95). Manual and automatic ("one-click") photo editing and enhancement. Includes batch image processing and editing tools.

- **Roxio PhotoSuite** (www.roxio.com; Windows; $29.99). Low-priced program with basic photo editing tools, including One Button Photo Fix.

- **Ulead PhotoImpact** (www.corel.com; Windows; $89.99). One of the best bargains out there; Photoshop-like editing power at a sub-$100 price. Includes advanced raw image editing and an easier-to-use ExpressMode (for less-experienced users).

FIGURE 17.4

Adobe Photoshop Elements 6—a consumer-level photo editing program.

Professional Photo Editing Programs

Now we come to the big dog of photo editing programs. It's such a dominant player that it really doesn't have any competition. When it comes to professional photo editing programs, there's only one player:

- **Adobe Photoshop CS** (www.adobe.com; Mac and Windows; $649). Photoshop CS offers powerful, nondestructive photo editing using layers, levels, curves, and filters; it's the de facto standard for professional photographers of all types and includes the Adobe Bridge photo organizer program.

Why is Photoshop CS in a class by itself? Well, it's partly about functionality and partly about popularity. The functionality is easy to see; Photoshop CS simply includes more editing tools than any other program currently on the market. This makes Photoshop CS a powerful program, capable of making almost any type of photo adjustment that you can think of. (It also makes CS a relatively difficult program to use; it has a steep learning curve.)

As to the popularity factor, it's a fact: Virtually every serious digital photographer uses Photoshop CS. Other programs might be popular among casual photographers, but CS is what the pros use. To that end, an endless number of Photoshop learning aids and tutorials are available, as well as a growing stream of plug-ins and add-ons to enhance the editing experience.

THE BIG COMPARISON: PHOTOSHOP ELEMENTS VERSUS PHOTOSHOP CS

Adobe has a stranglehold on the digital darkroom market. I don't know whether that's a good thing or a bad thing; it just is. As you learned earlier in this chapter, there are many competitors, but none of them approaches the dominant market share that Adobe does via its combination of Photoshop Album, Photoshop Lightroom, Photoshop Elements, and Photoshop CS software.

For most users, the big decision is which of Adobe's two photo editing programs to use. Both Photoshop Elements and Photoshop CS can be used to edit and enhance digital photos; in fact, they share many of the same tools. But at just a shade under $100, Elements is a good $550 lower priced than CS. Is Photoshop CS worth that excessive premium?

It all depends—on your particular needs and on your personal skill level. If you're a casual user or if you have fairly common needs (cropping, brightness and color enhancement, that sort of thing), Photoshop Elements will do the job. In fact, for casual users the Elements Quick Fix pane and "auto correct" buttons are much, much easier to use than the more advanced editing tools of CS. Elements even includes a few tools that CS lacks, designed specifically for casual photographers. I'm particularly fond of the Remove Color Cast and Adjust Color for Skin Tone controls in Elements, both of which are much faster and easier to use than the CS controls for fixing color balance problems.

In addition, Elements offers many of the same editing tools and functions that you find in CS. I'm talking nondestructive editing via layers, level adjustment, digital filters, and raw image handling; they're all in Photoshop Elements, just as they are in the higher-priced program.

What Elements lacks, however, are the more advanced and often esoteric image enhancement tools that are part and parcel of Photoshop CS. If you want to view RGB histograms, edit individual color curves, adjust image exposure, apply realistic photo filters, and perform true black-and-white conversion, you have to use CS. In short, the additional tools in Photoshop CS let you perform more types of edits, often more precisely and sometimes in an easier fashion.

With all these features, CS offers many different ways to achieve similar effects. That's both a plus and a minus, of course. The different options let you pick and choose the right tool for any given situation, but also make it confusing to decide exactly which tool to use. As I said earlier, it's a steep learning curve.

Personally, I'm a longtime user of Photoshop Elements; almost everything you can do in CS can also be done in Elements. Note that word, "almost." Having bitten the bullet and switched to CS, I'm finding that I can do a little bit more, often a little bit easier, with the pro-level program. Even though I don't always use Photoshop CS's power tools, it's good to have them there when I need them.

Is Photoshop CS worth the cost? That's for you to decide. But if you want to remove all barriers to your photo editing and enhancement, there's only one choice, and it's Photoshop CS.

18

Essential Photo Editing Techniques

I n the old days of film photography, any enhancement of the original image was done to the film negative in a darkroom. In today's world of digital photography, enhancements are made digitally in a photo editing program.

In Chapter 17, "Choosing Photo Editing Software," we presented all the various programs you can use to edit your photos. As discussed there, the two most popular photo editing programs are Adobe Photoshop Elements (for casual photographers) and Adobe Photoshop CS (for more serious and professional photographers). These two programs share many key features and require many of the same skills and techniques.

It is those essential features and techniques that we discuss in this chapter—the basic skills you need to edit and enhance your digital photos, no matter which photo editing program you're using.

Mastering the Workspace

All photo editing programs open to some sort of editing workspace. Depending on the program, the workspace may be simple or complex. In fact, some programs may have multiple workspaces, each designed for a particular type or level of user.

For example, Photoshop Elements 6 features three different workspaces: Full, Quick, and Guided. The Full workspace, shown in Figure 18.1, allows access to layers and other advanced editing features; the Quick workspace is designed for more casual users, with a bevy of easy adjustment controls and "auto fix" buttons; and the Guided workspace walks you step-by-step through some of the most common photo touch-ups and edits.

FIGURE 18.1

The Full workspace in Photoshop Elements 6, with access to all the program's advanced tools and controls.

The most well-known photo editing workspace belongs to the Photoshop CS program. As you can see in Figure 18.2, Photoshop includes a toolbox on the left and a palette bin on the right. All the editing tools you use are located in the toolbox or on the main menu system; the palette bin is where you work with the various layers of your photograph.

Other programs have similar workspaces with similar elements. It pays to familiarize yourself with your program's workspace and interface before you begin serious editing.

FIGURE 18.2

The workspace in Photoshop CS3—toolbox on the left, palette bin on the right.

Opening and Importing Files

The first step in your photo editing workflow is opening or importing the photo you want to edit. You'd think this would be a straightforward process, but there are details to consider.

Opening JPG and TIF Files

The easiest types of photos to open are those in the JPG and TIF formats. In most instances, all you have to do is invoke your program's open file command—in Photoshop, that's File > Open. Select the image you want to edit; then click the Open button.

Importing Raw Files

Working with rawformat files is slightly more complex. For one thing, you can't just open a raw file; you have to import it, which then lets you save the file in either the JPG or TIF formats.

You can't save an edited file in raw format. It must be saved in JPG, TIF, or similar formats.

When you import a raw format file in Photoshop CS, you're confronted with the Camera Raw window, shown in Figure 18.3, which lets you edit the file to some degree as it's converted. You can, for example, adjust the image's exposure, brightness, contrast, white balance, color temperature, tint, and the like.

In fact, some of the controls in this window, such as the white balance control, do not exist within the main Photoshop program itself.

FIGURE 18.3

Importing a raw file in Photoshop CS.

Why edit the raw image during the import process? Because the enhancements you make are directly to the raw, unprocessed, uncompressed file; the results are generally better than similar adjustments made to the resulting JPG or TIF file.

Importing Multiple Raw Files in a Batch

Most photo editing programs let you import only one raw file at a time. There are, however, ways to import multiple raw files at once, using batch import.

In Photoshop CS, this is accomplished via the accompanying Adobe Bridge program, shown in Figure 18.4. From within Bridge, select the multiple files and then select File > Open in Camera Raw (to edit within Bridge) or File > Open With > Photoshop CS3.

Adobe Bridge also lets you apply raw editing to JPG and TIF files. Just select the JPG or TIF image(s) and then select File > Open in Camera Raw.

FIGURE 18.4

Use Adobe Bridge to manage your photos—and batch import raw files.

Understanding Key Editing Tools

In Photoshop CS, as in most other photo editing programs, key editing tools are organized into a single toolbox or toolbar. Table 18.1 details the available tools in Photoshop CS3.

Table 18.1 Photoshop CS3 Tools

Tool	Description	Shortcut Key
Move	Moves the selected object or area.	Shift+V
Rectangular Marquee	Selects a rectangular area.	Shift+M
Elliptical Marquee	Selects an elliptical area.	Shift+M
Lasso	Selects an area via freeform drawing.	Shift+L
Polygonal Lasso	Selects an area by drawing straight-edged segments.	Shift+L
Magnetic Lasso	Makes a selection by drawing around an area or object; border automatically snaps to defined edges.	Shift+L
Magic Wand	Selects a consistently colored area.	Shift+W
Quick Selection	Selects an area by "painting" that area; automatically finds and follows defined edges.	Shift+W
Crop	Trims unwanted portions from the edges of an image.	Shift+C
Slice	Divides an image into multiple smaller images; typically used to "slice" large images for web page use.	Shift+K
Slice Select	Selects a predefined image slice.	Shift+K

Continues...

18

Table 18.1 continued

Tool	Description	Shortcut Key
Spot Healing Brush	Automatically covers selected area with a sample from the surrounding area.	Shift+J
Healing Brush	Covers selected area with a sample selected from elsewhere in the image.	Shift+J
Patch	Covers selected area with an irregularly shaped area selected from elsewhere in the image.	Shift+J
Red Eye	Removes the red eye effect from images.	Shift+J
Brush	Paints the current foreground color in soft-edged strokes.	Shift+B
Pencil	Paints the current foreground color in hard-edged lines.	Shift+B
Color Replacement	Replaces the image's current color with the foreground color.	Shift+B
Clone Stamp	Paints ("clones") a sampled image area over the selected area.	Shift+S
Pattern Stamp	Paints a predefined pattern over the selected area.	Shift+S
History Brush	Restores selected part of the image to a previously saved state.	Shift+Y
Art History Brush	Restores selected part of the image to a previously saved state, but with artistic effects applied.	Shift+Y
Eraser	Totally erases selected area.	Shift+E
Background Eraser	Erases selected pixels on a background layer, thus making the selected area transparent.	Shift+E
Magic Eraser	Changes all similar pixels in a background layer to transparent; when a spot is clicked, all pixels of that same color are changed.	Shift+E
Gradient	Adds a gradient color blend to the selected area.	Shift+G
Paint Bucket	Fills selected area with a new color; when a spot is clicked, it recolors all adjacent pixels of the same color.	Shift+G
Blur	Softens hard edges.	Shift+R
Sharpen	Increases contrast along edges to increase apparent sharpness.	Shift+R
Smudge	"Smudges" color along the path of the cursor, simulating a finger painting effect.	Shift+R
Dodge	Lightens the selected area.	Shift+O
Burn	Darkens the selected area.	Shift+O
Sponge	Decreases color saturation in the selected area.	Shift+O
Pen	Draws a path (most precise).	Shift+P
Freeform Pen	Draws a freeform path.	Shift+P
Horizontal Type	Lets you enter normal horizontal letters.	Shift+T
Vertical Type	Lets you enter vertical letters.	Shift+T
Horizontal Type Mask	Creates a selection outline in the shape of horizontal letters.	Shift+T
Vertical Type Mask	Creates a selection outline in the shape of vertical letters.	Shift+T
Path Selection	Selects any component of a path.	Shift+A

Tool	Description	Shortcut Key
Direct Selection	Selects a single point on a path.	Shift+A
Rectangle	Draws a rectangular object.	Shift+U
Rounded Rectangle	Draws a rectangular object with rounded corners.	Shift+U
Ellipse	Draws an elliptical object.	Shift+U
Polygon	Draws a polygonal object.	Shift+U
Line	Draws a straight line.	Shift+U
Custom Shape	Draws a variety of predefined shapes.	Shift+U
Notes	Attaches text notes to a file.	Shift+N
Audio Annotation	Attaches audio notes to a file.	Shift+N
Eyedropper	Samples tonal values.	Shift+I
Color Sampler	Samples color values.	Shift+I
Measure	Precisely measures the distance between two points.	Shift+I
Hand	Moves the image.	Shift+H
Zoom	Increases or decreases the magnification.	Shift+Z
Foreground Color	Selects foreground color.	N/A
Background Color	Selects background color.	N/A
Quick Mask	Converts selection into a mask.	Shift+Q
Screen Mode	Selects standard (resizable window) or full screen viewing mode.	N/A

Note that some buttons in the toolbox access more than one tool. If you see a little triangle in the lower-right corner of a tool button, that means that there are several related tools from which you can choose. Right-click that button to display a pop-up menu that lists the tools. For example, if you right-click the Dodge tool, you can then select the Burn and Sponge tools.

When you select a tool, the Options bar at the top of the workspace changes to reflect options specific to that tool. For example, when you select one of the Brush tools, the Options bar displays options for the type and size of the brush, brush mode and opacity, and so on. When you select the Crop tool, the Options bar displays options for the width and height of the crop. And so on.

Other editing and enhancement controls, such as levels and layers, are located on the program's main menu system. Familiarize yourself with your program's menus before you start editing.

18

Working with Brushes

We're discussing photo editing programs here, but most of these programs have some basic drawing functions that require the use of brushes. Similar functionality is used when using the program's Eraser tool, when "painting" an area of a layer to mask it

> It's always better to choose a smaller brush when working with fine details, and a larger one when "painting" larger areas of an image.

off from the rest of the image, or even when trying to clone or heal a part of the image.

Whenever you select a tool that draws, paints, clones, or heals an area of the screen, you can control how that "paint" is applied. That is, you select the type of brush that paints on the screen.

In Photoshop CS this is accomplished via the Options bar at the top of the workspace. When you select a paint-type tool, the Brush Options bar appears, as shown in Figure 18.5. From here you can select the size, shape, performance, and opacity of the brush and its effects.

FIGURE 18.5

Use the Options bar to select the appearance and performance of a brush.

Selecting Areas to Edit

You don't always need or want to edit an entire picture. Sometimes part of the image looks perfect, but another part needs a little work.

This often happens with lighting, for example. To get decent lighting in one part of a photo, you might have to sacrifice lighting in another part. If you end up with half of the photo too light or too dark, you don't have to correct the entire image—only those areas that really need changing.

You might also run into a situation where there's just a part of the picture, or maybe a single object, that you'd like to somehow edit. Maybe you want to change the color of a piece of clothing, or make a particular object a little sharper, or even remove

> If you want to edit more than one area of a picture with the same tool in Photoshop, you can select multiple areas of your picture and then edit them all at once. You select multiple areas using the Add to Selection option in the Options bar, and then use your selection tool of choice to select the additional area(s).

something—like an unwanted item or even the entire background.

To make any of these fixes, you need to select a specific area of the photo. When you select just a section of your photo, you can confine your modifications to the selected section; the rest of the photo remains untouched.

> To draw a perfect square or circle instead of a rectangle or ellipse, hold down the Shift key while you're drawing.

But how do you select just part of a picture to edit? Most photo editing programs offer a number of methods; which one you use depends on the type of area of you need to edit.

Using the Marquee Selection Tools

If you're really fortunate, the area you want to edit is a specific geometric shape, such as a rectangle or ellipse. For selecting these specifically shaped areas, you use the marquee selection tools. These tools—Rectangular, Elliptical, Single Row, and Single Column—let you draw that shape on your image, thus selecting everything within that shape.

Using the Lasso Selection Tools

As nice as the marquee selection tools are, most of the areas you'll need to edit are more irregular in shape. This means you'll need to switch to another set of tools.

To select an irregularly shaped area of a photo, you can manually draw around the border of that area with one of Photoshop's Lasso tools. There are three different Lassos you can use.

The plain Lasso tool enables freehand drawing around an area or object. It's a good tool if you're good at tracing. It works best if you're using a graphics pad to literally draw around the area; it's harder to use with a mouse.

If the area you need to select consists primarily of straight edges, you can use the Polygonal Lasso tool instead of the normal Lasso tool. To use this tool, you click at each corner of the area, where two straight sections intersect. The Polygonal Lasso "fills in" the straight lines between the corners for you.

Finally, there's the Magnetic Lasso tool, which lets you trace roughly around the area or object and then automatically snaps its border more precisely to the selection, based on how the edge of the area contrasts with the surrounding area. It's a useful tool for selecting difficult-to-draw areas.

18

If the Magnetic Lasso tool in Photoshop doesn't snap precisely to a given area, you can try adjusting the following options in the Options bar:

- To select an area or object with well-defined edges, such as the edge of a building, enter higher Width and Edge Contrast numbers.

- To select an area or object that has softer edges, such as the hair on a person's head, enter lower Width and Edge Contrast numbers.

- To draw a more precise border around a really jagged area, have the Magnetic Lasso use more fastening points by entering a higher Frequency number.

If, while you're drawing a border, the Magnetic Lasso doesn't recognize a point on the edge of the selection area, click the mouse to manually add a fastening point there. If you need to undo any fastening points while you're selecting, press the Backspace key (Mac: Delete) to delete points in reverse order.

Using the Magic Wand Tool

When you want to select an irregularly shaped area, a better tool to try is Photoshop's Magic Wand tool. This is an interesting little tool, in that it selects an area based on its color in contrast to surrounding areas. So, if you need to select a red object against a green background, or a person with a white shirt framed against a dark wall, or even a gray automobile against a deep blue sky, the Magic Wand does a pretty good job. If, on the other hand, the area you need to select blends in with its surroundings, the Magic Wand isn't so magic.

Note that the Magic Wand doesn't always automatically select precisely the area you want to edit. If you want to select a larger area based on a broader range of color, try increasing the Tolerance value in the Options bar. Conversely, to select a smaller area based on a narrow range of color, decrease the Tolerance value.

If you want to select all the areas of a given color in your photo—even if they're not touching—deselect the Contiguous option in the Options bar.

STOP The Magic Wand tool isn't completely magic. Because it relies on color values to make its selections, it's not that useful if the area you want to select is too close in color to its surroundings or is full of several colors.

Using the Quick Selection Tool

Photoshop CS3 and Photoshop Elements 6 add a new selection tool called the Quick Selection tool. This tool works similarly to but better than the Magic Wand tool.

That's because it's like a Magic Wand tool with a brush option; you can use this tool to quickly paint a selection area.

Simply select the tool in the toolbox, select a brush size and shape, and then start "painting" the selection area in the photo. That's all there is to it; you'll find this a faster and more accurate selection tool for many types of photos.

Sometimes it's quicker to select the area of the image you *don't* want to edit. You can then invert the selection—turn the unselected area into the selected one—by selecting Select > Inverse.

18

Refining Selection Edges

In many instances, it's okay to have a "hard" border between the area you're editing and the rest of your picture. Sometimes, however, it's better to soften the border so that the edited area blends in better with its surroundings.

All the selection tools let you soften the edges of your selection via *feathering*. When you feather the edge of a selection, you blur the transition from one area to the next. The amount of blurring is specified in pixels; the more pixels you feather, the softer the edge becomes.

To soften the edge of your selection in Photoshop CS, click the Refine Edge button on the Options bar. When the Refine Edge dialog box appears, as shown in Figure 18.6, enter a value (in pixels) into the Feather box. The higher the value, the more the feathering.

FIGURE 18.6

Refining the edge of a selection via feathering.

18

Making Quick Fixes

For most types of image enhancement, there are several different ways to make the edits. Some methods are relatively quick and easy; other methods may take more time and skill but produce more professional results.

Using Auto Fix Controls

Not all images or enhancements require detailed enhancement. Some fixes can be quick and dirty—especially when you're working with candid photos.

In Photoshop CS and Elements, the easiest fixes are automated. Both programs include one-click Auto Color, Auto Contrast, and Auto Levels controls; Elements also has Auto Sharpness and Auto Red Eye controls, as well as a general "Smart Fix" button. In Elements, the auto fix controls are in the Quick view, in the right-hand pane. In CS, the auto fix controls are located on the Image menu.

These one-click controls analyze the image and try to apply the "best" fix for existing conditions. They do a good job sometimes, and sometimes they don't. I recommend trying these controls as a first step, but if the resulting image looks worse than the original, undo your changes and try another approach.

Adjusting Basic Settings

Beyond the simple one-button or one-click automatic adjustments, you can easily apply other basic adjustments to an image. Think of these adjustments as being like the brightness or color controls on your television set; they make rather broad universal adjustments directly to your image. The adjustments capable with these settings aren't nearly as fine as you can make with other editing tools, but they're also a lot easier to understand and to use.

What settings am I talking about? Here are some of the most popular:

- Color Balance
- Hue/Saturation
- Brightness/Contrast
- Shadow/Highlight
- Exposure

For example, when you select Image > Adjustments > Brightness/Contrast in Photoshop CS, you see the Brightness/Contrast dialog box, shown in

When you apply settings from the Image > Adjustments menu, the changes are made directly to the original image. A better approach is to use an adjustment layer, as discussed in the "Using Adjustment Layers" section later in this chapter.

Figure 18.7. Adjust the brightness slider to the left to darken the image, or to the right to lighten it. Likewise, move the contrast slider to the left to reduce the contrast of the image, or to the right to increase the contrast. The other settings work similarly.

FIGURE 18.7

Adjusting brightness and contrast, the easy way.

You can apply these adjustments to the entire image (no selection required), or to selected areas. To apply an adjustment selectively, start by using one of the selection tools to select the area you want to edit. With that area selected, select the adjustment tool and make your adjustment. Only the selected area is affected.

Using Layers

The concept behind layers is deceptively simple. By default, any photographic file consists of a single layer—it's a flat, two-dimensional picture. But if you overlay semitransparent layers on top of the picture, similar to overhead transparencies, you alter the way the photo appears.

Let's take a simple example. We start with a black-and-white picture, consisting of a single layer—nothing complicated yet. But if we add a second layer to the picture, and tint that layer red, then the picture we see (the combination of the two layers) isn't black and white anymore; it's tinted red.

Now imagine all sorts of filter layers applied to your pictures—dark filters, light filters, colored filters, soft-focus filters, you name it. And imagine using filters over only part of your picture, so that you alter only selected elements. That's how the layers feature works in most photo editing programs; it's a powerful picture-editing tool.

Why Use Layers?

Layers sound complicated, but they're surprisingly easy to use. Even if you're new to

You're not limited to adding a single layer to your image. You can add as many different layers as necessary—kind of like stacking multiple transparencies on an overhead projector.

photo editing, you shouldn't be intimidated by them. Layers can fix a lot of photos that would otherwise be unusable.

I recommend using a separate layer for each edit or enhancement you make to a photo. For example, if you want to change the photo's brightness, add a Brightness/Contrast adjustment layer. Then, if you want to change the photo's color cast, add a Color Balance adjustment layer. If you want to sharpen the photo, add a duplicate layer and apply the Unsharp filter to that layer. And on and on.

The advantage to using layers to enhance your photos is that layers make all your edits nondestructive; the original image remains untouched as the underlying background layer. In addition, as long as each enhancement resides on its own layer, it's easy to go back and change each edit—or remove it entirely—by returning to that specific layer.

One more thing about layers. A layer doesn't have to cover the entire image area. You can select a specific area of your photo and create a layer that covers only that area. This lets you apply area-specific edits and enhancements, one layer at a time.

Understanding Layers in Photoshop

In Photoshop CS and Elements, you add new layers to an image via the Layers menu, shown in Figure 18.8. There are all sorts of layers you can add, from simple duplicate layers (that you can then edit any way you see fit), to adjustment layers (that let you adjust levels, brightness, color, exposure, and the like), to fill layers (that let you "paint" your image). We'll discuss each type of layer later in this section.

The layers you add are displayed in the Layers palette, shown in Figure 18.9. The main part of the palette shows each layer in your picture as a thumbnail. The highlighted layer is the active layer you're currently working on.

The pull-down list at the upper left of the palette lets you select the *blending mode*. This determines how the selected layer reacts with the layers beneath it. The default mode is Normal, but you can also select Darken, Lighten, Multiply, and a dozen or so other modes.

The pull-down list at the upper right of the palette determines the opacity of the selected layer. Select a higher opacity to see more of the selected layer and less of the layer beneath it; select a lower opacity to see less of the selected layer (in other words, make it more transparent).

To select a layer, simply click that layer in the Layers palette. You can activate more than one layer at a time.

FIGURE 18.8

The Layers menu in Photoshop CS.

FIGURE 18.9

The Layers palette in Photoshop CS.

Creating New Layers

How do you create a new layer for an image in Photoshop CS or Elements? It depends on the type of layer you want to create:

- To create a new blank layer, select Layer > New > Layer.

- To create a new layer that duplicates the existing image, select Layer > Duplicate Layer.

- To create a duplicate layer for only part of the image, select that part of the image and then select Layer > New > Layer Via Copy.

- To create an adjustment layer, select Layer > New Adjustment Layer; then select the type of adjustment you want to make.

- To create an adjustment layer to edit only part of the image, select that part of the image and select Layer > New Adjustment Layer; then select the type of adjustment you want to make. The enhancement is applied only to the selected area.

- To create a fill layer, select Layer > New Fill Layer; then select the type of fill you want to apply.

Using Adjustment Layers

To me, the most useful type of layer is the adjustment layer. In Photoshop, an adjustment is a tool that lets you change or correct the tonal range, color, exposure, and other aspects of an image.

By applying these corrections in separate layers, you don't alter the original image, which continues to exist in its own layer. If you make a mistake with an adjustment, or just want to go back and change it, you can; all you have to do is reopen that adjustment layer and make the change. The original image remains untouched, its original pixels intact. It's truly nondestructive editing.

To create an adjustment layer, select Layer > New Adjustment Layer, and then select the type of adjustment you want to make. In Photoshop CS3, the following adjustments are available:

- Levels
- Curves
- Color Balance
- Brightness/Contrast
- Black & White
- Hue/Saturation
- Selective Color
- Channel Mixer
- Gradient Map
- Photo Filter
- Exposure
- Invert

18

Threshold

Polarize

When you create a new adjustment layer, a dialog box for that adjustment opens. For example, if you add a Color Balance adjustment layer, you'll see the Color Balance dialog box, shown in Figure 18.10. Adjust the settings in this dialog box, click OK, and the adjustment is applied.

To change the setting for any adjustment layer, simply double-click the layer thumbnail or icon for that layer in the Layers palette. This reopens the accompanying adjustment dialog box; make your changes and then click OK.

FIGURE 18.10

Adjusting Color Balance via an adjustment layer in Photoshop CS.

Using Fill Layers

A fill layer lets you fill all or part of an image with a solid color, gradient, or pattern. The effect of the fill layer can be adjusted via the layer's Opacity control; 100% opacity shows nothing but fill, while lower opacities let more of the underlying layer show through.

To create a fill layer, select Layer > New Fill Layer, and then select the type of fill you want. A Fill dialog box appears; make the necessary selections and then click OK. The fill is then applied to your image.

For example, Figure 18.11 shows an image both before (top) and after (bottom) of having a gradient fill layer applied. In this instance, the fill layer functions like a graduated neutral density filter, darkening the top of the image only.

Using Layer Styles

Layer styles are special effects applied to an entire layer. A variety of layer styles are available, including lighting effects, textures, and overlays.

18

Photoshop CS3 includes the following layer effects:

- Drop Shadow
- Inner Shadow
- Outer Glow
- Inner Glow
- Bevel and Emboss
- Satin
- Color Overlay
- Gradient Overlay
- Pattern Overlay
- Stroke

You can make multiple adjustments by adding multiple adjustment layers. Just stack each new correction on top of the last, one layer at a time. Know, however, that each new adjustment affects all layers below the new layer.

FIGURE 18.11

An image with a gradient fill layer applied.

To apply a style to the current layer, select Layer > Layer Style; then select the style you want. The Layer Style dialog box appears, as shown in Figure 18.12; select the desired characteristics and then click OK. The layer style is then applied—to the current layer only.

You can apply multiple styles simultaneously.

FIGURE 18.12

Applying layer styles.

Here's where layer styles become really useful. Let's say you select part of your image, and then create a new layer (via copy) containing only that selection. Apply a layer style to the layer for that selection, and you get an effect like that shown in Figure 18.13.

FIGURE 18.13

Notice the glow around the sign, added via a layer style.

Flattening Multiple Layers

When you're done adding layers to your photo, you can opt to leave the image with multiple layers, or flatten the image into a single layer. Leaving the layers lets you return to the file at a later date to edit the layers you've added; unfortunately, multiple layers also add to the file size.

STOP Merging and flattening layers can't be undone. After you've merged multiple layers, you can't separate the layers at a later time.

For this reason, you may want to flatten your image into a single layer. You do this by selecting Layers > Flatten Image. All the layers in your image are now merged into a single layer.

Photoshop CS also offers a range of filters that mimic traditional photo filters—warming filters, color filters, and the like. You apply these filters via a new adjustment layer; select Layers > New Adjustment Layer > Photo Filter, and then select the filter you want from the Photo Filter dialog box.

You don't have to flatten all your layers, however. Photoshop lets you *merge* two or more layers into one; this is often useful if you've created a lot of layers in an image and want to simplify the layer structure. In Photoshop CS3 you do this by selecting the layers to merge in the Layers palette, and then selecting Layers > Merge Layers.

Applying Filters

Most photo editing programs include some assortment of digital filters. A filter in a photo editing program is like a physical filter you attach to your camera lens, except that it's applied digitally. And, because the effects are digital, a much wider variety of filters is possible; you can use filters to sharpen or soften your photo, apply rendered lighting effects, or turn your photo into an artistic sketch.

In Photoshop Elements or CS you can apply filters directly to the original image, by pulling down the Filter menu and selecting a filter. Or, even better, you can create a duplicate layer and apply the filter to that layer; this lets you blend the filter effect into the original image. (Plus, it doesn't alter the original image, which is always a good thing.)

Any filter you select has its own adjustment dialog box; you use the controls in this dialog box to fine-tune the effect of the filter. Adjust the necessary settings; then click OK to apply the filter.

Understanding Histograms, Levels, Channels, and Curves

When it comes to adjusting a picture's brightness, contrast, and colors, you have many options. We've already discussed the basic brightness/contrast control, but you can also use *levels* and *curves* for more precise adjustments. We'll discuss each in turn, along with the preferred method for viewing the tonal range of an image—the *histogram*.

Working with Histograms

A histogram is a graph, like the one in Figure 18.14, that displays the tonal range of an image. You'll find histograms in various places in most photo edit-

ing programs; in Photoshop CS, you can view the histogram for any image in the Histogram palette.

FIGURE 18.14

A histogram displayed in Photoshop CS's Histogram palette.

Reading a histogram is relatively easy. The horizontal axis represents brightness, with darker pixels to the left and brighter pixels to the right. The vertical axis represents the number of pixels at each brightness level; the more pixels at any given point, the darker or lighter the image is.

Knowing this, you can quickly glance at a histogram to see how dark or light your image is. If a histogram has more weight on the left side, as in Figure 18.15, you have a dark or low-key image. If a histogram has more weight on the right side, as in Figure 18.16, you have a light or high-key image.

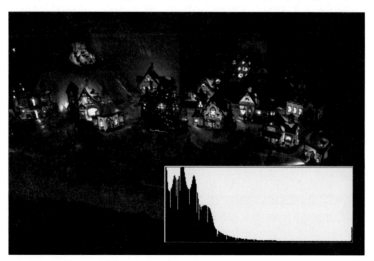

FIGURE 18.15

A low-key (dark) image and its accompanying histogram.

18

FIGURE 18.16
A high-key (light) image and its accompanying histogram.

Working with Levels

Histograms are most important when you're working with an image's *levels*. Levels let you adjust the relative intensity levels of the shadows, midtones, and highlights of an image.

You adjust an image's levels either by adding a level adjustment layer (select Layers > New Adjustment Layer > Levels) or directly on the main image (select Image > Adjustments > Levels). As you can see in Figure 18.17, the Levels dialog box contains a histogram of the image. You adjust the sliders under the histogram to adjust the levels of each component of the image; the left slider adjusts shadows, the middle one adjusts midtones, and the right one adjusts highlights.

Adjusting levels is generally a more accurate approach to changing the lightness or darkness of an image than you get with the basic brightness and contrast controls. It helps that you can use the histogram to see precisely what levels you're adjusting.

Just because an image is low-key doesn't mean that it's underexposed. While some dark images *are* underexposed, others just have a lot of black in them. The same for high-key images; while a high-key image may be overexposed, it also might just have a lot of white in it.

FIGURE 18.17
Adjusting levels in Photoshop CS.

Working with Color Channels

By default, Photoshop's histograms display the tonal range for the entire image. You can, however, use histograms to display an image's red, blue, and green (RGB) color levels separately. For example, when you select Colors from the pull-down menu in the Histogram palette, you display the levels for each color separately, as shown in Figure 18.18.

FIGURE 18.18
Viewing levels for each color in Photoshop's Histogram palette.

Each color in an image is a separate *channel.* In an RGB image, you have channels for red, green, and blue. In a CMYK image, you have channels for cyan, magenta, yellow, and black (K). By adjusting the levels for each color channel separately, you gain even more control over your final image.

> The one adjustment I make to practically every photo I edit is to tweak the picture's levels. When you set the picture's black level in the Levels dialog box, you really make a photo come to life—it's an essential adjustment.

You can adjust the level for each color channel separately in the Levels dialog box. Just pull down the Channels list and select a color; the histogram for that color is now displayed, and the changes you make to the levels apply to that color only.

Learn more about adjusting levels and curves in Chapter 19, "Touching Up and Editing Your Photos."

Working with Curves

Using levels is just one way to adjust the tonal range of an image. Even more fine adjustment is possible by editing the image's *curves*.

STOP Because of the precision and range of adjustments possible, adjusting curves can be daunting to the casual user. For that reason, most lower-end editing programs, such as Photoshop Elements, don't offer curve adjustments.

When you adjust levels, you adjust three variables—shadows, midtones, and highlights. Adjusting an image's curves lets you adjust *any* point along the tonal scale; as you can imagine, this results in much more precise adjustments to an image. (Photoshop lets you make up to 14 individual adjustments along the curve.)

To adjust an image's tonal curves in Photoshop CS, you can select Image > Adjustments > Curves, or use a curves adjustment layer (select Layers > New Adjustment Layer > Curves). In either case, you end up with the Curves dialog box, shown in Figure 18.19.

FIGURE 18.19

Adjusting tonal curves in Photoshop CS.

Initially, the image's tonal values are a straight diagonal line; this is because the input levels (original values) and output levels (changed values) are identical. To change any value, just click and drag a point on the line. This creates a new output curve and adjusts the image accordingly.

> By default, you use the Curves dialog box to adjust the full range of tonalities; RGB should be selected in the Channel list. However, you can also adjust the curve for each color channel separately, by selecting that color from the Channel list.

18

Know that the adjustments you make to an image's curve affect precise tonal values. Unlike the levels adjustment, where you adjust the entire range of shadow, midtone, or highlight values in a single adjustment, curves let you adjust a single point within those values. So you can fine-tune individual tones within the shadow range, for example, or change only a portion of the midtones. Compared to using levels, curve adjustments are like wielding a scalpel instead of a hatchet.

BRIGHTNESS/CONTRAST, LEVELS, OR CURVES— WHICH TO USE?

You have a photo that's underexposed, and thus a tad too dark. Which of the many available photo editing tools do you use to fix it?

If it's a simple matter of underexposure, Photoshop CS offers an Exposure adjustment, both in the RAW import window (if you shot in raw format) and in the main program itself. Sometimes increasing the exposure slightly solves the problem.

Most dark photos, however, need more than just a simple exposure boost. The fix involves both brightening the picture and adjusting the contrast. Knowing this, most casual users head directly for the Brightness/Contrast control; adjust the Brightness slider to the right and the Contrast slider whichever direction looks best. An easy fix, right?

Maybe. More often than I'd like to admit, it's not the whole picture that's dark; it's only part of the entire tonal range that's not bright enough. For this reason, it's often a better approach to use your editor's Levels controls to make the fix. Tweak the Shadows slider to adjust the black levels and the Highlight slider to adjust the whites, and then fine-tune things with the Midtones slider. You'll get much better results from this method than you will by a simple brightness and contrast adjustment.

18

In fact, I adjust the levels for almost every picture I take. After you get used to it, it's a quick and easy process that really punches up most photos. Trust me on this one; the Levels adjustment is a necessary one.

Beyond levels, many professional photographers prefer to adjust the photo's curves. Just as levels enable more precise adjustment than do the brightness and contrast controls, curves allow even more precise adjustment than does the levels control. You can pinpoint a defined tonal range and tweak it up and down, without affecting the entire shadow, midtone, or highlight range. When exact adjustments to specific tonal values are necessary, curves are the way to go.

So here's what I recommend. If you're an occasional or technophobic photo editor, go ahead and adjust brightness and contrast; it's easy and delivers acceptable results. If you're a more serious photo editor, use the levels control; the improvement in the final image is noticeable. And if you're a professional photographer, get to know the curves control; you'll need this type of precise enhancement to create print-quality photos.

Touching Up and Editing Your Photos

No matter how good a photographer you are, not every photo you take will be perfect. Maybe you didn't get close enough to the subject. Maybe you miscalculated the lighting and underexposed the image. Maybe you held the camera at a slight angle and tilted the horizon line. Maybe you forgot to use your camera's white balance control to compensate for artificial lighting. Maybe you forgot to clean your lens and got a speck of dust on the image. Or maybe you just want to punch up a photo that looks a little dull.

Whatever you need to do to fix or enhance an image, chances are you can do it. That's one of the benefits of digital photography, after all—after-the-fact image editing in the so-called digital darkroom.

This chapter shows you how to perform the most common image edits and enhancements in a series of step-by-step tutorials. While we use Photoshop CS as our example program, you can perform most of these edits in any photo editing program.

Basic Photo Touch-ups

We'll start with some of the most basic digital photo touch-ups—eliminating the red eye effect, cropping poor compositions, and straightening tilted images.

Eliminating Red Eye

The red eye effect is arguably the most common problem faced by digital photographers—especially when you're shooting with the built-in flash of a point-and-shoot camera.

If the one-click approach doesn't remove all the red in the pupil of the eye, there's another technique you can use. With the Red Eye tool selected, click and drag the cursor to draw a rectangle over the entire red area of the eye. When you release the mouse button, all the red should be gone.

Because red eye is such a common problem, virtually every photo editing program makes it easy to fix. In the case of Photoshop CS and Elements, there's a special tool just for fixing red eye, called (appropriately enough) the Red Eye tool. It's a fix so easy that just about anyone can do it.

To remove red eye from a picture, follow these steps:

1. Zoom into the area of the photo that contains the red eyes.
2. Select the Red Eye tool from the Toolbox.
3. Position the cursor over the red area of the pupil, as shown in Figure 19.1, and then click once.
4. Repeat step 3 for each eye you need to fix.

FIGURE 19.1
Using Photoshop's Red Eye tool to remove the red eye effect.

It's a simple fix—and it works!

Cropping a Picture

When the important part of your picture is too small, too far away, off-center, or inadvertently overshadowed by something else in the picture, it's time to crop that picture down to size. When you crop a picture, you cut off the unwanted parts, effectively zooming in on the part of the picture you want to keep. It's a great way to improve a picture's composition after the fact.

Cropping a picture with Photoshop's Crop tool is as easy as drawing around the part of the picture you want to keep and then double-clicking your mouse. Everything outside the area you select is cropped, or cut off. Here's how it works:

1. Select the Crop tool from the Toolbox. Your cursor now changes into the Crop tool shape.

2. Position the cursor at the upper-left corner of where you want the crop to start.

STOP If you crop too much out of a picture, you can end up with too few pixels left for a quality print. This is especially true if you shot at a low resolution, with a low-megapixel camera, or at a small photo size.

3. Click and hold the mouse button while you draw down and to the right until you've selected the entire region you want to keep in your final picture.

4. Release the mouse button; the selected area is surrounded by a flashing rectangular border and the area outside the selection dims, as shown in Figure 19.2.

5. Double-click within the selected area to make the crop.

To make sure your final picture is a standard print size, you need to specify the dimensions of the area you want to crop to. You do this in Photoshop by entering the desired dimensions in the Width and Height boxes in the Options bar. For example, if you want to end up with a standard 5×7-inch print, enter 7 into the Width box and 5 into the Height box. This constrains your crop to the shape necessary to result in the selected dimensions. When you select the crop area, the height and width automatically adjust in conjunction with each other. The result is a cropped picture that prints at the precise size you specified.

FIGURE 19.2

Using Photoshop's Crop tool to recompose a picture.

Correcting a Tilted Picture

Taking a level picture is more difficult than it seems. No matter how hard you try to position the horizontal and the vertical, it's easy to end up a few degrees off. Fortunately, most photo editing programs let you rotate the picture; a rotation of just a degree or two might make all the difference in the world.

To rotate a picture in Photoshop CS, follow these steps:

1. Select Image > Rotate Canvas > Arbitrary.

2. When the Rotate Canvas dialog box appears, as shown in Figure 19.3, enter the number of degrees you want to rotate the photo.

3. Select CW to rotate the image clockwise, or CCW to rotate the image counterclockwise.

4. Click OK.

FIGURE 19.3

Determining the degree of rotation.

Rotating the image is just the first step in this process, however. As you can see in Figure 19.4, you need to crop off the edges of your newly rotated picture to finish the straightening process. Select the Crop tool from the Toolbox, drag to select the desired final picture area, and then double-click to complete the crop.

FIGURE 19.4

A rotated image—edge cropping still required.

Correcting Exposure and Brightness

The room was too dark. Or maybe it was too light. You forgot to use a flash. Or maybe you used a flash when you didn't need to.

Whatever the cause, your picture is incorrectly exposed—either too dark or too light. In theory, fixing an underexposed picture in a photo editing program is as simple as lightening it up. The problem is how to add brightness without losing contrast and detail—which is why there are several different approaches you can take to fix a dark picture.

Adjusting Exposure

The solution is simple: Change the exposure of the image. But this solution may not be available in all programs. For example, Photoshop CS offers this particular solution; Photoshop Elements doesn't.

In Photoshop CS, you can adjust the exposure when importing a RAW-format file, or within the program on any format file. To make the adjustment within the program, using an adjustment layer, follow these steps:

1. Select Layers > New Adjustment Layer > Exposure.

2. When the Exposure dialog box appears, as shown in Figure 19.5, adjust the slider to the right to increase the exposure (lighten the image) or to the left to decrease the exposure (darken the image).

3. Click OK.

FIGURE 19.5

Dialing in a new exposure in Photoshop CS.

Adjusting Brightness and Contrast

As easy as it is in Photoshop CS to change the exposure, it doesn't always get the job done. Sometimes it's not the exposure that's the problem; sometimes it's the actual brightness and contrast of the picture that are off.

The quickest and easiest way to adjust brightness and contrast in either Photoshop CS or Elements is by using the Brightness/Contrast control in an adjustment layer. Follow these steps:

1. Select Layers > New Adjustment Layer > Brightness/Contrast.

2. When the Brightness/Contrast dialog box appears, as shown in Figure 19.6, increase the picture's brightness by moving the Brightness slider to the right.

3. The brighter you make your picture, the more washed out it will appear—due to a lack of contrast. You fix this side effect by moving the Contrast slider to the right.

4. Click OK.

You'll need to play with both the Brightness and Contrast sliders together to achieve the optimal effect.

FIGURE 19.6

Adjusting a picture's brightness and contrast.

Adjusting Levels

A better way to brighten up a dark picture is to manually adjust the intensity levels of the picture's bright and dark areas. This can get a little complicated, especially if your picture is all midtones. However, if your picture contains clearly defined white and black areas, this approach produces much more satisfactory results than a simple brightness/contrast adjustment.

The best way to adjust levels either Photoshop CS or Elements is via an adjustment layer. Follow these steps:

1. Select Layers > New Adjustment Layer > Levels.

2. When the Levels dialog box appears, as shown in Figure 19.7, start by setting the picture's black level. To do this, click the Set Black Point button (the leftmost eyedropper); then click your mouse on a point in your picture that you know should be deep black.

3. Next, set the picture's white level; click the Set White Point button (the rightmost eyedropper) and then click your mouse on a point in your picture that you know should be bright white. (If you don't have a pure white area in your photo, skip this step.)

4. We'll ignore the middle eyedropper, the Set Gray Point button, because it tends to affect the picture's color cast. Instead, click the midtone levels slider, which is the middle triangle underneath the histogram graph. Drag this slider to the left to further lighten the picture or to the right to darken it.

5. To further fine-tune the image's bright and dark levels, adjust the highlight and shadow sliders—the little triangle controls under the histogram on the far right and left, respectively.

FIGURE 19.7

Adjusting a picture's black and white levels in Photoshop CS.

Adjusting Curves

As effective as the Levels control is, the most precise way to adjust brightness and contrast is via curves. The Curves control in Photoshop CS lets you adjust any specific tonal value in your image, without affecting the surrounding shadow, midtone, or highlight tonalities.

To adjust curves using an adjustment layer, follow these steps:

1. Select Layers > New Adjustment Layer > Curves. This displays the Curves dialog box, as shown in Figure 19.8.

2. Move to your image and select a point that represents a tonal value you want to change. Ctrl+click (Mac: ⌘+click) that point in the image. This adds a point for that tonal value to the curve.

3. Return to the Curves dialog box and drag the newly created point up (to lighten the tonal value) or down (to darken it).

4. Repeat steps 2 and 3 for any other tonal values you want to change.

I recommend adjusting the levels for almost every photo you edit. Just about any photograph can benefit from a subtle tweaking of shadow and highlight levels.

Learn more about levels and curves in Chapter 18, "Essential Photo Editing Techniques."

Unlike some other controls, small adjustments to the Curves control have a big impact. Too-large a change can adversely affect the image.

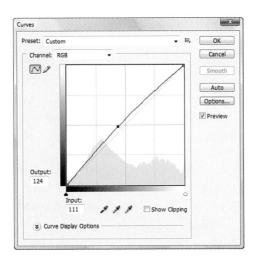

FIGURE 19.8

Adjusting an image's tonal curve.

As you can see, adjusting an image's tonal curve is a time-consuming process, but it can result in very precise adjustments. It's not a tool for the casual user, but professionals should find it useful.

Correcting Color

It's often difficult to get the colors to come out right in your photos. You take what you think is a great picture, only to discover that the deep blue sky came out a washed-out light blue, or that a soft red blouse ended up blooming bright red, or that everything in the picture was colored with a sickly green tint.

In most instances, bad color is the result of lighting conditions. As you learned in Chapter 12, "Color," too little light can result in poor color rendition, and different types of indoor lighting impart all manner of unwanted casts on the images you photograph. The solution, of course, is to use your photo editing program to correct the bad color—which it can do easily.

Some photo editing programs have more automatic or intuitive controls to adjust color cast. For example, Photoshop Elements includes a Color Cast tool (select Enhance > Adjust Color > Remove Color Cast). Unfortunately, Photoshop CS does not offer an equally easy-to-use tool for this task.

Adjusting Color with Levels

In Photoshop CS or Elements, the place to start when you want to remove a color cast

is the Levels control—the same control you used to adjust the image's dark and light levels. Follow these steps:

1. Select Layers > New Adjustment Layer > Levels.
2. When the Levels dialog box appears, click the Set Gray Point button (the middle eyedropper); then click your mouse on a point in your picture that you know should be neutral gray.
3. Click OK.

If you choose the right gray area, this should automatically correct any color cast in your image. Of course, if your picture doesn't have any neutral gray in it, you'll have to use a different approach—so continue reading.

Adjusting Color Balance

More precise adjustment of a color cast can be made with the Photoshop CS Color Balance control. As with most such controls, it's best to make changes via an adjustment layer, as follows:

1. Select Layers > New Adjustment Layer > Color Balance.
2. When the Color Balance dialog box appears, as shown in Figure 19.9, select Midtones to focus your changes on the midtone levels.
3. Drag the appropriate slider toward the color you want to increase in the image, or away from a color you want to decrease.
4. When finished adjusting, click OK.

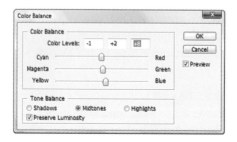

FIGURE 19.9
Adjusting the color balance of an image in Photoshop CS.

Adjusting Hue and Saturation

If you need even more precise color adjustment, or want to change an image's color saturation (amount of color), you have to use the Hue/Saturation control found in both Photoshop CS and Elements. You can also use this control to adjust one color at a time.

This method is recommended only if you have a good eye for color—and if your monitor is properly calibrated. If you and your system are up to the task, here's how it works:

1. Select Layers > New Adjustment Layer > Hue/Saturation.

2. When the Hue/Saturation dialog box appears, as shown in Figure 19.10, make sure Master is selected in the Edit menu; this lets you adjust all the colors in the image at one time.

3. Start by adjusting the saturation of color in your photo. Drag the Saturation slider to the left to reduce the overall color level or to the right to increase the color level.

4. If your picture is too dark or too light, drag the Lightness slider to the left (darker) or right (lighter).

5. Now let's work on the picture's tint or color cast. Drag the Hue slider to the left to make the color more red, then purple, then blue; or to the right to make the color more yellow, then green, then blue.

6. If your picture needs more or less of a particular color, pull down the Edit menu, select the color, and then adjust the Saturation slider accordingly. For example, to add intensity to a blue sky, pull down the Edit menu and select Blue; then drag the Saturation slider to the right until the blue level increases to your tastes.

7. When you're satisfied with the results, click OK.

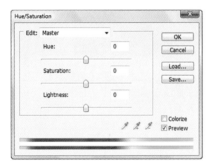

FIGURE 19.10

Adjusting an image's color hue and saturation.

Making Your Picture Sharper

Whether the cause is a moving subject, a shaky camera, or just poor focus, Photoshop CS and Elements offer several ways to sharpen a blurry picture. We won't discuss them all, as there is one sharpening technique used by most serious photographers—the Unsharp Mask filter.

Even though the name says "unsharp," this filter is actually used to sharpen the appearance of soft or blurry images. The Unsharp Mask filter works by adjusting the light and dark lines on each side of an edge; this emphasizes the object's edge, creating the appearance of sharpness. It can be used to sharpen blurry pictures or to make hard edges even harder.

The Unsharp Mask filter isn't a one-button technique; it requires a bit of user judgment to achieve the best results. In other words, this is a technique that lets you tweak the correction effect. The quality of the fix depends on the choices you make while applying the filter—so make sure you observe the results as you make your adjustments in the preview window in the Unsharp Mask dialog box.

Here's how to use this technique:

1. Select Layers > Duplicate Layer. We'll use this duplicate layer to make our adjustments.

2. Select the duplicate layer in the Layers palette.

3. Select Filter > Sharpen > Unsharp Mask to open the Unsharp Mask dialog box, shown in Figure 19.11.

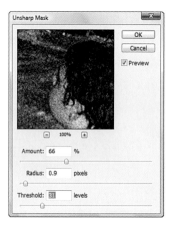

FIGURE 19.11

Use the Unsharp Mask filter to sharpen the edges in an image.

4. Drag the Amount slider (or enter a value in the Amount field) to determine how much to increase the contrast of the picture's pixels. In general, 100% is a good level for smaller or lower-resolution pictures; 150% is good for larger or higher-resolution pictures.

5. Drag the Threshold slider (or enter a value in the Threshold field) to determine the threshold of the effect. The lower the number, the greater the sharpening effect.

6. Drag the Radius slider (or enter a value in the Radius field) to determine the number of pixels to sharpen around edges. A lower value sharpens only the edge pixels, whereas a higher number sharpens a wider band of pixels around the edge of the object.

7. Click OK to apply the filter.

STOP If you set too high a Threshold number, the filter sharpens all pixels equally, resulting in some blockiness (called *digital artifacts*) in areas of relatively flat color, such as flesh tones.

While every picture is different, I've found some general settings that work best with specific types of pictures. You can use the settings in Table 19.1 as a starting point when working with the Unsharp Mask filter.

The reason you want to set the Radius last, even though it's the middle of the three controls, is because you can use it to "eye" your results. That is, the best way to set the Radius value is to adjust the slider until you like what you see.

Table 19.1 Recommended Unsharp Mask Filter Settings

Type of Picture	Amount	Radius	Threshold
General	100%	1	4
Portraits	75%	2	3
Objects with naturally soft edges	150%	1	10
Objects with naturally hard or well-defined edges	200%	3	0
Blurry pictures	75%	4	3
Badly out-of-focus pictures	400%	0.1	0

Repairing Damaged Images

So far in this chapter we've addressed what might be called touch-ups or enhancements. Now we go in for the harder stuff—repairs to digital photos or scanned pictures.

Healing Unwanted Spots

Let's start with the small problem of spots. We're talking a small area on an image that shouldn't be there—a spot of dust, perhaps, or maybe even a blemish on a portrait.

When you're dealing with a small area that you want to get rid of, the best approach is to use the Spot Healing Brush tool found in both Photoshop CS

and Elements. This tool samples pixels around the affected area and matches their texture, lighting, transparency, and shading to the spot you want healed. It's an easy tool to use:

1. Select the Spot Healing Brush from the Toolbox.

2. From the Options bar, choose a brush size that is slightly larger than the area you want to heal.

3. Also in the Options bar, choose the Type of healing you want. Proximity Match uses the pixels around the edge of the selected area to heal the spot; Create Texture blends pixels both outside and inside the selected area. For most photos, Proximity Match is the best choice.

4. Position the cursor over the spot you want to heal, as shown in Figure 19.12, and then click the mouse.

FIGURE 19.12
Using Photoshop's Spot Healing Brush tool to fix a bad spot in a picture.

Picture information from the adjacent area is now used to replace the selected spot with a new, unblemished area.

Cloning Over Bad or Unwanted Areas

Next up on the repair list are larger areas that need fixing—scratches, rips, and tears in a scanned picture, or unwanted wrinkles or skin patches in a digital portrait. This type of repair is accomplished by cloning a good part of the image over the unwanted area, using the Clone Stamp tool found in both Photoshop CS and Elements. It works like this:

1. Select the Clone Stamp tool from the Toolbox.

2. In the Options bar, select an appropriate-sized, soft-edged brush. Then make sure the Mode is set to Normal and the Opacity is set to 100%.

3. Now you have to select a "good" area to clone from. Position the cursor over an undamaged area close to the area you want to repair, as shown in Figure 19.13; then press Alt (Mac: Option) and click the mouse to sample this spot.

4. Move the cursor over the damaged area; then click and hold the mouse button to clone the sampled area over the damaged area.

FIGURE 19.13

Sampling an undamaged area with the Clone Stamp tool.

As you paint with your mouse, the sampled good area is cloned over the bad area. Repeat steps 3 and 4 as necessary to resample the undamaged area and clone over additional damage.

Removing Grain and Noise

Photoshop CS and Elements both include several tools you can use to smooth out a noisy image. The first tool to try is the Despeckle filter. As the name implies, this filter removes the "speckles" from your photos by blurring all of the photo except the hard edges around objects. So, even though the graininess is blurred out, the objects you shoot remain distinct.

Using the Despeckle filter is a two-step operation:

1. Select Layers > Duplicate Layer to create a duplicate layer; you'll apply the filter to this layer.

2. Select the duplicate layer in the Layers palette.

3. Select Filter > Noise > Despeckle.

If you're working with a very grainy picture, you might need a stronger solution than that provided by the Despeckle filter. Instead, you might want to try the Photoshop CS Reduce Noise filter. This filter smoothes transitions between different colors by averaging the color values of the pixels. The result is a softer image, overall, which blurs out the graininess.

To apply the Reduce Noise filter, follow these steps:

1. Select Layers > Duplicate Layer to create a duplicate layer; you'll apply the filter to this layer.

2. Select the duplicate layer in the Layers palette.

3. Select Filter > Noise > Reduce Noise.

4. When the Reduce Noise dialog box appears, as shown in Figure 19.14, adjust the Strength control to select the amount of noise reduction applied.

5. Adjust the Preserve Details control to determine how much edge detail is retained in the original image.

6. If you notice random color pixels in the image, adjust the Reduce Color Noise control to get rid of them.

7. If you notice blocky image artifacts when working with a low-resolution JPG file, click the Remove JPEG Artifact option.

8. Click OK to apply the filter.

Removing Dust and Scratches

If you're working with a photo that's been scanned from an older print, you may have to deal with minor scratches and dust that have manifested themselves over the years. Fortunately, both Photoshop Elements and CS contain a Dust & Scratches filter just for this purpose.

Follow these steps:

1. Select Layers > Duplicate Layer to create a duplicate layer; you'll apply the filter to this layer.

2. Select the duplicate layer in the Layers palette.

3. Select Filter > Noise > Dust & Scratches.

FIGURE 19.14

Selecting options for the Photoshop CS Reduce Noise filter.

4. When the Dust & Scratches dialog box appears, as shown in Figure 19.15, you want to blur the picture until the dust and scratches disappear. Drag the Radius slider to the right to increase the blurring effect or to the left to decrease the effect.

5. Drag the Threshold slider to the right until the dust or scratches become noticeable again; then back off slightly.

6. Click OK to apply the filter.

FIGURE 19.15

Applying the Photoshop CS Dust & Scratches filter.

Applying Special Effects

Photo editing programs aren't just for fixing flaws in your digital photos; they can also be used to enhance your photos by adding all kinds of special effects. We'll discuss a few of the many available effects here; most programs offer many more such effects, all of which warrant a good read of the program's instruction manual.

Adding Lens Flare and Other Lighting Effects

We'll start our tour of special effects by looking at a few of the lighting effects offered in Photoshop CS. Applying these rendered lighting filters creates the effect of different types of lighting in a photo—without you having to purchase or configure the actual physical lighting beforehand.

First, take a look at the Lens Flare filter, which creates the effect of lens flare in an image, as shown in Figure 19.16. You apply this filter by selecting Filter > Render > Lens Flare. When the Lens Flare dialog box appears, as shown in Figure 19.17, click the spot in the photo thumbnail where you want the flare to appear.

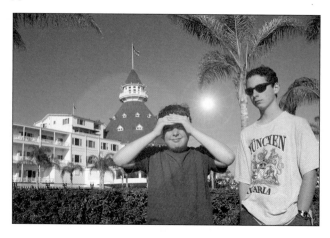

FIGURE 19.16

Lens flare added to a photograph.

FIGURE 19.17

Applying Photoshop's Lens Flare filter.

Then there's the Lighting Effects filter, which lets you create many different lighting effects—spotlight, floodlight, soft direct lights, circle of light, and so forth. (Figure 19.18 shows a photograph enhanced with the spotlight effect.) To apply this filter, select Filter > Render > Lighting Effects. When the Lighting Effects dialog box appears, as shown in Figure 19.19, select the Style of lighting, Light Type, light color, light properties (Gloss, Material, Exposure, and Ambience), and the direction/position of the light(s). It's really easy.

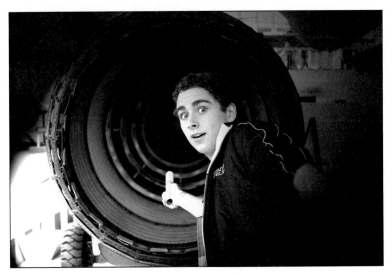

FIGURE 19.18

A spotlight effect added to a photograph.

FIGURE 19.19

Applying the Lighting Effects filter.

Converting Your Photo into an Artistic Sketch

Photoshop CS and Elements both offer a bevy of filters that let you apply various artistic effects to your photos. You can apply everything from simple film grain (shown in Figure 19.20) to a comic-book-like poster edges effect (shown in Figure 19.21).

FIGURE 19.20

A film grain effect added to a photograph.

The easiest way to apply an artistic filter is via the Filter Gallery, shown in Figure 19.22. Open the Filter Gallery by selecting Filter > Gallery; select the filter in the middle pane, adjust filter settings in the right pane, and preview the result in the left pane.

19

FIGURE 19.21

A poster edges effect added to a photograph.

FIGURE 19.22

Applying an artistic filter in Photoshop's Filter Gallery.

Merging Multiple Images into a Panorama

Finally, here's a trick that photographers use to create wide panoramic photographs. Photoshop CS and Elements let you stitch together multiple photos into a larger continuous panorama. The effect is impressive, when you do it right.

> If your photos don't all align to the same vertical dimensions, you may need to crop the resulting photo to the same top and bottom edges.

The first step is to shoot a series of side-by-side photos, all on the same horizontal level. (A tripod is essential for this.) You want the photos to cover the total landscape of the desired panorama; the photos should overlap each other by a small degree.

Merging the multiple photos into one is accomplished with the Photomerge tool. Select File > Automate > Photomerge to display the Photomerge dialog box, shown in Figure 19.23. Here is where you select the photos you want to merge, and how you want to merge them.

You can choose from the following Layout options: Auto, Perspective, Cylindrical, Reposition Only, and Interactive Layout. (Auto is the best choice in most instances, because Photoshop figures out the best way to merge the photos.) You'll also want to check the Blend Images Together option; this lets Photoshop adjust levels, colors, and other settings in each photo to create a seamlessly blended panorama.

Browse for and select the photos you want to merge and then click OK; Photoshop merges the photos together. The result, in most cases, is a panorama that looks as if it's a single photo, as shown in Figure 19.24.

FIGURE 19.23

Getting ready to merge multiple photos with Photomerge.

FIGURE 19.24

Multiple photos merged into a panorama.

THE ETHICS OF PHOTO MANIPULATION

When I was growing up, if you wanted iron-clad evidence of something you got "photographic proof." People could lie, but photographs couldn't. If you saw it in a photograph, you could believe it.

In today's era of the digital darkroom, however, photo enhancement and manipulation have become common. There's nary a photo you see in a newspaper or national magazine that hasn't been doctored in some fashion, if even just to punch up the contrast or adjust the color balance. But doctoring is doctoring; a photo that has been digitally white balanced is not an exact representation of the original scene.

We've come to accept this type of "innocent" digital enhancement, in the name of creating better-looking photographs. But where does simple enhancement end and blatant manipulation begin? When do you stop believing what you see?

Take, for example, *Time* magazine's digital darkening of a cover photo of O.J. Simpson in 1994, which many said made Simpson appear more menacing. The cover of a 2000 brochure for the University of Wisconsin in Madison was actually a 1993 photo of white football fans doctored to include a token black student. In 2004, an ad for President Bush's reelection campaign showed a manufactured audience of soldiers, created by cloning several real soldiers over and over again to fill the frame. And Reuters, in 2006, published a dramatic photograph of the Lebanese capital after an Israeli air raid, later shown to be manipulated to show more and darker smoke from the attacks.

These incidents, just a few of many since exposed, may all have been innocent attempts to create more appealing photographs. Or they may have been less-innocent attempts to subtly influence viewers. In any case, they helped to undermine the public's confidence in the photographic arts.

19

The issue is not an unimportant one; if people can't believe what they see, of what value is a photograph? To help clarify the issue, the National Press Photographer's Association (NPPA) has issued a Digital Manipulation Code of Ethics. It states, in rather efficient language, the following:

"As journalists we believe the guiding principle of our profession is accuracy, therefore, we believe it is wrong to alter the content of a photograph in any way that deceives the public."

That's nice and all, but it also isn't very descriptive. What exactly does it mean to "alter the content of a photo in any way that deceives the public?" Yes, digitally extracting a protestor from a photo of a political rally fits this definition, but what about making the flowers in the Rose Garden more red? They're both deceptive, in their way, even though the latter is probably an aesthetic enhancement rather than a political one. It's not an easy issue.

Of course, photo manipulation is not new to the digital era. Even when we thought we could trust the accuracy of a photograph, that accuracy was challenged by a photographer's darkroom skills. A little more or less time in the soup could change the film's exposure, and the process of dodging and burning let a photographer lighten or darken selected areas of a print. Then there were blatant photographic hoaxes, also accomplished via darkroom magic, such as the "fairy" photographs from Elise Wright and Frances Griffiths in 1917. And you can't neglect the former Soviet Union's penchant for airbrushing disgraced commissars from official photographs.

The bottom line is that photographs have never been the absolute visual recordings that we used to think they were. Today, they're even less so, given that any reasonably intelligent 15-year-old with a copy of Photoshop can photo-realistically clone anyone's head onto anyone else's body. Any photographer who claims to be a chronicler of events, however, owes it to his audience to keep the manipulation to a minimum. It's one thing to punch up the levels and color saturation, but it's another thing entirely to make a photograph show something that wasn't there in reality.

VII

Digital Photography Techniques

20

Portrait Photography

I n this section of the book we look at various types of photographs, and how to create them—both in the camera and with assistance from a photo editing program. We'll start by looking at what is probably the most common photographic subject—people.

If you're like most photographers, you take a lot of shots of people, either formal portraits or more candid shots. Both types of people photos have their own particular requirements; a great photo involves more than just having the subject say "cheese" and pressing the shutter release button. No, you have to deal with posing, backgrounds, lighting, and more—and, when it comes to portraits of children, much, much more.

We'll deal with candid people photography in Chapter 21, "Candid Photography"; this chapter focuses on portraits. In the following pages we'll work through everything you need to take pro-quality portraits, from equipment to backgrounds to props. We'll even discuss how to enhance portraits using Photoshop and other photo editing programs. So read on to learn how to create professional-looking portraits—in your own home or studio.

Shooting the Perfect Portrait

For our purposes, a portrait is a formal portrait, the kind of shot you might go to a professional photo studio for; it's a posed indoors shot with flattering lighting, attractive background, and the like. But you don't have to use a professional photographer to get a professional-quality portrait; with the right tools and planning, you can shoot quality portraits in the comfort of your own living room. Let me tell you how.

Selecting the Right Equipment

What kind of equipment do you need to take a professional-caliber portrait photograph? A bit more than a low-priced point-and-shoot camera with built-in flash, I'm afraid.

The camera first. While you can use a point-and-shoot camera, you'll get better results with a prosumer or digital SLR (D-SLR) camera. That's because you want a shallow depth of field, to provide a slightly out-of-focus background. While this can be achieved with some point-and-shoot cameras, it's much easier to do if you can set the aperture and shutter speed manually—which the more expensive cameras let you do.

If you do use a point-and-shoot camera, look for the camera's automatic portrait mode. With most point-and-shoot cameras, this mode dials in the large aperture you need to create the shallow depth of field.

If you're using a prosumer or D-SLR camera, switch to the camera's aperture priority mode and then select a low f/stop number. This widens the aperture for the desired shallow depth of field.

You'll want to mount the camera on a tripod, to keep it as steady as possible during the shooting. You may also want to use the camera's remote control or purchase a shutter release cable, so that you don't accidentally jar the camera when pressing the shutter button.

Concerning lenses, you want to use a standard lens or a short telephoto lens. You don't want to use a wide-angle lens because that will distort the subject's facial geometry. Instead, use something in the 85mm to 135mm range.

Depending on the effect you want to achieve, you may want to purchase a diffusion or soft focus filter for your camera. This softens the picture for that slightly out-of-focus effect you see in a lot of glamour photographs. Also worth considering is a center spot filter, which blurs the edges of the frame while keeping the subject in the center in sharp or slightly muted focus; it's an interesting effect for some, but certainly not all, portraits.

Some portrait photographers prefer so-called soft F/X filters. These filters are designed to minimize facial imperfections but, unlike soft focus filters, don't interfere with the overall clarity of the image. The subject's eyes stay sharply focused, even while skin blemishes are evened out to some degree.

> Don't forget some sort of stool or chair for the subject to sit on. A rotating stool is the best approach if you have one, because it lets the subject turn this way or that, as well as provides adjustable height. And, because no two subjects are the same size, being able to quickly adjust the height of the seating is important.

When it comes to lighting, you don't want to use the camera's built-in flash; the flash light is way too harsh and provides the kind of direct lighting that is unflattering to the subject. Instead, you'll want to purchase two or more studio lights; the exact number of lights you need depends on the type of lighting effect you want. We'll discuss this in more depth in the "Portrait Lighting Techniques" section, later in this chapter.

You also need to consider what background you want behind the subject. A plain white wall might work just fine, but you may also want to consider seamless background paper or some sort of cloth or muslin background. We'll discuss this further in the "Choosing the Right Background" section, coming up next.

Choosing the Right Background

The subject isn't the only thing you see in a portrait photo. You also see what's behind the subject—which makes choosing the right background of vital importance.

The background can either enhance or detract from your portrait. A neutral background helps the viewer focus on the subject, while a busy background draws attention to itself instead. And the color of the background should complement rather than compete with the coloring of the subject and the subject's clothing.

Of course, the choice of background is just that—a choice. There are no hard-and-fast rules about what type of background you should or shouldn't use in a portrait.

Some photographers prefer a flat, single-color background. For this effect, you can shoot against a plain white wall, use single-colored background paper, or just throw up a single-colored cloth or muslin sheet. The color you choose is also a personal choice—a plain white background accentuates the subject and creates a stark effect, as you can see in Figure 20.1; more muted or pastel colors create a warmer, more embracing effect, as you can see in Figure 20.2;

and brighter colors create a more energetic or youthful effect, as demonstrated in Figure 20.3.(Also note how the different background colors affect the perceived color of the subject's skin tones.)

FIGURE 20.1
A portrait shot against a plain white background—a stark effect.

FIGURE 20.2
A portrait with a muted colored background—warm and embracing.

FIGURE 20.3

A portrait with a more brightly colored background—youthful and energetic.

Of course, the background doesn't have to be a flat color. Add some (but not too much) interest to the shot by using a patterned background, or one that includes small splashes of color in moderation.

As to where you get your backgrounds, they can be found (using an existing wall or object) or manufactured—seamless background paper, cloth, or muslin, all available for purchase at your local camera store.

Working with Wardrobe

Technically, what the subject wears isn't the purview of the photographer. But as you're responsible for the final portrait, you should have some input into the subject's wardrobe to achieve the desired results.

Every subject is different; clothing that flatters one person might look horrible on the next. Here are some general wardrobe tips:

- Choose clothing that reflects the subject's taste and personality.

Add a touch of bright color to the background by aiming a flood onto the background from below. For added effect, put a colored gel on the light to match the color of the background—this deepens the background color.

Several sources of photographic backgrounds are detailed in Chapter 6, "Choosing Camera Accessories."

20

Unless you're deliberately striving for a particular effect, avoid clothing that isn't natural for the subject.

- Simplicity is best; go with solid colors or simple patterns. Avoid wild checks, stripes, and busy patterns that tend to draw attention to themselves. Remember, the clothing should complement the subject's face, not be in conflict with it.

- The subject should dress comfortably, especially if it's going to be a long photo session. While suit and tie are de rigueur for many official portraits, more casual portraits may call for turtlenecks, v-necks, open-collared shirts, and sweaters.

- It's a good idea for the subject to bring at least one change of clothes. This provides some flexibility and offers more choices when it comes to choosing the final shot.

- Women should generally avoid showing bare arms. Better to wear long-sleeved shirts and blouses instead. (And the no-bare-arms rule goes double for men!)

- Similarly, women in full-length portraits should wear slacks, a long skirt, or dark stockings. It's not a good idea to show a lot of skin that draws attention away from the subject's face.

Remember, a good portrait draws attention to the subject's face, not away from it. Provocative clothing in a full-length female portrait might flatter the subject's figure, but it draws attention away from her face.

As to clothing color, here are some guidelines:

- Darker colors are generally better than lighter colors; the best colors are generally medium shades of blue, green, rust, and burgundy—or even black, as shown in Figure 20.4.

- White, yellow, pink, and similar colors tend to overpower the face and make the subject look pale, as you can see in Figure 20.5.

- Avoid bright reds and orange, which draw attention away from the subject's face, as demonstrated in Figure 20.6.

FIGURE 20.4

Dark clothing flatters the subject's face.

FIGURE 20.5

Light clothing makes the subject look pale.

20

FIGURE 20.6

Bright clothing draws attention away from the subject's face.

Using Props

Portraits don't have to be boring. You can liven up a staid portrait by adding some props to the shot.

The prop can be something in the background (a vase, a statue, flowers), something the subject wears (jewelry, a scarf, a hat), or something the subject holds (a glass of wine, a cigarette, a book). For example, Figure 20.7 shows the subject holding a colorful umbrella, which makes for a fun shot.

The time of day you shoot affects the mood of the subject. It's generally best to schedule the photography session earlier in the day (for morning people, anyway), when the subject is likely to be more fresh and alert.

Props not only add interest to a shot, they also sometimes help your subject relax. Not all subjects are naturals in front of the camera, remember; some people are decidedly camera shy. You can take the subject's mind off being photographed by giving her something to do with her hands. It's a simple trick, but it works.

Props are especially effective when photographing children. The props not only keep the children from getting bored, they also make for more natural "action" shots.

FIGURE 20.7

Use props to enliven the shot.

Whatever type of prop you use, it should be something that reflects the subject's personality. Don't give a party girl a copy of *War and Peace* to hold, or make a stuffy businessman grip a nine iron. The perfect prop is one that says something about the subject as well as puts him at ease with the process.

Positioning the Camera

Where you place the camera is as important as how you pose the subject. Start by positioning the camera 3 1/2 to 5 feet in front of the subject. Any closer and you'll have to use a wide-angle lens, which can distort the subject's facial features. Any farther away and the longer telephoto lens will compress perspective and flatten the subject's features.

Camera height is also important. It's best to position the camera at the subject's eye level. Which means, when shooting children, you have to crank down the tripod to get face-to-face. Remember, shooting downward diminishes the subject, while shooting upward produces an unattractive head shot. (Do you really want to peer up the subject's nostrils?) Figure 2.8 shows you the correct positioning.

> For casual portraits, a person's pet might make a good "prop." If you use a pet in the shot, make sure there's someone there to handle the pet during the session; neither you (the photographer) nor the subject will be able to devote that much time to keeping the pet occupied between shots.

20

Subject

3.5-5 feet

Camera

FIGURE 20.8

Proper camera positioning.

20

Posing and Composing

When it comes to posing the subject and composing the shot, there's only one rule to follow: The subject's face is the most important part of the shot. Not her hair or clothing or accessories; it's the face that counts.

With that in mind, you should compose the shot so that as much of the frame as possible is filled by the subject's face. (Unless, that is, you're shooting a full-length portrait, in which case you can forget the face advice.) Compose the shot vertically, in portrait mode; a horizontal portrait does nothing more than waste a lot of space on the sides.

It also helps to apply the rule of thirds, with the focal point being the subject's eyes. So while the subject's face or body might be centered top-to-bottom in the frame, make sure one or both of the subject's eyes are positioned along the top two horizontal gridlines (at the top third of the frame).

As for posing, start by positioning the subject so that her head and body face in different directions. For example, if she's gazing stage right, position her body straight to the camera, or swiveled slightly to the left. If she's facing into the camera, angle her body to the right or left.

Avoid having the subject directly facing and staring into the camera, as shown in Figure 20.9; that's a pose best reserved for mug shots. If you want the subject looking

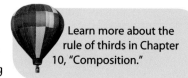

Learn more about the rule of thirds in Chapter 10, "Composition."

into the camera (and you don't have to), have her turn her head slightly and give a sideways glance into the lens, instead. This sort of pose is generally more interesting than a straight-into-the-camera gaze.

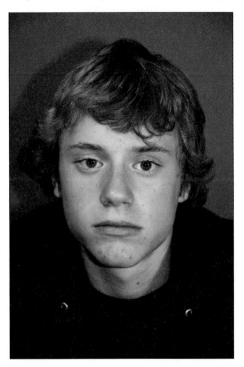

FIGURE 20.9

Avoid this sort of straight-on shot; it can be either boring or unnerving, depending on the intensity of the subject.

For torso shots, you have to deal with the subject's hands—and most people don't know what to do with their hands. Have the subject hold their hands separately or laid on top of each other; fingers should not be intertwined. Fingers should be slightly bent at each joint, never lying completely flat. And, of course, you can also have the subject pose with a prop in her hands.

Taking the Shot

After you've set up the lights, positioned the camera, and posed the subject, all you have to do is shoot the photos. Note that I said photos, plural; never snap one shot and say you're done. Always shoot a few "safety" shots with any given pose or exposure, as

As a general rule, women's hands should be more open, and men's hands more closed.

well as take the time to photograph the subject in different poses and from different angles. Have her face left, then right, then up, then down; have her smile and look pensive and maybe even try to make her laugh. The more variety you have, the more shots you'll have to choose from—and the better the odds for finding that one terrific photo.

STOP If you find that part of the subject's face goes out of focus (for example, if her eyes are in focus but her nose isn't), go one f/stop higher. This slightly increases the depth of field, enough to keep all the focal planes of the subject's face in focus.

The key to shooting portraits is to keep the subject in focus while you throw the background out of focus. That means striving for a shallow depth of field. To do this, set your camera to aperture priority mode and dial in the lowest possible f/stop number. A good place to start is at either f/4 or f/5.6, with shutter speed at 1/125 or so, and a 100 ISO setting. Experiment from there; for example, if the depth of field isn't shallow enough, dial in a lower f/stop number.

Now focus the shot, with the primary focal plane being the subject's eyes. With everything properly set, press the shutter release button (or use the camera's remote control shutter release) to take the shot.

Portrait Lighting Techniques

Portrait photography requires a mastery of lighting. The right light can make or break a portrait; professional photographers often spend more time getting the lighting right than posing the subject.

How you light your subject depends on the effect you want to achieve and on the type of lighting you have available. We'll look at a number of different setups and let you see the results of each.

Lighting with Camera Flash

When it comes to shooting portraits with your camera's built-in flash, I have just three words for you:

Don't Do It.

Camera flash is the worst kind of harsh direct lighting you can use. As you can see in Figure 20.10, it makes your subject look like a wanted criminal; the lighting is too strong and positioned too directly. The front-firing flash doesn't create any flattering shadows on the subject's face; it instead blows out the shadows and leaves the face looking flat.

20

FIGURE 20.10

A portrait shot with camera flash—less than ideal.

If camera flash is the only artificial light you have to work with, consider using natural light instead. Position the subject near an open window, or shoot by candlelight (using a very slow shutter speed), or go outside and shoot in the shade. Any of these alternatives will prove more effective than using camera flash.

Lighting with an External Flash

What if you have a speedlight, instead? That's a better alternative than the camera's built-in flash, but only by a little. The speedlight lets you bounce the light off the ceiling or nearby wall, thus diffusing the light and giving a softer effect, as shown in Figure 20.11. If the speedlight is tall enough, you may even be able to achieve a semblance of the butterfly lighting effect, discussed later in this chapter. That's all good.

Unfortunately, the position of the speedlight is still directly above the camera lens. Front-firing light, even diffused light from a bounced speedlight, doesn't create those face-flattering shadows we're looking for. That's not good.

20

FIGURE 20.11

A portrait shot with bounce light from a speedlight—better than camera flash, but still less than ideal.

Of course, if you can move the speedlight off the camera with an extension cable, you have more attractive options. Move the speedlight as far away from the camera as you can, ideally an arm's length or more to the side. If you can position the speedlight at a 45-degree angle to the subject, even better; this lets you achieve broad or short lighting effects, as you'll learn about later in this chapter.

Learn more about studio lighting in Chapter 11, "Lighting and Flash."

In addition to the lights you use, consider using one or more reflector cards. You use reflectors to provide reflected fill light, filling in any unwanted shadows. You can even use colored reflector cards to add a warm glow to the portrait. Using a reflector is an inexpensive way to get more light onto your subject—it's a lot cheaper than purchasing an extra light.

Lighting with Studio Lighting

The best lighting for portrait photography is studio lighting, either continuous or strobe. Continuous lighting is the more affordable

alternative, but strobe lighting (also called *studio flash*) is the best way to go; because it's not on all the time, it gives off much less heat—for which your subject will thank you.

Lighting height is also important. To minimize facial textures, wrinkles, and the like, position the light lower. To emphasize facial texture, position the light higher.

Whichever type of lighting you choose, you also have to select how many lights to use. Again, this is a function of the effect you want to achieve and your budget. Here's how you might use different numbers of lights:

- **One light**. If you only have a single light, position it 45 degrees from the camera-to-subject axis, to the right or left of the camera. The light should be positioned 3 to 4 feet from the subject. This produces the most pleasing shadows that best define the subject's facial structure. If possible, use a soft box or similar device to diffuse the light from this single source to soften the lighting effect. You can also get more mileage out of the single light by adding a reflector on the other side of and closer to the subject to reflect some of the light onto the opposite side of the subject's face.

- **Two lights**. When you add a second light to your setup, use it as a fill light. Place this light on the other side of the main light, at a similar 45-degree-to-axis position. This light definitely needs to be diffused and positioned at camera level or slightly higher. More important, the fill light needs to be three to four times weaker than the main light, or else you'll get double shadows on the subject. Fill light is used to control contrast; when you increase the power of the fill you reduce the amount of contrast in the photo.

- **Three or more lights**. Any extra lights you add to your setup should be used as background lights of some sort. You can position a light behind and below the subject, shining up to provide a backlight effect. Or the background light can be positioned higher and to the side, to create a more distinct silhouette around the subject's head. Or you can shine the third light backward to add a spot of light to the background. Of course, if you have multiple background lights, you can achieve all these different effects—and more.

With these general approaches in mind, there are a half dozen or so common styles of lighting used in portrait photography—which we'll discuss in more detail next.

Broad Lighting

Broad lighting uses a single light, positioned to illuminate the side of the face turned toward the camera. This kind of lighting tends to de-emphasize facial

features and can be used to make thin faces appear wider; it's not a good choice for people with fatter or wider faces.

> Broad lighting gets its name because it lights the broad side of the subject's face; the short side of the face goes into shadow.

Figure 20.12 shows how to set up broad lighting. Start by posing your subject to show a two-thirds or three-fourths view of her face. Position your main light at a 45-degree angle to the camera-to-subject axis on the side of the subject's face that's closest to the camera. This light should be positioned at approximately shoulder height; diffuse the light with a soft box or umbrella, if you want. You can use a reflector card or fill light on the other side of the camera, positioned at waist height, to provide a slight amount of fill lighting. The resulting portrait is shown in Figure 20.13.

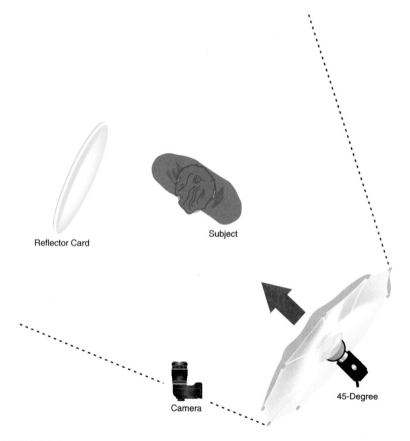

FIGURE 20.12

The proper setup for broad lighting.

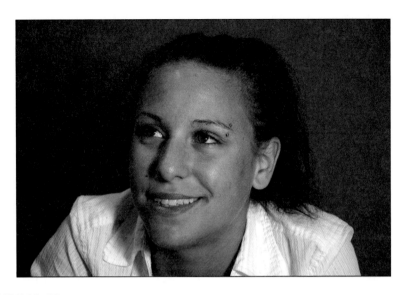

FIGURE 20.13

A portrait shot with broad lighting.

20

Short Lighting

Short lighting is the opposite of broad lighting; it illuminates the side of the face turned away from the camera. This type of lighting is good when the subject has a wider or more oval face; it emphases facial features more than broad lighting does, creating a more dramatic effect.

Figure 20.14 shows the proper setup for short lighting. Pose your subject with a two-thirds or three-fourths facial view, and then position your main light at a 45-degree angle to the camera-to-subject axis on the side of the subject's face that is turned away from the camera. This light should be positioned at approximately shoulder height; diffuse the light with a soft box or umbrella, if you want. You can use a reflector card or fill light on the other side of the camera, at waist height, if you want. The resulting portrait is shown in Figure 20.15.

> Short lighting gets its name because it lights the short side of the subject's face; the broad side of the face goes into shadow. It is more popular than broad lighting.

20

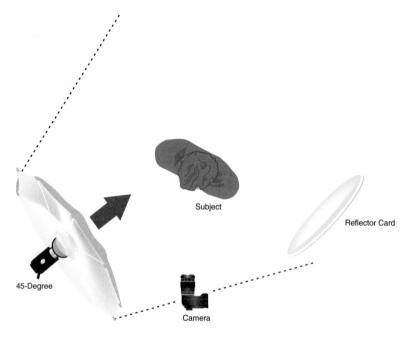

FIGURE 20.14

The proper setup for short lighting.

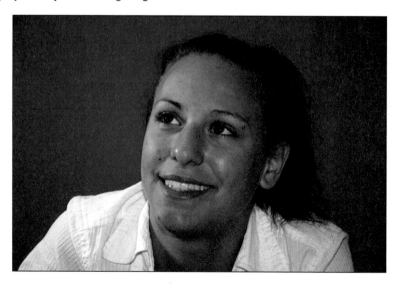

FIGURE 20.15

A portrait shot with short lighting.

Butterfly Lighting

Butterfly lighting uses a single main light, positioned in line with the camera directly in front of the camera's face, as shown in Figure 20.16. The light should be high above the camera, higher than you can typically achieve with a built-in flash or speedlight; it should be positioned downward at about a 45-degree angle. Adjust the height of the light until you see the characteristic shadow on the subject's face.

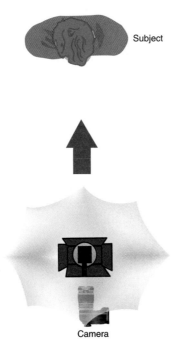

20

FIGURE 20.16

The proper setup for butterfly lighting.

This style of lighting, demonstrated in Figure 20.17, is associated with that style of glamour photography used in Hollywood portraits of the 1930s and 1940s. It's a dramatic look, best suited for women with strong cheekbones; it tends to overaccentuate the ears on males.

You can soften this effect somewhat by using a fill light below the main light, at roughly head height. Likewise, a reflector card placed under the face can lighten the shadows under the chin, as shown in Figure 20.18.

> Butterfly lighting gets its name from the butterfly-shaped shadow beneath the subject's nose. It's sometimes called Paramount lighting, for the famous movie studio, or glamour lighting.

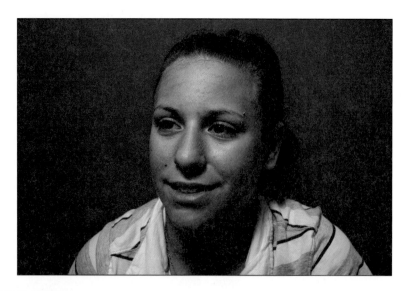

FIGURE 20.17

A portrait shot with butterfly lighting.

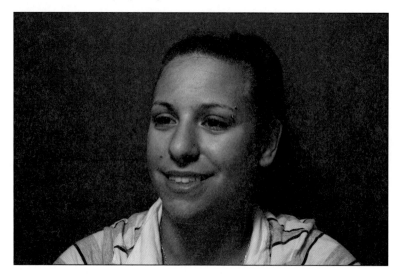

FIGURE 20.18

The butterfly lighting effect softened by use of a second fill light.

Rembrandt Lighting

Rembrandt lighting, sometimes called 45-degree lighting, is a combination of short and butterfly lighting. The chief characteristic of this lighting is the

attractive illuminated triangle produced on the subject's cheek closest to the camera.

Rembrandt lighting gets its name from lighting employed in portraits by the famous painter.

Figure 20.19 shows the typical Rembrandt lighting setup. The main light is positioned 45 degrees from the camera-to-subject plane, on either the broad or short side of the subject's face. This light should be positioned higher than the subject's head, directed downward at about a 45-degree angle. A fill light can be positioned on the other side of the subject, farther from the subject and at waist height.

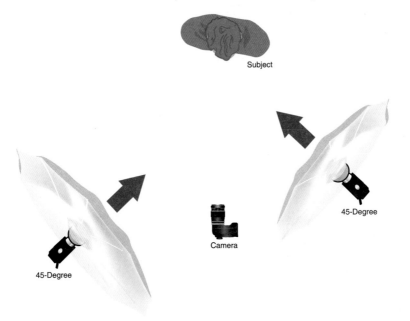

FIGURE 20.19

The proper setup for Rembrandt lighting.

The result of Rembrandt lighting is shown in Figure 20.20. There's a reason why this is perhaps the most popular of the portrait lighting setups; the effect is flattering for most subjects.

Side Lighting

Side lighting, sometimes called *split lighting*, places a single light to the side and almost—but not quite—behind the plane of the subject's face. This type of lighting is dramatic and particularly effective in black-and-white portraits. Half the face is lit; half the face is in shadow.

20

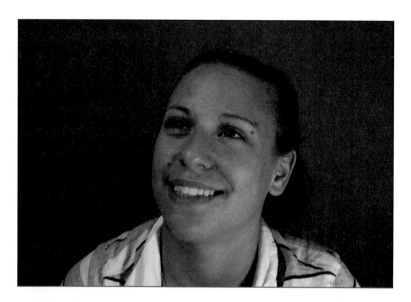

FIGURE 20.20

A portrait shot with Rembrandt lighting.

Figure 20.21 shows a typical side lighting setup. Start by positioning the light at the standard 45-degree axis, and then move it toward the side of the subject. It's positioned properly when the shadow-side highlight disappears. The light should be at or slightly above head level. Figure 20.22 shows a side-lit portrait.

You can soften the effect of side lighting by placing a fill light in front of the subject or opposite the main light, or by using a hair light on the opposite side of the subject.

Flat Lighting

When you want to minimize shadows on your subject's face, *flat lighting* is called for. This is a simple two-light setup, as shown in Figure 20.23, with both lights at 45 degrees on either side of the subject. Both lights should be at the same height (close to head height) and with the same power. Use diffusers to even out the light even more, and you end up with a flat, two-dimensional portrait, like the one shown in Figure 20.24.

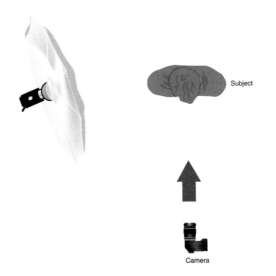

Subject

Camera

FIGURE 20.21
The proper setup for side lighting.

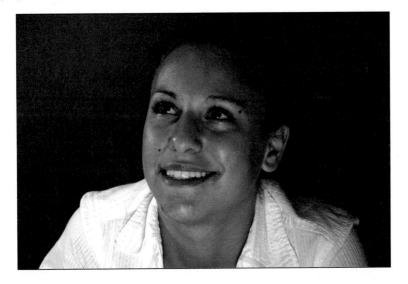

FIGURE 20.22
A portrait shot with side lighting.

Subject

45-Degree

45-Degree

Camera

FIGURE 20.23

The proper setup for flat lighting.

FIGURE 20.24

A portrait shot with flat lighting.

Supplemental Lighting

In addition to the main lighting techniques just discussed, there are two types of supplemental lighting you might want to consider—hair lighting and rim lighting.

Hair Lighting

Hair lighting is used to illuminate the subject's hair; it's particularly useful when photographing dark hair against a dark background. The hair light is a low-powered light positioned slightly behind the subject, directly opposite the main light. Place the hair light slightly higher than the subject's head. Figure 20.25 shows the effect.

FIGURE 20.25

The halo effect of hair lighting.

Rim Lighting

Rim lighting is more dramatic than hair lighting. A rim light is a light positioned behind the subject and creates a halo effect around the subject's head and shoulders, as shown in Figure 20.26. Always use rim lighting with some sort of front main lighting—or, for a more dramatic effect, a front fill light only.

FIGURE 20.26

The halo effect of rim lighting—note the light spillover around the edge of the subject.

Different Types of Portraits

Not all portraits are the same. Some subjects are more difficult to shoot than others, and sometimes you may even want a special photographic effect. Let's take a look at some specific types of portraits, and how to achieve the desired results.

Taking Children's Portraits

There are probably more formal portraits of children shot each year than portraits of adults; all parents want a "good" picture of their child to hand out to friends and family. However, photographing a child presents some unique challenges that you don't normally face with adult portraits. While the general techniques are the same, kids are just different from adults—which should go without saying.

When you want to shoot a great portrait of one or more children, like the one in Figure 20.27, here are some tips to keep in mind:

FIGURE 20.27

This portrait of two young girls captures the exuberance of the moment.

- Shoot a lot of photos. With children, your ratio of good shots to bad will be a lot lower than it is with adults; kids blink and fidget and even cry sometimes. You may want to shoot in burst or continuous shooting mode to increase your chances of capturing the right shot while the child is playing around.

- Be prepared to catch extemporaneous moments. It's difficult for children to hold a pose; they get bored and finicky and wiggle around a lot. Play that to your advantage, and be quick on the trigger to shoot the child in a more natural pose when he lets his guard down.

- Use props. Kids get bored, so give them something to play with. Letting a child hold a ball or a doll or a stuffed animal can not only keep the child's interest, it can also enliven an otherwise static shot.

- Be a clown. Small children can be frightened of photographers. You're a strange person in a strange place with lots of strange equipment; of course it's frightening. Relieve the tension by being funny and trying to

make him smile and laugh. With younger children, make a noise, squeeze a squeaky toy, or play peek-a-boo; with older children, play around and tell jokes. No parent likes pouty portraits; that one smiling or laughing shot might be the keeper.

- Take your time—and be patient. Just because the child gets upset and cries doesn't mean you should, too. Plan plenty of time for the shoot and take plenty of breaks. In addition, make sure you have drinks and snacks for the child, and maybe a drink or two for yourself, as well. (If you know what I mean.)

- When you have two or more children together, experiment with different poses. Have them interact with each other, rather than staring individually into the camera. Or, if they're fighting with each other, go the opposite direction and pose them back to back.

Taking a Group Portrait

You shot the mom. You shot the kid. Why not just shoot the whole family?

Group portraits represent a unique photographic challenge. With so many people in the shot—mom, dad, and kids—how do you make them all look their best? Heck, it's hard enough just to get a half-dozen people all smiling at the same time, with no one blinking.

An effective group portrait, like the one in Figure 20.28, requires a lot of work from everyone involved. Here are some tips to make the process a little easier:

- You may need to switch from telephoto to wide-angle lens to capture a large group shot. For the same reason, you'll probably be shooting in horizontal or landscape mode, rather than vertical.

- Have the subjects think through their wardrobe beforehand. The best small group portraits have everyone wearing complimentary colors, or colors from the same palette. You might, for example, instruct everyone to wear khaki slacks and white polo shirts, or have everyone dress in green, or something like that. What you don't want is four people in blue and one in bright red; you want the group to blend together as a whole, not to have one or two individuals stand out like proverbial sore thumbs.

- Experiment with different compositions, especially with larger groups. Yes, it's traditional to put the short people in front and the tall people in back (and with very large groups, you may have no other option), but there are other ways to approach things.

FIGURE 20.28
An effective family portrait, with everyone in similar dress.

- Consider height, and avoid creating straight lines from the subjects' heads. It's better to stagger the heights of everyone's heads; if everyone is the exact same height, have some stand on boxes or sit on stools.

- That brings up the point that not everyone has to be standing, or sitting. In a group portrait some people can stand, some can sit, some can kneel, and some can even lie down on the ground. Varied poses make for a more interesting portrait.

- Get everyone in close. If it's a family portrait, have some or all of the people touching each other in some fashion, even if it's just shoulder to shoulder. These people are supposed to like each other, and your portrait should reflect that.

- Sometimes an informal shot is better than a formal one. After everyone's done smiling into the camera, let the group break up a bit but keep shooting. A shot with people talking to and smiling at each other may be the keeper.

- In smaller groups, try to capture the chemistry between the people. This is especially important in couples' portraits, like the one in Figure 20.29; there should be something in the shot—an exchanged look, the touching of hands, even the intimation of a kiss—that puts a spark in the photo.

Shooting Black-and-White Portraits

Most people today prefer color portraits. With this, as with many things, I am a contrarian. I think many people look better in black and white; the contrast and shadows inherent in black-and-white portraits accentuate the lines and curves that give most people their distinctive look. In addition, black-and-white portraits, to me, are more dramatic; people just seem to look more thoughtful and profound in black and white than they do in color.

FIGURE 20.29

Try to capture the chemistry between a couple.

When you shoot in black and white, remember that you're shooting everything in shades of gray. The colors you see with your eyes must be converted to their corresponding grayscales. Black against white is the ultimate contrast; red against blue, not so much in grayscale.

Background is important with black-and-white portraits. You want to provide a noticeable contrast between the background and the subject; if the tonal values are too close, even if the colors are different, the subject will fade into the background. Use a lighter background with darker-skinned subjects, and a darker one with lighter-skinned subjects.

You may want to adjust the subject's makeup for grayscale tonalities. Add highlighter to the darker areas of her face, such as under the eyes. Don't ring the eyes with hard black eyeliner, instead blend a hazier charcoal-to-black shadow. In addition, you don't want to make the lips too shiny; this effect is much more noticeable in black and white.

For dramatic effect, have the subject dress in all black against a black background; as you can see in Figure 20.30, the only light area is the subject's face, which really pops. A much different effect is achieved by dressing the subject in white clothing against a white background, as you can see in Figure 20.31.

FIGURE 20.30

Black-and-white portraiture lets you accentuate the subject's face.

FIGURE 20.31

Create an ethereal effect with light tones in black and white.

Lighting is also key in black-and-white photography. While you can go with the standard lighting that we discussed earlier in this chapter, black and white affords the option of creating much more dramatic lighting effects. Experiment with different light positioning; it's okay to leave some of the subject's face in heavy shadow, for a somewhat theatrical "film noir" effect.

> Learn more about shooting in black and white in Chapter 27, "Black-and-White Photography."

By the way, if your camera only lets you shoot in color (a limitation of many of today's digital cameras), you can use Photoshop or any other photo editor to turn a color photograph into a black-and-white one. However, it's not as simple as just removing the color; you'll need to readjust the brightness and contrast for the black-and-white image, and perhaps even apply some color filters before the conversion to enhance specific tonalities. Don't worry; we discuss all this in Chapter 27.

Converting Portraits to Sepia Tone

Also of interest are sepia tone portraits. A sepia tone portrait has a vintage or antique feel to it, as you can witness in Figure 20.32. While you probably can't do sepia tone in camera, you can use a photo editing program to apply a sepia tone effect to any color or black-and-white portrait.

FIGURE 20.32

The vintage feel of a sepia tone portrait.

For example, Photoshop CS3 includes a built-in sepia filter. To convert a normal image to sepia tone, start by selecting Image > Adjustments > Black & White. This removes the color from the image while letting you adjust the individual color channels, creating an effective grayscale image.

> In programs without a dedicated sepia tone filter or control, you can manually create a sepia tone effect by converting the original photo to grayscale, reconverting it to color, and then applying a yellow-orange hue to the image.

Next, select Layer > New Adjustment Layer > Photo Filter. When the Photo Filter dialog box appears, select Filter: Sepia, Density: 75% (or higher, depending on your preferences), and Preserve Luminosity: Selected. Click OK, and the sepia tone effect is applied.

Enhancing Portraits in Photoshop

Because you're shooting in a controlled studio environment, the photos you end up with should be pretty much what you intended to shoot. The operative phrase here is "should be"; because portraits are so important, any glitches or blemishes will be noted and complained about.

Fortunately, you can use a photo editing program to make your portraits look more perfect. You can alter the background, or you can alter the subject—by performing a kind of digital plastic surgery.

Changing the Background

If you shoot the perfect portrait but hate the background, you can always change the background after the fact in your photo editing program. For example, Figure 20.33 shows the subject (that's me, folks) shot against a plain white background, then with the same background changed to blue, and finally with the original background replaced with something completely different. These sorts of changes are actually easy to do.

If you're using Photoshop CS3, start by selecting the background (*not* the subject), using whichever selection tool you prefer. You may want to put a slight feather (2-3 pixels) around the edges of the subject, to soften the foreground/background transition.

> Throughout this section of the book, we'll use Photoshop CS for our examples, but you can make most of the same fixes in any photo editing program.

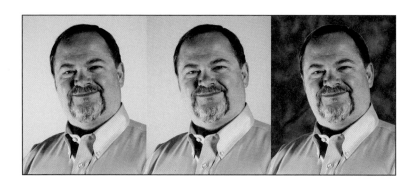

FIGURE 20.33

A portrait with a white background changed to a blue background changed to a completely different background.

Changing the background color itself is relatively easy. With the background selected, select Layers > New Adjustment Layer > Color Balance. When the New Layer dialog box appears, click OK; this displays the Color Balance dialog box. Select Midtones in the Tone Balance section; then use the sliders in the Color Balance section to select the new color. Click OK, and the background is changed.

Replacing the background with something different is only slightly more challenging. To do this, you need a photo of another background open in Photoshop. Switch to this second photo; select Select > All, then select Edit > Copy. Now return to your original photo with the background selected and select Edit > Paste Into. The selected area is now replaced by the background you copied from the second photo.

Removing Circles from Under the Eyes

Let's start with a common feature of today's harried worker, those dark circles under the eyes that can make even a relatively young person look old and haggard. These circles may be a result of normal aging, a hard day (or night), or just bad lighting. (Harsh overhead lighting accentuates these dark circles.) In any case, eye "bags" are generally unflattering and ripe for digital removal. (Figure 20.34 shows the original eye circles and the circles digitally removed.)

If the background color isn't deep enough, open a second adjustment layer for Hue/Saturation, and change the color saturation there.

To paste a new background into your portrait, make sure the second photo is as large as if not larger than the first to fill the entire background area.

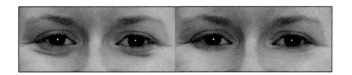

FIGURE 20.34
Removing circles from under a subject's eyes.

The best way to lighten under-eye shadows is to replace the undesirable circles with smoother, lighter flesh from elsewhere on the subject's face. For this, use the Clone Stamp tool (Mode: Lighten, Opacity: 50%) to clone a lighter, smoother area over the dark circles.

Removing Wrinkles

Ever wonder how those 40- and 50-something Hollywood stars keep looking so young? Well, part of it is makeup and part of it is plastic surgery, but a big factor in their eternal youthfulness is photo retouching to remove the wrinkles that everyone gets with age. In other words, they really don't look that young in person; their youthfulness only comes through when those wrinkles disappear in their digitally retouched photos.

Fortunately, you can use Photoshop to remove wrinkles from any portrait you shoot, as shown in Figure 20.35.

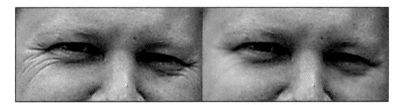

FIGURE 20.35
Removing wrinkles for a younger-looking portrait.

The key to reducing wrinkles, rather than eliminating them, is to employ Photoshop's Layers feature. You combine the original picture (with wrinkles intact) with a duplicate layer that has the wrinkles completely removed, and then blend the two layers so that a small degree of wrinkles comes through.

The goal with digital wrinkle removal is to make your subject look realistic. That means adding back enough wrinkles to be believable, but not so many that they become dominant again. You'd be surprised how just a hint of age lines can look significantly better than a completely smooth face.

20

Start by copying the picture's background layer by selecting Layer > Duplicate Layer; when the Duplicate Layer dialog box appears, click OK. Select this new layer and then use Photoshop's Blur tool to remove the wrinkles. When you're done doing this, return to the Layers palette and adjust the Opacity level for this layer until just enough wrinkles return for your tastes.

Removing Blemishes

Some people are particularly sensitive about skin blemishes, from freckles and acne to moles and scars. Your subjects will be impressed when you use Photoshop to remove these types of blemishes; they'll end up looking better in the photo than they do in person, as you can see in Figure 20.36.

The first thing to try is blurring the blemish with Photoshop's Blur tool. This technique works best when the blemish is only slightly darker or lighter than the surrounding area. You'll probably have to paint over the blemish several times to properly blur it into the rest of the skin. But be careful—blur too much, and you'll blur the skin texture away!

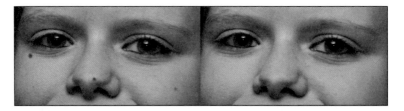

FIGURE 20.36
Instant blemish removal, via Photoshop.

If that doesn't work, you can try using Photoshop's Spot Healing Brush tool. Choose a brush size slightly larger than the blemish and then double-click the offensive spot. Ideally, this tool "heals" the blemish by blending it with the surrounding skin.

To fix these more prominent blemishes, you may need to clone a clean area of skin over the offending blemish; choose the right area to clone, and it will blend right in with the surrounding skin. Use the Clone Stamp tool to select a blemish-free area of skin, and then clone that skin over the blemish.

Creating the Glamour Beauty Effect

Even with all the wrinkles and blemishes removed, some close-up portraits are less than flattering to their subjects. The closer you get with the camera, the

more the lens captures every little skin imperfection. Not that you want to create a professional glamour photograph, but it would be great if you could smooth out uneven skin, soften freckled patches, and add a kind of glamour glow to the subject. To do this requires slightly blurring parts of the picture to create a kind of soft-focus effect—without losing overall picture sharpness.

To view this effect, observe Figure 20.37. The "before" photo is a standard wedding portrait; the "after" version has the glamour beauty effect applied. See the difference?

You start the process by adding a duplicate layer and then blurring that layer. Select Layer > Duplicate Layer to create the new layer; when the Duplicate Layer dialog box appears, click OK. Now select the new layer and select Filter > Blur > Gaussian Blur. When the Gaussian Blur dialog box appears, adjust the Radius control until the picture is sufficiently blurry. (Probably somewhere between 3 and 6 pixels.) Click OK when done.

Your picture now looks extremely blurry. You want to blend this blurry layer with the still-sharp original layer, so go to the Layers palette and adjust the Opacity for this layer to 50%.

FIGURE 20.37

A normal portrait, with glamour beauty effect applied.

Your picture now looks only slightly blurred, which is better—but not yet perfect. The problem is, you don't want the entire picture to be blurred, only the skin area. So now you want to add some sharpness back in the nonskin areas, which you'll do by erasing some of the duplicate layer.

Start by going to the Toolbox and selecting the Eraser tool. Now go to the Options bar, pull down the Brushes list, and select a soft-edged brush. Also select a relatively small Size, and make sure Opacity is set to 100%.

You get a nice glamour portrait effect by leaving the background of the picture blurry, which simulates a shallow depth of field. You do this by *not* erasing any bits of the background during this process.

With the Eraser tool selected, click and drag the mouse over those areas of the face you want to sharpen—eyebrows, eyes, teeth, lips, hair, and so on. What you're doing is erasing parts of the blurred layer so that the sharp original layer shows through. Avoid dragging the Eraser tool over open areas of skin, or you'll make those areas appear too sharp in the portrait.

The result is a professional-looking portrait, with the kind of soft-focus effect a professional glamour photographer would charge big bucks for!

THE BENEFITS OF SOFT LIGHTING

Most people have less-than-perfect faces. There may be a few wrinkles here, a few blemishes there, maybe a bit of uneven skin tone in places. The point is, if there's any way to disguise these slight imperfections, the portrait will benefit.

Here is where lighting is your friend. Harsh direct lighting accentuates every detail on a face, but softer indirect lighting evens things out a bit and makes the subject look just a tad more glamorous.

What is soft lighting? It's light not shone directly on the subject. Outside, you get softer lighting by shooting in the shade or on a cloudy day, as opposed to the harsh light of direct sunlight. Indoors, you soften the light by using diffusers and reflectors. You place the diffuser over a light to spread it out and make it softer; the reflector is used to reflect direct light, diffusing it in the process.

Direct lighting has its place, of course; it can help create dramatic shadows and highlights in black-and-white photography, for example. But for most posed portraits, soft lighting is better. Your subject will thank you for it.

Candid Photography

ormal portraits aren't the only way to photograph people. If you're like most photographers, you'll shoot a lot more candid shots than you will formal portraits—especially when you're shooting children and other family members.

Shooting a candid photograph is much different from shooting a formal portrait. You have less (or no) control over setting, lighting, and pose, which makes it challenging to get a good shot. What you end up with, however, is a much more natural photo that better reflects the subject's personality.

Selecting the Right Equipment

I won't pretend to tell what you what type of digital camera to use for your candid photography; you'll use whatever camera you have. That said, different types of cameras have their own pros and cons for shooting candids:

- **Point-and-shoot cameras**. These are the most popular cameras for candid photography, as they have the benefit of portability; they're easy to take anywhere. On the downside, most cameras stick you with a measly 3X zoom, which isn't that great for capturing shots from a safe distance.

> You should outfit your lens, no matter the type of camera, with a polarizing filter. As you learned in Chapter 9, "Using Filters," a polarizing filter helps you capture richer colors when you're shooting outdoors on a sunny day.

- **Prosumer cameras**. A prosumer camera may be the best compromise for candid photography. They're more portable than a D-SLR but offer many of the same advantages, including manual exposure (if you like) and much longer zoom lenses—up to 12X or 15X, which let you shoot from quite a distance.

- **Digital SLR (D-SLR) cameras**. A D-SLR lets you choose your own manual exposure settings, plus you can use different lenses (such as longer zooms, which are nice for candid shots from a distance). On the downside, these cameras are big and bulky and not that easy to lug around.

Whatever type of camera you use, take advantage of the zoom or telephoto lens. The best candid shots come when the subjects aren't aware they're being photographed, and the way to do that is to keep your distance and get closer with the zoom. To that end, a longer zoom is always better.

Beyond your camera and a flash or speedlight, you don't need much more in the way of equipment. The important thing in candid photography is to be in the right place at the right time—with your finger on the shutter button.

Lighting the Shot

In most instances, it's best to light your candid photos with available light, both indoors and outdoors. You won't have time to set up any fancy lighting, nor will you need to. And, of course, when you're shooting outdoors, natural sunlight should provide all the light you need.

That said, sometimes it still helps to use a little flash—or, even better, a little bounce from a speedlight. This is particularly so if the subjects are backlit, as shown in Figure 21.1. In this shot, the fading sunset provides the backlighting, so a little fill flash from the front is necessary to light the main subjects.

FIGURE 21.1

A candid backlit shot with fill flash illuminating the subjects.

If you're shooting indoors, you may need to supplement the available lighting with your camera's flash. If you're using a prosumer or D-SLR camera, I recommend using a speedlight instead of the built-in flash; the speedlight provides a softer, more diffuse light for indoor shots, especially when bounced off a wall or ceiling.

Choosing the Setting and Background

When you're shooting friends or family members in candid settings, you pretty much have to shoot them where they are. However, there may be some choices you can make, even if it's just moving them a foot or two to one side or another.

What a subject is standing in front of is the primary thing to worry about. As with any type of shot, you don't want the background to draw attention away from the subject—unless you're shooting the subject in front of a monument or other notable object, of course.

Instead, you want the background to complement the people in the foreground. If you can, try to isolate your subjects away

Learn more about shooting "on location" in Chapter 22, "Travel and Vacation Photography."

from other people and objects. A plain natural background, such as the beach in Figure 21.2, serves to focus attention on the subjects, with no distractions.

FIGURE 21.2

A candid shot in front of an attractive natural background.

In general, you want to avoid posing your subjects in front of glass windows, mirrors, and other reflective surfaces. You should also avoid brightly lit signage, murals, and other "busy" backgrounds. If you have a choice, darker backgrounds are better than lighter ones, if only to avoid distracting shadows when you're using flash. Of course, that's a generalization; sometimes a brightly colored background makes the foreground subject "pop."

Some of the best candid photos don't have flat backgrounds at all. In fact, the farther away the subject is from objects in the background, the better. If appropriate, go for a shallow depth of field that blurs the background. If not appropriate, get the subject far enough away from the background so that the person's shadow doesn't fall on the wall behind him.

Photographing Individuals

The danger in shooting a candid photo of a single person is that it can look posed. Let's face it; as soon as you tell the subject to smile at the camera and say "cheese," the person is posing.

The challenge, then, is to achieve a truly candid photograph, like the one in Figure 21.3. To this end, a longer lens is invaluable. Shooting someone from across the room or even across the street helps the person forget that the camera is there; the result is a much more candid shot than you'd get closer up.

FIGURE 21.3

A candid individual photo, capturing the subject unawares.

As in the studio, camera flash is to be avoided. If you're shooting outdoors, use natural light; if you're shooting indoors, use either available light or a speedlight with plenty of bounce. Use a shallow depth of field to get an out-of-focus background, and make sure you have just the right amount of shadow on the subject's face.

Photographing Groups

You'll find many opportunities for candid group photography—family gatherings, sporting events, business meetings, or just about any random group of people. Whether you're shooting two people or twenty, the same techniques apply.

If what you really want is a posed shot in a nonstudio setting, you need to revert to some of the studio portrait techniques you learned about in Chapter 20, "Portrait Photography." You may not have the lighting setup to work with, but you can apply some of the other techniques for posing, composing, and even lighting the subject.

Shooting Couples

Dealing with fewer people is easier than dealing with a lot of them. To that end, couples photography can be rewarding.

The key to shooting couples—whatever their relationship—is to capture them interacting. It's the relationship between the two that makes the shot, as demonstrated in Figure 21.4.

FIGURE 21.4
A candid shot of a loving couple.

Whether you're shooting a husband and wife or a brother and sister, try to get them interacting. If you can, position them close enough so that their bodies are in contact. Not only does this force some degree of interaction, it also makes for a nice, tight composition. In most instances, you want to avoid two people standing at opposite sides of the frame with miles of empty space between them.

If at all possible, try to capture the couple in a true candid situation, not posing for the camera. Even if it's an informal portrait, try to get them to relax and have a good time. It's supposed to be a candid shot, after all.

When it comes to lighting, simpler is better. Get both people in the same light, and make sure one doesn't cast a shadow on the other. As with most candid photography, try to avoid camera flash if at all possible; natural lighting is best, and a speedlight is better than built-in flash.

Shooting Groups

It's more difficult to shoot groups of people. Composition, in particular, can be tricky.

With smaller groups, you have many options. While you can shoot three or four people lined up in a perfect horizontal row, you don't have to. Instead, pose them at different distances to create a more interesting shot, as with the one shown in Figure 21.5.

FIGURE 21.5

Vary the composition when shooting small group photos.

With very large groups, the chief challenge is getting everyone in the shot and making sure that everyone's face is visible. This typically results in the short people in front, tall people in back type of photo, but often that's the best you achieve.

Within those confines, you can play around with lines (tall to short, tall in the middle short on either side, and so on) and symmetry/asymmetry. Avoid centered, totally symmetrical compositions; they're boring. Try to break up the lines somewhat, and go for balance rather than exact symmetry. And be on the lookout for interesting settings for your photos, like the playground playset in Figure 21.6; in this instance, the playset helps to create a unique composition for the group shot.

FIGURE 21.6

A large group shot enlivened by an interesting setting.

Focus is also an issue with group candids. In most cases, you want to go for the largest depth of field you can; deep focus is necessary to keep everyone in the shot in focus. That means shooting with a small aperture (high f/stop).

Similarly, you'll probably want to use a fast shutter speed to keep motion blur to a minimum. Remember, the more people in a shot, the higher the odds that someone will be moving when you're shooting. A fast shutter speed helps freeze any unwanted movement.

The same advice regarding backgrounds for individuals applies to group shots. In addition, try to avoid mixing light sources for the group; don't have some people in sunlight and others in shade. Do your best to get everyone under the same light source, and against the same background.

> The larger the group, the more pictures you should take. That's because *someone* will be blinking or coughing or whatever in any given shot. The more shots you have, the more likely you'll be able to find a shot that's flattering to the majority of people there.

Photographing Children

Kid-specific photo advice is necessary for a number of reasons. First, children are less likely to pose patiently for your photos than adults are. Second, you don't really want posed photos of your kids, do you? I think it's a lot better to capture the spirit and energy of kids at play, which you can't do if they're standing still with a fake smile on their faces.

To create the type of candid photo shown in Figure 21.7, keep these points in mind:

FIGURE 21.7

A great candid shot of a boy at play.

- Try to get the shot without the kids knowing you're doing it. If they see you with the camera, they'll either freeze or pose; you want to capture a more spontaneous image. One of the best ways to do this is to keep your distance and use a telephoto or zoom lens. A zoom lens is probably best, as you can quickly adjust the focal length as the kids move back and forth.

- While you're using that zoom lens, zoom in close on the kids. The sure sign of an amateur shutterbug is a shot where the children fill less than half the frame. You want to see your children's faces; the only way to do that is to zoom in on them.

- Because kids move around—a lot—you'll want to use a fairly fast shutter speed.

- As with most types of photography, natural light is best if you can get enough of it. Avoid the harsh light of the camera flash.

- Bend down or kneel down to take your shot. If you shoot from normal adult eye level, you'll be looking down on your kids. Take a kid-level shot to make them appear more important.

Photographing Babies

All babies are cute. Or so my girlfriend tells me; to me, all babies look like Winston Churchill. But not all baby pictures are good pictures. Let's face it; it's tough working with a subject who isn't even aware that you're in the room, let alone interested in striking an attractive pose.

To create a truly interesting baby picture, like the one shown in Figure 21.8, consider these tips:

FIGURE 21.8

A heartwarming baby picture—the kid has a great smile, doesn't he?

- Small babies (younger than six months) don't have a lot of mobility, which means they're relatively easy to pose; they won't move around much on you. You can pretty much put 'em in place and leave them be.

- Older babies (older than six months) are more interesting, but they're also more mobile. You can try to pose them, but they'll move just as

soon as you get back behind the camera. Better to try for a more candid shot, which means using a faster shutter speed.

- If you're not careful, shooting a newborn can result in a photo that looks like something out of *Alien*. Get the baby cleaned up before you shoot, try not to use a flash (that's for the baby's benefit; a sudden flash of light can be upsetting), and then wait for the baby to open his eyes and look like he's actually aware of his surroundings. This will take some patience, but a picture of baby looking around the room is infinitely more desirable than a picture of sleeping baby. You'll have more than enough of those over time.

- As with shots of larger human beings, use your camera's zoom to make the baby's face fill the camera frame. Don't be afraid to get in close!

- With older infants, try to catch them interacting with their environment. Try using various props; a child's favorite toy is always good. It's better to have the baby doing something than just lying there.

- Don't shoot baby from above. Get down to baby's eye level to shoot from the little tyke's perspective.

- A shot of an infant is good, but a shot of an infant and his mother or sister interacting is even better, as evidenced by the shot in Figure 21.9. Capture the love, and you'll capture a great shot.

- Pay attention to the background. A brightly colored towel or blanket can really spruce up an otherwise mundane baby picture.

FIGURE 21.9

Don't limit your baby pictures to babies only.

Photographing Pets

Photographing your family pet is often more complicated than shooting your human family members. There's a lot of work involved in taking a photo like the one shown in Figure 21.10.

FIGURE 21.10

A photo of the family pets—dogs and cats do get along!

First, realize that it's difficult to get your pet to pose. That means you'll be capturing more candid shots, which requires good lighting and a fast shutter speed.

It may be more interesting to have a family member holding your pet. Try to capture the loving interaction between pet and human; as with couples photography, it's the interaction that makes the shot. (In addition, the person in the shot can help to hold the pet still.)

Similarly, it's a good idea to have some of the pet's favorite toys handy. Not only can the toys keep the pet occupied between shots, you can also capture some fun shots of the pet at play. This is especially the case with younger puppies and kittens, who are naturally frisky, anyway.

Next, know that the wrong kind of lighting will result in animal red eye—which is more likely green or yellow. Red eye is worse when you're using your camera's built-in flash, so try to use natural lighting whenever possible. (Shooting outdoors is always a good idea, for reasons beyond lighting.) If you

must augment the available light, use a speedlight with bounce lighting; the key to eliminating pet red eye is indirect lighting.

Of course, you should be prepared to use a relatively fast shutter speed. That's because your dog or cat (or ferret or badger or whatever) will not stay still; animals like to move around. So unless you want to capture Fido as nothing more than a blur moving through the frame, you'll need a fast shutter to freeze the animal's motion.

Finally, there's the question of angle. Don't shoot your pet from human eye level; it's too extreme an angle. Better to lower the tripod or get down on the floor and shoot from the pet's eye level. That's the best way to capture your pet's true personality, as in the shot in Figure 21.11.

FIGURE 21.11

A fun shot of a cat at play, shot at ground level.

Enhancing Candid Photos in Photoshop

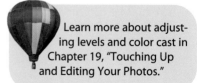

As you'll find throughout this book, we use Photoshop CS for most of our examples, but you can make most of the same fixes in any photo editing program.

One of the hazards of candid photography is getting stuck in imperfect conditions, or with a less than ideal angle on the subject. You may end up with the subject too far away, or with other people or things nearby interfering with the shot. Because you're not in the studio under controlled conditions, you pretty much have to take what you get—except for those things you can fix in a photo editing program.

Enhancing Brightness, Contrast, and Color Balance

Most candid photos can benefit from a bit of brightness and contrast enhancement. You'll probably want to make the blacks slightly blacker and increase the contrast a tad. While you can do this with the Brightness/Contrast control, the better approach is to add a new levels adjustment layer, by selecting Layer > New Adjustment Layer > Levels. Then, when the Levels dialog box appears, adjust the shadows (left) and highlights (right) sliders until the picture looks the way you want it to.

While you're in the Levels dialog box, you might as well correct your photo's color cast, especially if you shot under indoor lighting. Click the Set Gray Point button (the middle eyedropper) and then click your mouse on a neutral gray point in your photo. This automatically corrects the color cast.

Cropping the Shot

When the subject or most important part of your picture is too small, too far away, off-center, or inadvertently overshadowed by something else in the picture, you can use Photoshop to crop that picture down to size. When you crop a picture, you cut off the unwanted parts, effectively zooming in on the part of the picture you want to keep. It's a great way to improve a picture's composition, after the fact, as demonstrated in Figure 21.12.

Cropping a photo is kind of like blowing up the most important part of the picture. It's easy enough to do, using Photoshop's Crop tool. All you have to do is select the Crop tool, draw around that part of the picture you want to keep, and then double-click. Everything outside the area you select is cut off, or cropped.

Learn more about adjusting levels and color cast in Chapter 19, "Touching Up and Editing Your Photos."

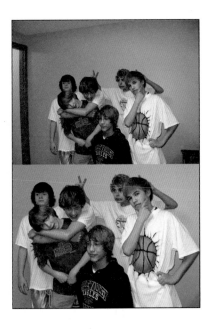

FIGURE 21.12

A poorly composed candid picture, cropped to put the subjects front and center.

Blurring the Background

Sometimes you get a great shot of your subject, but the background is so cluttered that it interferes. That's what we have in the "before" shot in Figure 21.13; the two women in the foreground are in a perfect pose, but all the stuff in the background (including the guy sampling the crock pot) is distracting.

The solution to this and similar problems is to blur the background. As you can see in the "after" photo, this gives the effect of a shallow depth of field; the subjects remain in sharp focus, while the entire background goes out of focus. And that out-of-focus background (and the people and things in it) is much less distracting.

> **STOP** Be careful that you do not crop too much out of a picture. You can end up with too few pixels left for a quality print. This is especially true if you shot at a low resolution, with a low-megapixel camera, or at a small photo size.

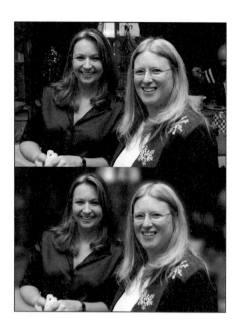

FIGURE 21.13

A busy background blurred for effect.

21

The key to blurring the background is to effectively select everything in the picture *except* the subjects in the foreground—those people you don't want to blur. Don't leave any unselected edges, and don't forget any patches of background unselected.

You blur the background by selecting Layer > New > Layer via Copy. Now select the new layer and select Filter > Blur > Gaussian Blur. When the Gaussian Blur dialog box appears, adjust the Radius control until the background is sufficiently blurry. Click OK when done.

Removing Unwanted Objects—And People

Having the background interfere with the foreground isn't the worst problem you can have with a candid picture. What do you do when you shoot something—or someone—you later wish wasn't there at all?

Although it reeks of the kind of revisionist history you used to see in old photos of the former Soviet Union's top brass, you can

Make sure to put a slight feather (3-5 pixels) around the edges of the selection.

This effect adds an appealing hazy glow around the subject. The greater the feather around the selection, the more apparent the glow.

use Photoshop to totally remove all traces of selected objects or people from your pictures. A few clicks of the mouse, and it's like that thing or person never existed.

Of course, the easiest way to remove an object from a picture is to crop it out. That is, you display only that part of the picture that includes the people you want to keep; you cut off the part of the picture that contains the person you want to get rid of.

The second, more difficult, way to remove someone from a photo is to use the Clone Stamp tool. This method is necessary in a photo like the one shown in Figure 21.14, where the unwanted person can't be easily cropped out without removing the other subjects, as well.

FIGURE 21.14

Removing an unwanted person from a shot.

The key to this technique is to use the Clone Stamp tool to clone adjacent parts of the background over the object you want to remove. This can be a long and involved procedure, depending on how large the object is that you want to remove and how complicated the background is that you need to clone. This method also requires some degree of artistic skill to re-create the background that the person is standing in front of, but it can help save an otherwise unusable shot.

WEDDING PHOTOGRAPHY

Although most couples hire a professional photographer to take "official" photos, there's still plenty of opportunity for us amateurs to snap a few shots, as well. In fact, the last wedding I attended it seemed as if every single guest had a digital camera in hand.

The key to taking candid wedding photos is to be unobtrusive. Don't draw attention to yourself; don't get in the way of the ceremonies; and don't get in the way of the professional photographer. You'll need to shoot from the sidelines, which is okay, because you'll capture things the photographer doesn't. And whatever and wherever you shoot, you should avoid using your camera's flash, especially in the church during the ceremony.

Although you certainly want at least one shot of the happy couple posing to best effect, a better choice is to take those shots that you won't find in the official wedding album, like the bride tossing her bouquet in Figure 21.15. Take shots of the guests at the reception, or the bride and groom interacting casually outside the normal festivities. There's no need to duplicate those shots that the professional photographer is taking.

FIGURE 21.15

Look for candid shots during the wedding ceremony and reception.

Travel and Vacation Photography

I f you're like me, a large percentage of your photographs are taken when you're on vacation. Travel photography is a mix of candid people photography (discussed in Chapter 21, "Candid Photography") and scenic photography (discussed in Chapter 23, "Landscape and Nature Photography"). While those two chapters are essential reads, there are other factors you need to take into consideration when you're photographing your vacations.

Read on to learn how to get the best shots the next time you travel.

Packing the Right Equipment

Before you leave on vacation, you need to pack all the photographic equipment you might need to take great travel photos. Naturally, you can't take your entire studio lighting setup, but there are things you don't want to be without—especially when you're miles away from the nearest camera store.

Here's a quick checklist of the key equipment you'll want to take with you to photograph your next vacation:

- Digital camera
- Wrist strap or neck strap for your camera
- Spare lens cap (just in case)
- Memory cards (one in the camera and a spare in the camera case)
- Rechargeable batteries (and plenty of spares; you don't want to run out of power in the middle of your shooting day)
- Battery charger
- Speedlight (for prosumer and D-SLR cameras)
- Zoom lens (for D-SLR cameras)
- Lightweight tripod or monopod
- Camera case (to carry everything around in)

If you're traveling to the seashore, consider investing in a low-cost underwater digital camera, or a waterproof case for your current camera. You can get some wonderful shots underwater—if you waterproof your camera! (And learn more about underwater photography in Chapter 28, "Special Shooting Conditions.")

As to what type of camera, the same pros and cons hold for travel photography as they do for any other type of photography. A point-and-shoot camera is easiest to carry, especially if you're doing a lot of walking at an amusement park or similar venue. But a digital SLR (D-SLR) will take much better pictures, especially if you're looking to shoot landscapes and other scenic attractions. Some people take both types of cameras; the point-and-shoot goes with them everywhere, tucked into a handy pocket or purse, while the D-SLR stays in the car until it's needed for those spectacular scenic photos. Use whichever approach works best for you.

Before you leave home, make sure you charge all your batteries and clear your memory cards. You want to be able to start shooting with a fresh slate—and plenty of memory space available to store your photos!

Deciding What to Shoot

Mom and dad and the kids in front of the amusement park. Mom and dad and the kids in front of the monument. Mom and dad and the kids in front of the boat dock.

Do a little research before you leave and find out where the most photogenic spots are along your route and at your final destination. There are plenty of travel sites on the Web that will clue you in on what types of shots to expect—and where to get them.

Mom and dad and the kids in front of the hotel. Mom and dad and the kids in front of the rest stop.

We've seen all these shots thousands of times before, and we really don't need to see them again. There are lots more interesting photos you can take on your vacation, if you think creatively. Let me offer some advice.

Take a Mix of Scenic and People Pictures

Some vacationers think it's important to photograph every single place they visit, free of people and other distractions. That's well and good, but what you often end up with is a series of postcards that look nice but interest no one.

Scenic shots are nice, but you need to mix them up with photos that include a human element. Viewers are interested in people—especially in vacation photos. You want to see the kids at Mount Rushmore, or your wife at the beach, or the whole family at the amusement park. Mount Rushmore, the beach, and the amusement park might be photogenic enough on their own, but the shots are much more interesting when people you know are in them.

The key is to take a variety of different types of shots. Yes, shoot that beautiful sunset over the ocean, but then shoot your kids playing in the surf. Mix it up and you'll create a decent travel portfolio.

In addition, when you put a person in the shot, you provide scale. That big scenic monument doesn't look quite as impressive until you pose someone in front of it; that's when you see how big it really is.

That said, you don't want to take the same shot of the same people in the same pose in front of each and every thing you encounter in your travels. If that's how you approach vacation photography, you might as well cut and paste the same people into any scene. Again, variety is the key; have your family pose differently at each stop, to break up the visual monotony.

Tell a Story

You want your vacation photos to be more than just a random assortment of scenic shots. The best vacation photos tell a story.

One way to achieve a narrative flow is to shoot more than just posed shots in front of the destination du jour. Take shots *between* the destinations—your kids passed out in the back seat, or your wife unpacking in the hotel room, or everyone piling

When you're shooting people, don't forget to shoot yourself. The primary photographer in most families ends up being in precious few photos. Give the camera to someone else once in awhile, to make sure you're captured in at least a few shots.

out of the car at a rest area. Take shots that aren't postcard views; capture the human element *living* the vacation, as illustrated in Figure 22.1. They'll be the shots you treasure in future years.

FIGURE 22.1

Capture the human element, not just the destination.

Shoot the Signs

One way to tell a story is to focus on the signs that lead you to and announce your destinations. You may think nothing of the exit sign off your local highway, but a similar exit sign leading to an exotic destination makes for quite an interesting photo. Road signs, restaurant signs, hotel signs, and all the signs at the destinations you visit—they all help identify locales and provide some local color to your photos, as you can see in Figure 22.2.

Capture the Atmosphere

Vacation photographs should do more than document your travels; they should also capture the atmosphere of where you've been.

How best to capture the atmosphere of a foreign city? Photograph the natives engaging in their everyday activities. How best to capture the atmosphere of an outdoors location? Photograph the local wildlife in action. How best to capture the atmosphere of a one-time event? Photograph the crowd doing its thing.

FIGURE 22.2

Photograph signs to add local color to your vacation photos—did you know that tanks have their own speed limit in Kosovo?

You get the idea. Photographing a location is one thing, but capturing the feel of that location is even better. Find the essence of that location, and then figure out how to capture that essence with your camera. It'll be worth the effort, as you can see in Figure 22.3.

Shoot the Wildlife

With some outdoor locations, an important part of the atmosphere is the wildlife. Shooting wildlife is challenging, of course; a lot of it is simply being in the right place at the right time, and then being ready to capture the moment with your camera.

If you're camping or hiking or whatever, that means always having your camera at the ready. You don't want to fuss with lens caps and batteries and memory cards when that deer or antelope or moose ambles out of the woods; you need to be able to aim your camera, focus, and shoot when the moment dictates. Otherwise, you'll never capture a shot like that shown in Figure 22.4.

FIGURE 22.3

Photograph everyday activities to capture the atmosphere of a location—in this instance, bricklayers at work.

FIGURE 22.4

Be ready to capture the moment when an animal appears. (Awesome sunset optional.)

Nature isn't the only place you can take great animal shots; zoos and wildlife preserves also afford interesting opportunities, as shown in Figure 22.5. When you're shooting an animal in a captive environment, try to avoid capturing the surrounding crowds in your shots; also try to keep fences and cages out of the frame. (And if you can't shoot around a fence, shoot *through* it, by getting close to the obstacle, using a long telephoto lens, and then setting a wide aperture to create a shallow depth of field.)

Wildlife photography requires a long zoom lens (at least 200mm at its most extreme), so you can get close to the animals without physically getting close—which you probably won't be able to do.

FIGURE 22.5

Zoos are great places to photograph wildlife—in this instance, a polar bear at the San Diego Zoo.

Don't Skimp—Take Lots of Shots

Finally, one of the keys to successful vacation photography is quantity, which means taking a lot of shots. You can always delete the ones that don't work, but you can't go back and reshoot any shots you missed. So shoot early and often, so you'll have many options to choose from.

Framing Your Shots

When you're on vacation, you often have to shoot under less than ideal locations. While you have to make the best of what you have to work with, you can also employ some basic techniques to get the best possible photos in any situation.

Get Close

The biggest flaw in most vacation pictures is that the main subject—whether that's a group of family members, a monument, or a scenic view—is too small in the frame. It's tempting to try to capture everything your eye can see, but a photograph needs to be more focused than that. When the subject is too small, the photo loses all interest, as you can see in Figure 22.6.

FIGURE 22.6

A typically bad vacation photo—the photographer is too far away from the subjects.

The solution to this problem is simple—get closer! That might mean physically getting closer to the subject, or using your zoom lens to zoom closer. You want the main subject, whatever it may be, to be prominent in the frame, as demonstrated in Figure 22.7.

FIGURE 22.7

Much better composition, achieved by zooming into the people (and the waterfall behind them).

When people are in the shot, you want them to be big enough so you see who they are. You don't want your family to look like a bunch of ants in front of the Washington Monument; get them closer to the camera so they can be seen in the picture. (And not just their heads, either; try to get at least their torsos into the shot.)

This presents a challenge when you're shooting small people in front of large landmarks and monuments. Here you need to get creative—and use distance to your advantage. Instead of posing your family directly next to a large landmark, have them stand an appropriate distance in front of the landmark, as demonstrated in Figure 22.8. This lets you use visual perspective to capture both your family and the landmark large in the same frame.

You may be able to crop a shot after the fact to make your subjects larger—but only if the rest of the shot is composed in proportion. Cropping in Photoshop sounds appealing, but not if you have to crop out something of interest to enlarge the subject appropriately.

22

FIGURE 22.8

Position your family an appropriate distance in front of a large landmark, to get both your family and the landmark into the same frame.

Use Off-Center Composition

When you're posing your family in front of a landmark or monument, not everything can or should go into the center of the frame. A better approach is to use the rule of thirds, and position your family members in the right or left third of the frame. The landmark or monument can then fill up the remaining two-thirds of the shot, as shown in Figure 22.9.

This off-center composition even works when you don't have a landmark in the shot. For example, if your kids are posing on the beach, position them to one side of the frame and let the scenery behind them fill the rest of the shot. It's a much more interesting composition than a simple centered pose—and it gives visual prominence to your location.

Learn more about the rule of thirds in Chapter 10, "Composition."

FIGURE 22.9

A family member positioned to the side of a landmark.

Avoid Stock Poses

If you take enough photographs, your family quickly learns to "assume the position" when you're ready to shoot. The ability to strike a pose is a valuable skill if you're a model, but not if you're the subject of a candid photo. It's better if you eschew the standard poses every now and then for more candid shots. Get your family doing something other than posing, and then take your shot.

What we're talking about is photographing an action shot, like the one in Figure 22.10. Instead of posing at the picnic table, capture your kids digging into their fried chicken and corn on the cub. Instead of posing at the water's edge, capture them splashing in the waves. Instead of posing in front of a landmark sign, shoot them playing around in front of it. You get the idea.

If you must pose a shot, try to do so creatively. Change the angle, move the camera to the side, shoot a silhouette—do anything to create a more interesting shot. You'll have more than enough posed shots in your family album; strive for at least a few that don't look quite so standard.

22

FIGURE 22.10

Action shots are better than posed ones.

Look for Interesting Angles

Speaking of angles, one way to create a unique vacation portfolio is to vary the angles at which you shoot all the standard landmarks. Avoid those shots that everybody else gets (and that you see immortalized on postcards); move your camera back or closer, to the side, up or down, or whatever to create a more unique and more interesting shot of an otherwise well-known landmark. Try crouching down to get a more dramatic angle upward, as shown in Figure 22.11, or move sideways to capture the monument from a side angle. Do whatever it takes to take a *different* photograph from what everyone expects.

Focus on the Details

Sometimes you can create a different photograph by not shooting the entire object. Instead of zooming out to capture all of a large landmark, zoom in to capture interesting details instead, as shown in Figure 22.12. Close-up pictures provide a unique perspective and add variety to your portfolio.

FIGURE 22.11

Choose interesting angles to create unique shots of well-known landmarks—in this instance, the Empire State Building.

22

FIGURE 22.12

Zoom in on the details of a landmark for a different perspective.

Get a Clean Shot

When you're shooting vacation photos of your family, it's your family you want in the photos—not other people. I can't tell you how many pictures I've had ruined by some stranger walking across the shot.

STOP If you're taking pictures of a landscape or large landmark, make sure no unwanted objects—telephone wires, street lamps, cars, airplanes, and the like—are in your shot. If necessary, change your position or shoot from a different angle to remove these objects from the composition.

While it may be impossible to remove all your fellow tourists from the scene, you can still capture good shots of your family if you're patient. Get ready to take the shot, but then wait a minute or so if necessary to let other tourists move out of the frame.

Consider the Lighting

Lighting is one of the things you have little control over when shooting on location; you pretty much have to use the light that's there. That said, when shooting outdoors you do have *some* control over lighting—by choosing the time of day that you shoot.

When shooting outdoors, always try to shoot under the best available light—which means shooting earlier in the morning or later in the afternoon. If at all possible, plan your activities so as to avoid shooting outdoors in the harsh midday sun.

And remember the so-called golden hour. Shooting a landscape, landmark, or other item of interest in the hour just before sunset results in warm tones and dramatic shadows, as shown in the photo in Figure 22.13. This is the time of day to be out shooting—not lounging around in your hotel room!

Learn more about golden hours and other types of lighting in Chapter 11, "Lighting and Flash."

FIGURE 22.13

Boats at a beach resort captured at the golden hour—warm and dramatic.

Enhancing Vacation Photos in Photoshop

In most cases, shooting on location means accepting what you get. You have to deal with less than ideal lighting conditions, fidgety subjects, and distracting objects (and people) in your shots. Fortunately, you can fix a lot of these problems after you get home, using Photoshop or some other photo editing program.

Correcting Exposure and Lighting Problems

Lighting can be a big problem in vacation photos. When you hit a particular destination midday, you have to deal with the harsh direct sunlight. When you arrive someplace on a cloudy or rainy day, you may have the opposite problem—too little light. And underexposure is a very real issue when you shoot inside a museum or historic location.

Fortunately, all these exposure and lighting problems can be fixed in Photoshop. If it's an exposure issue, like the shot shown in Figure 22.14, create a new adjustment layer to adjust the exposure, by selecting **Layer, New Adjustment Layer, Exposure;**

We use Photoshop CS for these examples, but you can make most of the same fixes in any photo editing program.

22

when the Exposure dialog box appears, increase or decrease the exposure to either lighten or darken the overall picture.

FIGURE 22.14
Compensating for an underexposed picture (left) by adding an adjustment layer (right).

You can also use adjustment layers to adjust brightness/contrast and levels, as well as color hue and saturation. If your problem is a too-dark interior photo, you may need to use several different adjustment layers; if the exposure is off, chances are contrast and color are off, as well.

Cropping the Shot

Remember the admonition to always get closer to your subjects? If you didn't listen to that, or just ended up with a few shots where the subject is postage-stamp sized in the frame, you can use Photoshop to recompose the shot via cropping. As you can see in Figure 22.15, selective cropping can turn a mediocre shot (top) into something a bit more interesting (bottom).

Removing Unwanted Objects

It's a common problem; you take a great shot, only to discover some stranger walking through the background. Or maybe you have a good angle for a great shot, but that angle includes a telephone wire or some other obstruction, as in the photo on the left in Figure 22.16.

 If you crop too much out of a picture, you may can end up with too few pixels left for a quality print. This is especially true if you shot at a low resolution, with a low-megapixel camera, or at a small photo size.

FIGURE 22.15

Cropping a shot to enlarge the subject.

You can try cropping the person or object from the shot, but this isn't always a viable option. If worse comes to worst, you can use Photoshop's Clone Stamp tool to clone other parts of the background over the offending object. Just take your time and try to match adjacent parts of the background to the object you want to remove.

FIGURE 22.16

Cloning a distracting telephone wire from a shot.

22

BE CREATIVE—AND HAVE FUN

Vacation photography doesn't have to be boring. Yes, there are stock shots and stock poses that everyone gets, and you should too, but you can do more than that. If you apply your creativity, and let your subjects use their imagination, you can come up with memorable shots from anywhere in the world.

It also helps if your subjects are having fun. For a good example of this, I turn to my nephews Alec and Ben, who know how to have fun just about anywhere. Take the photo in Figure 22.17, taken on a trip to Disney World, where they saw the potential for a fun shot in front of the giant AT-AT Walker at the Star Wars Tour ride. The result is one of my favorite vacation photos in my collection, a really fun shot.

FIGURE 22.17
On the run from the AT-AT Walker at Disney World.

The key to this kind of shot is creativity on the part of both the photographer and the subjects, and the ability to think outside the box of traditional vacation photography. These types of shots don't replace the standard holiday snaps, but do provide added interest to the entire vacation photo album.

23

Landscape and Nature Photography

I love nature photography. I love the patterns that nature produces, the colors—both vivid and muted, the awe-inspiring vistas of the grand outdoors, and the intimate details of a single flower. Some of my favorite photos are nature shots, with not a human being in site.

Nature photography presents its own challenges, of course. Few of the techniques you learned to create portraits and candid people shots apply to photographing landscapes and other scenery. You need the right lens and the right light to shoot great outdoors photos—as well as a good eye for the beauty of nature.

Finding the Right Light

We start our examination of nature photography by talking about the lighting. Of course we're talking natural light—whatever the sun is producing today. But there's good sunlight and bad sunlight, and which you work with determines the quality of your final photograph.

Shooting at the Golden Hours

As you've learned throughout this book, the worst lighting to work with is direct lighting; it's harsh and unflattering. In terms of nature photography, direct lighting is what you get at midday, with the harsh sunlight shining straight down on you and the landscape. For that reason, you want to avoid shooting from mid-morning to midafternoon.

Many pros prefer early morning over late afternoon, as the wind is normally calmer earlier in the day; this makes for less movement in the shot. (In addition, fewer people up are out and about that early, which means fewer human distractions.)

You get much better light when you shoot in the early morning and late afternoon—the hours just after dawn and just before dusk. These are the golden hours for landscape photography.

The golden hours are golden for a number of reasons. First, the color of the sunlight is warmer, which puts a golden hue over the landscape. Second, the light is coming at a low angle, which creates flattering long shadows and reveals the texture of the scenery.

Bottom line, that scene that looks flat and washed out at noon comes alive when photographed in the early morning or late afternoon sun. For the professional landscape photographer, these are the only times of day to shoot.

Shooting Sunrises and Sunsets

Get up a little earlier or keep shooting a little later and you can capture some wonderful sunrise and sunset photos. Obviously, you need to be facing east to capture the scenery at sunrise, and west to capture the landscape at sunset. And you only get about a half hour of shooting, which means you have to be quick about it. But the results are worth the trouble, as you can see in Figure 23.1.

Here are some tips to get the most out of sunrise/sunset photography:

- Try to arrive about an hour before sunrise/sunset. This gives you a half hour or so to get everything positioned before the best shots present themselves.

- To capture a sweeping landscape in the rising/setting sun, use a wide-angle lens. To capture the sun itself dominant in the shot, use a telephoto lens.

- Use a tripod to ensure your camera doesn't move while you're shooting.

FIGURE 23.1

A dramatic shot of the setting sun—look at those colors!

- Turn off your camera's auto white balance mode. In the auto mode, you're likely to lose some of the warm golden tones of the sun. Instead, switch to the "shade" or "clouds" mode, usually used for cool lighting; this forces your camera to warm up the shot a tad.

- Position the horizon at the bottom rule-of-thirds horizontal line. This puts the sunset and sky in the top two thirds of the frame.

- Experiment with different manual exposures. Overexpose to see more of the foreground and blast the sky brighter; underexpose to capture richer colors from the sunrise/sunset itself.

- Shoot silhouettes against the sun, like the one shown in Figure 23.2. Expose for the sun itself, and all foreground subjects will be underexposed to black. The silhouette can be a person, place, or thing; it can even be the horizon itself.

- Don't just shoot the sunrise/sunset; look around you at how other aspects of the landscape are captured in the sun's new or dying rays. Often the best shot will be of some object in the gentle glow of the sun.

- Don't shoot just a single shot; a sunrise or sunset constantly changes over time. You'll capture different colors and different effects over the course of the sun's movement, so shoot a lot of photos to capture all the variety.

23

FIGURE 23.2

A sailboat silhouetted against the setting sun.

Photographing Landscapes

There are many different types of nature photography. We examine the three most common types—landscapes, flowers, and wildlife. Landscapes first.

Put simply, a landscape is that part of the scenery seen from a single view-point. A landscape can include any and all aspects of nature, including fields, trees, and water. You can have mountain landscapes, desert landscapes, ocean landscapes, and forest landscapes. A landscape shot can include structures (farmhouses, barns, fences, and the like) but seldom includes people or animals—unless they're very small in the frame and used to show scale.

Using the Right Equipment

You can use any digital camera to shoot landscapes, although a digital SLR (D-SLR) with a 3:2 aspect ratio produces better results than the squarer 4:3 frame of a point-and-shoot camera; the wider frame produces a more cinematic effect. A D-SLR also lets you shoot in aperture priority mode, which is necessary to set the small apertures necessary to capture a large depth of field.

It may seem odd to use a wide-angle lens to shoot distant scenery and a tele-photo lens to shoot close-up portraits, but that's the way the world of photography works.

Whether you use a point-and-shoot or D-SLR, you want to add a polarizing filter to the lens, to help create richer colors in the sunlight. You may also want to consider a neutral density filter (to compensate for overbright scenes, especially when shooting water) or a graduated filter (to darken a bright sky).

You may also want to consider using a cable release or remote control for your camera. This lets you take the shot without physically pressing the shutter button.

As to the lens, the best lens for shooting wide landscapes is a slight wide-angle lens. A wide-angle lens lets you include more in the frame and opens up the perspective. It also keeps the entire shot in balance without introducing false perspective.

Also useful is a tripod. That's because you'll be using a small aperture, which requires a slow shutter speed. Slow shutter speeds can result in blurry shots if the camera moves during the exposure. Hence the need for a tripod to keep things steady.

Working with Depth of Field and Focus

A large depth of field is part and parcel in landscape photography. You want the entire shot, back to front, in sharp focus. You can contrast this approach with that of portrait photography, where you want the background deliberately blurred with a shallow depth of field.

To achieve the large depth of field desirable in landscape photography, shoot in aperture priority mode with a small aperture—that's a large f/stop, something in the f/8 to f/11 range. The smaller the aperture (larger the f/stop), the greater the depth of field.

To compensate for the small aperture, you'll be using a slow shutter speed and perhaps a high ISO. In addition, you'll want your camera's auto focus set at infinity—or switch to manual focus and focus on the middle distance.

Composing the Shot

Any good landscape photo consists of three distinct parts:

 Foreground. The part of the landscape closest to the camera. You give your photo a sense of depth by putting various points of interest into the foreground. These foreground elements can include small trees or shrubs, flowers, vines or roots, even man-made objects such as picnic benches, boats, or cars. These familiar objects help the viewer determine scale (size and distance).

■ **Middle ground**. The part of the landscape between the nearest objects and the sky or distant scenery. Look for some interesting element—typically part of the scenery, such as a tree or a lake or something similar—to position in front of the background. (And remember, the middle ground is what you manually focus on with your camera.)

When you're shooting in a forest, you can leave out the foreground. Dead branches, leaves, and the like clutter the shot and distract from the beauty of the trees.

■ **Background**. The farthest element in the frame. This may the sky itself, or a distant piece of scenery (mountains, hills, and so forth). All the other elements are framed against this background.

When all areas of a landscape photo are in focus, the viewer's eye wanders. To that end, you want to make sure that each area of the photo—foreground, middle ground, and background—contains some item of interest. Figure 23.3 provides a good example of this compositional strategy.

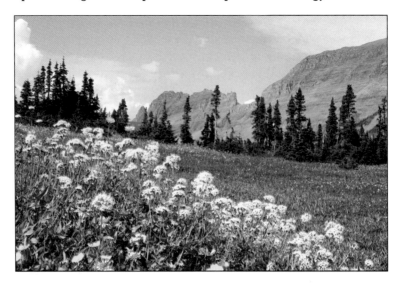

FIGURE 23.3

A landscape with interesting foreground, middle ground, and background.

You should shoot most of your landscapes in landscape or horizontal format. Use the rule of thirds to position the background (top third), middle ground (middle third), and foreground (bottom third) in the frame.

23

Working with the Horizon

The rule of thirds is also used to position the horizon line—at the bottom third if you want to emphasize the sky or background

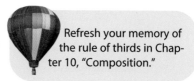

Refresh your memory of the rule of thirds in Chapter 10, "Composition."

elements, or at the top third if you want to emphasize foreground elements. Avoid having the horizon bisect the frame, where it doesn't emphasize anything.

And here's something equally important. When the horizon is in the frame, it must be level. I've ruined too many landscape shots by having the camera slightly tilted; nobody wants to see an ocean that runs uphill. Take the time to level the horizon in your camera's viewfinder; use the viewfinder's grid display, if necessary, to keep it straight.

Working with Lines

Because you typically don't have a dominant subject in a landscape photograph, lines are important.

Lines, you say? That's right, lines—lines created by the natural architecture of the landscape, or by individual pieces of scenery. Lines can be formed by a row of trees, patches of flowers, the ridges of a hillside or mountain range, or the breaking of ocean waves. Lines can even be man-made, such as the road moving into the distance in Figure 23.4. Look for the natural geometric shapes of the landscape, and use them to compose your photos.

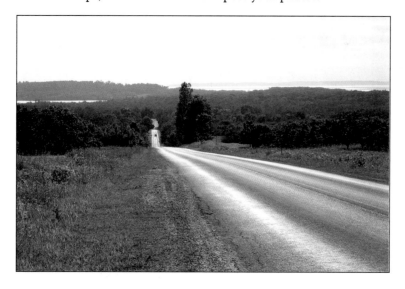

FIGURE 23.4

Use lines to lead the eye and lend interest to a landscape photo.

Horizontal and vertical lines can help frame the scene or provide visual boundaries. They can also, however, serve as "speed bumps" for the viewer, keeping the eye from flowing across the picture. Use these types of static lines judiciously.

Diagonal lines are better; they're more dynamic than horizontal or vertical lines, and help the eye arc across the frame. Look for diagonals that serve as leading lines towards a dominant feature of the landscape, such as a tree or riverbank.

Even better are converging lines—two or more lines coming from different parts of the scene to converge on a single point. Converging lines function as powerful leading lines; make sure they converge to something of particular interest.

Curved lines are also interesting; they add aesthetic appeal to almost any nature shot. S-curves are particularly appealing, appearing in winding rivers and streams, twisting roads, swirling clouds, warped tree trunks and branches, and the like.

Working with Shapes and Frames

Lines aren't the only geometric elements that appear almost by design in nature. Elements of the landscape can create all manner of geometric shapes; you should be on the lookout for these shapes and use them to provide interest to your nature photos.

You can also use natural elements to frame your landscape shot. Look for overhanging branches to provide an upper frame, or a row of plants to provide a lower frame. These framing elements then draw attention to objects in the middle ground of the image, as demonstrated in Figure 23.5.

Provide a Focal Point

All this discussion of leading lines and frames reinforces the point that all photographs—even landscapes—need some sort of focal point. Without a center of attention (not literally centered in the frame, of course), the viewer's eyes wander through and out of the image, without stopping.

What is the focal point of a landscape photo? It can be any dominant element—a tree, flower, boulder, rock formation, building or other structure, fence, silhouette against the sky, you name it. It can be defined by size (largest element), shape (most interesting element), or color (brightest element). Whatever the focal point, all the lines and elements of the photograph should draw the eye to it, as illustrated in Figure 23.6.

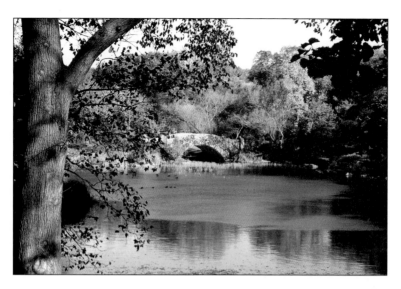

FIGURE 23.5

Let nature frame your shot for you.

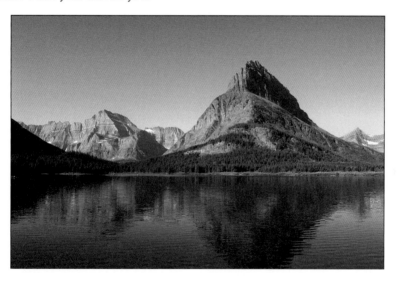

FIGURE 23.6

Draw attention to the focal point of the photograph.

23

As with other types of photography, you should position this main element using the rule of thirds. Try to place it at one of the four points where the rule of thirds lines intersect, or at least along one of the horizontal or vertical lines. Do not place the focal point dead center in the image.

Emphasizing the Sky

When you're shooting outdoors, the sky becomes an important element of your photographs. Unless you're shooting in a heavily wooded forest, most landscape shots will have a prominent sky, typically filling the top third of the frame.

As such, you want the sky to be as interesting as possible. A washed out mid-day sky is to be avoided; the early morning or late afternoon sky (enhanced with a polarizing filter) presents a much deeper color for your photograph's background. Equally if not more interesting are clouds, as you can see in Figure 23.7; in fact, if the cloud formations are dramatic enough, you might want to make the sky the focus of your shot, by lowering the horizon to the bottom third of the frame.

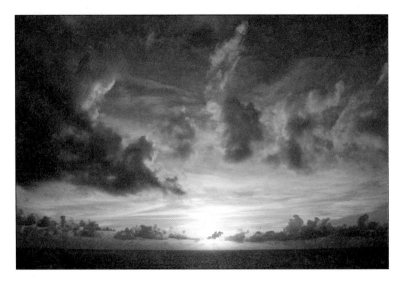

FIGURE 23.7

A dramatic sky can make for an interesting photo.

Dealing with the Elements

Outdoors photography entails dealing with the elements—both personally (don't get too wet on a rainy day!) and in your photographs.

It goes without saying that interesting weather can make for interesting shots. For example, low hanging clouds and fog create a soft, diffused effect, as demonstrated in Figure 23.8.

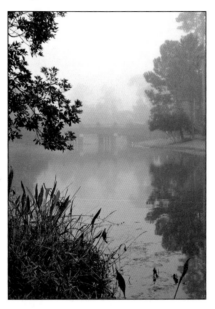

FIGURE 23.8

A foggy landscape.

Some weather is less interesting. For example, when you shoot on a cloudy day (which creates a nice diffuse lighting effect for your foreground subjects), try to keep the sky out of your shot. Gray skies aren't appealing, even if the resulting diffused light is.

Shooting in the wintertime presents interesting challenges. Avoid underexposure caused by the bright white stuff. Bring up the exposure so that the foreground or other subjects aren't in shadow; Figure 23.9 shows how it should look.

The same advice that works for snow scenes also applies to shooting at the beach. The bright sand presents the same challenges as does the white snow.

23

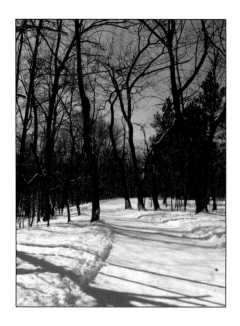

FIGURE 23.9

Step up the exposure when shooting in the snow.

Photographing Flowers

One important subset of nature photography is the flower shot. I'm not talking the typical indoor still life shot; the focus here is on photographing flowers outdoors, in their natural environment or in a flower garden. Let's face it; the most colorful outdoors shots always have flowers in them.

Using the Right Equipment

Shooting a flower or group of flowers is almost the opposite of shooting a scenic vista. Instead of using a wide-angle lens, you want to use a telephoto lens, to get the small flower as large as possible in the shot. A tripod is still helpful, of course, to keep the camera steady. And a polarizing filter is always valuable.

As to the camera, you again want to shoot in aperture priority mode. For this type of photography, you want a large aperture (lower f/stop number) to create a shallow depth of field; you want the background blurry behind the flower. You may need to

We discuss floral still lifes in Chapter 25, "Still Life Photography."

focus manually if the lens is close enough to the camera to fool your camera's auto focus system.

Of course, the key to shooting flowers is to get the plant large in the frame. This means getting physically close to the subject (or using a zoom or telephoto lens to achieve the same effect), at the "eye level" of the flower.

You may want to experiment shooting with your camera's macro mode, which lets you get closer to small subjects. Learn more about macro mode in Chapter 26, "Macro Photography."

Isolating the Subject

Shooting a single flower is different from shooting a patch of flowers in a landscape photo. For this type of shot, you need to somehow isolate that single flower from its background; otherwise, all the other flowers and stems will distract from the main subject.

You may be able to isolate the subject by manipulating depth of field, as shown in Figure 23.10. By blurring everything behind the subject with a shallow depth of field, the flower itself stands out. This is made easier when the background consists of green leaves and stems, rather than similarly colored flowers.

FIGURE 23.10

Use a shallow depth of field to isolate the flower from its background.

Another approach is to place an artificial background behind the flower. This can be accomplished with a simple sheet of black or colored cardboard, without disturbing the natural flower arrangement.

If a flower is being tossed around in the wind, use a piece of cardboard to block the wind. Just make sure the cardboard doesn't show in the frame!

Using Creative Lighting

Natural lighting might not be the best choice when shooting flowers outdoors. Direct sunlight can wash out a flower's colors; the softer lighting of a cloudy day might be a better choice.

Also worth considering is some sort of backlighting, either natural or artificial. As you can see in Figure 23.11, light shining through the petals can really make a flower shine. You can accomplish this by shooting into the sun, or by using a reflector card to bounce the sunlight from behind the flower. Make sure you adjust the exposure to compensate for a strong backlight.

FIGURE 23.11
Let backlighting shine through the translucent flower petals. (Dig that rainbow effect!)

Shooting Raindrops

Here's one of the best reasons to shoot flowers in the natural environment. When you shoot just after a rain shower, you can capture raindrops on the

petals and leaves. There's something especially appealing about raindrops in close-up, whether on flowers, grasses, leaves, tree trunks, or the like. Get as close as you can and work with the lighting to make those raindrops gleam; the effect, as shown in Figure 23.12, really makes the shot.

FIGURE 23.12
Photograph just after a rain shower to capture beaded raindrops.

Photographing Wildlife

One interesting subset of nature photography is wildlife photography. It takes a lot of patience and a fair amount of luck, but capturing a great photograph of a wild animal is particularly rewarding.

It's also somewhat challenging, if only because wild animals don't just sit around waiting to be photographed. Animals in the wild try to avoid human beings, which means you have to seek them out—most often at a distance. It's a matter of knowing where and when to look, but also of being in the right place at the right time.

Using the Right Equipment

I don't recommend using a standard point-and-shoot camera for wildlife photography; the standard 3X zoom just doesn't cut it. You need a much longer

23

zoom or telephoto lens, as you probably will be some distance from the animals. That argues for a prosumer camera with a 12X or 15X zoom, or a D-SLR with a long zoom or telephoto lens; I'd recommend a 200mm lens at minimum.

Naturally, you want a polarizing filter on that lens. And, if the lens is long enough, you might need a tripod to steady it. That said, you may need the flexibility of handheld shooting, so a tripod isn't mandatory.

Instead of using a tripod, try shooting at a fast shutter speed—the fastest your camera and lens are capable of. This minimizes the effect of camera shake if you're going handheld and also helps to capture the animal in motion.

Of course, the fast shutter speed dictates a wide aperture (small f/stop). You'll also want to shoot at a relatively high ISO setting.

Be Patient—And Plan

The key to capturing a wild animal in its element, as in the shot in Figure 23.13, is to be patient. Very patient. Extremely patient. You may have to wait for hours before that animal appears; be prepared for a long wait and for a flurry of action when the time is right.

FIGURE 23.13

Capturing a shot like this requires patience—and planning.

When the animal appears, you need to be prepared and ready to shoot at a moment's notice. Don't be caught unaware.

Because you might only have a second or two to capture a shot of an animal in the wild, you probably want to prefocus your camera. Here is where manual focus is handy. Manually focus your camera on an object near where you think the animal will appear—a tree or fence or whatever. Then, when the animal appears, you're prepared.

> **STOP** Keep your distance from wild animals. Even an animal that appears tame can be dangerous if it thinks it's cornered. There's a reason to use a long telephoto lens when photographing wildlife—it lets you shoot from a safe distance.

Also try to frame your shot beforehand. If at all possible, you want an unobstructed shot of the animal. That means positioning yourself at an angle that minimizes tree branches, leaves, and such between you and the animal. Work it out ahead of time, because you might not have a chance to move after the animal appears.

Shooting Animals in Their Natural Environment

When you're photographing small animals, you need to lower the camera. Don't shoot standing up from above; hunker down to get the shot at their level.

When composing the shot, you don't need to fill the frame with the animal. In fact, you might create a better photo by including some of the surrounding environment in the shot. This also helps to provide a sense of scale.

To avoid blurring the shot of an animal in motion, practice panning your camera. You want to follow the path of the animal as it moves; you may create a bit of a blurred background, but that's a nice effect when the animal is moving.

And here's one final, important tip. If you can, focus on the animal's eyes. Photographing an animal from the rear isn't very interesting, but if you can capture the animal looking at the camera, with the eyes in focus, you have your shot right there. As you can see in Figure 23.14, when you capture the animal looking at you (or at the camera, as it were), you create an emotional connection for the viewer. The eyes are the key.

23

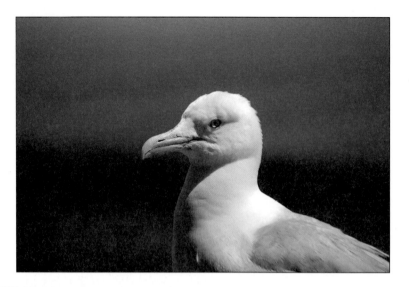

FIGURE 23.14

Focus on the animal's eyes for a more dramatic shot.

Enhancing Nature Photos in Photoshop

Photoshop is the nature photographer's friend. While you're at the mercy of the elements when you're shooting outdoors, you can correct for nature's mistakes when you get back inside, at your computer.

Cropping Wildlife Shots

Photoshop's Crop tool is useful when you're shooting wildlife shots. With active animals, it isn't always possible to keep them properly framed; you may not be able to get close enough to them for a proper composition. As you can see in Figure 23.15, this is where the Crop tool comes in. Crop the photo to make the animal larger in the frame, or to provide better composition. It's not cheating.

Correcting Exposure in Landscapes

Cropping generally isn't a problem with landscape photography, but exposure is. Here's the problem—if you expose for the sky, the foreground is too dark; if you expose for the foreground, the sky is too bright. Unless you use a graduated filter on your camera, you end up with half your photo either under- or overexposed.

23

FIGURE 23.15

Crop a shot to better frame an animal—in this case, a seal at play in the ocean.

The solution is to adjust the exposure for the bad part of the shot in Photoshop. Select that area of the photo you need to fix, and then add an adjustment layer to adjust either exposure, brightness/contrast, or levels.

As in previous chapters, we use Photoshop CS for these examples, but you can make most of the same fixes in any photo editing program.

I prefer to adjust the exposure. After selecting the area to fix (using whatever selection tool you prefer), select Layers > New Adjustment Layer > Exposure; when the Exposure dialog box appears, move the Exposure slider to the left (to decrease the exposure and darken the selected area) or to the right (to increase the exposure and lighten the selected area). Figure 23.16 shows the before and after effect, in this instance adjusting the exposure for an overexposed background.

Depending on the particular photograph, you may get better results by adjusting the levels of the selected area. In this instance, select Layers > New Adjustment Layer > Levels; when the Levels dialog box appears, adjust the shadows and highlights sliders as necessary.

23

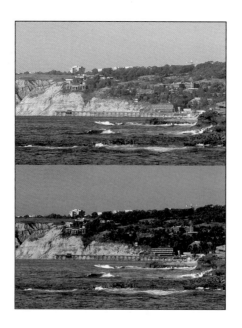

FIGURE 23.16

Fix an overexposed background (top) by editing only that area of the photograph (bottom).

PHOTOGRAPHING THE URBAN LANDSCAPE

Not all landscapes are natural; when you're in a big city, you can capture the hustle and bustle of the urban landscape.

An urban landscape can be captured in shades of gray (via black-and-white photography), in the muted colors of its architecture, or in the surprisingly brilliant colors of its signs and vehicles (especially at night). Figures 23.17 through 23.19 illustrate all three types of shots.

Know, however, that it's not really an urban landscape photo if there are people in it; that's another type of photography, as we discussed in the previous chapter. Although, to be fair, the *evidence* of people can sometimes add interest to an otherwise impersonal shot; use your own best judgment.

Some urban cityscape shots work best with a wide-angle lens; others require a telephoto. To that end, a general-purpose zoom might do the trick. Because you'll be traversing the city on foot, you probably don't need a tripod.

23

FIGURE 23.17

An urban landscape in black and white.

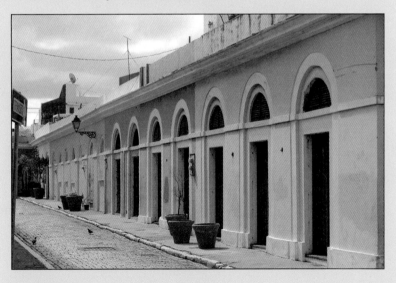

FIGURE 23.18

The muted colors of an urban landscape.

23

FIGURE 23.19

Bright lights, big city.

Depth of field is totally up to you. Some shots work best with the sub-
ject in focus and the rest of the scene not (shallow depth of field);
other shots dictate a deeper focus (large depth of field). As I said, let
the shot decide.

As in all outdoors photography, natural light is the best light; in an
urban canyon, you don't have to worry about direct sunlight washing
out the shot. Look for interesting shadows created by the nearby build-
ings, and play off them. And don't neglect night shooting; the vibe of a
city changes tremendously when the sun goes down and the lights go
on. A cityscape at night can be a truly beautiful thing.

23

Sports and Action Photography

In many ways, sports and action photography is the opposite of landscape and scenic photography. Landscape photography uses wide-angle lenses; sports photography uses telephoto lenses. Landscape photography uses aperture priority and long shutter speeds; sports photography uses shutter priority and short shutter speeds. And so on.

But these two types of photography also have a lot in common. They both require a solid knowledge of your equipment and of photographic technique. They both require practice and skill to perfect. And they both require the photographer to have a good eye for composition.

Of course, the composition in sports photography revolves around the action—the players or vehicles or whatever it is that's moving across the frame. The goal is to capture the excitement of the game in the camera lens. You'll learn how in this chapter.

Selecting Your Equipment

Let's start with the equipment you need to capture the action at just about any sporting event. This equipment advice is informed by the facts that you'll be somewhat distant from the action (you're shooting from the stands or the sidelines, not from the field itself) and that you'll be shooting rapidly moving subjects.

Choosing the Right Type of Camera

We'll start with the camera. Most point-and-shoot cameras, unfortunately, are horrible for sports and action photography. First, the lens isn't long enough; a 3X zoom doesn't get you close enough to the action, especially if you're in the stands. More important, most point-and-shoots have noticeable shutter lag; there's so much time between the press of the shutter and the actual taking of the shot that the action may pass you by.

While prosumer cameras solve the lens problem (a 12X or 15X lens is plenty good to get you up close to the action), the shutter lag problem often persists. If you're not sure whether a given camera is fast enough for action photography, try it before you buy it.

If you're serious about sports photography, there is no substitute for a good digital SLR (D-SLR) camera. A D-SLR lets you use any length lens you want (assuming you can afford it, of course) and has a much, much, *much* faster shutter response. In fact, the shutter lag in most D-SLRs is barely noticeable; you press the button, and the camera takes the shot, just like that. It's worth the investment.

Choosing the Best Lenses

Given that you can use a variety of different lenses with a D-SLR, what lenses are best for action work? I recommend a long zoom lens; the zoom makes it easier to capture action at various distances, as opposed to using a fixed telephoto.

How long a zoom you need depends on the sport you're shooting—and how far away you'll be from the action. For example, a 135mm zoom or telephoto (or its digital equivalent) should work fine for a midcourt seat in basketball, relatively close to the action. For shooting a football or soccer game, however, where you're more distant to the action on a larger field, you may need a lens that goes up to 300mm or even 400mm.

Learn more about choosing lenses in Chapter 8, "Using Different Lenses."

In general, each 100mm in lens focal length gets you about 10 yards in coverage. But don't get too long a lens, or you won't be able to capture action closer to the camera. Or you can do like the pros do—carry two or more lenses, with different zoom ranges, for shooting different distances.

STOP Some venues and events prohibit flash photography. Find out what's allowed before you shoot.

The speed of the lens also makes a difference. Shooting outdoors is easy enough with a low-priced lens, as there's plenty of light. But shooting indoor sports is a different deal; a low-light situation combined with the necessary fast shutter speeds presents exposure challenges. For indoor sports, you may need to spend more to get a faster lens—one that can shoot at wider apertures. For example, an f/4.8 lens might let in enough light for outdoor shots, but you may need an f/1.8 lens for low-light indoor shooting.

And don't ignore the need for a normal or wide-angle lens. Telephotos and long zooms are great for capturing action farther down the court or field, but you'll need a wider angle to shoot close-up action from the sidelines. You can try changing lenses when you need to switch to wide angle, but that might take too much time. A better solution for many photographers is to carry a second camera with a wide-angle lens installed, and switch to that camera for close-up shots.

Using Tripods and Filters

When you're shooting with a long lens, even at fast shutter speeds, it helps to steady the camera with a tripod or monopod. No filters should be necessary for indoor shooting; a polarizing filter is always recommended for outdoor shots.

Getting Ready to Shoot

It takes a lot of preparation to capture a shot of only 1/4000th of a second. Successful action photography is all about doing your homework before that split second when you press the shutter release.

Setting Shutter Speed and Depth of Field

Capturing rapid action requires a fast shutter speed. This means you need to set your camera to shutter priority mode and use one of the fastest shutter speeds on your camera. Most shots can be taken at 1/640 to 1/1000, although you can go even faster if shooting really fast action, such as racing automobiles. Anything slower will result in capturing blurred motion.

24

A fast shutter speed, of course, demands a reciprocal wide aperture (low f/stop number). This results in a shallow depth of field, which is both a blessing and a curse. The blessing is the way the blurred background isolates the subject; the curse is that it requires a fine touch on the focus dial. Get the focus a little bit off, and the player is out of focus, not the background.

If you're shooting with a point-and-shoot camera that doesn't have a separate shutter priority mode, use the camera's built-in sports or action mode instead. This mode should do a good job of optimizing shutter speed, aperture, and ISO to give you a good action shot.

Working with Focus and Prefocus

Whatever sport you're shooting, you need your subject to be in crisp focus. This can be accomplished in many instances by using your camera's auto focus (AF) system, although AF isn't always the most reliable way to go.

The problem with using auto focus in sports photography is that your subject is constantly moving; by the time the AF system locks into the subject, he will probably be some distance down the field. If you focus on where the player was as opposed to where he will be, you get an out-of-focus shot.

You can work around this issue by using your camera's prefocus function. To prefocus, you have to anticipate the shot—know where the action is going to lead. For example, if you're going to shoot an after-the-shot rebound at a basketball game, prefocus on the backboard; if you're going to shoot a baseball play at first base, prefocus on the base itself. Your focus is now locked and ready for the action.

Another option, of course, is to turn off the auto focus and manually focus, instead. Manual focus is a better choice if you're following the action with your camera, moving it to follow the players or the ball. Move your camera with your right hand while you adjust the focus ring with your left; it requires a bit of skill (and a speedy left hand), but you'll always be on top of the focus.

Learn more about using prefocus in Chapter 14, "Focus and Depth of Field."

Anticipating the Shot—And Dealing with Shutter Lag

Timing is everything. You have to anticipate the action to get your camera in position to frame the shot; otherwise, you'll be aiming downcourt when the big play is happening upcourt.

This type of *follow focus* works best when the movement is side-to-side, so that the camera-to-subject distance is not changing substantially.

It helps, of course, if you know a little bit about the sport, so you can predict which way the action will travel. While there are always unpredictable moments that demand a fast response, much of the flow is predictable.

Anticipating the shot becomes even more important if you're using a point-and-shoot camera with a noticeable shutter lag. If it takes a second or so for your camera to respond to a press of the shutter release button, you have to factor that shutter lag into your timing of the shot.

In most instances, you need to press the shutter button slightly *before* the action. It's this anticipation that's tricky, but it's necessary to capture the action at just the right moment.

Some portion of shutter lag is due to your camera's auto focus system; it may take a half-second or more for your camera to properly focus on any given spot. You can thus reduce shutter lag to some degree by prefocusing your camera, or by switching to manual focus mode (if available).

Shooting in Burst Mode

Here's a neat little tip that will help you capture the best shot when everybody's moving around. Instead of squeezing off one shot at a time, set your camera to shoot in continuous shooting or burst mode. This lets you shoot multiple photos in rapid succession, with a single press of the shutter release button. With a D-SLR camera, burst mode may deliver four or more shots per second, which will capture a lot of action; burst mode is slower in point-and-shoot and prosumer cameras, but still useful.

Photographing Indoor Sports

Shooting outdoor sports is tricky enough; shooting indoor sports, as shown in Figure 24.1, adds the challenge of dealing with lower light. And, as you may suspect, mastering the combination of low light and fast shutter speeds is particularly difficult.

First, you may want to dial down the shutter speed just a tad. This lets slightly more light into the camera, which may be necessary. Of course, the trade-off is slightly more blurry action, which argues for the mastery of follow focus, as discussed previously.

Setting a high ISO may also help. The faster (higher) the ISO, the lower the light in which you can shoot. For shooting indoor sports, you want to dial in an ISO of at least 400, and possibly as high as 1600. Do a little experimenting, and choose the lowest ISO setting that delivers the best results.

24

FIGURE 24.1

Photographing indoor sports, such as a basketball game, presents a separate set of challenges.

Because you're shooting in a confined space, you don't have to use as long a lens as you would for outdoor sports. This is a good thing, as a shorter lens is generally a faster lens, the better to let in more light. Leave that 400mm zoom at home and use the 200mm zoom, instead.

> Don't forget to set your camera's white balance control to compensate for the color temperature of the indoor lighting.

What about using flash indoors? I don't recommend it, especially the low-powered flash built into most consumer digital cameras. The weak built-in flash typically doesn't throw far enough to hit the players, so you're just wasting the light. A higher-powered speedlight might reach far enough to hit the court, but I'm still not a fan; you're better off shooting with the available lighting. Of course, that speedlight is useful when shooting the team photo after the game, but that's a different situation.

Composing the Shot

Now we come to the actual composition of the shot. How you frame the action determines whether you have an average or an exceptional action photograph.

Vertical Versus Horizontal Composition

Landscape photography involves a lot of horizontal composition; scenery is most often wider than it is tall. Action photography, however, involves a lot of vertical composition. That's because the players are human beings, and human beings are taller than they are wide.

So be prepared to tilt your camera sideways to shoot in vertical (portrait mode). This is the mode to use when you're capturing a single player in action, like the one shown in Figure 24.2; this orientation lets the player fill the entire vertical frame.

FIGURE 24.2

Use a vertical orientation to capture a single player in action.

If you want to capture a group of players in action, however, it's okay to revert to standard horizontal composition. As you can see in Figure 24.3, this is the only good way to get lots of players into the frame.

Horizontal composition is also called for when you want to convey sideways movement, whether that be down a football field or running track. The widescreen aspect ratio naturally conveys left-to-right or right-to-left movement, as shown in Figure 24.4.

FIGURE 24.3

Use a horizontal orientation to capture a group of players in action.

FIGURE 24.4

Use a horizontal orientation to convey side-to-side movement.

Leading the Action with the Rule of Thirds

When you're shooting action horizontally, you can use the rule of thirds to help frame the shot. Position the main subject in the left or right third of the picture, centered along one of the vertical rule-of-thirds line; as you can see in Figure 24.5, this provides the best balance for the shot.

If you take this approach, you want the player facing into the frame. That is, you want to show where the player (or race car or bicyclist or whatever) is going, not where he's come from. For example, if a race car is driving left to right, position it in the left third of the frame, heading into the right side of the picture. This lets the viewer anticipate the path of pending action, which is a good way to draw viewers into the photograph.

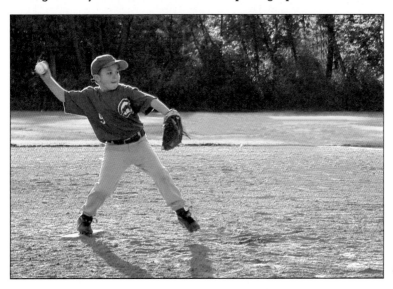

FIGURE 24.5

Use the rule of thirds to lead the subject into the frame.

Focusing on the Individual—Or the Conflict

Another choice you have when shooting sporting events is whether to focus on a single player or group of players. It's a simple matter of what story you're trying to tell.

When you focus on a single player, you're telling the story of that player. This is good when you're trying to document individual accomplishments.

When you focus on a group of players, you're telling the story of the team, or of the team conflict. This is good when you're trying to document the wide action.

24

A third alternative, of course, is to focus on two players in conflict, as shown in Figure 24.6. This is often the most interesting type of shot, as it captures the raw emotion of the sports dual. It may be two basketball players fighting for a rebound, or two hockey players literally fighting; when captured properly, the result can be a dynamic photograph.

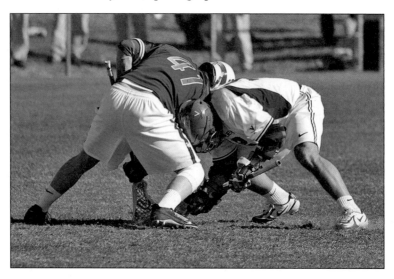

FIGURE 24.6

Create a dynamic shot by focusing on two players in conflict.

Capturing Faces

Action photography is more than just bodies in motion. Each of those bodies has a face, and the face makes the shot. A shot of an athlete's face as he strives for success, like the one shown in Figure 24.7, is much more powerful than one of the back of the same athlete swimming away from the camera.

People like to see faces, all the more so in sports photography, so give it to them. Of course, this is more challenging in some sports than others. Any sport that requires the players to wear facemasks or helmets (football, hockey, and so on) makes face shots difficult if not impossible. If you're close enough to the subject, however, you can use fill flash to get past the shadows cast by the face gear (except with full-helmet sports such as auto racing, of course).

If you have the option of using your camera's LCD display or optical viewfinder, choose the optical viewfinder for composing panned shots. Most LCDs have a slow refresh rate, which produces a jerky picture with fast panning.

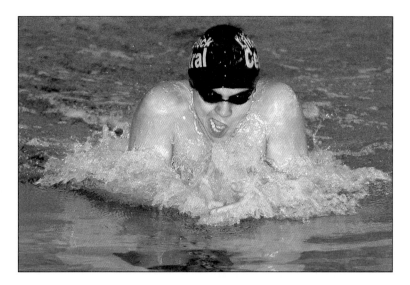

FIGURE 24.7
Make the action personal by capturing the player's face.

Capturing Movement with Panning

When you're shooting an action shot, you have two choices in terms of how you capture the action. You can freeze everything—the main subject and the background—by using a very fast shutter speed and a stationary camera. Or you can convey movement by freezing the subject while the background moves behind it, as in Figure 24.8.

FIGURE 24.8
Pan the camera to show the subject moving past the background.

The movement effect is created by panning your camera with the action. You do this by holding the player in focus in the middle of the frame, and then

moving the camera as the player moves. This blurs the background from side-to-side while the subject alone stays in sharp focus.

Panning is especially effective when capturing the speed of motorsports, horse races, and the like. The streaking effect is accentuated if you can slow down the shutter speed a bit, to 1/125 or less. Panning is also more noticeable when the player is moving against a darker background.

After the Action

The action on the field or court is only part of the story. There's also plenty of drama on the sidelines or after the game. Your camera can capture the dejection of a player prematurely benched or the elation of a team that's just won the title. As you can see in Figure 24.9, it's a different kind of sports shot, but it can be equally dramatic.

FIGURE 24.9
The emotion off the field can be just as dramatic as the action on.

Shooting Different Sports

Every sport is different. The flow of play, the number of players involved, even the speed of the action varies wildly depending on which sport you're shooting. This argues for a keen understanding of each particular sport before you shoot; experience with that sport certainly helps.

To that end, here are some tips and advice for shooting different types of sports.

Football

Covering the large football field requires a long zoom lens, 300mm or larger. If you're shooting night games you'll need a fast lens, as well; with a slower lens, you'll need to boost your camera's ISO speed.

While there are few predictable shots in a football game, the motion itself within a play is fairly predictable. Start by focusing on the quarterback, and then follow the movement of the ball from there, whether on the ground or in the air.

Football is one sport where you don't want to keep a static position. Shooting only from midfield, for example, causes you to miss most of the action. Instead, set up 5 to 10 yards downfield from each play; this way you'll get the ball (and the players) coming toward you. Or, if you want to capture the entire play, get up in the stands a bit.

Basketball

As an indoor sport, basketball requires the mastery of low-light shooting techniques. Fortunately, the small court means that you can use a shorter lens—135mm or so if you're shooting from the sidelines, 200mm if you're shooting from the stands.

There are three predictable shots you can be prepared for—the tip-off at center court, static shooting from the free-throw line, and rebounding off the backboard after a shot. Past that, it's a matter of following the action and being prepared for anything. You can get great individual shots as well as player-on-player conflict. Zooming in on faces or upper torsos is particularly effective.

As to where to shoot from, there are three main choices. You can capture a lot of the side-to-side action from the midcourt sidelines; this also gives you a good angle on the action at both the baskets. Another option is to position yourself under one of the goals on the sidelines; this is good for capturing the player's faces as they battle for the ball, or (with a long zoom) the drive to the basket at the other side of the court. Finally, you can sit in the stands, which gives you a higher angle on the entire court but requires a longer zoom.

Baseball

Baseball is a deceptively tranquil sport. There are long periods with little happening, followed by short spurts of extreme action. You need to be prepared for that action.

24

To capture action anywhere in the infield and outfield, you'll need a long zoom lens—400mm or more at the most extreme. Slightly shorter lenses are usable if you're shooting Little League games, as the field is smaller.

Night games are particularly problematic, as the field is poorly lit by the out-field lights. A fast zoom or telephoto lens is necessary to capture the action without blurring; raising your camera's ISO setting may also help.

There are several predictable shots in the baseball game. Be prepared to cap-ture the pitcher throwing the ball, the batter batting, and the catcher getting a sign from the dugout. After that, action can happen anywhere—runners at any base or any outfielder catching a pop fly. Learn how to follow the ball as it leaves the bat, and get ready to snap as the action develops.

Soccer

The ball and the players are always moving in soccer. The flow of action changes from moment to moment; you can seldom predict the direction of the ball.

That presents a challenge, but it's also fun. Scrap the tripod and use your handheld camera to capture the action. You'll need a longish lens (400mm to cover the entire field) and a mastery of follow focus; auto focus should also do a good job.

Stock shots include players kicking or dribbling the ball, as well as throw-ins from the sideline. Good shots can also come from focusing on the goalies as the action gets close. And, if you're shooting grade school games, don't neg-lect close-up shots on the individual players; cute kids always make for good photos.

Hockey

Like soccer, hockey is a game of constant movement; you never know which direction the puck will go. Action is confined to a smaller area, of course, which means you can use a slightly shorter (300mm) lens. The indoor nature of the sport, however, means you'll also need a faster lens.

One of the quirks of hockey is that you'll probably be shooting through the glass that surrounds the rink. This may affect the angles you can use to avoid reflections off the glass. You also won't have the freedom of movement that you have along the soccer sidelines.

Another unique challenge to shooting hockey games is the ice itself. The bright white ice will lead your camera's auto focus to underexpose the shot; to compensate, you'll need to manually overexpose by at least one stop.

Predictable shots include face-offs and shots on goal. Past that, just follow the action and take shots as they develop.

Winter Sports

The challenge of shooting outdoors in the snow is dealing with your camera's tendency to automatically underexpose the shot; it's the result of all that bright white. You'll need to manually overexpose to compensate.

Whichever winter sport you're shooting, position yourself to capture the athletes at the apex or most extreme part of their action—the skier in midjump, the snowboarder twisting in the air, the bobsled team turning a fast corner. Try to avoid capturing the spray of the snow; you want as clean a shot as possible.

Volleyball

The nice thing about shooting volleyball is that the court is relatively small, and you can probably get close to the action. You won't need a really long lens to do a good job.

Indoor volleyball requires a faster lens to compensate for the low lighting; outdoor volleyball may call for a neutral density filter to compensate for the bright sand.

It's probably a good idea to turn off the auto focus, as you're likely to capture the net rather than the players in full sharpness. Use manual focus and follow the ball; be prepared for both static set shots and dramatic spikes. Go for close-up shots to capture the players' faces in action.

Tennis

Tennis matches can be either indoors or outdoors; choose your lens, shutter speed, and ISO accordingly. You can try following the ball, but that's a bit tricky. A better approach is to focus on a single player, and anticipate that player's swings. You can position yourself midcourt on the sidelines or bleachers to capture either player from the side, or at the end of the court to capture the opposing player face on (with a long telephoto lens). Using a tripod is a good idea.

Track and Field

Track and field is a fun set of sports to shoot. There's a lot of variety with all the different events, from sprinting to long-distance running to shot put to the long jump. And every event presents its own opportunities and set of challenges.

Most events let you get relatively close, which means you don't need quite as long a lens. However, you should still take a long zoom with you, to capture longer-distance runners on the other side of the track.

24

Look for shots that capture the immediate action—the shot put or javelin in flight, the high jumper or pole jumper in midjump. When shooting races, concentrate on the finish of the event; there's nothing better than capturing the winner at the finish line. The best shots in relays, however, are often when the baton is passed. Your position is key in capturing this action.

Gymnastics

Gymnastics events are typically held indoors, with no flash permitted. Like track and field, you have a variety of events to choose from, many occurring simultaneously. Your direct access to events may be limited, which means shooting with a zoom or telephoto lens from the sidelines. Lighting conditions dictate a fast lens; you may also want to steady the camera with a tripod.

Focusing shouldn't be a problem, as most events are confined to their own small space; you don't have to worry about the subject moving out of the shot. Try to capture the athletes at the apex of their action, or, for a different emotional impact, at the finish of their routine. Given the elegant nature of many gymnastic routines, you can achieve some artistic shots.

Figure Skating

Figure skating combines the challenges of gymnastics and hockey. It's an indoor sport in most instances, which provides the expected lighting problems. You probably can't get close to the action, which means using a longish lens; the indoor lighting also dictates a fast lens. A tripod is probably necessary.

You'll be shooting skaters as they move back and forth across the ice, so get comfortable with your follow focus. The bright white of the ice causes your camera to underexpose, you'll have to compensate by manually overexposing by a stop or two.

Swimming

Swimming is primarily an indoor sport, so be prepared with all your low-light shooting tricks. You want to use available light if you can; flash casts unwanted reflections off the surface of the water.

It's that water that presents the biggest challenge in shooting swimmers. For most of the race, the swimmers are underwater. You have to catch them when they rise above the surface to breathe, or at the start and finish of the race. Shoot with a fast shutter to freeze the water in midsplash.

Photographing high divers is another issue and quite fun. You want to capture the diver at the apex of the dive and as the diver hits the water. Both shots can be dynamic.

Motorsports

Automobile and motorcycle racing are some of my favorite sports. The sheer speed of these vehicles can create some exciting shots.

Panning the shot is essential to capturing that speed. A car against a frozen background is much too static; you get no sense of velocity. Instead, pan the shot so that the background (and slower cars) are streaks behind the lead vehicle.

When panning, you want to use follow focus. To capture a car or group of cars moving sideways past your position, prefocus is called for. Get comfortable with the variety.

Auto races are also colorful; all those bright paint jobs and flashy decals help to create interesting shots. Look for color contrasts when composing your shots, as well as two- or three-car duals. The best shots are those with the cars approaching your position and speeding sideways past the camera; avoid shots from the rear, if you can.

The biggest challenge in shooting an automobile or motorcycle race is the size of the track and the fact that you're stuck in a single position. Here is where the length of the average race works to your advantage. If you can move around through the course of the race, do so; racing action is different in different corners, and on the straightaways. Good shots can also be captured in the pits. Of course, you want to be near the start/finish line at the end of race to get the winner capturing the checkered flag. It's a stock shot, but it's a good one.

Golf

Golf is a unique sport in that you don't have to worry about capturing fast action. You should have plenty of time to set up shots of the players taking their shots.

That said, you do have to follow the ball after it's been hit off the tee, and that means tracking the ball over a long distance. You definitely need a zoom lens, and a long one (400mm or more), if you intend to follow the ball down the fairway.

You'll probably need a long lens to capture the golfers, as you can't always get close to the tee or green. Part of the reason for the distance is the necessity of quiet for the players to concentrate on lining up their shots. Be aware of the noise of your equipment, especially your camera's various motors. A golf course is a quiet place; you don't want to be the noisiest person there and distract the players.

Golf is all about predictable shots—off the tee and on the green. Even shots on the fairway are easy to anticipate and set up. Make sure you capture the golfer both before and after hitting the ball; the backswing follow-through is particularly dynamic.

As in previous chapters, we use Photoshop CS for these examples, but you can make most of the same fixes in any photo editing program.

Improving Your Action Shots in Photoshop

The best sports photography doesn't have to be enhanced; it captures the action and the drama of the moment right in the camera lens.

That said, a few Photoshop touchups are common to action photography. We'll examine them here.

Cropping to the Action

When you're using a point-and-shoot camera, it isn't always possible to get as close to the action as you'd like. As demonstrated in the top image in Figure 24.10, it's all too common to capture the entire field when you want to focus on the players around the ball. No problem; you can use Photoshop's Crop tool to make the important action fill the frame. Just remember to compose the crop using the rule of thirds; make the players face into the frame rather than out of it.

Adding Motion Blur

If you accidentally shoot with too high a shutter speed and freeze both the foreground and background, your action shot doesn't have enough action. All is not lost, however; you can use Photoshop to add a little motion blur to the background. (Figure 24.11 shows one such example, a go-kart race enhanced by motion blur.)

To do this, start by selecting the background behind the main player or players. Now create a new layer based on this selected background, by selecting Layers, New, Layer via Copy. With this layer selected, select Filter, Blur, Motion Blur; when the Motion Blur dialog appears, select a relatively large Pixels number (40 or more) and

When dramatically cropping far away action, it helps to have as high a resolution as possible in the original picture. This argues for using a camera with a high number of megapixels—7 at the minimum, and the more the better. This enables your cropped picture to maintain a high-enough resolution for acceptable prints.

The motion blur effect works best when there is obvious left-to-right or right-to-left motion in the shot.

the proper angle for the blur. Obviously, you want the angle to follow the direction of the action in the shot. Click OK to apply the blur and convey some action in your previously static photo.

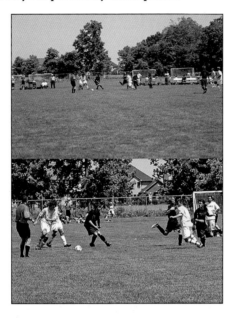

FIGURE 24.10

Cropping a shot so that the action fills the frame (bottom).

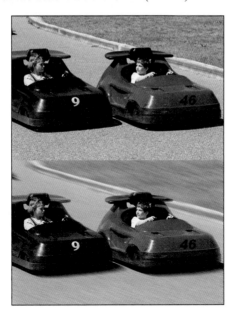

FIGURE 24.11

Adding motion to a static shot by blurring the background.

POSITION MATTERS

The quality of your action shots depends a lot on the position of the camera. An upward angle from the sidelines will create a much more dramatic shot than one taken from high in the bleachers. Both shots are valid; the sidelines shot gets you close to the players, while the bleachers shot provides a higher angle on the action.

In general, the closer you are to the action the better—unless you're trying to shoot the entire court or field, that is. It's generally better to focus on one or two players than the entire team, which is easier to do when you're on the same level as the players. In addition, you have more shots available to you when you can get close and isolate the action.

Of course, you may not always have control over where you are. When you're shooting a junior high basketball game, for example, you're probably going to be stuck in the stands, sorry. Same thing for many sports, from hockey to ice skating, where there's no sidelines to stand in. But if you can get on or near the field, you'll be better positioned for some good shots.

Wherever you are, try to get away from the crowd. The last thing you want is a bunch of heads or the hot dog vendor in your shot. Move around until you have a direct view of the action, no obstructions. You should also try to get what light there is at your back, so your shots will be properly lit without unwanted backlighting. In fact, when you're shooting outdoors, pay particular attention to the backdrop *behind* the field; you may be concentrating on the action on the field, but what's behind the action often works its way into the shot.

25

Still Life Photography

For centuries, artists of all stripes have created stunning images from still life scenes. A still life is nothing more than a grouping of inanimate objects, or just a single object, arranged and lit in an artistic fashion.

In some ways, still life photography is easier than other types of photography; you're working with controlled lighting and composition, and you don't have to worry about capturing movement or finicky human beings. On the other hand, still life photography at its best requires a fine eye and artistic vision—things that not every photographer possesses.

Of course, the field of still life photography encompasses more than just artistic still life photos. The term "still life" also describes the types of product photos you shoot for eBay and other online sites, as well as food photography for advertising and food blogs.

All these types of still life photography require mastery of the same basic skills. Composition and lighting are key, as you'll learn throughout this chapter.

Mastering Essential Still Life Techniques

Whatever type of still life shots you take, the same techniques apply. You need to choose your equipment carefully and shoot with a skilled eye.

Camera Equipment and Settings

Let's start with the type of camera to use. Still life photography can be done with any type of digital camera; unlike other types of photography, you can create impressive still life photos with a low-end point-and-shoot camera just as well as you can with a high-priced digital SLR (D-SLR).

It helps if your camera lets you shoot in aperture priority mode, the better to control depth of field. But you can fake this by using your camera's automatic portrait mode to create a shallow depth of field or sports mode to create a large depth of field.

You want to shoot with either a normal lens or a short telephoto lens (100mm or less). More important, you'll need a camera with a good macro mode, for getting close-up shots of smaller objects.

Also important is a tripod, to steady the camera for rock-solid shots. Consider also a shutter release cable or wireless remote control, so you won't jostle the camera by manually pressing the shutter release button.

In addition to the camera, you need to think about how you'll arrange your still life subjects—and, more importantly, on what. You'll need a table, waist height or higher, large enough to hold your subjects; the table should be able to back against whatever photographic paper or material you use for your background.

Camera Settings

Most still life photographs require a shallow depth of field, so that the background is slightly out of focus. For these shots, use your camera's aperture priority mode and select a large aperture (low f/stop number), somewhere around f/4 or f/5.6.

If you're shooting a larger subject, a shallow depth of field will force some of the subject out of focus. In this instance you want a larger depth of focus, to keep the entire item sharp in the shot. This requires a larger aperture (higher f/stop number), somewhere in the f/22 range.

The smaller the subject, the closer you want to get with your camera. If you find you're so close that your camera's auto focus system isn't working properly, switch to manual focus and see what you can accomplish by hand. For

extremely close shots, or when photograph-
ing very small objects, switch to you cam-
era's macro mode, which is designed for
just this kind of work.

Learn more about using
your camera's macro
mode in Chapter 26, "Macro
Photography."

Background

The background behind your subject is a key aspect of any still life photo-
graph. There are many options for background material, including

- Seamless photography paper in various colors, typically held in place
 by floor-mounted stands.
- Large sheets of single-color construction paper, which functions like
 seamless photography paper for smaller objects.
- Professional cloth or muslin photography backdrops, either single color
 or patterned.
- A single-colored sheet or a few yards of cloth or similar fabric from a
 fabric store, which functions well for photographing smaller objects.
- A piece of black velvet, which works particularly well when photo-
 graphing jewelry and glass objects—it absorbs light and unwanted
 reflections.

A neutral color background works best in most instances. Use a lighter back-
ground for darker objects, and a darker background for lighter ones. A middle
gray background is a good compromise for photographing most items.

The background, of course, should also function as the base. That is, the items
you're photographing should be placed on the background material, which
then sweeps upward behind the items. (Figure 25.1 shows a typical setup for
still life photography.)

Lighting

There is no single best way to light a still life shot. Some photographers prefer
to use natural lighting; others go in for elaborate studio lighting setups. The
only agreement comes in the universal dislike of flash photography; avoid
using your camera's built-in flash in
almost all instances, as it provides uneven
coverage, unwanted glare, and all the
other negatives associated with flash pho-
tography.

Learn more about light-
ing setups in Chapter 11,
"Lighting and Flash."

25

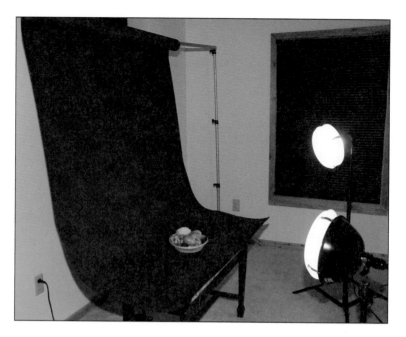

FIGURE 25.1

Base and backdrop for a still life photo session.

Natural Lighting

Many photographers prefer to use natural lighting for their still life photos. Natural light requires no white balance correction; when used correctly, it's also soft and flattering.

Of course, you still need a sufficient amount of light, which presents some challenges. For this reason, some still life photographers set up their shots near windows, to capture the light from outdoors. You can use curtains or other gauzelike material to diffuse this light, as well as employ reflector cards to bounce some of the light back onto the subject.

Obviously, window light is somewhat weak, which means you'll need to set slower shutter speeds to capture more of it through the lens. This dictates the use of a tripod and remote shutter release of some sort, to avoid blurring the long exposures.

Studio Lighting

Other photographers prefer total control over their lighting, which argues for a studio lighting setup. The ideal setup, shown in Figure 25.2, includes a main

25

light with softbox or other diffuser, positioned at a 45-degree angle to the camera-to-subject axis, either right or left of the camera. You can then use a weaker diffused fill light perpendicular to the main light, or a reflector card at the same position.

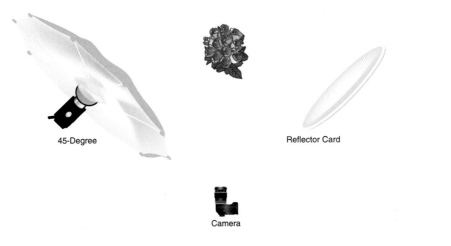

45-Degree Reflector Card

Camera

FIGURE 25.2
The ideal lighting setup for still life photography.

If you don't have this type of studio lighting setup, you can use a speedlight instead. The key is to configure the speedlight for bounce lighting; bounce the light off the ceiling above you or the wall behind. On no condition should you use the direct lighting of your camera's built-in flash.

Creating Artistic Still Life Photos

Any subject can make for an artistic still life photo. Natural objects, such as flowers, fruits, and vegetables, are good. As are man-made objects, such as jewelry, pottery, glassware, even personal items and memorabilia. (Figures 25.3 and 25.4 demonstrate just a few different types of artistic still life photographs.)

The key is to assemble one or more items that develop a theme or tell a story. The items should then be arranged in an aesthetically pleasing manner that reinforces that theme or story. The lighting should also reinforce the visual design and the theme.

25

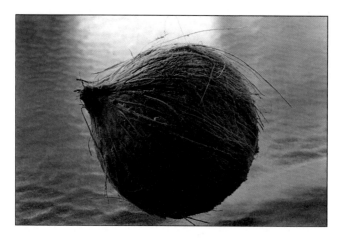

FIGURE 25.3

A still life with a single subject.

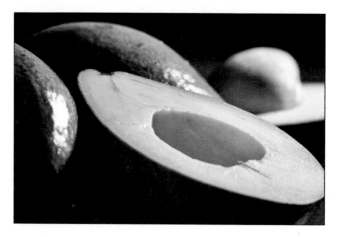

FIGURE 25.4

A group of items, aesthetically arranged.

That said, you shouldn't overthink things—or overdesign the shot. Simplicity is often the best approach; a single subject might be better than a group of items. Or start with a single item, and add items one at a time until you create a pleasing arrangement. Experiment with different groupings until you create the best balance in the frame.

Because you only have a few elements to work with, pay attention to each one. That means experimenting with different lighting effects and with different camera angles. You don't have to shoot every still life at table level; some shots work better at a higher angle, or shot from the side.

Also have an eye for contrasts within the frame. Light and dark, bright and muted, hard and soft, smooth and textured—these contrasts make for a more interesting still life photograph. Seldom do you want uniform texture and tonality throughout the frame.

Of course, the framing is important to a successful still life—and most still lifes have similar framing. You want the item or items to fill the frame; few still lifes incorporate empty space. You can use the rule of thirds to position the heaviest part of the group or item along one of the vertical third lines, or just center the shot. Let your eye be the judge.

Finally, the background shouldn't compete in any way with the items in the foreground. In fact, the background should be so neutral as to be "invisible" in the shot. No bright colors, no distracting patterns, just a single neutral color that highlights the main subject of the shot.

Shooting Flowers

We talked about shooting flowers outdoors in Chapter 23, "Landscape and Nature Photography." Shooting flowers *indoors* is a slightly different proposition—it's a still life shot that requires the same techniques used in other still life photography.

The keys to effective still life flower photography are focus and diffuse lighting. Your camera's auto focus mode is probably not the best way to go. Work in aperture priority mode and set a large aperture (small f/stop) to create a shallow depth of field; this not only blurs the background, but also blurs some of the flower if you're shooting close enough. This is a nice effect but requires careful focus—hence the advice to turn off the auto focus and manually focus on that part of the flower where you want to draw attention. The different depths of the flower will be in different focal planes, so pick the best focal plane to get most of the flower in focus—probably the center of the flower, or maybe the front. This forces the back of the flower slightly out of focus, which lends a feeling of depth to the photo, as you can see in Figure 25.5.

25

FIGURE 25.5

Use a shallow depth of field for floral portraits.

As to lighting, flowers look best in diffused lighting; direct lighting, such as from your camera's flash, often results in harsh reflections and equally harsh shadows. You get much better results by turning off the flash and using an external light with a softbox or some similar diffuser. This puts a nice soft light on all the parts of the flower, more or less equally. You can enhance this diffused lighting by using a similarly diffused backlight, shining through the petals; it makes the flower seem to glow from within.

Backgrounds are also important. Some flowers look best against a black background; others become somewhat ethereal against a glowing white background. Experiment with both white and black backgrounds, depending on the color and nature of the flowers you're photographing.

Also experiment with just how you frame the flowers. You can try to get both the flower and the stem and leaves in the shot, or you can zoom in to let the flower itself fill the frame. More artistic photos can also result from shifting into macro mode and focusing on just part of the petals; most flowers are composed of interesting geometric shapes, as you can see in Figure 25.6.

FIGURE 25.6
Zoom in to just part of a flower for a more artistic shot.

Shooting Product Photos

They may not be artistic, but the product photos that you find on eBay and similar sites need to be every bit as powerful. These are photographs of products for sale; they must provide customers with an effective substitute for seeing the items in person.

A good product photo is almost identical to an artistic still life. You need good lighting to show off the product and to highlight its details (both good and bad—you need to show the flaws as well). The photo has to represent the product to customers on the Web or in a catalog, so it needs to be both accurate and flattering.

The standard still life lighting setup works just fine for product photos. Always use diffuse light from an angle; never use your camera's built-in flash. (The flash creates glare off shiny surfaces; it's particularly bad when shooting shrink-wrapped items.) And always mount your camera on a tripod; it's the best way to ensure against blurry photos.

For shooting smaller objects, such as jewelry and some collectibles, you may want to use a light box or light tent. Put the item inside the tent, and then light the tent from outside. This surrounds the product with a soft, diffused light, perfect for eBay use.

25

Don't worry too much about artistic composition. The key thing to remember is that the product needs to be big in the frame. This means getting the camera physically close to the item, or using a slight zoom or telephoto lens to accomplish the same effect. For smaller products, this may mean using your camera's macro mode.

When creating photos for eBay, don't obsess over high resolution. The photos displayed on the eBay site are decidedly low res; big enough to display comfortably in a web browser but no bigger than that. Whether you do it in the camera or afterward in a photo editing program, reduce the resolution to no more than 500×500, and a little lower is probably okay.

Your main photo should be of the front of the item—but not literally the front. Most items are a tad more appealing when shot from a slight angle. Instead of moving the camera, turn the item so that you're shooting a three-fourths profile, as shown in Figure 25.7. Make sure the product stands out by using a plain black, white, or gray background.

FIGURE 25.7

A typical eBay product photo, shot at an attractive angle.

In addition, for most products you want to take more than one photo. Photograph the item from the angled front, of course, but if the sides and top are important, angle the item (or move the camera) to shoot them, as well. You may also want to shoot close-ups of any product details, as shown in

Figure 25.8—the base of a collectible, the plaque on a painting, the seal on a certificate of authenticity. Photograph anything that's important to potential customers.

FIGURE 25.8

Remember to shoot close-ups of important product details, such as the model number and serial number from inside a guitar.

That doesn't mean that a product photo has to be boring. If it's a grayish, visually boring item, it's okay to put it against a brightly colored background. For that matter, there's no rule against accessorizing the item with a brightly colored item. Use your imagination, and remember that the photos are being used to *sell* the item. You want to make that product as appealing as possible.

Finally, although it's okay to adjust brightness and color to a small degree in Photoshop, it's not a good idea to perform wholesale touchups after the fact. Customers want to see what the product really looks like, not a vision of the ideal product. Use Photoshop to correct for poor shooting conditions, not to touch up flaws in the product.

You should also closely photograph any product flaws. It's important for customers to see both the good and the bad of the product, in extreme detail.

25

Shooting Food Photos

One interesting subset of still life photography is food photography. Food photos are interesting as pieces of art, as subjects of product advertising, and as documentation for the growing number of food blogs on the Web. And, as you might suspect, food photography presents a unique set of challenges.

We divide our discussion of food photography into two distinct types—candid shots, as you might use in a food blog, and professional shots, as you might use in advertising.

Candid Food Photography

A candid food photo, like the one shown in Figure 25.9, is an impromptu still life of an actual plate of food. There is minimal enhancement or "styling" of the food; you're documenting a real dinner at a real restaurant.

FIGURE 25.9

Candid food shots capture reality with no artificial enhancement. (And the dessert tasted as good as it looks!)

When shooting food in the real world, you don't have a lot of fancy lighting to work with. If you're using a point-and-shoot camera you're stuck with using your camera's built-in flash—although you can (and perhaps should) turn it off to shoot under the existing light. If you have a prosumer or D-SLR

camera you can use a speedlight, which produces much better results; position the speedlight to bounce the flash off a nearby wall or ceiling. (Food doesn't look its best under harsh direct lighting.)

Because you'll probably be shooting indoors (unless you're photographing a picnic), color temperature becomes a potential problem. Use your camera's white balance control to adjust for unflattering artificial lighting. The last thing you want is a plate of mashed potatoes to take on that sickly shade of green common to fluorescent lighting.

For best results when shooting under low lighting conditions, shoot with a tripod or monopod. If neither is handy, try to find something on which to steady the camera, even if you're using a point-and-shoot model; the low light will trigger a slow shutter speed, which more often than not results in blurry shots.

Here are a few more tips for taking candid food photos:

- If you don't have a speedlight, ask for a table near a window so you can use outdoor light for the shot.
- Make sure the plate and glasses are clean before you shoot. That means wiping everything down to get rid of smudges and fingerprints that will stand out more in a photo than they do in real life.
- Fill the frame with the dish—which means getting in close, either physically or with your camera's zoom. You may need to use your camera's macro setting to bring the dish into sharpest focus.
- For a more artistic candid shot, switch to aperture priority mode and choose a large aperture (small f/stop) to blur the background in a shallow depth of field.
- Pay attention to the background. Clear the table around the plate, so that stray silverware and napkins don't distract from the main dish.
- Shoot quickly. Food looks its best when it's hot from the kitchen; the longer it waits on the plate, the more wilted or congealed it gets.

And here's something else—not all foods are equally photogenic. Shiny fruits and vegetables can be appealing; a dish with a thick brown sauce, not so much. Unless you specifically need to shoot a dish for a blog post or article, avoid those less colorful, less appealing dishes.

Professional Food Photography

Professional food photography is much different from the candid kind. For one thing, you get to use all manner of lighting and professional photography tools. In addition, you also get to enhance the food—or, in some instances,

25

replace it with substances that look more photogenic and hold up better under studio lighting.

The lighting first. Professional food photographers prefer a variety of direct lighting, rather than diffused lighting; diffused lighting is lackluster, where the stronger shadows from direct lighting create more interest in the shot. You have to be careful in the positioning of the lights, however, to avoid hotspots, particularly off any plates or glassware in the shot.

For such a small still life, the number of lights you use can be somewhat large. In addition to a main light and one or more fill lights placed in front of the food, you can use a key light behind the subject to highlight the top ridge of the food in the shot. This is particularly important when you want to show steam rising from the surface of the food; the light from low and behind shines through and highlights the steam. And, of course, side lighting is necessary to reinforce the shape or texture of a food item.

If you're shooting a food with a wet or glossy texture, position a key light *above* the food. As you can see in Figure 25.10, this creates interesting reflections and highlights on the surface.

FIGURE 25.10

Use top lighting to create reflections and highlights on the shiny surface of certain foods.

A rear light is useful when shooting drinks. As you can see in Figure 25.11, the backlight brings out the translucent color of the liquid. It's tough to position a light behind a glass of see-through liquid, however; you may need to

position the backlight at an angle so that it's outside the shot, use a carefully-positioned mini-LED light, or shine a normal photoflood through a hole in the backdrop.

FIGURE 25.11

Use backlighting to shine through the liquid in a glass.

Because studio lights run hot, some food dishes don't hold up so well. It takes but a few minutes for ice cream to melt, sauces to dry out, and lettuce to wilt. You can postpone the inevitable by using studio flash or strobe lights instead of continuous lighting, but you still have only a limited amount of time before your food turns on you.

 When lighting liquids and anything else in shiny glass containers, take care to avoid capturing a reflection of your lights in the glass. Try bouncing the light instead, or somehow diffusing it.

One solution to this problem is to use "stand in" food. That is, use an artificial prop of some sort to help you set up the shot and the lighting, and then replace the fake food with the real thing when you're ready to snap the shutter.

 When you're working with stand-in food, the real food is referred to as the *hero* food.

Another solution is to use fake food, period. Although this isn't an option for shooting photos for product packaging or

advertising (by federal law), you can get away with substitute food for magazine layouts and cookbooks.

Substitute food can involve completely different substances or special effects for existing items. For example, mashed potatoes can substitute for ice cream, acrylic cubes for ice cubes, and white glue for milk in a cereal bowl. Or you can simulate wet surfaces on fruits and vegetables by using a glycerin spray. You get the idea.

> Enhance your food shot with interesting food-related props, such as napkins, silverware, garnishes, and the like. And don't forget the plates; a visually interesting plate can enhance the appearance of the food it holds.

There are many other tricks for "styling" food for photo shoots. For example, you can use a small propane blowtorch to melt butter on waffles or vegetables, or to create grill marks on meat. Here's another one: You can create steam on demand by microwaving cotton balls soaked in water. Fun stuff.

Whether you use real food, fake food, or "styled" food, the key is to create a shot rich in color and texture. The photograph has to convey the sense of flavor emanating from the food; it has to make your nose twitch and your taste buds tingle.

Enhancing Your Still Life Photos in Photoshop

The best still life photos are perfect in the frame and require no artificial enhancement. But not all still life photos are perfect; that's why we have Photoshop.

Adjusting Brightness and Color

If you don't use the right kind of lighting, or don't properly adjust your camera's white balance control, you can end up with a shot that's too dark and off-color. This is often a problem when shooting quick-and-dirty shots for eBay use. Fortunately, you can use Photoshop to fix these problems without a lot of fuss and bother, as demonstrated in Figure 25.12.

Poor lighting can be adjusted a number of different ways. I like to try adjusting the exposure first, by using an adjustment layer. Select Layer, New Adjustment Layer, Exposure; when the Exposure dialog box appears, adjust the Exposure slider to the right to increase the exposure, thus lightening the photo. If this doesn't make enough of a difference, you can adjust the picture's levels by selecting

> As in previous chapters, we use Photoshop CS for these examples, but you can make most of the same fixes in any photo editing program.

25

Layer, New Adjustment Layer, Levels, and then moving the shadows and highlight sliders as necessary.

FIGURE 25.12

Correcting brightness and color.

The color cast of the photo can be adjusted in several different ways. If you're importing a raw image, you have the option of adjusting white balance during this process. If you're editing a non-raw image, you can try a quick adjustment via the Auto Color command; select Image, Adjustments, Auto Color. If this doesn't quite do the job, select Layer, New Adjustment Layer, Color Balance; when the Color Balance dialog box appears, check the Midtones option and adjust each of the sliders until any white area in the photo is a true white.

Reducing the Image Size for Online Use

One important thing to keep in mind when shooting product photos for eBay or other online use is that you don't want to upload overly large photos. This means you'll need to reduce the resolution or image size of your product photo; for eBay use, you don't want to exceed a 500×500 size. You'll also want to save your final image in JPG format.

In Photoshop, you do this by selecting File, Save for Web & Devices; in Photoshop Elements, select File, Save for Web. When the next window appears, select JPEG Medium and set the width and height no larger than 500 pixels. Click the Save button, and a version of the image is saved in JPG format at the resolution you specified.

Some photo editing programs have more effective tools for removing color cast. For example, Photoshop Elements includes a Remove Color Cast command (select Enhance, Adjust Color, Remove Color Cast) that lets you click an area that should be white and then automatically adjusts the white balance to that area.

25

STILL LIFE PHOTOGRAPHY OUTDOORS

Not all still life photos require elaborate studio setups. A still life image can also be a found in nature, like the one shown in Figure 25.13.

FIGURE 25.13

A still life composition in nature.

There are many opportunities for still life photos outdoors. Leaves in a pond, shells on a beach, pebbles on a path, even litter on a city street can make for striking images. And if nature doesn't get the arrangement quite right, you can take a little artistic license and rearrange things for a better composition.

One nice thing about working with natural still life images is the lighting. You don't have to worry about fancy studio lighting rigs; instead, you have the natural light to work with. Naturally, early morning or late evening sunlight is best for catching dramatic shadows. You can also supplement the available light with a bit of fill flash, as necessary.

The key for outdoors still life photography is to keep your eyes open for appealing natural arrangements of objects. As with all still life photography, look for shapes, color, and contrast; the right composition should be apparent.

Macro Photography

M*acro photography* is the art of taking close-up photographs of very small objects. And it is an art, both in terms of the artistic skill required and the artistic results you can create.

A good macro photograph involves more than just putting your camera close to the subject and pressing the shutter release. You have to master your camera's macro mode, consider the use of a separate macro lens, and figure out the best way to light and focus on the small subject.

Sound like a lot of work for such a small subject? It is—but the results are worth it.

Understanding Macro Photography

The problem with photographing small objects close-up is focusing on them. When you get your camera too close to an object, your camera's auto focus system simply doesn't work. It either refuses to lock in or produces a blurry picture.

26

For this reason, most digital cameras feature a special macro mode. This mode enables focusing at close distances; in essence, it's a close focus mode. When you switch to this mode, your camera is capable of focusing on closer subjects, and you can create stunning close-up photographs, such as the one shown in Figure 26.1.

FIGURE 26.1

A close-up photograph taken using the camera's macro mode.

You want to use the macro mode when shooting close to a subject. On some cameras the macro mode overrides any manual aperture and shutter settings; on other cameras, you can still select aperture or shutter priority mode while in macro mode. If your camera allows, you probably want to use aperture priority and set a large aperture (small f/stop) to create a shallow depth of field. If you can't set aperture while in macro mode, your camera probably sets a large aperture for you.

Choosing the Right Equipment

Great macro photographs can be taken with any type of camera. It's more a matter of technique than equipment— although having the right equipment helps, of course.

The macro mode is just one of the automatic exposure modes on your camera. It's typically signified by use of a "tulip" icon; you select the macro mode from the automatic mode control, or perhaps from your camera's main LCD menu. Consult your camera's instruction manual for details.

Camera Choices

Almost any type of digital camera, including the lowliest point-and-shooter, can take macro photographs; just make sure the camera has a dedicated macro mode.

That said, as with most types of photography, you'll get better results with a digital SLR (D-SLR) camera. When you're using a D-SLR, you have the option of attaching a special-purpose macro lens, which should generate better results than doing macro photography with a standard zoom lens.

26

Lens Choices

Using a normal lens in your camera's macro mode gets you close to true macro photography—but not quite there. The results are more close-up photography than macro photography, but you can still approach the 1:1 ratio.

To get true 1:1 (or greater) macro shots, you need to use a dedicated macro lens, such as the one shown in Figure 26.2. This is an option only for D-SLR cameras, of course; with a point-and-shoot or prosumer camera, you have to use the camera's standard lens for macro work.

FIGURE 26.2
Nikon's 105mm Micro-Nikkor macro lens.

Most major camera and lens manufacturers make macro lenses, in focal lengths from 50mm to 200mm. You can use a smaller focal length when shooting in a controlled studio environment, where you can get the camera physically close to the subject. When you're shooting outdoors, such as for macro insect photography, you can't get as close to the subject, which dictates a longer macro lens. Obviously, the longer lenses are more expensive—approaching $1,000 for the best quality.

For shooting very small items on a table top, a minipod (tabletop tripod) might be a better choice than a full-sized tripod.

Other Equipment

What other equipment do you need for macro photography? A tripod is a must when shooting macro in the studio, as any camera shake whatsoever will be visible in the enlarged images—including shake invoked when you press the shutter button. For that reason, you may also want to invest in a shutter release cable or remote control, so you can take shots without physically pressing the camera's shutter release button.

Setting Up a Macro Shot

Your home studio is the best place to set up a macro shot. Indoors, you can control the lighting, background, and position of both the subject and the camera.

Lighting the Shot

When it comes to lighting a macro shot, there are many options, each with its own pros and cons. These options include

- **Natural light**. Natural light is probably not a good option indoors; there won't be enough of it to properly exposure the small subject. Outdoors, however, this becomes a viable option, especially for insect and other nature macro photography—although, even then, you may want to enhance the shot with a bit of fill flash.

- **Camera flash**. Your camera's built-in flash is not well suited for macro photography. Because the camera is close to the subject, so is the flash—too close, in most instances. First, the angle of the flash may be such that it hits the lens instead of the subject, causing the lens to cast a shadow on the subject. Even if no shadow is cast, the flash might be so close as to overexpose the tiny subject. Finally, you get your normal harsh direct lighting effect—very direct, in this instance.

- **Speedlight**. A much better solution is to use a speedlight or external flash. The speedlight will be far enough away from the subject to eliminate lens shadows; you can also bounce the flash to eliminate hotspots and overexposure. Good results can be obtained by adjusting the flash to hit the subject at a 45-degree angle, or by angling the flash up to bounce the light off a nearby surface or reflector card. Alternately, remove the speedlight from the camera and hold it several inches off to the side of the subject, with a piece of white paper on the other side serving as a reflector.

- **Ring flash**. A ring flash or ring light is a special flash unit that attaches around your camera's lens, as shown in Figure 26.3, thus lighting macro subjects without any lens shadow. While a ring flash will adequately light the subject, it provides a dull, flat light with no flattering shadows. You also end up with the odd effect of a bright foreground and a dark background; many photographers think this looks unnatural.

- **Twin light**. Some manufacturers offer special macro flash units, often referred to as *twin lights*. These small lights are positioned 45 degrees off axis on either side of the camera lens, as shown in Figure 26.4; they connect to a master unit that attaches to your camera's hot shoe. Many photographers believe that a twin light produces a more pleasing lighting effect than the full lighting from a ring flash unit.

- **Studio lighting**. Studio lighting can be used for macro photography, although you may need to dial down the power to get the light close without overhighlighting the subject. One light to the side of the subject with a reflector card on the other side is probably the best approach.

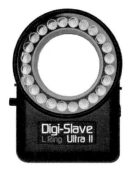 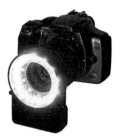

FIGURE 26.3

The Digi-Slave L-Ring Ultra II ring light (www.srelectronics.com), both alone and mounted on a camera.

26

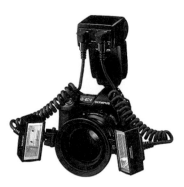

FIGURE 26.4

The Olympus STF-22 twin flash lighting kit (www.olympusamerica.com).

And here's an even simpler approach to lighting small objects—use a normal incandescent desk lamp. That's right, the same gooseneck lamp you have on your office desk can be used to provide effective lighting for indoor macro photography. You'll need to adjust the white balance on your camera, of course, but this type of lighting fixture enables precise positioning of the light, which is what you need when lighting small objects close up.

Also good are small consumer LED lights, such as flashlights or hobby lights. You want the light to be small and flexible enough to get close to small subjects, but not so bright as to overpower the subject.

Choosing a Background

You don't need to think too hard about the background for your macro photos. Simplicity is the key—white or black work well, but any plain contrasting color is good. Besides, the shallow depth of field means that whatever the background is, it will be out of focus in the final shot, as demonstrated in Figure 26.5.

Positioning the Subject

If you're working with an extremely small subject, you probably don't want it lying flat on the table surface. Instead, use a clamp of some sort, perhaps itself mounted on a small block of wood, to lift the item off the table. This not only keeps the item steady, it also provides some "air" around the item so that you don't light the tabletop along with the item.

26

FIGURE 26.5

Macro shots work best with the blurry background associated with a shallow depth of field.

Setting Exposure, Depth of Field, and Focus

Configuring your camera to get the best exposure is relatively easy in macro photography. When you use your camera's macro mode, the aperture is opened up so you get a shallow depth of field; you can achieve the same effect by switching to aperture priority mode and selecting a small f/stop number.

Because of the extremely small depth of field, you'll have to position your subject carefully to place it in the plane of focus. Even then, it's best to use your camera's manual focus mode and eyeball the proper focus through the lens finder. In fact, many macro photographers focus by moving the camera, rather than by adjusting the lens's focus ring. A small movement back or forward makes a big difference when the focal plane is around a centimeter or so.

If your subject itself has some depth, the depth of field issue presents the challenge of where on the subject to focus. As you can see in Figures 26.6 and 26.7, you have to choose whether to focus on the front of the subject, the middle, or the rear. The effect is different with each approach.

FIGURE 26.6
With a shallow depth of field, do you focus on the front of the subject…

FIGURE 26.7
…or the rear?

Framing and Composing the Shot

Composition in macro photography is no different from composition in normal photography. You can position the subject dead center if you want, and this may work well when you're trying to completely fill the frame, but better

results often result by using the rule of thirds. Position the subject in the left or right third of the frame for better effect.

Macro Insect Photography

One specific subset of macro photograph is that of insect photography. As you can see in Figure 26.8, the results can be spectacular.

Most of the challenges of insect photography come from shooting outdoors, rather than in a controlled indoor environment.

STOP One of the challenges of composing a macro shot is to avoid capturing dust, debris, smudges, fibers, and even small hairs that might not be apparent to the naked eye when you're shooting—but that show up remarkably well in the resulting close-up photograph. Keep a clean working environment and always, always check your work on a large computer screen!

26

Shooting outdoors means, in most instances, not using any special lighting setup or a tripod. Handheld macro photography is particularly challenging; you have to hold the camera precisely in position to maintain focus on the small focal plane. For this reason, you might want to consider using a monopod, which is easier to carry around than a tripod yet still gives good support.

FIGURE 26.8

Getting up close and personal with the insect world.

Lighting will most often be natural, although you want to make sure the insect isn't shadowed by its surroundings (leaves, branches, even you, if your

26

back is to the sun). You may want to try using a bit of fill flash from a speed-light, for effect and to remove any lingering shadows.

Because you're shooting with an extremely shallow depth of field, you shouldn't have to worry too much about having a distracting background; whatever's there will be blurry. That said, a field of green behind the subject is much more attractive than a blurred mixture of brown and yellow and who knows what.

The final challenge comes from the fact that you're shooting a living thing. Butterflies and other flying insects like to fly, and thus are tough to catch at rest, as was accomplished in Figure 26.9. Even grasshoppers and praying mantises do their share of hopping around, so you'll need to be quick on the shutter release button. You'll also want to use a relatively fast shutter speed, so you can freeze whatever movement the insect might make.

FIGURE 26.9

A nice shot of a butterfly at rest.

Macro Product Photography

In Chapter 25, "Still Life Photography," we discussed techniques for photo-graphing products for eBay and other online sites. As you learned, general still life techniques apply, although you need to resize the images to fit on the web page.

When the product you're selling is extremely small, however, you need to adopt macro photography techniques. We're talking items such as stamps, coins, buttons, pins, even some jewelry. When you need to get up close to a small product, it's time to shift into macro mode.

There are no super-secret tricks for shooting macro product photos. As with all macro photography, you need to place the item against a neutral background (black is best for most products), arrange appropriate lighting, switch your camera to macro mode, and then take the shot. The result should be a photo that captures all the product's details, like the one shown in Figure 26.10.

FIGURE 26.10
A macro photo of a piece of jewelry, ready for use in an eBay listing.

Lighting is the challenge when shooting certain types of products. Coins and jewelry are particularly reflective, and thus require nondirect or diffuse lighting. A black velvet background helps to cut down on the reflections; using a light box or light tent can provide the diffuse lighting you need.

Enhancing Macro Photographs in Photoshop

To be honest, because most macro photography is done in a controlled studio environment, not a lot of after-the-fact enhancement or correction is necessary in most instances. Nature macro photography, however, is a different story. When you're trying to capture a leaf in the wind or an insect on the

26

wing, you may not always get the subject properly framed. I find that the most-used tool when editing outdoors macro photos is the Crop tool; that insect flying out of the shot can be cropped to more properly fill the frame.

MACRO OR CLOSE-UP PHOTOGRAPHY?

There is some debate as to what exactly qualifies as a macro photograph. By strict definition, macro photography is any shot that reproduces the subject at a 1:1 or higher ratio. At a 1:1 ratio, the photo of the subject is the same size as the subject itself. At a higher ratio, 1:2 let's say, the subject is reproduced twice as large as life.

Photographs with ratios approaching but not quite 1:1 are more accurately defined as *close-up photography*. For example, a ratio of 2:1 reproduces the subject at half its actual size—still pretty good, but not quite life-size reproduction.

So when you're using your camera's macro mode, are you shooting macro photographs or close-up photographs? What you call it doesn't really matter; what's important is that you're capturing small objects in a large fashion, using all the photographic tools available to you. Don't worry about what it's called—focus instead on getting the best possible photograph you can. Figure 26.11 shows such a borderline photo; is it a true macro photograph or just a close-up photo?

FIGURE 26.11

A close-up photograph of euphonium valves—or is it a true macro photo?

27

Black-and-White Photography

When I got my first 35mm SLR camera, I shot a lot of black-and-white film. Even back in the early 80s this was unusual; I had a difficult time finding a film processor that would work with black and white. Still, I thought the results were worth the trouble—and I still do. There's something about a good black-and-white photo; black and white is timeless and imparts a certain gravity to the subject.

The key to understanding black-and-white photography is to understand it's more than just an absence of color. Black-and-white photography requires an understanding of grayscale tonalities, the balance between light and shadow, and the value of texture and shape. When you take the color out of an image, everything that's left becomes more important.

Shooting black and white with a digital camera presents some unique challenges—least of all, the fact that many digital cameras don't have a black-and-white mode. You have to learn how to "see" in black and white while you're shooting in color, and then convert that color image to black and white using Photoshop or a similar photo editing program.

It's a lot of work, but if you like the style, it's worth it.

Shooting Black and White with a Digital Camera

In the 35mm film world, you shot in black and white by using special film optimized for black-and-white images. With this film loaded, your images came out in black and white; no color was possible.

With digital photography, the issue of shooting in black and white isn't as simple. The digital image sensor in your camera captures color images and color images only; those red, blue, and green sensors do just what you think they do. Because the image sensor always captures a color image, shooting in black and white involves removing the color from that image, by some means. How you do so depends on your camera—and on the quality of image you want.

Shooting in Black-and-White Mode

Some, but by no means all, digital cameras have a black-and-white shooting mode. In this mode the color image, as captured by the camera's image sensor, is converted to black and white before it is saved to the memory card. The conversion takes place in the camera; the file stored on the memory card is a grayscale image, with no color information included.

How well this black-and-white mode works depends on your camera. Most low-end cameras, for example, simply remove the color information from the image. The results of this approach are less than ideal, because you really need to adjust the brightness and contrast to best convert the color image to grayscale.

The conversion process is more sophisticated on other cameras. For example, the black-and-white mode on the Nikon D80 digital SLR not only removes the color from black-and-white images, it also applies some degree of tone compensation to the image, thus resulting in a more appropriate conversion from color to grayscale. It also lets you apply in-the-camera color filter effects; you can choose to apply digital yellow, orange, red, or green filters. (As you'll learn later in this chapter, color filters help enhance certain grayscale tonalities.)

To find out whether your camera has a black-and-white mode, check the instruction manual. The mode may be selectable along with the camera's other automatic shooting modes, or it may be buried somewhere in the camera's main LCD menu.

Shooting in Color for Black and White

Not all digital cameras offer a black-and-white mode, however. If your camera doesn't feature black-and-white shooting, you have to shoot in color and then convert those images to black and white in a photo editing program. (We'll discuss how to do this conversion in the "Using Photoshop with Black-and-White Photos" section, later in this chapter.)

More important, even those cameras that have a black-and-white mode might not do a great job converting the color image to black and white in the camera. (The camera's color image sensor still sees color, after all; the camera's "brain" just converts that color image to black and white.) You may have better control over the end results if you shoot in color and do the conversion to black and white yourself.

Which Approach Should You Use?

For casual photographers, shooting with your camera's black-and-white mode (if available) is probably the best approach. Why? Because you'll be able to see the converted black-and-white image on the camera's LCD screen, which helps you better compose the shot.

For more serious photographers, however, you'll get more control over the end photo (and better results, theoretically) by shooting in color and then converting to grayscale after the fact in Photoshop or some similar program. Even the best digital SLRs (D-SLRs) don't do that great a job converting to black and white in the camera; Photoshop offers a lot of more options for how your photos are converted.

Considerations for Black-and-White Photography

Shooting in black and white is a bit different from shooting in color. Besides the obvious fact that there's no color in the image, other aspects of the photo take more prominence. It's a matter of learning how to "see" in black and white—and of working with your camera settings to capture the best grayscale image.

Thinking in Grayscale

A black-and-white photo isn't really black and white; there are many shades of gray between those two extremes. As you can see in Figure 27.1, the grayscale is a spectrum of tonalities, like the colors of the rainbow but in a series of gray tones.

FIGURE 27.1

Grayscale tonal values.

The key to successful black-and-white photography is to master the grayscale. You may want to compose a striking photograph with strong contrast between widely varying shades of gray, or you may want to create a more subtle image with closer grayscale tonalities. What's important is to recognize the tonalities of the grayscale, and make them work for you.

It's particularly important, then, to see the world of color in shades of gray. As you can see in Figure 27.2, different colors translate into different values of gray. In fact, some colors translate into the *same* value of gray; for example, red and green have similar grayscale values. So you need to learn the tonal values of each color, and how they interact. And don't expect eye-catching colors to contrast with each other the same way when converted to grayscale.

FIGURE 27.2

A range of colors converted to grayscale—it's not a linear conversion.

Working with Exposure

When shooting in or for black and white, pay particular attention to the brightness and contrast of the image. A slight overexposure of the image results in lighter tones; a slight underexposure results in darker tones. In other words, you can shift the tonal values of the grayscale lighter or darker by playing around with the exposure settings.

You may also need to adjust the exposure if you're shooting with a color filter. (More on that later in this chapter.) Any color filter darkens some part of the grayscale; you can increase the exposure to compensate, if necessary.

Adjusting ISO

One more thing to know about black-and-white photography. Unless you're shooting for a grainy effect, you should use the lowest ISO setting you can get away with. That's because the increased noise inherent with higher ISOs is particularly visible when the image is viewed in black and white. You'll get a cleaner picture with a low ISO setting.

Composing in Black and White

27

Good composition is good composition. Most of the techniques you've learned throughout this book apply to black-and-white photographs just as they do to color ones. Most but not all, of course.

Obviously, in black-and-white photography you can't use color as a compositional tool. Instead, you have to emphasize the remaining aspects of the picture when creating your compositions.

Choosing the Subject and Background

Let's start with choosing the subject of your black-and-white photograph. Not all subjects do equally well; some subjects that look interesting in color look dull in shades of gray.

The important thing to consider is the tonal makeup of the subject, in grayscale tones. When creating a black-and-white portrait, it's better if the subject is dressed simply and in solid colors, not in prints. When shooting landscapes, make sure that the dominant elements have contrasting tonal values. And in all instances, make sure that the subject's grayscale value is different from that of the background; a red apple on a green background will virtually disappear in black and white, as you can see for yourself in Figure 27.3.

That said, you can shoot just about any type of photograph in black and white. We've all seen romantic black-and-white portraits, subtle black-and-white still lifes, and dramatic black-and-white landscapes. As long as you keep the tonal composition in mind, there's no subject you can't convert into a black-and-white image.

27

FIGURE 27.3

A bad choice of subject and background; the grayscale values of the apple are too similar to the values of the green background.

Working with Contrast

Contrast is the difference between the light and dark areas in a photo and is an essential element in any black-and-white photograph. The amount of contrast in the image helps to define the photograph's overall character.

For example, a high contrast image has an extreme range between light and dark areas, with minimal tones of gray in between. As you can see in Figure 27.4, the contrast between almost-literal black and white helps to separate one element from another and draw the viewer's attention to the main element.

A low contrast image, on the other hand, consists of tonal values primarily in the midrange. That means a lot of grays and few overly dark or bright areas; this type of shot tends to convey serenity and peace, as you can see in Figure 27.5.

Somewhere in the middle are shots with normal contrast. In this type of shot, some things are white, some are black, and some are gray; there is no predisposition toward one or another. An image with normal contrast provides the most "realistic" presentation, although it's often less striking than one with higher contrast.

Some photographers talk in terms of contrast and *key*. A high key image has predominantly light tones, while a low key image has predominantly dark tones. Contrast and key are not the same; a photograph may be low in contrast yet high in key.

FIGURE 27.4

A high contrast image—just what is that thing?

FIGURE 27.5

A low contrast image of a flower.

27

Working with Light and Shadow

Without color to work with, you need some other way of emphasizing parts of an image. One of the most effective ways to do this is with light and shadow.

Diffused lighting is not ideal for most black-and-white photography. Harsher light produces more dramatic shadows, and those shadows provide interest in a black-and-white photograph.

Take, for example, the photograph in Figure 27.6. It was taken late on a sunny afternoon; the low angle of the sun creates long shadows that are not only interesting in and of themselves, but also help to accentuate the texture of the sidewalk. Taken in the more diffuse light of a cloudy day, this shot would be far less appealing.

FIGURE 27.6

Dramatic shadows from low direct lighting.

You can also use light and shadows to lead the viewer's eyes to a particular point in the picture, or to frame the main subject. When working outdoors, it pays to wait for the right lighting; when working indoors, you can use lights, reflector cards, and gobos to deliberately cast shadows on your subject. I particularly like the photo in Figure 27.7, which was staged to cast a patterned shadow on the subject's face; it's a very film noir-like effect.

Learn more about reflectors, gobos, and other studio lighting accessories in Chapter 11, "Lighting and Flash."

FIGURE 27.7
A black-and-white portrait with deliberate film noir-like shadows from nearby window blinds.

Emphasizing Texture

Without color to interfere with the image, black-and-white photographs are great for emphasizing texture. As you can see in Figure 27.8, certain textures photograph well in black and white.

What kinds of textures are we talking about? Anything with definite pattern, such as wood grain or certain textiles, capture light and shadow in a way that really pops in black and white. Try shooting the veins in a plant leaf, the weave in a sweater, even the wrinkles on an old person's face. You'd be surprised how the lack of color makes the texture more prominent—and visually interesting.

Using Lines and Shapes

Similar to the way texture works in black and white, lines and shapes take on more significance in a black-and-white picture. You can use lines and shapes to lead the viewer's eyes through the image to the main subject. Think of a fence in a field, rocks along a cliff, even a row of birds in flight; the lines are more noticeable in black and white than they are in color.

27

27

FIGURE 27.8

Texture is emphasized in black-and-white photographs—like this close-up shot of the surface of a cymbal.

And, remember, light and shadows can create lines and shapes; the contrast itself becomes an element in the photograph, as illustrated in Figure 27.9. Follow the contrast between dark and light areas and see how it forms patterns and leads your eyes. Just remember good compositional technique—diagonal lines work better than straight vertical or horizontal ones.

FIGURE 27.9

Use the contrast between light and dark areas to emphasize different areas of the photo.

Using Color Filters to Control Contrast

As you learned in Chapter 9, "Using Filters," you can control and enhance the contrast of black-and-white photos by using color filters. That's because each individual color has its own distinct gray value when rendered in black and white. You can thus control the tonal value of a black-and-white shot by using color filters to enhance the saturation for specific colors—that is, you use a color filter to make areas of that particular color appear darker in the black-and-white image.

For example, the color blue is captured as a relatively light shade of gray, which might not produce enough contrast to the sky in outdoors shots, as demonstrated in Figure 27.10. The color red, however, registers as a darker shade of gray. To make the sky darker and provide more contrast in a black-and-white shot, use a red filter to turn the blue sky to red, and thus to a darker shade of grey, as shown in Figure 27.11.

27

FIGURE 27.10

A black-and-white landscape shot without filters; the blue sky registers as light gray.

27

FIGURE 27.11

A black-and-white landscape shot with a red filter, to darken the sky and enhance contrast.

Here are some of the more common filter uses in black-and-white photography:

- To darken the sky in outdoors shots, choose either a yellow, deep yellow, or red filter. (The effect is more dramatic as you move from the lighter yellow to the darker red.)
- To lighten green foliage and provide more detail in shots of plant life, use a green filter.
- To provide more pleasing skin tones outdoors, especially against a blue sky, use a green filter.
- To reduce haze in distant scenes, use a yellow filter.
- To enhance shadows in snow scenes under a blue sky, use a deep yellow filter.
- To make water look darker under a blue sky, use a yellow filter.
- To enhance the brilliance of a sunset, use a yellow filter.

As you can see, a handful of color filters (red, yellow, and green) provide a wide variety of uses when shooting in black and white. It's a small investment if you're serious about black-and-white photography.

You can also apply virtual color filters to a black-and-white photo from within Photoshop—which we'll discuss in the "Converting from Color to Black and White: The Better Way" section, later in this chapter.

Just make sure you use the filter when shooting—even if you're capturing a color image to later convert to black and white.

> As in previous chapters, we use Photoshop CS for these examples, but you can make similar adjustments in any photo editing program.

Using Photoshop with Black-and-White Photos

When using a digital camera to shoot black-and-white photos, your photo editing program is your most useful tool. You can use Photoshop or any similar program to convert color photos to black and white; enhance the contrast of black-and-white images; apply color filters to enhance the grayscale equivalents of specific colors; and add spot color back into a black-and-white photo. Read on to learn more.

Converting from Color to Black and White: The Easy Way

At its most basic, converting a color image to black and white involves removing the color (chrominance) information from the image. There are several ways to do this from within Photoshop; we'll look at the easy way first.

The simplest approach to converting a color picture to black and white involves a single step. Load the original picture into Photoshop and then select Image>Mode>Grayscale. This discards all the color information from the image, replacing it with a single gray channel.

Although this approach is easy, it unfortunately produces the least satisfactory results; you don't get deep blacks or bright whites, and the resulting contrast leaves a lot to be desired. If you go this route you should then adjust the new picture's brightness and contrast, ideally via a new adjustment layer (select Layers>New Adjustment Layer>Brightness/Contrast).

Converting from Color to Black and White: The Better Way

A more satisfactory black-and-white image is created when you use Photoshop's Black & White adjustment layer. This feature lets you determine how much of the information in the original color channels are fed to the converted black-and-white image. The result is similar to using color filters when shooting black and white. (Figure 27.12 shows a color photo converted to black and white using both the grayscale and Black & White adjustment layer methods.)

FIGURE 27.12

Converting a color photo to black and white, using both the grayscale (middle) and the Black & White adjustment layer (bottom) methods.

To convert in this fashion, open your original color photo and select Layers>New Adjustment Layer>Black & White. When the Black and White dialog box appears, as shown in Figure 27.13, you have two ways to proceed.

First, you can pull down the Preset list and select a specific type of filter adjustment—blue, green, high contrast blue, high contrast red, infrared, maximum black, maximum white, neutral density, red, yellow, or custom. These selections have the effect of applying the specified filter to the original photograph.

Alternately, you can adjust any or all of the color sliders to increase or decrease that channel in the grayscale mix. Watch the results in the Preview window to see how moving each slider affects the resulting black-and-white image. For example, increasing the Red slider makes red areas of the picture lighter; moving the slider to the left makes red areas darker. The same for the other color sliders.

The result is a much better-looking black-and-white image—and one better tailored to your personal tastes. You still may need to tweak the brightness and contrast, however, but you'll start out a lot closer to what you want than if you use the simple grayscale conversion technique.

FIGURE 27.13

Using Photoshop's Black and White dialog box to convert an image to black and white.

Adjusting Brightness and Contrast in Photoshop

Most black-and-white images require different contrast and brightness settings than do their color counterparts. Figure 27.14 shows how adjusting these parameters can really punch up a black-and-white photo.

FIGURE 27.14

A converted image after adjusting the brightness and contrast.

Contrast is more important in black and white; you don't have the different colors to help contrast one area of the image with another. For that reason, you may need to tweak the brightness and contrast of an image after you

convert it, to make the blacks blacker and the general contrast higher. This is easy enough to do via an adjustment layer. Select Layers>New Adjustment Layer>Brightness/Contrast; when the Brightness/Contrast dialog box appears, adjust the sliders as necessary. I find that most converted images look better with a slight increase in contrast; the brightness can go either way, depending on the image.

If the Brightness/Contrast control works for you, great. However, serious photographers skip this adjustment and go directly to the levels control, which provide more refined results. To do this, select Layers>New Adjustment Layer>Levels; when the Levels dialog box appears, adjust the shadows and highlights sliders as necessary.

Adding Spot Color to a Black-and-White Photo

If you want to get creative, you can use Photoshop to add color *back* to a black-and-white photo. As you can see in Figure 27.15, just a spot of color can draw attention to a specific item in the picture; it's an effect you see a lot in advertisements.

FIGURE 27.15

A black-and-white photo with a spot of color—love that red hat!

There are a few different ways to accomplish this effect. One of the easiest ways, and the way to retain the original color, is to not convert that area to

black and white in the first place. To do this, you start with the original color photograph and select all of the image *except* the area you want to stay in color. You then use one of the previously discussed methods to convert the selected area to grayscale. What you end up with is the entire image in black and white except for the nonselected area, which remains in color.

The other way to go is to convert the entire image to black and white, using a Black & White adjustment layer. Select the adjustment layer and then use the Eraser tool to "erase" the black and white adjustment for the area you want in color. Whatever you erase reclaims its original color.

WHY SHOOT IN BLACK AND WHITE?

Like many photographers of my generation, I learned to shoot in black and white. I appreciate the impact and mood of a good black-and-white photo, as far too few people do these days. With color photography so dominant, why would you want to shoot in black and white?

First, there's the impact or feel you get from a black-and-white photo. A color photograph is fully representative of the subject, but a black-and-white photo has an air of timeless elegance about it. Put another way, most color photographs are ordinary, while a black-and-white photograph can be special, even a work of art.

In addition, some images simply look better in black and white. The vibrancy of color can sometimes detract from the desired effect; black and white better presents subtle details of texture and lighting that are lost in most color photographs. A drab color shot can often be turned into a spectacular black-and-white photograph.

Black and white is often a better choice when shooting outdoors on an overcast day. In color, the cloudy lighting desaturates the color, making your photos look bland and washed out. In black and white, the same photos gain an appealing moodiness; the focus moves away from the color (or lack of it) to the shapes and textures of what you're shooting.

I'm also a big fan of black-and-white portraiture. In shades of gray, uneven skin tones are mellowed and blemishes don't stand out as much, creating a more flattering portrait.

Black and white is also a good choice when you're shooting in difficult lighting conditions. Direct light is less harsh in black and white; where

27

it might wash out the colors in a color photo, it simply adds contrast to a black-and-white shot. In fact, the very kind of high contrast lighting that can make a color photo unusable works to your advantage in black and white. And, of course, you don't have to worry about artificial lighting and color casts when there's no color in the image.

Finally, on occasion I use black-and-white conversion to save an otherwise hopeless shot. Sometimes there's little you can do to make the original work in color, especially if the color balance or saturation is way off. But when you remove the color and twiddle the contrast and brightness a bit, the result may be a perfectly fine black-and-white photo. When color isn't working, it's black and white to the rescue!

27

28

Special Shooting Conditions

Throughout this part of the book we've covered all different types of photography, from portraits to landscapes to black and white and to macro photography. But we haven't covered all possible shooting conditions—there are still a few different scenarios you may encounter that don't fit in any of the standard categories.

That's what this chapter is about.

Night Photography

Let's start with the topic of night photography—shooting outdoors after the sun has gone down. What's there to shoot at night, you might ask? The answer is, plenty, especially in a city environment rife with night life. You might want to shoot your friends outside a theater, for example, or the bright lights of the big city, or taxis driving down a rainy street, or any number of other equally interesting shots.

The question is, how do you take a photograph at night when there's not enough light to shoot?

It all depends on what type of night scene you want to capture.

Photographing People at Night

We'll start with a fairly common type of night photograph. You're out on the town with your friends and want to record the occasion in a photograph. You just happen to have your digital camera with you, but how do you light and capture the shot?

This is actually one of the easiest types of night shots to do, thanks to the night or night portrait mode found on even inexpensive point-and-shoot digital cameras. Switch your camera to the night/night portrait mode, have everyone say "cheese," and you end up with a shot like the one in Figure 28.1.

FIGURE 28.1

A candid portrait at night.

Night portrait mode works by setting a slow shutter speed and wide aperture, and then activating the flash. The combination of slow shutter and wide aperture brings in enough light to let you see the background, while the flash provides foreground lighting for your subjects.

With a digital SLR (D-SLR), you can capture the same effect (and fine-tune it) by manually setting both shutter speed (slow) and aperture (wide). You can then use a speedlight or your camera's built-in flash to provide the foreground lighting.

Photographing Night Scenes in Ambient Light

When you don't have to worry about lighting a foreground subject, you can take night shots using ambient light. This is a good approach when shooting lit buildings or monuments, as in Figure 28.2.

FIGURE 28.2

A lighted building at night, shot with available light.

There are several tricks to shooting in low ambient light. (And there is light at night, just not much of it.) These include

- Switch to shutter priority mode and set a slow shutter speed to take a long exposure—1/15 or longer. (In very, very low light, you might be talking about exposures in terms of several seconds.)
- Avoid blurriness from those long exposures by using a tripod, and possibly a cable release or remote control for your camera's shutter, both to minimize unnecessary camera movement.
- Set a high ISO. The higher the ISO, the faster the shutter speed you can use. (And you'll get less blur from movement in the shot with a faster

28

shutter.) For example, an ISO of 100 might require a 2-second exposure; increasing the ISO to 400 might let you use a 1/2-second exposure, instead. Know, however, that higher ISO speeds result in more noise or grain in the photo—which isn't necessarily a bad thing. Experiment with ISO settings of 200, 400, and 800.

- Turn off the flash. You may have to do this manually, as most digital cameras automatically fire the flash in low-light conditions. But if you want to capture the nighttime mood, flash will ruin the shot. In addition, your camera's built-in flash is only strong enough to hit foreground subjects a few feet away; it won't do a thing about lighting that building down the street.

You can also use these techniques to shoot inside a building from the outside, through a window, as shown in Figure 28.3. Expose for the scene inside the window, and then bracket the shot by a few stops. You may find that a slight overexposure is necessary to capture details outside the window.

FIGURE 28.3
The view from outside a shop at night.

Photographing Moving Lights

Figure 28.4 shows another popular type of night photograph—the streaking lights behind moving cars. It's a colorful shot rife with motion, and it's not that hard to do.

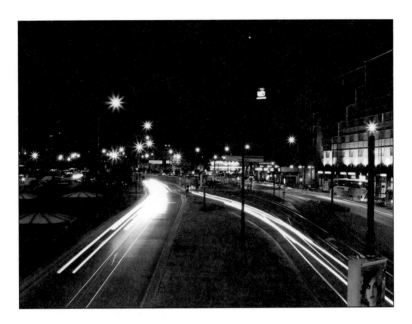

FIGURE 28.4
Downtown traffic becomes a colorful blur at night.

The key to this type of shot is a very long exposure; the longer you keep your shutter open, the more of the streaking light you'll capture. Put your camera on a tripod, turn off the flash, and set your shutter speed for somewhere between 5 and 20 seconds. (You'll need to experiment.) The more the lights streak, the more ghostly the cars themselves become.

Photographing Fireworks

Here's a special subset of night photography—shooting fireworks displays. As you can see in Figure 28.5, these can be stunning photos, if you set up everything correctly.

Here's what you need to do:

- Steady your camera on a tripod, and consider using a cable release or remote control.

- Aim at that portion of the sky where you expect the fireworks to display.

If you use a tripod, lock your camera in one position for multiple shots. You can later combine those shots in Photoshop (via copying and pasting) to create a multiple-burst photograph.

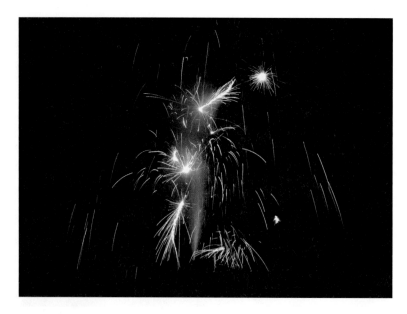

FIGURE 28.5

Fireworks!

- Switch your camera to shutter priority mode and set an exposure of 1 to 4 seconds. The longer the exposure time, the more of the burst that will be recorded.

- If you have a choice of aperture (full manual mode), go with a midrange setting between f/8 and f/16.

- Choose a low ISO, around 100; you don't want a lot of noise in the shot.

- Turn off your camera's flash. It isn't strong enough to hit the fireworks hundreds of yards away.

In addition, you have to choose the proper orientation for the photograph. I find that a vertical orientation works best for most displays, but your experience may be different.

Photographing Through Windows

What do you do when you see a great shot as you're driving down the road—or flying in a plane? The problem is that little piece of glass between you and your subject; what you want to shoot is outside the vehicle, and you're inside it.

As you can see in Figure 28.6, it's possible to take good photographs through a window—any window. You can shoot out the window of airplane, through the windshield of a moving car, or even out (or in) the window of a house or other building. The key is remembering that you're shooting a subject on the other side of the glass, not the glass itself.

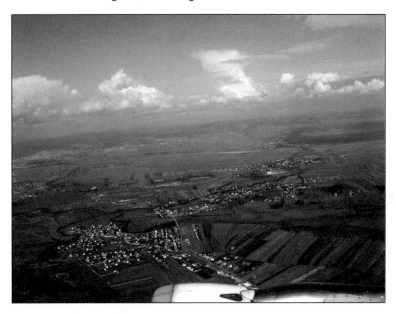

FIGURE 28.6

The view from up above—shot through the window of an airplane in flight.

Let's start with focus. You want to focus *through* the window, not *on* the window. In most instances, this means using manual focus, because your camera's auto focus system gets confused by the hard windowpane.

This advice also applies to exposure. You want to expose for the scene on the other side of the glass, not for the side where the camera is. If you're using auto exposure (which is okay to do), make sure you're aiming through the glass at the subject on the other side.

Then there's the issue of reflections. The last thing you want is to see a reflection of yourself in the photo you take; in fact, you want the photo to look as if there's no glass there at all. The key here is to move the camera as close to the window as possible. The closer the lens is to the window, the less likely you are to see reflections of objects on this side of the glass—including you, the photographer.

In addition, you can use your left hand to cup around the camera lens, thus shielding it from reflections to some degree.

Finally, don't forget the standard admonition to turn off your camera's flash. If you use the flash, all you'll see in the shot is the flash reflecting off the glass. Flash is a bad thing when trying to shoot out a window.

> **STOP** Although you want to get the lens close to the window, don't rest it *on* the window. This can actually result in unwanted camera shake, as you won't be supporting the camera properly against your body.

Underwater Photography

The final type of photography we discuss is one that not everyone has access to. Underwater photography requires not only water (and we're talking oceans here, not bathtubs) but also the ability to swim or dive through that water. Before you can shoot stunning underwater shots, you need to be experienced in snorkeling or scuba diving.

Assuming you have the proper diving gear and a place to dive, you then have to consider what type of photography equipment to use. You can't take a normal digital camera underwater as-is; you'll short out all the electronics at the first dip. Instead, you need either a special underwater housing for your camera or a dedicated underwater camera. Although relatively low-cost waterproof point-and-shoot cameras exist, if you're playing in the D-SLR world, waterproof housings and cameras SLR can set you back a pretty penny.

When shooting underwater, most of your shots will be wide angle with the subject in the foreground, or close-up/macro shots of individual fish or plant life, as shown in Figure 28.7. You don't see many distance shots underwater, shot with telephoto lenses, and for good reason; light gets absorbed as it travels through water. The longer the shot, the less light you get.

For this reason, ditch your camera's telephoto or zoom lens (if you're using a D-SLR) and use a wide-angle lens instead. If you're using a dedicated underwater camera, it should come with a wide-angle lens standard.

Speaking of light, not all types of light get absorbed at the same rate. Warmer colors (reds and yellows) get absorbed faster than cooler colors (blues and greens). This is why most underwater shots have a blue or blue/green tint. And the farther away you are from the subject, the bluer the shot is.

 As discussed in Chapter 3, "Choosing a Digital Camera," underwater cameras are available from Bonica (www.bonicadive.com), Sea & Sea (www.seaandsea.com), and SeaLife (www.sealife-cameras.com).

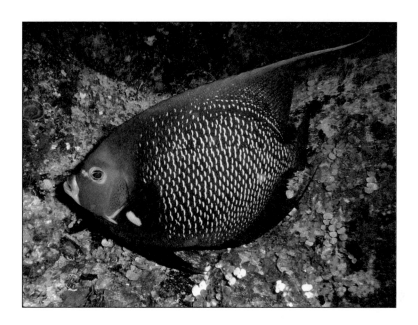

FIGURE 28.7

An example of close-up underwater photography.

So if you want perfect color, you need to shoot close up—with plenty of light. Because most of the natural light is absorbed the farther you dive beneath the surface, you have to supply the light yourself, via an underwater flash unit, like the one shown in Figure 28.8. It's safe to say that this type of external flash unit is a required piece of equipment for any serious underwater photographer.

The nice thing about shooting underwater is that sea life isn't as afraid of you as land animals are. As long as you don't make a lot of sudden movements, fish of all kinds will come right up to your lens. And remember, the best shots are the closest ones—so let the fishies get close, and then start shooting.

Underwater flash units are often called *strobes*.

28

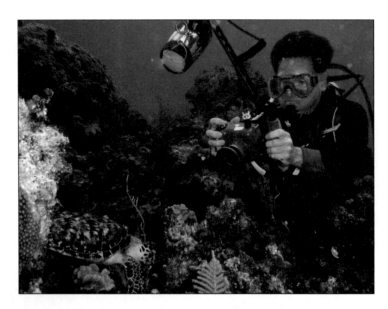

FIGURE 28.8

Getting up close and personal with a curious turtle—shooting with an underwater camera and flash unit.

EXPECT THE UNEXPECTED

Whether you're shooting at night or during the day, underwater or on dry land, you have to be ready for the shot you least expect. Good photography is about preparation, yes, but it's also about being ready when a great shot presents itself.

Some photographers wait all their lives for a money shot, only to be caught unprepared when it happens. You can't have your camera in your hand with your finger on the trigger 24/7, but you can be comfortable enough with your camera and your skills to take a fast shot when necessary. That means knowing where all the important controls are on your camera, and how to use them. Automatic exposure and focus modes are best for capturing surprise shots, but you should also be able to quickly switch to manual modes when necessary.

In short, you have to train yourself to aim, meter, adjust, and shoot within a matter of seconds. Let's face it; when the photograph is important, you can't be too prepared.

Photo Printing and Sharing

29

Printing Your Photos

You've taken a great photo, and then touched it up in Photoshop. Now you want to create a print of that photo, to put on your desk or hang on your wall or pass around to friends and family.

Creating a photo print can be as simple as pressing the Print button in a photo editing program or taking your camera's memory card to a photo processing service. But how do you guarantee the best results—a photo print that accurately reproduces your original photograph?

Optimizing Your Files for Printing

The first step in creating a great photo print is optimizing your file for printing. That involves touching up the photo as necessary, cropping the photo to the right size for your print, setting the proper resolution, and choosing the right file format. We'll look at each of these processes.

Touching Up the Photo

A photograph might be great right out of the camera. Or not. In any case, a little touch-up in your favorite photo editing program might help to make a better-looking print.

Learn more about monitor calibration in Chapter 2, "The Digital Darkroom."

We discussed basic photo touch-ups in Chapter 19, "Touching Up and Editing Your Photos," so I won't repeat that information here. But know that a slight adjustment of an image's levels and color balance can make a world of difference to the finished print.

Also know that what looks good on your computer monitor might not look as good on a hard-copy print. That's because most users adjust their monitors by hand in an attempt to create images that look good to their eyes. But what your eye perceives as "right" might not be totally accurate. To that end, I recommend you use a monitor calibration device to professionally calibrate your monitor to generally accepted color and brightness levels. If you do this, what you see onscreen will accurately represent what will eventually be printed.

Cropping to a Standard Print Size

Have you ever printed a photo, only to find part of the image cropped off at the sides? This happens when your photo is one size and your print is another; the excess image has to be cropped off to fit.

The problem is when you leave this cropping to your printer or print program. The cropping is somewhat arbitrary; you could end up losing something important—like someone's head. A better approach is to crop the image yourself before you send it to your printer. This way you have control over the contents of the final printed image.

Both Adobe Photoshop Elements and Adobe Photoshop CS provide a way to accurately crop your photos to specific print sizes. When you select the Crop tool, the options bar displays Width, Height, and Resolution boxes, as shown in Figure 29.1. Enter your desired dimensions into these boxes, and your printer's dpi or ppi setting into the Resolution box. For example, to create a precise 8×10-inch portrait print for a 200 ppi printer, type 8 into the Width box, **10** into the Height box, and **200** into the Resolution box. When you select the crop area, the height and width automatically adjust in conjunction with each other. The result is a cropped picture that prints at the precise size you specified.

FIGURE 29.1

The options bar for the Crop tool in Photoshop CS.

Setting Resolution

Note that one of the settings you can configure when you crop your photo is
resolution—the number of pixels or dots per inch. Resolution is important, as
you want to precisely match the output resolution of your printer.

You can change the resolution of an image without cropping. All you have to
do is select Image > Image Size to display the Image Size dialog box, shown in
Figure 29.2. Uncheck the Resample Image option and then enter the resolu-
tion of your printer into the Resolution box. When you click OK, Photoshop
resizes the image to the resolution you selected. (The total pixel count remains
the same, so this change doesn't affect the quality of the original image.)

FIGURE 29.2

Use the Image Size dialog box in Photoshop CS to change the resolution of an image.

Choosing the Right File Format

The file format you choose for your photo also affects the print quality.
Obviously, you need to convert raw-format images into another file format for
editing and printing, but you may also want to convert your other photos to
another file format.

If you're using a home printer, the JPG format is fine for printing; make sure
you choose the highest quality setting for best print quality. But if you're send-
ing your photos to a professional printing service, especially if they're larger-
sized prints, consider using the TIF format instead. TIF files have less

compression, and thus fewer compression artifacts. For quality prints, the difference is noticeable.

You choose the file format when you first save a photo. Select File > Save As and Photoshop CS displays the Save As dialog box. Choose your file format and click the Save button; then Photoshop displays another dialog box with options for the file format you selected. For example, Figure 29.3 shows the options available when you save a JPG-format file. The key option here is the Quality setting; select a higher-quality setting to reduce compression artifacts and produce a cleaner print (and a slightly larger file, as well).

FIGURE 29.3
Setting JPG file options in Photoshop CS.

Creating Photo Prints

There are three ways to print your photos—on a home printer, at a local photo processing service, or over the Web via an online printing service. We'll look at each in turn.

Printing at Home

For most casual photographers, creating photo prints at home is an affordable option. All you need is a low-cost photo printer, the right ink for the printer, and the right type of photo paper. Depending on your equipment and supplies, a 4×6-inch print costs between 25 and 50 cents, not counting the amortization of the printer itself.

For best results, use paper specially designed for photo prints. While you *can* print on regular printer paper, the results will be less than stunning, and the prints will fade over time. Photo paper holds more vivid colors and doesn't fade nearly as fast.

Learn more about different types of photo printers in Chapter 2.

You can print directly from your photo editing program. In Photoshop CS3, select File > Print to display the Print dialog box, shown in Figure 29.4. From here you can configure a number of settings, although for most prints you only need to fiddle with a few key ones:

FIGURE 29.4

Printing a photo from Photoshop CS.

- To fit the image onto the paper size, check the Scale to Fit Media option.

- To change the print from portrait to landscape orientation, click the Page Setup button to display the Properties dialog box; select the Layout tab, and then pull down the Orientation list and select Landscape.

- For most users, the best results come from letting your printer determine how colors are mapped from Photoshop to the printer. To do this, select Color Management from the list at the top right; then pull down the Color Handling list and select Printer Manages Colors. If you're an advanced user, you can instead select Photoshop Manages Colors and then select a specific profile from the Printer Profile list.

Those settings made, click the Print button to print the photo.

Other programs offer other print options. For example, when you select File > Print in Photoshop Elements, you see the Print Preview dialog box shown in Figure 29.5. This is a slightly more user-friendly dialog box than that offered

in Photoshop CS, especially when it comes to creating specific-sized prints. Just pull down the Print Size list and select from the most common sizes for photo prints; the preview window shows you what the photo looks like at that size, including any automatic cropping necessary.

FIGURE 29.5

Printing a photo from Photoshop Elements 6.

Printing at a Photo Processing Service

If you don't have a photo printer at home, or prefer more professional prints, you can take your photos to a photo processing service instead. Many different outlets offer photo processing, from your local drugstore or supermarket to traditional camera stores.

Most photo processors accept your photo files on a number of different media. Most services accept your camera's memory card; many also let you burn your photos to a CD and submit that.

In many locations, the printing service is via a self-serve kiosk. Just insert your memory card or photo CD, follow the onscreen instructions, and come back a half hour later for your finished prints.

Depending on the service, you'll probably have a choice of print size and paper type (glossy or matte, bordered or borderless). Prints should cost about the same as those you make yourself with a home printer. Just make sure that your processor accepts your particular file type. (Almost all print JPG files; most but not all print TIF files.)

Printing from an Online Photo Printing Service

Thanks to the Internet, you don't have to leave your home to obtain professional-quality prints. Numerous online photo printing services let you upload your photos to their site from your web browser, and then send you the finished prints via postal mail.

The quality of prints from these online services is similar to the quality of prints from your local photo processor. Pricing is in the same range as local services, and sometimes much lower.

Some of the most popular online photo printing services include

- FotoTime (www.fototime.com)
- ImageEvent (www.imageevent.com)
- Kodak EasyShare Gallery (www.kodakgallery.com)
- PhotoWorks (www.photoworks.com)
- Printroom.com (www.printroom.com)
- Shutterfly (www.shutterfly.com)
- Snapfish (www.snapfish.com)
- Wal-Mart Digital Photo Center (www.walmart.com/photo/)
- Walgreens Photo Center (photo.walgreens.com)
- Webshots (www.webshots.com)
- winkflash (www.winkflash.com)

Wal-Mart, Walgreens, and some similar sites let you upload your photos and order online, but then pick up your prints at your local store.

29

Many online photo printing services also host photos for online sharing and viewing. Learn more about photo sharing in Chapter 30, "Sharing Photos Online."

Preparing for Professional Printing

Creating photo prints to pass around to friends and family is one thing. Preparing a photo for print in a professional publication is another. While space doesn't permit an in-depth look at professional printing, we'll present a brief overview of the issues involved.

Understanding Color Spaces

When you're printing for publication, in either a magazine or book (like this one), you have to deal with the issue of *color spaces*. In brief, a color space specifies how color information is represented on a particular device or in a specific medium. The color space defines the range or gamut of colors available.

As you first learned in Chapter 12, "Color," transmissive media (such as computer monitors and television sets) use the RGB (red, green, blue) color space. Reflective media (such as books and magazines) use the CMYK (cyan, magenta, yellow, black) color space. Other color spaces are available, but these two are the most common—and the easiest to understand.

The chart in Figure 29.6 shows how the RGB and CMYK color spaces compare. As you can see, they're subtly different; neither one re-creates the full range of available colors. Because of this difference, the photo you view on your computer monitor won't look quite the same in print—unless you convert the image from RGB to CMYK.

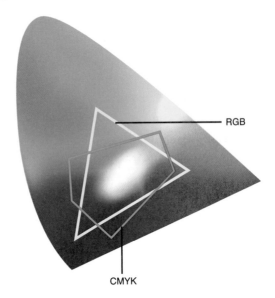

RGB

CMYK

FIGURE 29.6

Comparing the RGB and CMYK color spaces.

Converting RGB Files for CMYK Printing

For more control over the appearance of a photo in print, it's best to convert it from RGB to CMYK prior to printing. You should do your basic editing and enhancement in RGB, and then convert to CMYK and perform any fine-tuning necessary to compensate for color changes in the conversion.

To convert from RGB to CMYK in Photoshop CS, select Image > Mode > CMYK. Photoshop automatically modifies all the colors in your original image to their nearest CMYK values. After the conversion takes place, examine the image for any unwanted color variations, and correct them as needed.

The standard RGB color space is sometimes referred to as sRGB; it's a 24-bit color space with 16.7 million possible colors. Adobe has its own proprietary RGB color space, dubbed Adobe RGB, which is wider than the sRGB color space. Adobe RGB has the same number of colors as sRGB, but the colors are more widely dispersed from the central area. When editing photos for Web use, use sRGB; if you need a wider gamut of colors for print publication, Adobe RGB is useful.

Choosing the Right File Format

When you're sending photos to print in a book, magazine, newspaper, or brochure, you don't want to use the JPG format; it's too compressed for quality printing. The best file format for print purposes is the TIF format, which isn't compressed and doesn't display the compression artifacts typical of JPG photos.

In Photoshop CS, you save your photo in TIF format by selecting File > Save As. When the Save As dialog box appears, select TIFF from the Format list and click the Save button. When the TIFF Options dialog box appears select NONE in the Image Compression section and then click OK. The file is saved with the .TIF extension.

29

WHERE TO PRINT

I'm not a big fan of in-home photo printing. The typical low-cost photo printers you find for home use do a good job, but not a great one. (Higher-cost printers do a better job, but then they cost a lot more.) Low-cost home printers are also slow, and print paper is somewhat expensive. In addition, I always end up wasting a few sheets of that expensive paper trying to perfect the print. These printers are okay for quick and dirty prints, but not for those photos I want to preserve for posterity.

So I definitely prefer using a professional photo printing service. Now the choice is to go online or local. As you might imagine, I have an opinion on this, too.

As to the online photo printing services, I've used several over the years, and they all seem to do a decent job. Not always a great job, however. In fact, that's one of the things I don't like about the online services; they're consistently inconsistent. Send the same photo to three different services, and you'll get three different-looking prints. Heck, send the same print to the same service three times, and you're likely to see differences between the prints. And since you're dealing with a faceless online service, it's a hassle to reprint those photos you don't like.

A better option is to deal with a local processor. Not necessarily the one inside Wal-Mart or Walgreens, but rather the service offered by your local camera store. You'll pay more at your camera store, but the prints should be of consistently higher quality. And if they're not, there's a real person behind the counter to deal with—and that person understands photography. That's better than the clerk at your local pharmacy or supermarket, who probably doesn't know an f/stop from a shortstop. As with all things photography-related, it's always better to deal with someone who knows the subject.

30

Sharing Photos Online

N ot all photographs are shared via print. In the world of digital photography, many photographers like to share their work over the Internet, via email, or on websites and blogs.

Sharing photos online isn't quite the same as sharing prints, however. There are specific steps you need to take to make your photos online-friendly. Read on to find out more.

Reducing Image Size for Online Use

Here's the thing about sharing photos online—a computer screen is only so big. A photo that's larger than the viewer's computer screen contains wasted resolution. Large photos are either automatically downsized to fit within the web browser window, or you only see part of the photo at a time.

If you're sure all your viewers are using newer computers and monitors, you can stretch the picture size to 1280×800—the resolution of a modern widescreen laptop PC screen.

Why Multimegapixel Photos Are Overkill

That's one reason why a multimegapixel picture is overkill on the Web. To best fit in most users' browsers, you want a photo's resolution to not exceed 800 pixels wide by 600 pixels tall. That's a big contrast to the 3,000×2,000 pixel resolution of a 6 megapixel camera; as I said, a lot of wasted pixels.

Another reason to reduce your photos' resolution is the size of the resulting file. A 6 megapixel JPG photo at the highest quality setting can run up to 1.5MB in size. A file that size takes a long time to download and view on the Web (especially over slower dial-up connections) and is cumbersome to email. In fact, some Internet service providers limit the size of file attachments you can send with your email messages, and big photos can end up getting rejected.

All this is to emphasize the point that while you want to shoot all your photos at a high resolution (for editing, archival purposes, and possible printing), you'll need to downsize those photos if you intend to send them via email or post them to the Web. (That includes any photos you want to include in your eBay product listings, of course.)

Saving Photos for Online Use

Fortunately, most photo editing programs include multiple ways to reduce the resolution of your photos. You may have to use the "image size" control, or there may be a separate "save for the Web" control. In either case, you want to convert the photo to JPG format and change the resolution to the parameters discussed previously.

In Photoshop CS, the easiest way to do this is to select **File > Save for Web & Devices**. When the Save for Web & Devices window appears, as shown in Figure 30.1, select JPEG Medium from the Preset list; this is a good compromise setting that achieves a decent picture quality at a relatively small file size. Then select the Image Size tab and enter a new width or height; try not to

exceed 800 pixels for the width and 600 pixels for picture height. Click the Save button, and a version of the image will be saved in JPG format at the resolution you specified.

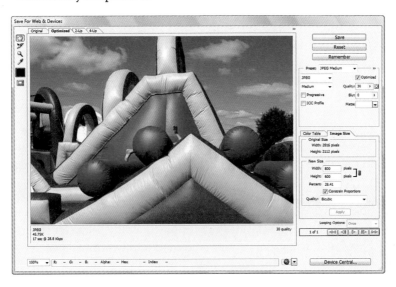

FIGURE 30.1

Using Photoshop to save a photo for the Web.

The result is a photo properly sized for viewing on the Web and sending via email.

Sending Photos via Email

As noted, send too large a file via email and you risk clogging up your outbox or the recipient's inbox. Most ISPs limit how much users can store in their inboxes; some ISPs even place a limit on the size of email attachments. A few 2MB JPG files can stop an email from reaching its intended recipient; don't even think about sending 20MB TIF files.

For this reason, you want to resize your photos before sending them via email to your friends and family. You can do this in just about any photo editing program, as previously described, or within some email programs.

For example, Microsoft Outlook includes an option to automatically resize any pictures you attach to your outgoing email messages. In Outlook 2007, open a new message and click the bottom right of the **Include** tab; this opens the Attachment Options pane. Go down to the Picture Options section and select any of the following from the Select Picture Size list: Small (448×336 px),

Medium (640×480 px), Large (1024×768 px), or Don't Resize, Send Originals. Outlook will automatically resize the photo as it's attached, no work necessary on your part.

Storing and Sharing Photos on the Internet

The Internet is also a good place to share your photos. If you have your own personal website, you can upload your pictures for viewing there. Same thing if you have a blog; most blogs let you include pictures in your blog posts.

Even better are sites designed specifically for photo sharing. There are a number of them on the Web, many of which do double duty as online photo printing services.

Exploring Photo Sharing Sites

Today's photo sharing sites vary in functionality. Some let you create personal photo albums to share with friends and family, while others let you share your photos with the entire Web. The most fully featured sites include topic-oriented groups and communities that let you share photos with like-minded photographers.

The most popular photo sharing sites include the following:

- dotPhoto (www.dotphoto.com)
- Faces (www.faces.com)
- Flickr (www.flickr.com)
- Fotki (www.fotki.com)
- MyPhotoAlbum (www.myphotoalbum.com)
- Picasa Web Albums (picasaweb.google.com)
- Pixagogo (www.pixagogo.com)
- Photobucket (www.photobucket.com)
- Picturetrail (www.picturetrail.com)
- Shutterfly (www.shutterfly.com)
- SmugMug (www.smugmug.com)
- Snapfish (www.snapfish.com)
- WebShots (www.webshots.com)
- Zooomr (www.zooomr.com)
- Zoto (www.zoto.com)

Most of these sites offer some sort of free membership, which sometimes has limited functionality. Some sites offer paid memberships with more advanced features; other sites make their money by offering photo printing services.

Using Flickr

Of all these sites, far and away the most popular among hobbyist and professional photographers is Flickr. As you can see in Figure 30.2, Flickr creates a home page for each photographer, where photos are grouped into "sets." From here you can click an photo to view it fullscreen, or choose to view all photos as an onscreen slideshow.

View many of the photos from this book on Flickr, at www.flickr.com/photos/ 12150723@N06/. (My Flickr name is PhotopediaPhotos.) Photos from photo editor Sherry Elliott, myself, and several other contributors are listed in the Photopedia Photos set; photos from other Flickr members can be found on the Favorites tab.

Flickr also lets you find geotagged photos by location on a world map and explore the site's many topic-specific photo groups. The groups not only display photos from group members but also include discussion forums where members can talk about the topic at hand.

Uploading photos to Flickr is as easy as clicking a few links (after you've opened your free account, of course). Just go to Flickr's home page and click the Upload Photos link. You're then prompted to choose the files to upload and add tags and descriptions to each photo. The photos you upload are then added to your personal page, for anyone (or selected users, if you made the photos private) to view.

FIGURE 30.2

The Flickr page for this book.

Flickr and similar sites are a great way to find inspiring photographs, meet other photographers, and share my own photos. In fact, several of the photographers who contributed to this book have their own Flickr pages—and we used Flickr to find many of the individual photographs included in these pages!

DIGITAL PHOTOGRAPHY: A FINAL WORD

If you've read this far in the book, you know how fun and interesting digital photography can be. You've probably picked up a few new techniques and are looking forward to experimenting with different types of photos. I hope that's what's happened, anyway; that's why I wrote this book.

Photography is not only a great way to capture your friends and family in time and space, but it's also a rewarding hobby—and, for the most serious among us, an expressive art form. It's easy enough, at its most basic, for anyone to attempt; the low cost of today's digital cameras provides an affordable entry point for even casual photographers. And as you get more serious (and spend more money on higher-end equipment), you can obtain higher-quality results, almost as good as the pros.

The thing to remember, though, is that no matter how serious you might get about your photography, always try to have fun. Yes, you can obsess about f/stops and lighting angles, but it's not worth doing if it's not fun. Advance your skills as you like, but make sure that what you're doing is enjoyable. The best photographs capture a certain joy, and that's something you as the photographer have to provide.

So keep learning, keep shooting—and keep having fun!

30

Glossary

35mm The most popular film size, 35 millimeters wide, used in most point-and-shoot and SLR film cameras.

45-degree lighting See *Rembrandt lighting*.

action mode See *sports mode*.

adapter tube See *lens adapter*.

additive color The color model used in transmissive media, such as computer monitors and television displays. In this model, all colors are created by blending red, blue, and green together. Also known as *RGB color space*.

Adobe RGB color space A proprietary RGB additive color space used in Adobe photo editing products; contains the same number of colors as the sRGB color space, but with the colors more widely dispersed.

antishake See *image stabilization*.

aperture The size of the opening of a camera's iris, measured in terms of f/stops. The relationship between aperture and f/stop is reciprocal; a large aperture has a small f/stop number, and a small aperture has a large f/stop number. A wide aperture (small f/stop number) lets more light into the camera and results in a shallow depth of field, while a small aperture (large f/stop number) lets less light into the camera and results in a wider depth of field.

aperture priority Determines exposure by manually setting aperture (f/stop); shutter speed is automatically set as appropriate.

artifact Blockiness in an image caused by too low a resolution or too much compression.

aspect ratio The relationship between an image's width and height. Most point-and-shoot and prosumer cameras create images with a 4:3 aspect ratio (4X wide by 3X high); most digital SLRs (D-SLRs) create images with a wider 3:2 aspect ratio (3X wide by 2X high).

auto focus Technology that uses reflected infrared light to automatically focus the camera lens on the desired subject.

automatic shooting mode On a digital camera, preconfigured combinations of aperture and shutter speed used for specific shooting situations.

backlighting Lighting with the light source (natural or artificial) positioned directly behind the subject. Backlighting can be either standalone or used to supplement traditional front or side lighting.

barndoor A hinged flap that attaches to a light's reflector; used to direct the light and control how wide or narrow an area the light covers.

Bayer array A specific pattern of colored filters used in a digital camera's image sensor, with twice as many green sensors as those for red and blue.

black-and-white photography Photographs taken sans color. Because some digital cameras take color photos only, color may need to be removed to create a black-and-white image.

blur An area of an image not in focus, created by movement of either the subject or the camera, or by a shallow depth of field.

bounce flash See *bounce lighting.*

bounce lighting Light bounced off a wall or ceiling or reflector so that it does not shine directly on the subject.

bracketing The act of taking three successive shots at a set exposure and one or more f/stops above and below that exposure.

broad lighting Studio lighting scheme that uses a single light, positioned to illuminate the side of the face turned toward the camera. Useful for making thin faces appear wider.

burn In the darkroom or digital darkroom, providing additional exposure to a selected area to lighten that area in the finished photograph.

burst mode A shooting mode that takes multiple shots in rapid succession, typically by holding down the shutter release button.

butterfly lighting Studio lighting scheme that uses a single main light, positioned in line with the camera directly in front of the camera's face, but above the camera. Associated with glamour photography of the 1930s and 1940s.

byte A basic unit of measurement of computer file size. The equivalent of 8 bits or one single character.

calibration The process of adjusting a computer monitor to accurately represent the colors and levels of a printed photograph.

CCD Charge coupled device; a type of image sensor used in digital cameras.

center spot filter A filter that diffuses the light around a clear center spot; used to create a soft-focus effect surrounding the main subject.

CF See *CompactFlash.*

channel One of the three primary colors (red, green, and blue) in an image; each color has its own channel.

chroma The color information in an image.

CMOS Complementary metal oxide semiconductor; a type of image sensor used in digital cameras.

CMY color space The gamut of colors used in the reflective color process; the three primary colors in this space are cyan, magenta, and yellow.

CMYK color space The gamut of colors used in the reflective color process, supplemented by a separate black (K) layer; the three primary colors in this space are cyan, magenta, and yellow.

color cast A color temperature that is different from pure white.

color correction The act of adjusting an image's color to more accurately reflect the original scene's white balance.

color depth A measurement of how many colors are capable of being reproduced, counting the number of bits assigned to each pixel in an image. A 24-bit color depth can reproduce 16.7 million different colors.

color filter A filter used to correct color temperature or add a color cast to an image. In black-and-white photography, color filters are used to accentuate the contrast between dark and light areas.

color management The process of mapping specific colors from one color space to another.

color space The range or gamut of colors available on a particular device or in a specific medium.

color temperature The color of white light measured in degrees Kelvin.

CompactFlash A type of flash memory card used in some higher-end digital cameras. Storage capacities run to 8GB.

composition The selection and arrangement of subjects within the picture area.

compression A process that reduces the amount of information in an image in an attempt to create smaller-sized files. Compression can be lossless (retains all the original picture information) or lossy (eliminates less-important picture information).

cone A cylindrical device that attaches to a light's reflector; serves to produce a round patch of light.

continuous lighting Studio lighting that remains on during and between photographs.

continuous shooting mode See *burst mode*.

contrast The difference between tonal levels in an image.

contrasting colors Colors that are opposite each other in the color spectrum.

conversion lens A lens that screws onto the front of another lens and converts it to a wide-angle or telephoto lens.

cool light White light with a higher color temperature, which has a slightly blue cast.

cropping The process of removing excess areas from the edges of an image in an attempt to better compose a photograph.

curve The continuous tonal scale of an image; brightness and contrast can be adjusted by changing any point along the curve.

darkroom In film photography, a small room used to develop film negatives.

deep focus The process of maintaining sharp focus across the entire focal plane of an image; both the foreground and background are in focus.

depth of field How much of the shot, front to back, that is in focus. Depth of field can be shallow (only part of the image in focus) or wide (all of the image in focus).

depth of focus See *depth of field*.

desaturate The reduction or removal of color information from an image.

diaphragm See *iris*.

diffuse lighting Lighting that is low or moderate in contrast; the opposite of harsh direct lighting.

diffuser A translucent piece of glass or plastic that fits over a light source; used to diffuse the otherwise direct light.

diffusion filter A filter that diffuses the incoming light; used to create a soft-focus effect.

digicam Another word for digital camera.

digital darkroom A catch-all term for the entire post-camera editing process in digital photography.

digital photography The art of photography as accomplished with a digital camera and digital image processing.

digital SLR camera The digital version of the traditional film single lens reflex (SLR) camera. Typically a higher-priced camera with a mix of automatic and manual operation, offering a viewfinder that sees through the camera lens, faster operation and burst mode, and the choice of interchangeable lenses.

digital zoom Zoom effect enabled by a camera's electronic circuitry; not a true optical zoom.

direct lighting Harsh light that shines directly on the subject; often creates unwanted highlights and reflections.

dodge In the darkroom or digital darkroom, reducing exposure for a selected area to darken that area in the finished photograph.

dots per inch (DPI) A measurement of printer resolution; the number of dots printed per inch. Identical to pixels to inch.

DPI See *dots per inch.*

drum scanner A typically high-priced scanner used to create high-resolution scans of prints and film negatives; the item to be scanned wraps around a rapidly spinning drum that contains the scan head.

D-SLR See *digital SLR camera.*

dynamic range A measurement of the difference between extreme light and dark areas of an image.

equivalent focal length The focal length for a digital camera lens translated into the corresponding values for a 35mm film camera.

EV See *exposure value.*

EXIF Exchangeable Image File Format; a standard for storing metadata about digital photographs.

exposure The amount of light that falls on the camera's image sensor when taking a photograph. The exposure is a function of shutter speed, aperture setting, and film speed.

exposure value (EV) A measurement of exposure in terms of shutter speed/aperture combinations. A value of 1 EV corresponds to the difference of one f/stop.

external flash A flash device, sometimes called a *speedlight,* that mounts on a camera's hot shoe; external flash units provide more powerful and flexible lighting than a camera's built-in flash.

feather When editing a photograph, the technique used to soften the edges of a selection, by blurring the transition from one area to the next.

fill flash See *fill lighting.*

fill lighting Lighting (either flash or studio) used in addition to available light to fill in and lighten shadows.

film scanner A scanner used to scan color film negatives, slides, and transparencies.

filter A transparent or translucent optical element placed in front of a camera lens that somehow modifies the light entering the camera lens.

FireWire A high-speed data transfer technology. Similar to but faster than USB; also known as IEEE 1394.

flash In photography, a camera's built-in light that "flashes" momentarily when a shot is taken.

flashgun See *speedlight.*

flash memory A type of electronic storage used in digital camera memory cards.

flash sync The ability to control external flash systems from a digital camera, typically via a sync cable or the camera's hot shoe.

flat An item that is low in contrast.

flat lighting Studio lighting scheme that uses two lights, each positioned 45 degrees on either side of the subject; produces a flat lighting effect that minimizes shadows on the subject's face.

flatbed scanner A scanner, typically used to scan photo prints, in which the item to be scanned rests on a clear glass plate and the scan head travels beneath the plate.

focal length In a camera lens, distance between the focal plane and the point where lens is focused on its farthest point (infinity).

focus A lens adjustment used to converge the incoming rays of light to form a sharp image.

focus lock The ability to prefocus on a subject and lock that focus by depressing the camera's shutter release button halfway.

focus point That part of the frame that is used to focus the camera; most digital cameras have multiple focus points that can be used.

focus range The range in which a camera or lens can focus on the selected subject.

front curtain sync Flash mode where the flash fires at the beginning of the exposure, just after the shutter opens; creates a stream of light ahead of a moving object.

front lighting Lighting with the light source positioned directly in front of the subject.

f/stop A measurement of lens aperture. The lower the f/number, the larger the aperture, the less light required for proper exposure, and the shallower the depth of field; the higher the f/number, the smaller the aperture, the more light required for proper exposure, and the deeper the depth of field.

gamma A measure of contrast in photographic images; a curve that defines the brightness level of midtones.

gamma correction The adjustment of tonal ranges in an image, typically by editing the tonal curve.

gamut The range of colors in a specific color space.

Gaussian blur An image-softening technique that utilizes a bell-shaped Gaussian distribution.

GB Gigabyte; a thousand megabytes.

gel A colored gelatin filter placed in front of a light source; used to correct white balance, change the color of the background, or create dramatic lighting effects.

GIF Graphics Interchange Format; a digital image file format widely used for illustrations on the Web. The high level of lossy compression makes the GIF format unsuitable for photographic images.

gobo A black card placed in front of a light source to block the light; derived from the phrase "go between."

graduated neutral density filter A filter that reduces brightness in only part of the frame; typically used to darken overly bright skies.

grain Sand-like or granular specks in a photographic image.

grayscale An image made up of varying tones of black and white; an image with no color information.

hair light A supplemental light positioned slightly behind the subject, used to highlight the subject's hair against a dark background.

harmonizing colors Colors adjacent to each other on the color spectrum.

high contrast An image with a wide range of tonal values; a large difference between dark and light areas.

highlights The brightest areas of an image.

histogram A graph that displays the distribution of tones in an image.

hot shoe The connector at the top of many prosumer and D-SLR cameras that lets you connect an external flash unit.

hue Color value; tint. Distinct from saturation, which is the amount of any given color in an image.

hyperfocal distance Distance between the lens and the nearest point that is in focus when the lens is focused on infinity (the *hyperfocal point*).

hyperfocal point The nearest point that is in focus when a lens is focused on infinity.

IEEE 1394 See *FireWire*.

image sensor A light-sensitive electronic microchip used to capture images.

image stabilization Technology that steadies the camera lens or image sensor to counteract unwanted camera movement.

infinity The farthest point on which a lens can focus; that point where the lens is moved as close as possible to the focal plane.

interchangeable lens A lens that can be removed from a camera and swapped with another lens with a similar mount. In digital photography, D-SLR cameras have interchangeable lenses, which let you use lenses of different focal lengths.

iris The physical mechanism on a camera that is opened or closed to change the size of the aperture.

ISO A measurement of sensitivity of a digital camera's image sensor or the film in a film camera, based on a scale published by the International Organization for Standardization. A higher ISO requires less exposure; a lower ISO requires more exposure.

JPG or JPEG A digital image format that uses lossy compression to reproduce both color and black-and-white photographs. Perhaps the most popular file format for photographic images due to its ability to create smaller file sizes, even though it is a heavily compressed format that often results in images with noticeable compression artifacts.

landscape mode Automatic shooting mode used to shoot outdoor landscapes; typically sets a small aperture for a wide depth of field.

landscape orientation An image oriented horizontally; that is, an image wider than it is tall.

layer When editing a digital photograph, a semitransparent level used to adjust or enhance the underlying background level in a nondestructive manner.

LCD On a digital camera, the liquid crystal display on the back of the camera that displays the camera's menu system, provides a view of the current shot, and plays back previously taken photographs.

LCD hood A device that fits over a camera's LCD display to block ambient light and make it easier to view the display.

lens Optical element capable of bending and focusing light; in a digital camera, the lens is used to collect light onto the camera's image sensor.

lens adapter A device that fits over the lens mechanism on a point-and-shoot camera to enable the attachment of conversion lenses and filters.

lens converter See *lens adapter*.

lens hood A device that fits over the end of a camera lens to block excess light from entering the sides of the lens.

lens speed The largest aperture (lowest f/number) at which a lens can be set. A fast lens transmits more light than a slower lens, and thus can be used in lower lighting conditions.

lens tube See *lens adapter*.

levels The relative intensity of an image's tonal values—shadows, midtones, and highlights. Used to precisely adjust brightness and contrast.

light box See *light tent*.

light meter A device used to measure the amount of light falling on or reflected by an object; used to calculate exposure settings.

light tent A translucent cube or tent, typically lit from the outside, used to photograph small objects.

lossless compression A compression scheme that discards none of the original picture information; the most popular lossless format is the TIF format.

lossy compression A compression scheme that achieves smaller file sizes by removing less-important pieces of an image; the most popular lossy format is the JPG format.

luminance Brightness.

macro lens A lens specially designed for photographing small objects close up.

macro mode Automatic shooting mode used for shooting close-up objects; enables close focusing with a shallow depth of field.

macro photography The art of taking close-up photographs of very small objects; typically uses special macro lenses or camera macro settings.

manual shooting mode The ability to manually set aperture and/or shutter speed on a digital camera.

MB Megabyte; one million bytes.

media card See *memory card*.

media card reader A device used to transfer information from flash memory cards to a computer.

medium gray A grayscale value of 18% gray; reflects 18% of light.

megapixel One million pixels; a measurement of the resolution of a camera or image.

memory card A small cardlike storage medium that incorporates flash memory; used to store image files taken with a digital camera. There are many different memory card formats, the most popular of which include SD, CompactFlash, and Memory Stick.

Memory Stick Sony's proprietary flash storage media, used in its own brand of digital cameras. Available in standard, Duo, and PRO Duo formats; storage capacities run to 8GB.

midtones The middle tonal values of an image.

MMC MultiMediaCard; a small flash memory card format used in some early digital cameras.

moiré An unwanted pattern generated by scanning an image that already contains a dot pattern.

monochrome See *black-and-white photography*.

monopod A single-legged camera support; like a tripod but with only one leg.

negative Developed film that contains a tonally reversed image of the original scene.

neutral density filter A filter that reduces the amount of light entering the camera, darkening all or part of the picture.

night landscape mode Automatic shooting mode used to shoot in low-light situations; typically sets a wide aperture and slow shutter speed with no flash.

night portrait mode Automatic shooting mode used to shoot portraits in low-light situations; typically sets a wide aperture and slow shutter speed with foreground flash.

normal lens A lens with a focal length between 35mm and 65mm.

operating speed How fast a camera can focus and take a shot.

optical viewfinder The eyepiece on a camera that the photographer looks through to compose the shot.

optical zoom Zoom capability enabled by the camera's lens.

overexposure The result of too much light entering the camera; creates too light an image.

panning The technique of moving the camera so that a moving subject remains in the same relative position in the frame as the subject moves.

panorama An extra-wide image stitched together from multiple photographs.

panoramic camera A camera specially designed to take wide landscape, panoramic, and 360-degree photographs.

parallax error The difference between what the camera's viewfinder sees and what the camera records—which is not always the same, due to the offset of the viewfinder. There is no parallax error in D-SLR cameras, because the viewfinder sees through the lens.

photo editing program Computer software used to edit and enhance digital photographs. The most popular professional-level photo editing program is Adobe Photoshop CS.

photo management program Computer software used to organize digital photos. Consumer-level photo management programs often include basic photo editing functions; professional-level programs are designed to mimic the workflow of professional photographers.

photo printer A computer printer designed specifically for creating photo prints; typically uses special inks or dyes, along with special photographic paper.

photoflood A low-cost continuous lighting unit, typically using incandescent bulbs.

Photoshop Adobe's family of photo editing programs. Programs include the web-based Photoshop Express, the consumer-level Photoshop Elements, and the professional-level Photoshop CS. The Photoshop family also includes Photoshop Lightroom, a professional-level photo management program.

pixel The smallest element of a digital image. Used to measure camera or image resolution in terms of pixels per inch.

pixels per inch (PPI) A measurement of digital image resolution; the more pixels per inch, the higher the resolution and the sharper the picture.

plane of focus The area inside a camera where light rays refracted through the lens re-form an image of the subject.

point-and-shoot camera A low-cost digital camera with primarily automated operation and a limited zoom lens.

polarization The effect of light waves aligned in a single direction. By changing the angle of the light waves, glare can be induced or reduced.

polarizing filter A filter that polarizes the incoming light; used to reduce or remove glare and reflections.

portrait mode Automatic shooting mode used for portrait photography; typically sets a large aperture for a shallow depth of field.

portrait orientation An image oriented vertically; that is, an image taller than it is wide.

positive The opposite of a film negative; an image with the same tonal relationships as the original scene.

PPI See *pixels per inch*.

primary colors Those main colors from which all other colors are created (by mixing different amounts of the primary colors). In the RGB color space the primary colors are red, green, and blue; in the CMY color space, the primary colors are cyan, magenta, and yellow.

print In photography, a positive hard copy printout of the photographic image.

processing The act of developing exposed photographic film. In digital photography, a photo processor is actually a photo print service.

prosumer camera A midpriced digital camera that balances the ease-of-use and automatic operation of a point-and-shoot camera with many of the manual features of a digital SLR; typically includes a longer (12X or more) zoom lens.

raw A digital image file format that contains all the information of the original image with no compression; the digital equivalent of a film negative.

rear curtain sync Flash mode where the flash fires near the end of the exposure, just before the shutter closes; creates a stream of light behind a moving object.

red eye effect Red eyes in a photographic image resulting from a camera's flash reflecting off the subject's retinas.

reflector A polished metal bowl that attaches around a light source, used to redirect light from the sides of the bulb forward onto the subject.

reflector card A large reflective card that serves to reflect light from the light source onto the subject or background.

refraction The bending of light, as when light strikes the concave surface of a camera lens.

Rembrandt lighting Studio lighting scheme that uses a single light positioned 45 degrees from the camera-to-subject axis. Arguably the most popular and flattering lighting style; can be augmented with a fill light or reflector positioned on the other side of the subject.

resolution Image density, typically measured in pixels per inch (ppi). The higher the resolution, the sharper the image—particularly at large print sizes.

RGB color space The gamut of colors used in the additive or transmissive color process; the three primary colors in this space are red, green, and blue.

rim light A light positioned behind the subject, used to create a halo effect around the subject's head.

ring flash A special flash unit that surrounds the camera lens with lights; used in macro photography.

rule of thirds A method of photographic composition in which the frame is divided into three horizontal and three vertical sections; the subject of the photograph is placed at one of the intersection points of the areas, or along one of the border lines.

saturation The intensity of color in an image.

scanner A device that converts photo film or print images into digital format.

scrim A translucent diffusion panel placed in front of a light source; used to soften the light.

SD Secure Digital; a type of flash memory card used in many digital cameras. Storage capacities run to 2GB.

SDHC Secure Digital High Capacity; a higher-capacity version of the standard SD memory card. Current storage capacities run to 8GB.

secondary colors Those colors that result from the mixing of the three primary colors in a color space. In the RGB color space, these colors are yellow, orange, and violet.

Secure Digital See *SD.*

selective focus See *shallow focus.*

sensitivity The amount of light required to create an acceptable image with a digital camera; measured in terms of ISO.

sepia tone A type of monochrome photographic image with brownish tones instead of the normal grayish tones.

shadows The darkest areas of an image.

shallow focus The process of keeping only the foreground focal plane of an image in focus; the background is blurry and out of focus.

short lighting Studio lighting scheme that uses a single light, positioned to illuminate the side of the face turned away from the camera. Useful when the subject has a wider or oval face.

shutter The mechanical system in a camera that opens to let in light and then closes to complete the exposure.

shutter priority Determines exposure by manually selecting the shutter speed; the aperture is automatically set as appropriate.

shutter speed How long the camera's shutter remains open, measured in seconds or portions of a second. A slow shutter lets more light into the camera, while a fast shutter freezes rapid movement.

side lighting Lighting scheme with a single light source positioned to the right or left side of the subject.

single lens reflex A system of mirrors that sends to the camera's viewfinder the exact image as seen through the lens.

slow sync Flash mode where a small amount of flash is paired with a slow shutter speed. Also known as "fill in" mode.

SLR See *single lens reflex.*

snoot A cylindrical device that attaches to a light's reflector; serves to produce a round patch of light.

soft focus A diffused image; an image with soft edges, typically achieved with a special diffusing or soft focus lens filter.

soft lighting Lighting that is low or moderate in contrast; the opposite of harsh lighting.

softbox A translucent fabric "box" that fits over a light source; used to diffuse and soften the otherwise direct light.

speedlight See *external flash.*

split lighting See *side lighting.*

sports mode Automatic shooting mode used for shooting action scenes; typically sets a fast shutter speed to freeze fast movement.

sRGB color space The "standard" RGB color space used for computer monitors and the Internet. See *RGB color space* for more information.

star filter A filter that turns points of light into sharply defined "stars."

step-down ring An adapter that screws onto the front of a lens and enables the attachment of a filter smaller than the lens size.

step-up ring An adapter that screws onto the front of a lens and enables the attachment of a filter larger than the lens size.

still life A photograph of an inanimate subject or group of inanimate subjects, typically arranged in an artistic manner.

stop A single aperture or shutter speed setting.

strobe lighting See *studio flash.*

studio flash Studio lighting that lights for only the short period of time necessary to take a photograph. Also called *strobe lighting.*

studio lighting Artificial lighting used in a photographic studio.

subtractive color The color model used in reflective media, such as photo prints and magazines. In this model, all colors are created by blending cyan, magenta, and yellow together, often with a separate black ink. Also known as *CMY* or *CMYK color space*.

telephoto lens A lens with a focal length of more than 65mm; typically used to shoot distant subjects.

tertiary colors Those colors that exist between the six primary and secondary colors.

thumbnail A small version of a larger image.

TIF or TIFF A digital image format that uses lossless compression to reproduce both color and black-and-white photographs. The preferred file format for producing high-quality or larger-sized photo prints.

tint See *hue*.

tonal range The shades of gray between extreme dark and extreme light in an image.

tripod A three-legged camera stand.

TWAIN The software standard used by scanner manufacturers that serves as the interface between the scanner hardware and the connected computer.

twin light A special lighting unit that positions two small lights 45 degrees off-axis on either side of the camera lens; used in macro photography.

umbrella Shaped like a traditional rain umbrella, a device that functions as a reflector for studio lighting. (Translucent umbrellas can be used as diffusers as well as reflectors.)

underexposure The result of too little light entering the camera; creates too dark an image.

underwater camera A completely waterproof camera designed for use with the high pressures associated with underwater photography.

unsharp mask A photo editing filter used to sharpen the appearance of soft or blurry pictures; works by adjusting the light and dark lines on either side of the edges of objects.

USB Universal Serial Bus; the most common data transfer technology used in digital photography.

viewfinder See *optical viewfinder*.

vignetting A darkening of the image around the edges, typically caused by obstructions around the outside of a lens.

warm light Light that has a slightly lower color temperature, which has a slightly orange cast.

water-resistant camera A camera, that while not designed for underwater use, is somewhat resistant to rain and water splashes.

weather-resistant camera See *water-resistant camera*.

white balance The calibration of a camera (or compensation in a photo editing program) to record or display true white.

wide-angle lens A lens with a focal length of less than 35mm; typically used to shoot landscape photos.

workflow The steps involved in shooting, managing, editing, and printing digital photographs.

xD-Picture Card A type of flash memory card used primarily in Olympus point-and-shoot digital cameras.

Zone System A technique for determining exposure using a segmented chart of tonal values; especially useful in black-and-white photography. Developed by photographers Ansel Adams and Fred Archer.

zoom lens A lens that is capable of variable focal lengths.

Index